Aboriginal Art Howard Morphy

ART&IDEAS

Φ

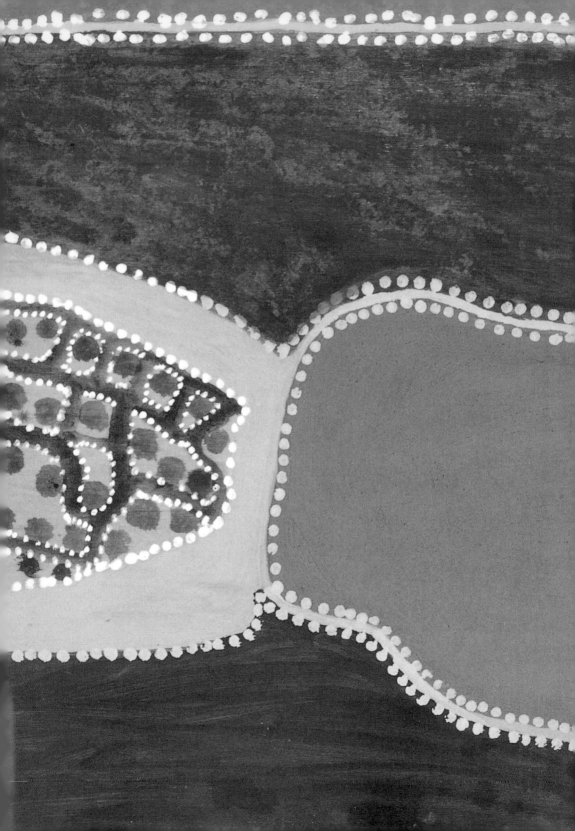

Opposite
Rover Thomas,
*Landscapes at
Kalumpiwarra,
Yalmanta and
Ngulalintji*
(detail of 91),
1984.
Natural
pigments and
gum on board;
90 × 180 cm,
35⅜ × 70⅞ in.
National Gallery
of Australia,
Canberra

In considering Aboriginal art it is important to be sensitive to the subtle relationship between past and present. The concept of the Dreaming, a uniquely Aboriginal way of placing people in time and space, forces one to think differently, and in a less linear way, about the relationship between creativity and form in art. At the same time, Aboriginal art has become known worldwide through the process of European colonialism, and the last two hundred years of colonial history have had an immense impact on Aboriginal society. The general theme of this book, if a single theme can be condensed from the many different pathways that are explored, is that the recent history of Aboriginal art has been a dialogue with colonial history, in which what came before – an Aboriginal history of Australia with its emphasis on affective social and spiritual relationships to the land – is continually asserting itself over what exists in the present. Aboriginal people are continually trying to insert, as precedents for action, values and beliefs about the world that have their genesis in pre-colonial times. Aboriginal engagement with history has not been backward looking, however; rather it has been designed to influence the course of future events while at the same time acknowledging change. Aboriginal art is itself dynamic and changing, responsive to new circumstances and challenges, influenced as well as influential. Robert Campbell junior's *Aboriginal Embassy* (1), for example, illustrates a representational style he developed which, though it shows many influences, does not fit neatly into any pre-existing category. The tent embassy was an integral part of the campaign for the recognition of Aboriginal land rights, and has become an important symbol of Aboriginal presence at the heart of Australian society and a reminder of the issue of sovereignty. The boundaries between Aboriginal art and non-Aboriginal art become blurred as Aboriginal art becomes part of contemporary world art.

For 40,000 years or more, before European colonization began in earnest in 1788, Australia had been a continent of hunters and

gatherers. Although they were by no means isolated from the rest of the world, Aborigines had nonetheless been able to maintain a distinctive way of life that centred on enduring, religiously sanctioned relationships between people and land. The form of the landscape was created by the actions of mythical ancestral beings who continue to be a powerful spiritual force today. Works of art – paintings, sculptures, songs and dances – which commemorated the actions of the ancestral beings were inherited by the human groups who took over from them. Art established a line of connection with the foundational events and enabled people to maintain contact with the spiritual dimension of

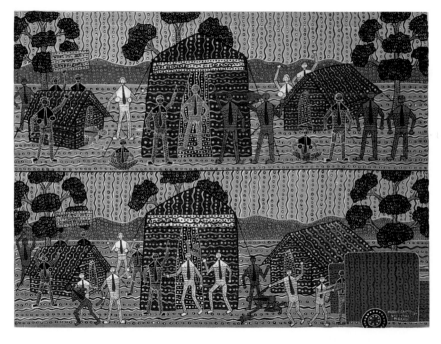

**1
Robert
Campbell
junior,**
*Aboriginal
Embassy,*
1986.
Acrylic on
canvas;
88 × 107.3 cm,
34⅝ × 43¼ in.
National Gallery
of Australia,
Canberra

existence. Art provides a sacred charter to the land and producing art is one of the conditions of existence. It keeps the past alive and maintains its relevance to the present.

Aboriginal art is also part of a system of restricted knowledge in which members of society maintain control over certain forms and their significance. Art is sometimes restricted on the basis of age or gender, certain ritual contexts being only for men and others for women. The basis of this restriction may be to protect other members of society

from spiritual danger or to protect the rights and interests of those belonging to certain categories or groups. This is reflected in the fact that rights to produce paintings are often vested in particular people. However, it would be quite wrong to overemphasize the secrecy of Aboriginal art. Most Aboriginal art forms can occur in public contexts and in general the issue is more one of maintaining control over the art than maintaining secrecy.

Aboriginal people lived, and in parts of Australia still live, for much of the year in small groups of kin, coming together at times of abundance for large ceremonial gatherings. In the well-watered riverine and coastal areas of Australia the Aboriginal population was quite dense and people lived semi-sedentary lives for most of the year, exploiting seasonally abundant resources. In the more marginal desert areas the population was lower and people had to travel more widely to gain a living from the land. Aboriginal people speak over two hundred different languages and each language often contains a number of different dialects. The people are divided up into groups – clans and moieties, sections and subsections – which vary in detail across the continent. Everywhere kinship is important in establishing relationships with people, and to land and sacred property. In many parts of Australia art is the property of groups, and rights in such things as paintings are carefully guarded and restricted. That has not meant that Aboriginal art has remained static over time. Indeed, Aboriginal art is characterized by its regional diversity and the range of different forms associated with particular places. Yet, despite regional variations, across Australia people are linked together in a network of connection. Art plays an important role in marking the relationships between groups and expressing identity. In the post-colonial context its mediating role has, if anything, increased in significance.

The complex recent colonial history of Australia combined with regional variation in art styles has resulted in the great diversity of contemporary Aboriginal art. The slow passage of the colonial frontier across northern Australia meant that the Aboriginal communities of much of Arnhem Land and central Australia came under effective colonial rule only between 1930 and 1950, just about the time that Aboriginal art was

gaining recognition. Elsewhere in Australia, from coastal Queensland across to the Perth region of Western Australia, the frontier had moved rapidly in the first half of the nineteenth century and Aboriginal populations had been destroyed, their land taken away from them and the process of cultural transmission rudely interrupted. The finely incised weapons of New South Wales and Victoria were recognized as art by Europeans long after the Aboriginal people had ceased to make them and the ritual life that was the context for so much artistic expression had been cruelly disrupted. The Aboriginal people in these regions did not cease to produce art nor to exist in historical continuity with their pasts. But their artistic and cultural practices diverged more from 'pre-contact' forms and shared more in common with the practices of their European neighbours than was the case further north. It would, however, be quite wrong to divide Aboriginal art into two mutually exclusive categories according to the nature of its colonial history.

Divisions that have been proposed between 'tribal' and 'urban', 'classical' and 'modern', 'traditional' and 'non-traditional', pose more problems than they help solve. Aboriginal people from Arnhem Land have been influenced by the presence of urban Darwin and many have lived there on and off ever since the township was established, even though they may have retained their own distinctive languages and cultural practices. There is nothing about being an urban dweller that in itself defines a person's artistic practice. In particular cases there will be demonstrable relationships between the environment in which someone lives and other aspects of their life, for example exposure to different influences and pressures, and different educational opportunities – but urban is too general a term. The term classical is similarly problematic. While it is intended to signify styles of art that exist in continuity with those existing at the time of European contact, it can result in an overemphasis on continuities of form. There is evidence of major changes in art styles before European contact, and post-contact regional art forms have maintained their dynamism as much in Arnhem Land and central Australia as in the southeast. The major problem with any dual division is that it simplifies the variety and internal dynamism of Aboriginal art and threatens to impose rigid external categories which constrain the development of the art and define its authenticity.

This book is ordered thematically rather than as a regional survey, partly because colonial history has made regional comparison difficult, partly because the same set of themes is relevant in different ways to understanding Aboriginal art across Australia. While our knowledge of the religious significance of Aboriginal art and the closeness of its relationship to land and social group is more comprehensive from the more recently colonized areas of northern and central Australia, the art of nineteenth-century southeast Australia was clearly integrated within society on a similar basis. Likewise, the process of European colonization has had an impact on all Aboriginal Australians, and with hindsight it is possible to see Aboriginal people throughout Australia developing similar strategies from the very beginning to try to come to terms with the invasion of their land and resist European domination either through force or persuasion. In each chapter I have taken examples that illustrate my argument, but I have also shown, where relevant, how the theme can be applied elsewhere in Australia.

This book covers painting, sculpture, weapons and a variety of other art forms. It concentrates on painting and two-dimensional works, reflecting the fact that painting on bark, rock surface and the human body is perhaps the major medium of expression. The more rare free-standing three-dimensional sculptures covered include figurative sculptures from Aurukun, the toas from the Lake Eyre region and the mortuary sculptures from Arnhem Land and Melville and Bathurst Islands. Also discussed are sculptures on the ground made from sand or earth, often incorporating complex constructions of branches, sticks and string, which were much more common and probably occurred throughout Australia. Indeed, if a broad definition of art is adopted, most of the techniques and raw materials used to make material culture objects could be used to produce art objects. Almost every artefact from string bags to weapons could occur in decorative forms. Aesthetic factors undoubtedly played a role in making the fluted and ochred artefacts of central Australia (2). Bodily ornaments made of seeds, feathers and shells, fixed with beeswax, ironwood resin or spinifex gum, suspended or woven into fibre string forms, occurred in abundance. Design in Aboriginal Australia cuts across particular media and it is possible to extend much of what is learnt about paintings to

2
Pitchi, used as
a baby-carrier
and food bowl,
Kimberley
region,
collected c.1896.
Wood and
pigment;
l.107 cm, 42 in.
Pitt Rivers
Museum,
University
of Oxford

other art forms. Designs are an inheritance from the ancestral past, and producing an artwork often involves fitting the design to the shape of the surface or nature of the space available as well as taking advantage of the particular properties of the medium concerned.

Australia can be divided into a number of geographical regions that reflect broad variations in the cultural and artistic systems of their Aboriginal populations (see map on pp.432–3). Although I have been conscious of the need to illustrate the regional variety of Aboriginal art, I have been equally concerned to allow the reader to gain some knowledge in depth of particular regional styles and even the range of work of individual artists. The south and southeast region, stretching from Adelaide in the south to Brisbane in the east, was the first part colonized by Europeans and knowledge of the art is less detailed than elsewhere. Nevertheless, the region does seem to have considerable unity, in particular in the widespread tradition of finely engraved and incised wooden artefacts.

The central region, stretching from Tennant Creek in the north to the Flinders Range in the south and from inland Queensland in the east across to the coast of Western Australia, is an arid zone with low population densities and considerable cultural continuities. Although it is possible to identify sub-regions associated with the better-watered region around Alice Springs and the interrelated linguistic groups of the Lake Eyre region, drawing rigid boundaries only results in oversimplification, masking both regional similarities and local differences.

Across the northern coastal region of Australia and the adjacent inland regions, where there is greater linguistic variation and where art styles can differ markedly in adjacent areas, it is possible to define a number

of more precisely demarcated regions. In the west are the Kimberleys, characterized by the Wandjina paintings (see 9), then follows Western Arnhem Land with its x-ray paintings (see 32), bordering on Eastern Arnhem Land with its intricate clan designs, and then on the eastern side of the Gulf of Carpentaria is Cape York Peninsula with its distinctive art forms showing some continuities with the Torres Strait Islands. However, again within each region there is considerable variation and in some cases, such as Melville and Bathurst Islands, and Groote Eylandt, sub-regions exist that have very distinctive art styles of their own.

Although there are enormous differences between art in different parts of Australia, there are also common factors in the position of Aborigines in Australian society and the way in which they have been incorporated in the Australian state that have influenced developments in Aboriginal art across the country. Differences between Aboriginal art traditions and differences between the works of individual artists need to be acknowledged. The particular form of artworks depends on a wide range of factors, including the historical position of the artist, the intellectual and aesthetic inheritance and the role that art has in society. Aboriginal art history is no different in these respects from any other art history. The struggle for the recognition of Aboriginal art has been partly about definition, about the right to be defined in terms of its own history rather than according to Western preconceptions.

A Journey to Recognition The 'Discovery' of Aboriginal Art

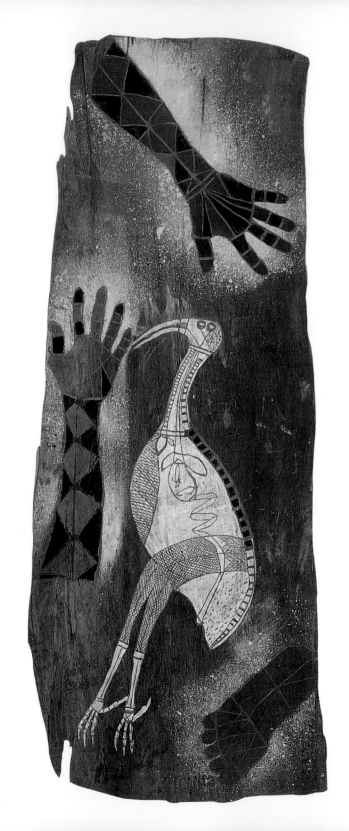

At Oenpelli in Western Arnhem Land, at the beginning of the dry season, an Aboriginal man sat in the shade of a tree painting the image of a bird on a rectangular sheet of bark. The year was 1913. It was early evening and the Gagadju artist had spent the day skinning buffalo for Paddy Cahill, a European settler who had established his homestead at Oenpelli in the 1890s. The painting (3) was destined to go on a long journey. It had been commissioned by Baldwin Spencer, anthropologist and professor of biology at Melbourne University, and it was heading for the collections of the National Museum of Victoria (now the Museum of Victoria). For most of the rest of the century the painting was to have a quiet and anonymous existence, remaining within the confines of the museum where it was viewed primarily as a work of ethnographic interest, rather than as a work of fine art.

Nonetheless, Spencer viewed the Gagadju artists very positively and drew analogies between them and artists from other parts of the world. He recorded:

Today I found a native who, apparently, had nothing better to do than to sit quietly in camp, evidently enjoying himself, drawing a fish on a sheet of stringy bark ... [he used] a primitive but quite effective paint brush, made out of a short stick, six or eight inches long, frayed out with his teeth and then pressed out so as to form a disc ... he held it like a civilized artist ... he did line work, often very fine and regular, with much the same freedom and precision as a Japanese or Chinese artist doing his more beautiful wash-work with his brush. They are so realistic, always expressing the characteristic features of the animal drawn ... there was relatively very much the same difference between them [Aboriginals] as between British artists.

In the 1990s the painting went on a second journey, this time as a recognized work of fine art to be exhibited in European art galleries, including the Hayward Gallery in London, as part of the *Aratjara: The Art of*

3
*White Ibis
Godolpa,*
c.1913.
Natural
pigments
on bark;
122 × 48·5 cm,
48 × 19 in.
Museum of
Victoria,
Melbourne

the First Australians exhibition. There it gained a title but retained its anonymity: 'The White Ibis Godolpa, by an unknown Gagadju artist'.

Aboriginal art today cannot be understood separately from these two journeys, the first of which was the consequence of its 'discovery' by Europeans and the second the result of the increasing recognition of its aesthetic value. Aboriginal art was discovered during the process of the colonization of Australia which entailed the usurpation of Aboriginal land and the destruction by violence and disease of much of the population. And its appreciation was part of the process of acknowledging the common humanity of Aborigines and their right to be part of the creation of value in their own land. Aboriginal art has become known to Europeans through its place in colonial discourse. It is important to begin here. Aboriginal art in its own world will be discussed later.

At the time that the Gagadju artist painted his ibis, Oenpelli was on the edge of the colonial frontier. The European colonization of the Northern Territory, as in most of northern and central Australia, had been as faltering as it had been destructive. It was a movement inspired by myth and fantasy, by images of inland lakes, mountains of gold and rich pastures for cattle, all of which were to prove illusory. The Northern Territory became a land of marginal enterprises, flourishing for a short while on hope and subsidy and sinking into despair occasioned by the climate and the environment – rich and bountiful for its hunter–gatherer inhabitants but full of problems for its white invaders. In the 1840s the explorer Ludwig Leichhardt passed close to Oenpelli on his route from Queensland to the embryonic township of Port Essington. Soon afterwards Port Essington was abandoned, to be replaced by Palmerston, later renamed Darwin, which became the focal point of European colonization of the Northern Territory. The building of the Overland Telegraph opened much of central Australia to European occupation, and by the end of the nineteenth century vast areas of the Northern Territory were dominated by cattle stations. The Pine Creek gold rush of the 1880s had brought an influx of people into the East and West Alligator rivers region in Western Arnhem Land (4) and left behind its legacy of contagious diseases, including the venereal diseases that eventually devastated the Aboriginal populations of the area by causing

infertility. But the frontier had stopped at Oenpelli, just as it had abandoned much of central Australia. The terrain was just too difficult to occupy for long, and Aboriginal resistance made the task even harder.

Paddy Cahill, like a number of other pioneers, had established himself right on the frontier. For much of the time he was able to carry out a profitable existence as a buffalo shooter and cattleman. He forged close relations with the local Aboriginal people, depending on their skills and knowledge of the environment for the success of his operations. The relationship had a symbiotic character, with Cahill providing protection from less well-motivated Europeans and giving access to trade goods, especially sugar, flour and tobacco, while the Aborigines mediated his relationship with the environment and ensured his physical and economic survival. Cahill, as with the missionaries who followed him into Arnhem Land, was always on the lookout for ways to increase income and provide support for the Aboriginal community that gathered around his settlement. Thus Baldwin Spencer's interest in bark paintings and artefacts was doubtless welcomed both by him and by the Aboriginal artists.

Spencer had been attracted to Oenpelli in the first place precisely because it was on the frontier. He was spending the year 1912 in Darwin on secondment from Melbourne University as a special investigator and 'protector' of Aborigines. Earlier he had established his authority as an expert on Aboriginal society through his pioneering anthropological work in central Australia with F J Gillen, the postmaster and local magistrate at Alice Springs (5). Their books on the Aranda had drawn the attention of the world to the richness of Aboriginal culture and the spectacular nature of Aboriginal ritual. Oenpelli was a safe and easily accessible place for contact with the cultures of Arnhem Land; in 1912, therefore, Spencer visited Oenpelli by boat, in a party that included Darwin medical practitioner Felix Holmes and Elsie Mason, who subsequently married the anthropologist Bronislaw Malinowski. Spencer stayed on after the others had left and in the limited time available made remarkably extensive accounts of the ritual life and social organization of the local Aboriginal population. However, he was most struck by the paintings that they produced on bark.

Oenpelli is a place of great natural beauty. Cahill's settlement was built beside a lake on the edge of the East and West Alligator rivers' flood plain beneath the towering walls of the Arnhem Land escarpment (6). Aborigines throughout Arnhem Land built substantial huts out of sheets of stringy bark on wooden frames, and it was on the walls of these wet-season huts by the lakeside that Spencer first saw the paintings. As he wrote, 'Collecting from their studios meant taking down the slabs on which they [the works] were drawn, that formed incidentally the walls of their huts.' Spencer commissioned a number of paintings from the artists and paid for them in sticks of tobacco according to their size. When he left Oenpelli he made arrangements with Paddy Cahill for the settler to continue collecting the paintings and to send them in consignments to the National Museum of Victoria. The *White Ibis* was one that arrived in the following year.

Spencer's description quoted at the beginning of this chapter tells us more about his own concept of art than it does about the value of the works to the Aboriginal painters. Spencer had himself been an artist before becoming a biologist, and to the end of his life he retained his

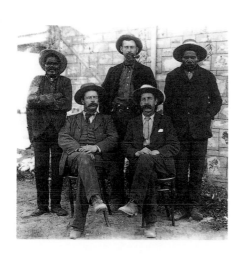

5
Baldwin Spencer and F J Gillen's 1901–2 expedition party at Alice Springs, May 1902. Seated l to r: Gillen, Spencer; standing: Purula, Harry Chance, Jim Kite (Erlikiliaka).

6
Kakadu men and boys hunting with spears in a dugout canoe on the Oenpelli Lagoon, Arnhem Land, photographed by Baldwin Spencer, 1912

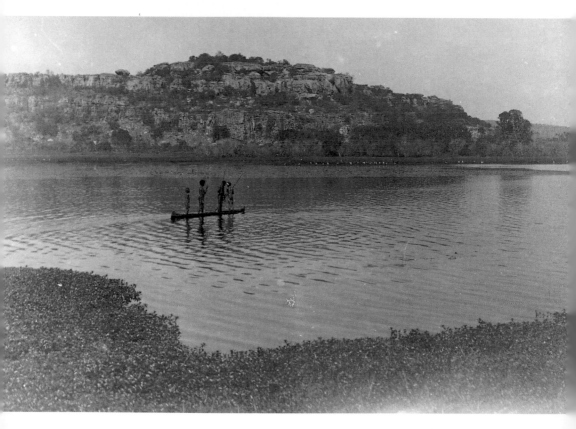

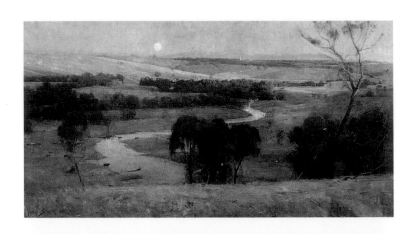

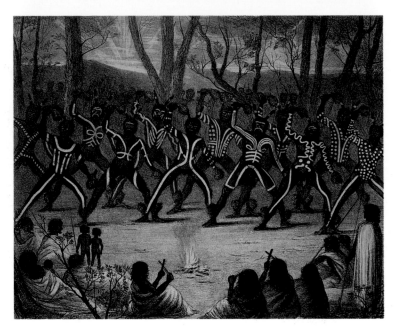

skill as a draughtsman and maintained a strong interest in art. As a sponsor and administrator Spencer played a crucial role in the development of European–Australian art in Victoria. He was a close friend of Arthur Streeton (1867–1943) and other artists of the Heidelberg school whose *plein-air* landscapes helped revolutionize Australian painting (7). As a trustee of the Felton Bequest, Spencer was responsible for authorizing the purchase of the National Gallery of Victoria's fine collection of European paintings. He was clearly excited by Western Arnhem Land art and responded to it in terms that are reminiscent of the discourse over 'primitive' art that was occurring at the same time in Europe as part of the development of modernism. Spencer's stress on the individual creativity of the artist, and the analogies he draws with Japanese and Chinese artists, reflect contemporary European concerns. At that time, however, Australia was relatively isolated from Europe and it would be some decades before the forms of Aboriginal art were to have any impact on European–Australian art. Spencer's collection of paintings remained for the most part in the National Museum of Victoria to be exhibited not as art but as ethnography, and no major new collections from the region were made until after World War II. Indeed, it was not until the late 1960s that Aboriginal art began to gain widespread recognition; the flight of the *White Ibis* to the Hayward Gallery would doubtless have surprised both the artist and Spencer.

The early European history of Aboriginal art is a history of invisibility and denial. There is little reference to art in early European explorers' accounts and few art objects were collected. Images of body paintings occur in some of the early European paintings and engravings (8) of Aboriginal rituals, and some references are made to rock art and ground sculptures, but the descriptions are generally thin and tend to be embellished with adjectives such as 'crude' or 'rough'. In cases where the works were admired for the skill of execution or aesthetic effect, there was always the likelihood that they would be attributed to an external origin. The most notorious case is Sir George Grey's attribution in 1837 of the Wandjina paintings of the Kimberleys to non-Aboriginal hands. Grey was the first European to document the Wandjina, a relatively recent tradition of Aboriginal rock painting which continued to flourish until the middle of the twentieth century and which remains an

7
Arthur Streeton,
Still Glides the Stream and Shall Forever Glide,
1890.
Oil on canvas;
82 × 153 cm,
$32\frac{1}{4} \times 60\frac{1}{4}$ in.
Art Gallery of New South Wales, Sydney

8
William Blandowski,
Corroboree,
1855/6.
Engraving and aquatint from
Australia Terra Cognita;
23 × 29 cm,
$9 \times 11\frac{3}{8}$ in.
National Library of Australia, Canberra

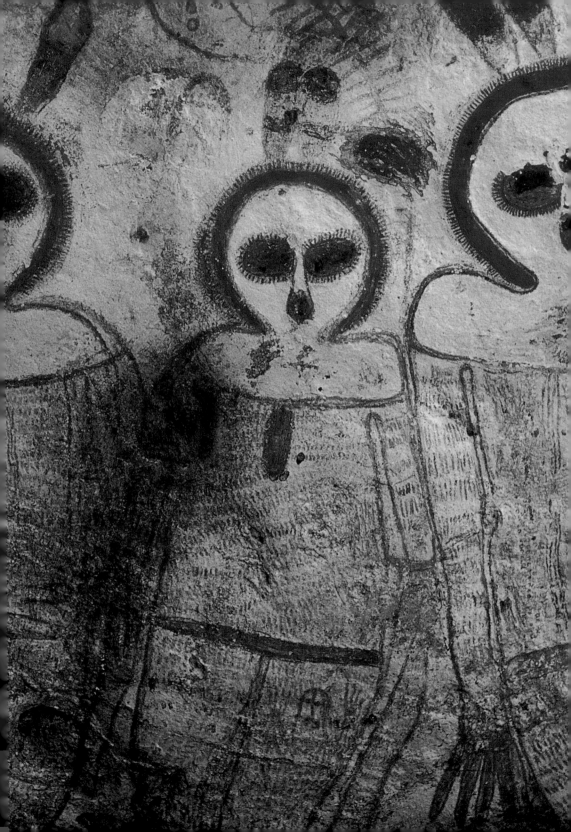

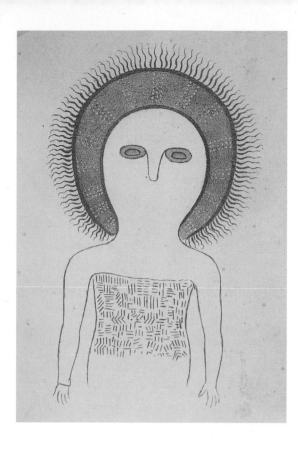

9
Wandjina
figures from
near the Barnett
River, Kimberley
region, Western
Australia

10
Sir George Grey,
Figure drawn
on the roof of
a cave, from
*Journals of Two
Expeditions of
Discovery in
North-West
and Western
Australia,*
1841.
Royal
Commonwealth
Society
Collection,
Cambridge
University
Library

integral part of the cultural life of the peoples of the region (9). Yet to Grey they were too good to have been painted by Aborigines: 'Whatever may be the age of these paintings, it is scarcely probable that they could have been executed by a self-taught savage. Their origin, there-fore, must still be open to conjecture.' This prejudice led Grey to reinterpret and redraw some of the motifs (10), and encouraged later interpreters to identify the details on the headdress of one of the figures as examples of exotic scripts.

There are many reasons why Aboriginal art remained largely invisible to European colonists. In colonial ideology Australia was *terra nullius*: an empty land without people. The less Aborigines were materially visible, the more the appropriation of their land could be consistent with this view. It was in the interests of colonialism not to see Aboriginal art. This view received reinforcement from the socio-evolutionary theory that developed towards the middle of the nineteenth century. Aborigines, as hunters and gatherers, were viewed as representatives of an earlier

form of society, precursors of the agricultural societies that eventually resulted in the evolution of European civilization. Aborigines lived in a state of being 'close to nature'; they were without either religion or art. The existence of art would have endowed them with powers and capacities that made them too like the colonists themselves and would have made the denial of their rights less tolerable. Well into the twentieth century, the discourse over Aboriginal art has involved the question of the capacity of Aborigines to be like the colonists. 'Being like the colonists' has generally meant acting like the colonists and assimilating their cultural forms. The watercolours of Albert Namatjira (1902–59) that received such acclaim in the 1940s and 1950s were exhibited partly as a sign of what Aborigines were capable of achieving once 'civilized', and in this respect could be seen as much as a denial of Aboriginal art as a recognition of it (11).

The rejection of Aboriginal works as art occurred in part because they did not fit with the contemporary European conception of what art objects were and what art looked like. Much Aboriginal art consists of geometric forms – the engravings on weapons and the carved trees of

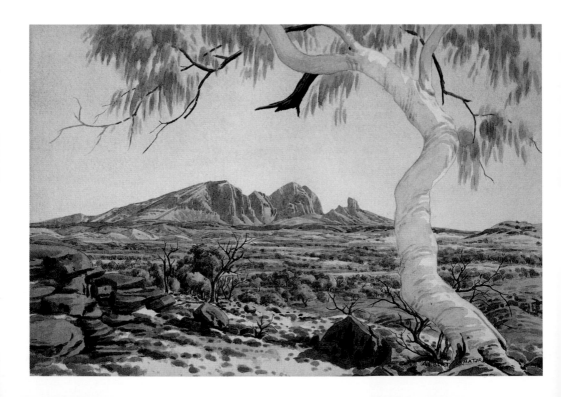

southeastern Australia, the painted shields of north Queensland – or is comprised of kinds of things that had no place in a nineteenth-century art gallery, such as ground sculptures or elaborately intersecting skeins of feather string. Many of these works are now more readily interpretable as artworks under a modernist or contemporary Western aesthetic. It is no surprise that the figurative art of Western Arnhem Land attracted Spencer's greatest praise, nor that these paintings formed an important part of the *Australian Aboriginal Art* exhibition of 1929, which was the first major exhibition of Aboriginal art held in Australia. (The very first exhibition of Aboriginal art, entitled *The Dawn of Art*, was held in the late 1880s and comprised figurative paintings and drawings by prisoners and staff at Palmerston Jail 'executed without aid of a master'.)

Much Aboriginal art was (and is) indeed largely invisible and uncollectable. It is frequently produced in ritual contexts, is often intended to be ephemeral and may even be deliberately destroyed during the course of the ceremony or allowed to disappear naturally within a few days of its completion. Body paintings, ground sculptures and ceremonial constructions are designed to last a matter of hours (or at most days) and more permanent forms such as hollow-log coffins and graveposts were exposed to the ravages of the elements. Many of the more permanent forms were (and are) secret objects used in initiation ceremonies, which were revealed only to members of the society in controlled circumstances and unlikely to be yielded willingly to outsiders, let alone invaders. The most durable of all forms, the rock paintings and engravings that are widespread throughout Australia, are by their nature uncollectable and were difficult to record in detail before the age of photography.

For much Aboriginal art, the act of production was as important as the finished object. Art represented the appearance of ancestral forces in ritual contexts: imminent, transitory, effective in achieving a particular purpose and then discarded, hidden or destroyed. A true clash of cultures occurred: an opposition between the Aboriginal perception and the Western conception of art, with its emphasis on the finished object, the collectable form and the independence of that form from the context

11
Albert
Namatjira,
*Ghost Gum,
Mount Sonder,
MacDonnell
Ranges,*
1957.
Watercolour
and pencil
on paper;
25·2 × 35·8 cm,
9⁷⁄₈ × 14¹⁄₈ in.
National Gallery
of Australia,
Canberra

of its production. As Eric Rowlinson, director of the National Gallery of Victoria, wrote, as late as 1981, 'Too much unfamiliar territory was between us and the objects. And the objects themselves displayed an uncompromising refusal to bend to fashions of our own artistry and hence cannot be drawn into a superficial relationship with our own artistic movements.' Only in rare cases did the Aboriginal object coincide with the Western conception of a collectable form that could be exhibited for aesthetic contemplation. The bark paintings of Arnhem Land were so attractive to Europeans because they were among the few objects for which, on the surface at least, the motivations of the artist coincided in part with the expectations of the European audience. In both cases the works were intended to be hung on walls, even if in the Arnhem Land case they became the very walls themselves (12).

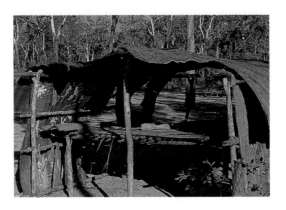

12
Bark hut at Mangalod on the Mann River, Central Arnhem Land

For the most part, however, the existence of collectable forms of Aboriginal art either involved the redefinition by Europeans of decorated and undecorated functional objects as artworks – shields, boomerangs, spearthrowers, baskets (13), string bags, direction signs, traps – or the creation of objects for use in new contexts – sand-painting designs in acrylics on canvas, or figurative wooden sculptures. Basketry provides an interesting case in point. Although the skills involved in manufacturing baskets were recognized early on and significant collections were made by museums, it is only recently that woven and basketry objects have begun to be exhibited as art. This in part reflects the position of basketry in Western art practice, where it is positioned on the boundaries between art and craft. The woven sculptures of

Yvonne Koolmatrie (b.1945) are of particular interest. Her works are based on the basketry of the Ngarrindjerri people of South Australia, emphasizing the sculptural properties of traditional forms. Her series based on the eel traps that were used along the Murray River were part of the exhibition *Fluent*, at the 1997 Venice Biennale (14).

The recognition of Aboriginal art has arisen through four interrelated processes: changing conceptions of art in general and non-European art in particular, increasing knowledge about Aboriginal art and culture, the developing economic role of craft production in Aboriginal communities, and the determination of Aborigines to receive recognition for the value of their culture, history and way of life.

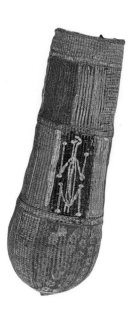

13
Basket, East
Alligator River
region,
*c.*1900.
Plant fibre
and pigment;
h.26 cm,
10¼ in.
Pitt Rivers
Museum,
University
of Oxford

The great museum collections of Aboriginal artefacts were built up over a forty-year period from the end of the nineteenth to the second decade of the twentieth century. The objects were collected initially as curiosities, as sources of information about exotic people and places. Later they were ordered into typological sequences to demonstrate the evolutionary nature of culture, or exhibited as examples of culture traits that purported to demonstrate the historical relations between different societies. Finally, they became ethnographic facts, 'objective' information about the diversity of human cultures. They were objects from exotic worlds, but they were not art.

Around the turn of the twentieth century, in Europe and elsewhere, artists began to show an interest in non-European forms that, by their very freedom from academic tradition and their implicit association with the primitive drives of human beings close to their natural state, were thought capable of liberating Western art from the constraints of its own historical tradition. Although this did not of itself lead to the recognition of these objects as works of art in their own right, it was an important stage in ensuring that they would be viewed for their aesthetic value. The danger was that the aesthetic of European art movements would irrevocably define the way they were seen.

Moreover, the art world and the ethnographers were united in their opinion that their value lay in their freedom from the contamination of European contact. This view removed the art from its contemporary context by creating the illusion that the 'primitive' artists worked outside the influence of the colonial invaders. In reality most of the objects that reached museums in the nineteenth century were produced by indigenous peoples who lived on the European side of the frontier and were making the artefacts for sale as well as for their own use.

14
Yvonne
Koolmatrie,
Eel trap,
1997.
Sedge rushes;
l.78 cm, 30¾ in.
Collection of
the artist

Although a few individuals such as Spencer began to show an interest in Aboriginal art at the turn of the century, its impact on the art world in Australia was a very limited one until after World War II. Tony Tuckson (1921–73), the artist and curator, argued that the conservatism of white Australian art held back the recognition of Aboriginal art until the late 1930s. Before the war the only artist to be influenced in a major way by Aboriginal art was Margaret Preston (1875–1963), who is recognized as one of the few major prewar modernist artists in Australia (15). Her interest in Aboriginal art parallels the earlier influence that primitive art had on the avant-garde artists in Paris in the first decade of the twentieth century. Preston was explicitly concerned to create a distinctively Australian art and in so doing she sought inspiration from Aboriginal art. She was initially inspired by the form of the art, although she first saw its virtues as the accidental product of an unschooled mind. She visited both central Australia and Western Arnhem Land, established friendships with the anthropologists Ursula McConnel and A R Radcliffe-Browne, and wrote a series of articles on Aboriginal art in the periodical *Art and Australia*. In retrospect her influence was crucial, although at the time it appears to have been limited in its impact. The inclusion of Aboriginal designs in her own work had little effect on overall attitudes to Aboriginal art and the doors of the art galleries still remained firmly closed to Aboriginal artists.

The situation began to change after World War II as a result of the cumulative influence of missionaries, anthropologists and some artists and gallery curators. Missionaries such as T T Webb, Wilbur Chaseling and Edgar Wells saw the marketing of art both as a way of making money for mission settlements and as a means of asserting the value of Aboriginal culture. The artist Albert Namatjira had produced traditional artefacts and souvenirs for sale through the Hermannsburg Mission before he began to exhibit his watercolours, also with support from the mission. In Arnhem Land the Methodist missions established at Milingimbi, an island off the coast of Central Arnhem Land, and Yirrkala, on the Gove Peninsula, in the 1920s and 1930s, encouraged the production of craft, including bark paintings, for sale to a wide market and provided major collections for museums in Sydney, Brisbane and Melbourne.

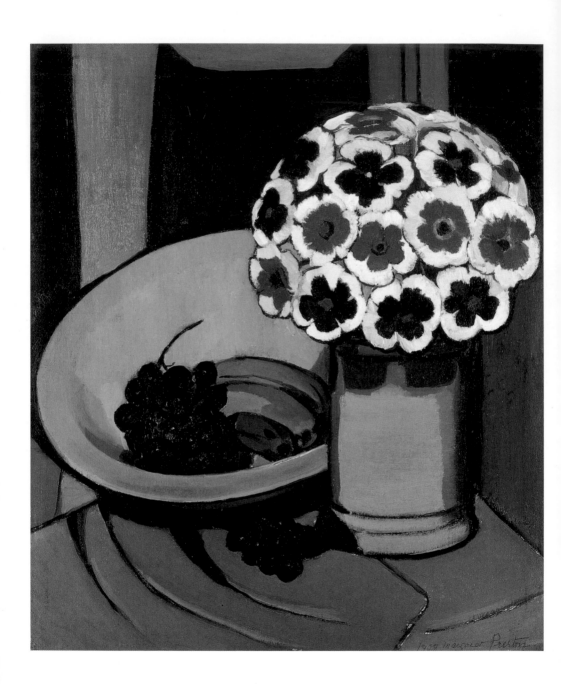

Anthropological interest in Aboriginal art increased around the time of World War II when this art began to be viewed as an expression of religious values rather than as an indicator of the evolutionary position of its creators. Donald Thomson made his extensive collections of art from Cape York Peninsula and Eastern Arnhem Land before and during the war (see 162), and immediately after it Charles Mountford (1890–1977), Fred McCarthy and Ronald and Catherine Berndt carried out their research in Western and Eastern Arnhem Land. It was important for anthropologists and others who saw Aboriginal art as a source of information about Aboriginal culture and society that it should be seen as art, for a number of reasons. One reason was simply to counter the biases of the evolutionary lens: fine art is a symbol of high culture, and the production of art was thus a sign of the equal status of Aboriginal and European society. A second reason was the hope that, if a viewer saw and valued the work as art, he or she would see beyond it to the value of the culture that produced it. The Australian anthropologist A P Elkin expressed this position when he wrote in 1950: 'The painting or the engraving must be the window through which we glimpse, or even the door through which we enter, an abiding world ... the world of spiritual relations, the world of meaning, which increases in depths and fades not away.' One sign of the difference between anthropological writing before and after the war was that for the first time the art lost its anonymity as the names of the artists who produced the paintings were acknowledged. No longer would the paintings that were collected have to be exhibited as 'by an unknown artist'.

Despite the increased interest in Aboriginal art, it was not until the late 1950s that major collections were acquired by an art gallery as opposed to an ethnographic museum. A few paintings collected by Mountford on the 1948 American–Australian Scientific Expedition to Arnhem Land had been distributed by the Australian government to the main state art galleries, but it was the collections from Yirrkala, and Melville and Bathurst Islands, made by Stuart Scougall and Tony Tuckson for the Art Gallery of New South Wales in 1958 and 1959, that had the more significant impact. Some of these works (16) were included in the first Adelaide Festival in 1960 and subsequently they formed the basis of a major touring expedition. Tuckson, as the deputy director of the Art

15
Margaret
Preston,
*Aboriginal
Flowers*,
1928.
Oil on canvas;
53.6 × 45.8 cm,
21⅛ × 18 in.
Art Gallery of
South Australia,
Adelaide

Gallery of New South Wales and a significant avant-garde artist in his own right, was an influential figure in Australian art. The gallery's decision to acquire and exhibit Aboriginal works as art was surrounded by controversy and there were negative as well as positive reviews of the exhibition. The more negative reviews were not concerned so much with the quality and form of the works as to whether or not they were art. This controversy has continued, emerging every so often with major new exhibitions of Aboriginal art (17). The *Art and Land* exhibition at the 1986 Adelaide Festival, in which toas, direction signs from central Australia (18), were exhibited for the first time as art, provoked a particularly intense discussion of the issue, and even by the time of

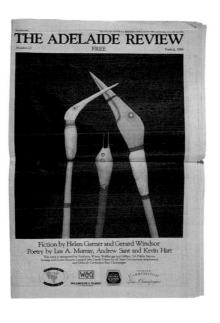

16
Munggurrawuy Yunupingu,
Figure of Garaginja, ancestral being and brother of Lany'tjung, before 1960.
Wood, hair, feathers;
h.87.5 cm, 34½ in.
Art Gallery of New South Wales, Sydney

17
Toas on the cover of the *Adelaide Review*, festival edition, 1986

18 Overleaf
Toas of the Lake Eyre region, c.1904.
Natural pigments on wood;
h. from 19 to 57 cm, 7½ to 22½ in.
South Australian Museum, Adelaide

the *Aratjara* exhibition at the Hayward Gallery in 1993 the question of whether or not an art gallery was the appropriate place for an exhibition of traditional Aboriginal art remained a live one.

The controversial nature of Aboriginal art as 'art' may explain why it was not until the late 1970s and early 1980s that other state galleries joined the Art Gallery of New South Wales in acquiring collections. When it opened in 1981 the Australian National Gallery included virtually no Aboriginal art; the only state gallery that had Aboriginal art from its inception, in 1971, was the Museum and Art Gallery of the

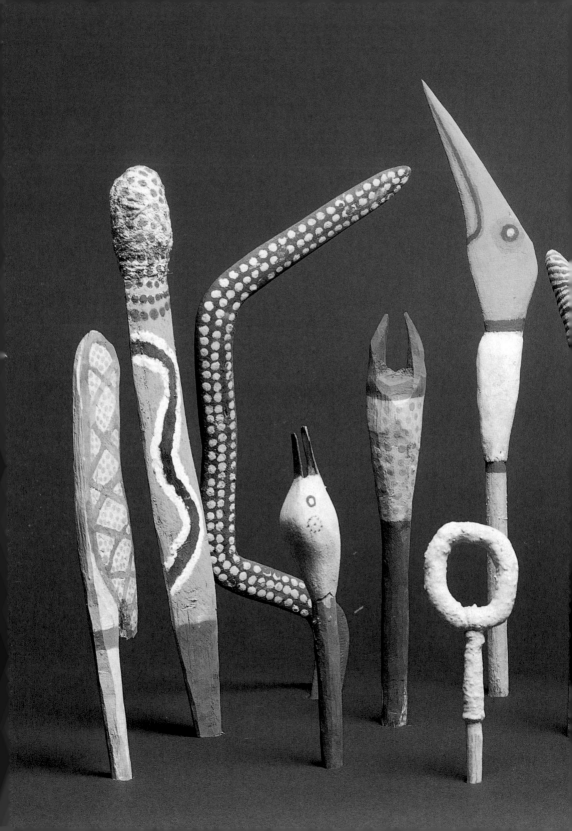

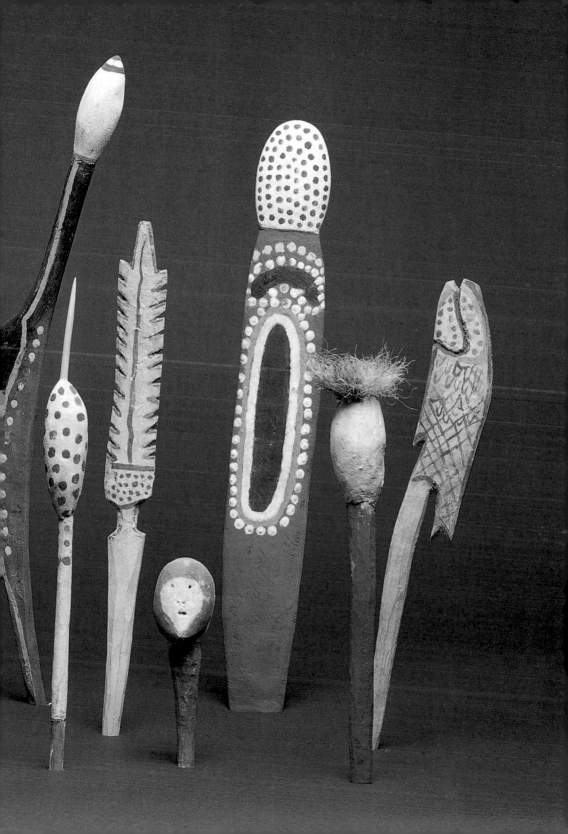

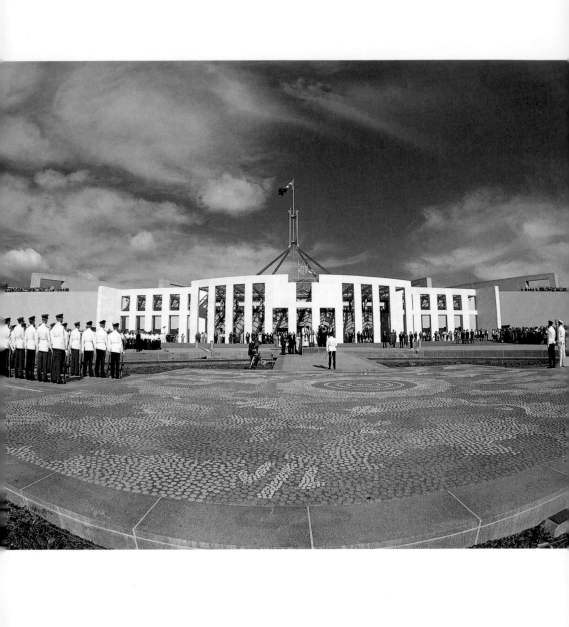

Northern Territory, where a significant proportion of the population was Aboriginal. Even the Art Gallery of New South Wales failed to make major acquisitions for nearly thirty years after its initial purchase.

By the mid-1980s, however, the situation had changed so dramatically that it became increasingly difficult to imagine that earlier attitudes had ever prevailed. Aboriginal art had moved out of the museums into the art galleries, all of which began to employ curators of Aboriginal art and compete with one another for the purchase of major works. Aboriginal art was commissioned for national institutions and public buildings, and was literally built into the fabric of the new Parliament House in Canberra, which opened in 1988, where the forecourt was paved with a mosaic (19) designed by the Western Desert artist Michael Nelson Tjakamarra (b.*c*.1949). Aboriginal art was proving a commercial success, with twenty-eight galleries in existence in Alice Springs alone in 1993. According to a survey produced by the Australia Council in 1990, 'half of the visitors to Australia are interested in seeing and learning about Aboriginal culture, thirty per cent of the visitors in the questionnaire survey purchased Aboriginal arts or items related to Aboriginal culture, and the value of the purchases was estimated at A$30 million for the current year.'

19
Forecourt of
Parliament
House,
Canberra, with
mosaic by
Michael Nelson
Tjakamarra,
1988

How these changes came about can only be summarized. There may be some truth in the essentialist argument that the richness of Aboriginal art became visible at last, whereas previously the evolutionary eye had been blind to it. Greater exposure to Aboriginal art, increased knowledge of the variety of its forms and the complexity of its meanings, together with a broadening Western acceptance of the diversity of art forms and an ever more inclusive extension of the Western category of art certainly all had an effect. Post-colonial Australia had become more sympathetic to Aboriginal society and more open to seeing the value in Aboriginal cultural forms. The increased interest also resulted from a combination of Aboriginal political action and Australian political circumstance. Aborigines used art as an instrument in asserting their rights both to land and to cultural recognition.

The determination of Aborigines to gain cultural recognition began with remote communities which had recently come under colonial control.

The people from Yirrkala whose paintings were purchased by Tony Tuckson for the Art Gallery of New South Wales independently shared many of his objectives. Leading artists from the community, such as Mawalan Marika (1908–67) and Narritjin Maymuru (c.1914–81), had visited Darwin and Sydney to perform traditional dances or to take part in cultural events and were well aware of the status that works of art had in European society. Narritjin told me of his pride in seeing his paintings exhibited in the Art Gallery of New South Wales on the same basis as the arts of other cultures, and of his determination to gain wider recognition as an artist. Mawalan's son Wandjuk Marika (1927–87) became a renowned artist in his own right and also served as chairman of the Aboriginal Arts Board, where he worked to gain increased rights for Aboriginal artists, in particular to ensure the protection of their copyright.

From early on artists from Yirrkala were conscious of the relationship between the recognition of the value of their culture and the struggle for political rights. In 1963, when their land was threatened by the discovery of one of the largest deposits of bauxite in the world, they sent a petition on bark to the government in Canberra (see 171, 172), a historic event that will be considered in detail in Chapter 7.

As Australian governments of the 1960s and 1970s became more sensitive to issues of Aboriginal rights, they saw support of art as one of the least divisive ways of furthering Aboriginal interests. Political action also increased the visibility of Aborigines in Australian society, particularly in the southern states where the potential market was, and at a time when communication between the north and the south became easier. Aboriginal art also benefited from the movement of Australian nationalism away from its European roots, and from the opportunities presented by the bicentennial celebrations in 1988 to dramatize the issues of national identity. A celebration of Australia's first two hundred years of 'nationhood' could only succeed if it came to terms with its colonial history and the Aboriginal holocaust on which it was built. Aborigines rejected the idea of celebrating the bicentenary, using it instead as a means of asserting their continued presence in Australian society by creating a counter-theme of a national year of mourning.

Many of the resources that were put aside for Aboriginal participation in the bicentenary were used indirectly to fund events that were a subversion of it. The National Gallery's purchase of two hundred hollow-log coffins as a memorial to the Aboriginal dead is one example. The Aboriginal Memorial now graces the entrance to the gallery, making both a political and a powerful aesthetic statement (20, 21).

The recent history of Aboriginal art has been one of widening audiences. Aboriginal art has moved from a local to a global frame. Yet precisely the same designs that are painted on hollow-log coffins in the National Gallery or make up the mosaics at Parliament House are still produced in restricted ceremonial contexts in Arnhem Land or central Australia. Aboriginal art has maintained value to its producers while gaining in value to outside audiences. The appreciation of art across cultures reveals shared sensitivities to visual forms while allowing for aesthetic values and interpretations of forms to differ. To the people of Arnhem Land the shimmering effect of the cross-hatched surface of bark paintings is seen as a manifestation of spiritual forces that are imminent in the landscape. Its connotations are likely to be different for those brought up in a Western urban environment under a different value system. Nonetheless, art provides a means of exchanging ideas and sharing values.

To Aboriginal people art is linked to land, history and identity, and in journeying to other places it carries those connotations with it. The hollow-log coffins in Canberra represent a movement of place. The exhibition space becomes the Blyth River region of Central Arnhem Land. The burial poles are ordered to reflect the geographical relationships between the clans that made them, who live on either side of the forested banks of the Blyth. The forest of poles represents the living people and cultures of Arnhem Land as well as alluding to the deaths of many Aboriginal people following European colonization. Yet communication through art is very much a two-way process. The artist Mawalan Marika, visiting Sydney for the first time from his homeland of Yirrkala in Eastern Arnhem Land, was able to use the forms of the art of the people of Eastern and Central Arnhem Land who call themselves Yolngu to create an impression of the shimmering city at night (22). The

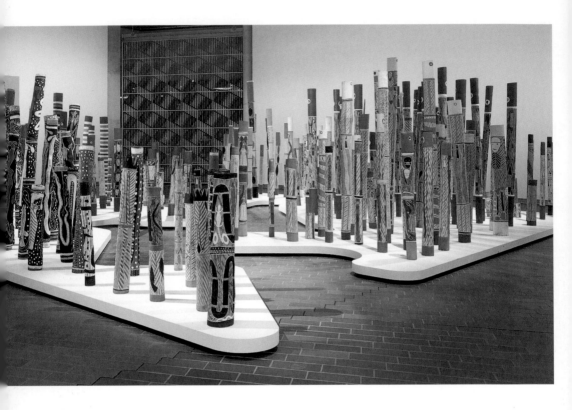

20–21
**Paddy
Dhatangu, David
Malangi, George
Milpurrurru,
Jimmy Wululu
and other
Ramingining
artists,**
*The Aboriginal
Memorial*,
installation of
200 hollow-log
coffins,
1987–8.
Wood and
ochres;
h. from 40 to
327 cm, 15 ¾ to
128 ¾ in.
National Gallery
of Australia,
Canberra

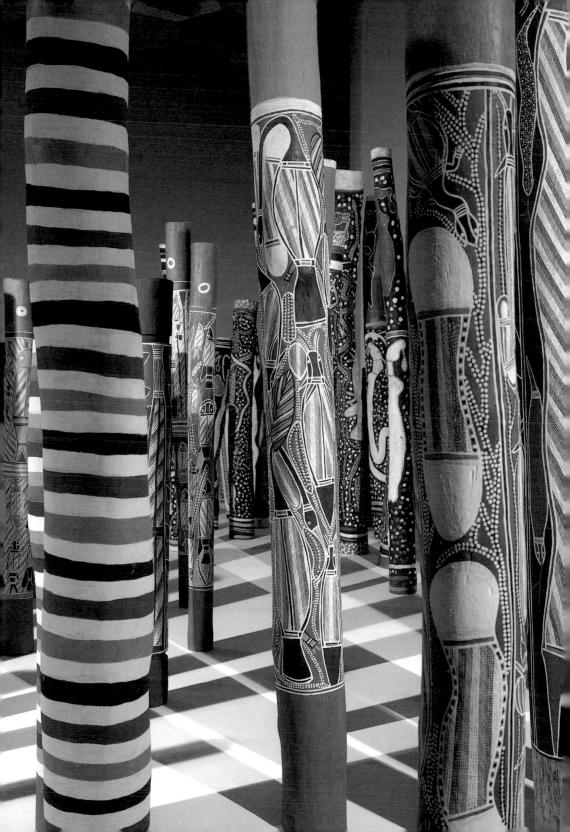

brilliance of the lights of the modernist city is brought home to Arnhem Land through an image redolent with spiritual power. Aesthetic forms are not limited to a particular content and can be used as a means of conveying experience cross-culturally: the Arnhem Land idea of spiritual power to the Sydney audience, the energy and electricity of the city to the Arnhem Land one.

22
Mawalan Marika, *Map of Painter's Travel by Plane from Yirrkala to Sydney*, c.1960. Natural pigments on bark; 92 × 42 cm, 36¼ × 16½ in. National Museum of Australia, Canberra

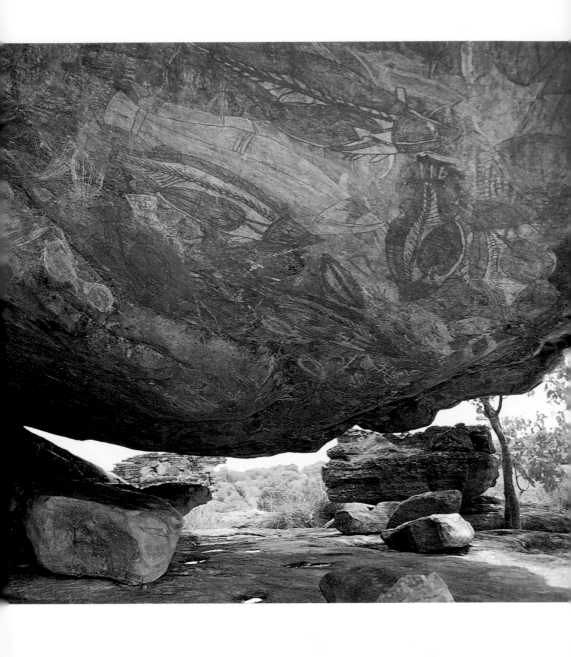

So far the *White Ibis* has taken us on a journey through recent
Australian history – through the two hundred years of European
colonization. We have followed the *White Ibis* forward into the Western
art world that engulfed Aboriginal art as part of the imposition of
colonial rule, and we have seen how its movement, from the bark hut
to the museum to the international art exhibition, was part of a process
whereby Aboriginal people moved from producing art on a local stage
to asserting their identity on a global scale. But if instead we had
looked behind the bark huts on the lake shore to the rock walls of the
Arnhem Land escarpment, or climbed up Ubirr, one of the outlying
massifs, we could have embarked on a different journey, back into the
prehistory of Australia. For the image of the white ibis could just as
easily have been painted on one of the rock shelters that overlook the
wide flood plain of the East and West Alligator rivers (23). The same
artists painted on rock walls and on sheets of bark, and when painting
on rock they were in contact with a past that had left its mark on the
surfaces of Ubirr for at least 20,000 years.

23
Painting on
Ubirr rock,
Kakadu
National Park,
Arnhem Land

Aboriginal people have been in Australia for over 40,000 years. When
they arrived by sea from Southeast Asia, Australia was part of a larger
continent which remained joined to New Guinea until as recently as
8,000 years ago. Contrary to popular misconceptions, Australia has
remained in touch with the rest of the world throughout its human
history. The earliest prehistory has yet to be reconstructed and the
details of relations with outsiders may never be fully recovered.
Contact across the Torres Strait with the inhabitants of coastal New
Guinea must have been continuous: there is considerable evidence
of trade, intermarriage and the diffusion of languages.

The history of contact with Indonesia and beyond, to China and
Southeast Asia is less certain. It is likely that there have been sporadic
relations with these areas over many centuries, and Aboriginal myth

suggests periods of close contact with more than one set of regular visitors. Who these people were and how early on their visits were first made remain open questions. However, the recent links between northern Australia and the people of eastern Indonesia have been well documented. Each wet season for nearly three hundred years, until 1906, when they were banned by the Australian government, Macassan traders from south Sulawesi came to coastal Arnhem Land to collect and prepare sea cucumbers (trepang) for trade with the Chinese.

Art is one of the main sources of information on the prehistory of Australia. The record is patchy, dependent on the chance survival of rock paintings and engravings. Early art is difficult to date and just as hard to decipher. It is possible that the first people to arrive in Australia were already artists; certainly ochres are included in the earliest human deposits excavated, suggesting that they were used as pigments from the start. The earliest extant rock engravings are likely to date from around 30,000 BP (before present) and surviving paintings from perhaps 20,000 BP. But pigments wear away with time, and rock engravings erode into shapelessness, so it is quite possible that Aborigines produced art from the beginning. Indeed, recent research in the Kimberley region of Australia by the archaeologist Sue O'Connor has uncovered possible evidence of rock paintings from 39,000 years ago, with the discovery of ochred rock fragments in deposits at Carpenter's Gap rock shelter.

24
Rock markings,
Koonalda Cave,
Nullarbor Plain,
20,000–15,000 BP

25
Concentric
circles,
rock engraving,
Ewaninga, Alice
Springs, Northern
Territory

Australian rock art shows great diversity in time and space but also some remarkable continuities of form. Some of the earliest markings on rock come from Koonalda Cave in the heart of the Nullarbor Plain in the south of Australia (24), dating back 20,000–15,000 years BP. The walls of the cave are soft and easily marked, and in places they have been covered by spaghetti-like patterns traced with fingers and implements. In some cases the patterns take on more systematic shapes, as if some regular form was intended – a fan, or a set of parallel lines – but for the most part they give the impression of sets of idly meandering lines. The earliest rock engravings seem to be geometric in form, consisting of pecked circles and linear motifs with scattered animal footprints. The interesting thing about these forms is that they never disappear from

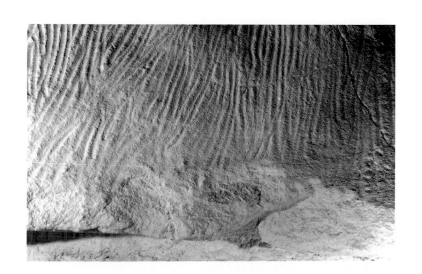

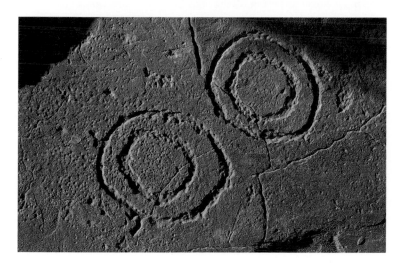

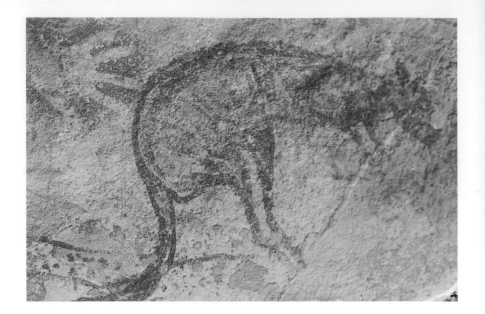

the art but occur again and again over time. Concentric circles can be found in both the earliest and most recent rock art (25). It may be a characteristic of continuing traditions of rock art that a form once taken up is never forgotten, so the possibility of re-emergence is always there. The motifs remain on the rock wall as a constant source of reference, a reminder of what once had been, and the simpler the form the more easily it is both replicated and connected with present meanings. The significance of geometric art will be returned to in later chapters, but it is important to remember that it was present from the beginning.

The earliest painted art is harder to define precisely because it is more subject to regional variation. In most places hand prints and hand stencils are among the first-known forms. The geometric art is ever-present but so too are animals. The images appear to be done largely in monochrome red, but again the nature of the evidence can be misleading. Red ochre seems to be the most durable of colours used, and in the right geological and climatic conditions it combines with the rock to produce a mark of near infinite durability (26). On the other hand, white clay, one of the most common pigments used today, is also the flakiest and within a decade a painting may have peeled away to leave only the bare rock surface. The rock painting of a kangaroo that I photographed near

26
Wallaby, near the Mann River, Central Arnhem Land

27
Kangaroo at Mangalod on the Mann River, Central Arnhem Land, c.1974

the Mann River in 1974, soon after it had been painted (27), has an elegant simplicity of form comparable with many of the earlier red-ochre paintings that have established a near permanent presence in the neighbouring rocks. But the white kangaroo is unlikely to last more than a few decades as the pigment wears away. Rock art is thus a partial and selective record.

Despite the many problems it presents, rock art opens the possibility of extending our understanding of Aboriginal art and society into the quite distant past. The record is at its most complete in Western Arnhem Land around Oenpelli. The eroded gorges, broken massifs and sloping rock shelters of the Arnhem Land escarpment provide one of the world's great canvases for rock art, and innumerable painted galleries are spread throughout the region. Following the path of Deaf Adder Gorge or moving from one rock shelter to another up the escarpment edge is an experience of immense richness. The climb up Ubirr starts in the partially enclosed environment of the tropical forest and the first rock paintings emerge from the gloom beside the path. Then, as the climb begins the trees thin out, the sky opens up and the towering red walls of the escarpment appear on one side and the flood plain of the Alligator rivers stretches out seemingly for ever on the other (28). And as the sun moves it illuminates one painted gallery after another.

Almost invisible in this rich landscape of paintings are early engravings, similar in form to the geometric art found elsewhere. The early paintings too fit into a familiar pattern of hand stencils and red-ochred animal forms. But then begins a sequence of styles, which lasts from 15,000–12,000 BP to the present, that is almost unrivalled anywhere in the world for its complexity and the information it seems capable of yielding. The paintings themselves record a time of enormous change, during which the landscape of the Alligator rivers region was transformed and new groups were constantly moving into the area.

Fifteen thousand years ago the Arnhem Land escarpment was a long way from the sea and represented a much more marginal hunting and gathering environment than it subsequently became. Australia was still joined to New Guinea, and the Gulf of Carpentaria and much of the northern coast had not been inundated by the inrushing sea that followed the end of the last Ice Age. The escarpment was a more arid and less habitable region, and Aboriginal people would have visited the rock shelters on a seasonal basis. The population of the region was sparse, as a result of the more limited inland food resources, and the small number of people may account for the limited amount of rock art from this early period. The rock paintings that do exist reflect the nature of the inland environment, with kangaroos, wallabies and other marsupials strongly represented, and an absence of salt-water and marine species. The material culture depicted also reflects the more open environment, and includes boomerangs, which later ceased to be used in hunting as the forest closed in and throwing implements became less useful. Styles seem to have lasted for a long time, perhaps the consequence of a period of cultural stability.

About 10,000 years ago there was an efflorescence in the rock art associated with a new dynamic figure tradition. 'Dynamic figures' refers to the graceful and energetic representations of human beings that characterize the art for a period of some 4,000 years. The figures are often finely detailed, some have elaborate headdresses, and weapons and other material culture objects such as goose-feather fans are precisely illustrated. The humans are sometimes shown hunting; on other occasions they seem to be participating in rituals, and there are

28
View across the Alligator rivers flood plain from the Ubirr escarpment, Kakadu National Park, Arnhem Land

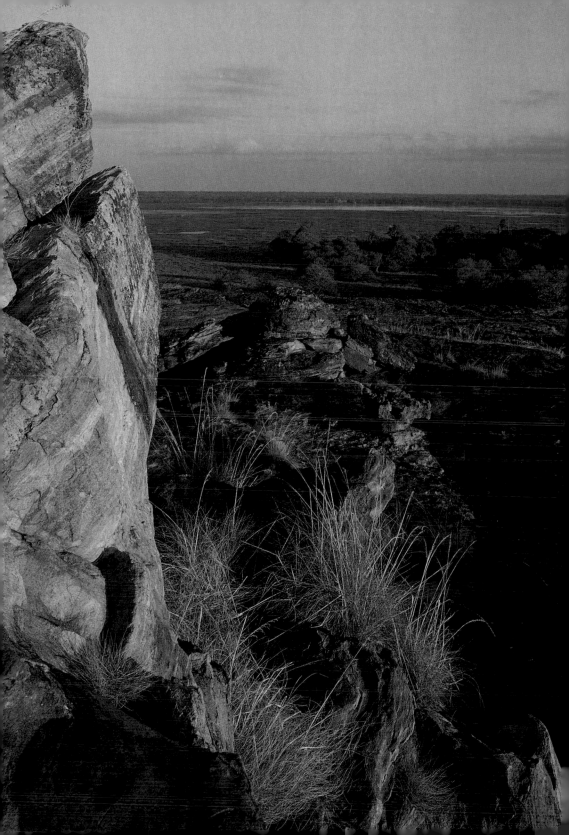

some examples of fighting scenes. The dynamic figure style corresponds to the time when the sea level had risen and the Alligator rivers region became a salt-water estuarine environment on the edge of the escarpment. Marine and estuarine species begin to appear more frequently in the rock art, and the rock shelters and valleys appear to have become more densely peopled. The increase in the population, caused by the development of a richer hunter–gatherer environment and by the retreat of populations as the sea level rose, may be reflected in the content of the rock art. The ceremonial dress of the figures may be a sign of the increase of ritual associated with territorial relations, and the fighting scenes may reflect a population under pressure. Scenes of fighting continue to occur in the later art (29), right up to the present, and the level of warfare may have remained higher in Arnhem Land than in most other parts of Aboriginal Australia.

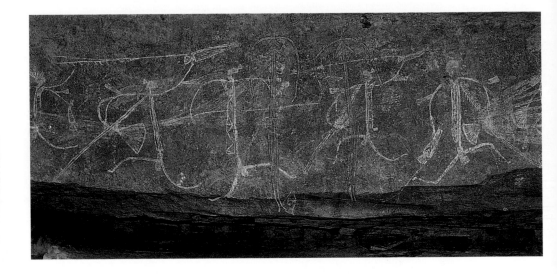

In Western Arnhem Land the dynamic figures were followed by simpler human figures and the less elegant yam-shaped forms characterized by somewhat swollen tuberous limbs. During this later period, c.3,000–6,000 years ago, the rainbow serpent appears for the first time: an elongated fantastical being which combines the features of many different animals organized along the body of a large python (30). Today the rainbow serpent is associated with regional ceremonies that bring people together from a wide area and emphasize themes of fertility

and community organization. It is tempting to see in the art signs of the development of these regional ceremonies which, together with the increased importance of clans, resulted in the systematic organization of the relationship between people and land that existed at the time of European colonization.

Throughout the period of the yam figures the estuarine environment was stabilizing and the region's vegetation was becoming more diversified. The final stage in the area's development occurred over the past one to two millennia, when the immensely rich freshwater flood plains emerged with their abundant supply of fish and wildfowl in the wet and early dry seasons, and tubers, rush corms and other vegetable foods during the dry season. It was during the last 3,000 years that the styles of art that characterize present-day Western Arnhem Land appear to have developed. Human figures continued to be painted in modified

29
Fighting scene, rock painting, Kakadu National Park, Arnhem Land, 3,000–1,000 BP

30
Rainbow serpent, rock painting, Kakadu National Park, Arnhem Land, 6,000–3,000 BP

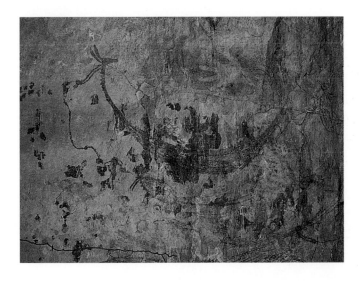

31 Overleaf
X-ray figures of mother, child and fish, Ubirr rock, Kakadu National Park, Arnhem Land, early 20th century

forms of many previous styles and there were also occasional battle scenes, but this latest period is characterized by the development, in its full glory, of the style of representation known as x-ray art. 'X-ray' refers to the fact that the internal organs and structure of animals were represented (31). Although an element of x-ray had occurred in art of earlier periods, only in the past 3,000 years did x-ray become a dominant feature. Out of this tradition came the *White Ibis Godolpa* (see 3).

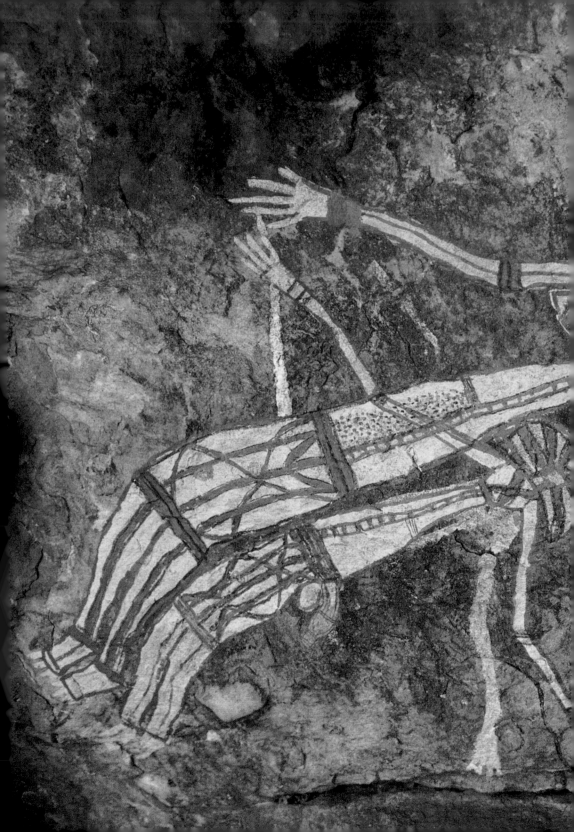

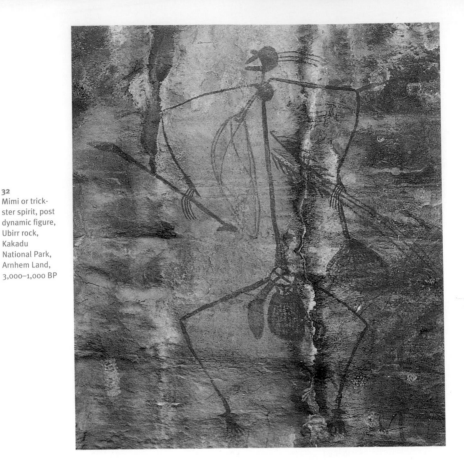

32
Mimi or trick-
ster spirit, post
dynamic figure,
Ubirr rock,
Kakadu
National Park,
Arnhem Land,
3,000–1,000 BP

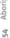
One must add a note of caution about the sequential history that is
beginning to emerge in Western Arnhem Land rock art. The interpreta-
tions are very tentative and are likely to be only part of a complex
history that will never be fully recovered. Part of the difficulty of
analysing rock art lies in its very permanence as a record. It is not
only the archaeologist who tries to understand the significance of the
images, but the artists themselves. Each generation has the potential
to reuse and reinterpret the images. The human figures that occur
throughout time in the rock art, and which are frequently schematic
in form (32), are now said to represent trickster spirit beings, called
Mimis. Today, Mimis are represented in bark paintings by stick figures
which draw inspiration from images in the rock art (see 110 and 114).

Styles of paintings may recur over time, though with some modification
and changed meanings. Contemporary bark painters tend to draw their

inspiration from many different styles of rock art representing various periods in the archaeological record. The same artist may produce an x-ray kangaroo, a sorcery figure or a battle scene with Mimi figures. There is no reason why artists painting on rock surfaces should not also have drawn their inspiration from earlier representations. While the historical pattern that is emerging from Western Arnhem Land is gaining some credibility, similar explanations for changes in rock art elsewhere in Australia are difficult to make, partly because of the complex nature of rock. Robert Layton, in his book on Australian rock art, has gone into this issue in considerable detail for the Kimberleys, the other part of Australia where detailed information exists about the meaning of rock art.

The art of the Kimberley region in northwestern Australia is dominated by what appear to be two very different styles of rock painting: the Wandjina style and the Bradshaw style. We have encountered the Wandjina in the last chapter (see 9), where these figures were believed by Sir George Grey to be evidence of a superior race of visiting voyagers. The Wandjina tradition is the dominant one in the western Kimberleys, where three languages, Worora, Wunumal and Ngarinyin, are spoken. The Wandjina themselves are spirit beings integrated into the spiritual and social life of the region. The Wandjina tradition dates from c.1,500 BP and continues into the present. They are said to have come out of the sea and sky, to have created features of the landscape and then to have been absorbed into the walls of rock shelters in the territories of different clans. Wandjina are impressive figures roughly human in form, up to 7 m (23 ft) in length, with eyes and noses often integrated into a conjoined form. Their heads are surrounded by a halo. They have no mouths but often have an oval form below their necks where the breastbone would be. The paintings, produced on an initial white ground, have features delineated in red with the occasional use of black and yellow. They often occur in sets together with other animals, fish, honey and eggs painted in a similar style.

The Wandjina were part of a regional religious cult, the *wunan*. Each clan had its own special centre for which it was responsible. Looking after the site involved the regular repainting of the Wandjina figures,

which ensured the fertility of the land and the regular flow of the seasons. Certain sites were also associated with spirit conception, the process by which new children were conceived. The repainting of the Wandjina contributed powerfully to their aesthetic impact. The Wandjina caves and shelters were often covered with clear, thickly pigmented and striking images in red ochre on a brilliant white ground. In each case the humanoid figures had a certain uniform starkness, but the organization of the images as a whole, in combination with other figures, created an often complex spectacle. The repainting carried on over the centuries effaced any temporality, making the paintings equally part of the present and the past. In contrast, in Western Arnhem Land, where repainting was very limited, the sequence of the paintings was marked by their differential ageing with time.

This quality is shared with the other main tradition of the Kimberley region, the Bradshaw figures (33). These figures almost certainly do predate most of the Wandjina, although the relative dating has not been well established. They show features in common with the dynamic tradition of Western Arnhem Land, and many date from a similar period, c.6000 years BP. A substantial number of the paintings consist of elegant representations of graceful human figures delineated in red ochre. The figures often seem to be floating or dancing in a trance-like state, their limbs elongated, weapons or ceremonial items held in their hands. But their actual significance so far remains elusive. The Aborigines today are unable to interpret them, and indeed treat them as if they belong to another era. However, even this apparent distancing may be misleading.

There is a another tradition of painting contemporary with the Wandjina which is associated with trickster beings and sorcery practice, the Wuruluwurulu. These are small figures painted in red ochre that some-times occur in caves cutting across the Wandjina or are painted in completely separate places. Just as the Wandjina themselves are in origin traces of the form of the ancestral beings as they disappeared into the rock surface, so the Wuruluwurulu can be interpreted as a supernatural occurrence, the challenge to the power of the Wandjina by darker spirits. And following this interpretation, the Bradshaw figures

33
Bradshaw figure, rock painting near the King George River, Kimberley region, Western Australia, c.6,000 BP

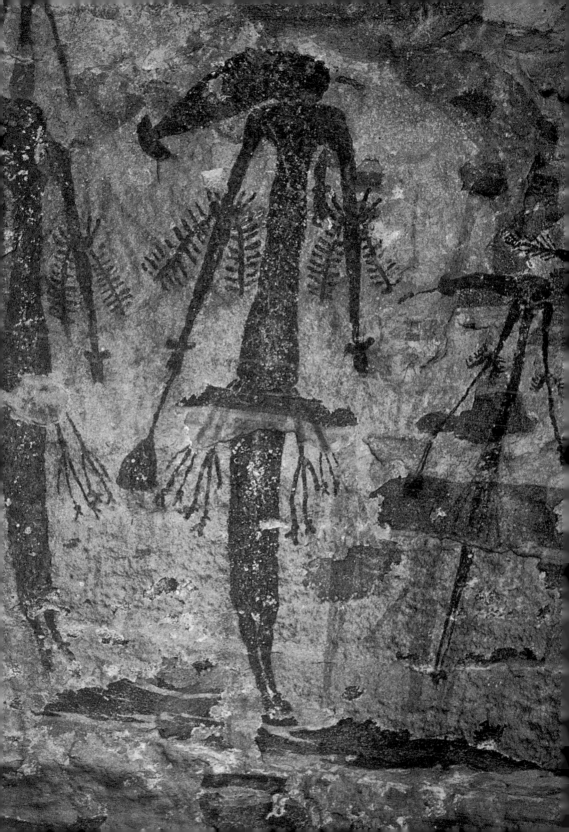

are sometimes discussed as negative beings, sorcery figures from the past. In this way the Kimberley rock art of the past has been incorporated within an interpretative schema of the present: the Wandjina on the one hand, repainted again and again over time, becoming part of an eternal present; the Bradshaws, fading in memory and reality over time, but still able to be connected to the present in the form of the capricious spirits who provide a potential source of disruption. The contemporary nature of the Wandjina is reflected in the fact that they, rather than Bradshaw figures, are represented in bark paintings from the region. The painting (34) by Charlie Alangowa (Numbulmoore) (c.1907–71) of the Wandjina captures on bark the spirit of the rock art.

The most recent phases of rock art in Australia provide records of external visitors. Macassan praus (boats) are painted on rock shelters in the Oenpelli region and also on Groote Eylandt. The Macassans are an important theme in Arnhem Land art and religion (see Chapter 7). In northeast Arnhem Land sacred objects represented aspects of Macassan material culture such as anchors, ships' masts, graveposts, flags and gin bottles. Macassan words and mythological themes occur in songs, and dances represent aspects of the daily life of Macassan visitors to Arnhem Land. On Melville Bay stone arrangements that represent Macassan forms still survive (35).

The arrival of Europeans is represented in art all over Australia, from the fine engravings of early European boats on rocks in the Hawkesbury region of Sydney signifying the arrival of the First Fleet, to engravings of wagons on rocks along the Hodgson River, south of Arnhem Land,

34
Charlie
Alangowa
(Numbulmoore),
*Untitled (Four
Wandjina
figures)*,
1970.
Natural
pigments
on bark;
71.5 × 111.5 cm,
28⅛ × 43⅞ in.
National
Museum of
Australia,
Canberra

35
Stone arrange-
ment, Melville
Bay, Eastern
Arnhem Land

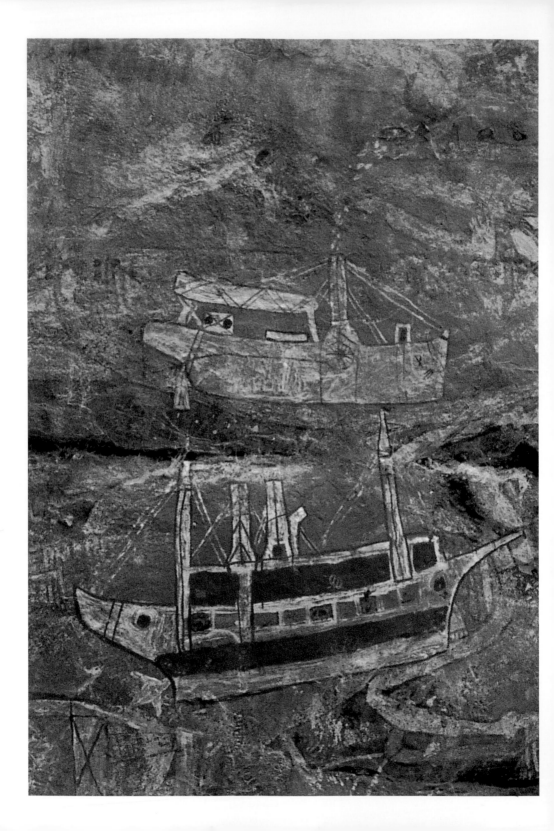

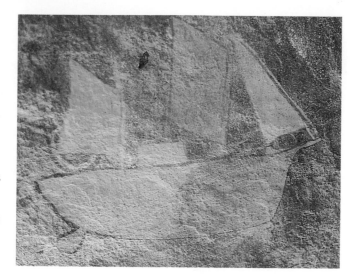

36
Boats,
probably
c.1840.
Rock painting,
Mt Borradaile,
Western
Arnhem Land

37
The mission
boat *The Holly*,
c.1920. Rock
painting,
Ayuwawa,
Groote Eylandt

marking the passage of early cattlemen into the Northern Territory.
In Western Arnhem Land these early records of Europeans are painted
in x-ray style, with x-ray horses and buffaloes, boats with cargo in
the hold, and even x-ray guns. The rock art of Western Arnhem Land
provides a record of many aspects of early colonial life: the policemen
and soldiers with their weapons; the Chinese workers on the nearby
gold-diggings; the barges and boats that plied the Arnhem Land coast
(36) and supplied the European settlers and mission stations, and the
military and civilian planes that were based at Darwin at the beginning
of the twentieth century. Over to the east, on Groote Eylandt, similar
themes are portrayed, including paintings from the missionary times,
such as one of the mission boat *The Holly* (37).

The contemporary Rembarrnga artist Paddy Fordham Wainburranga
(b.1941) is renowned for his reflective historical paintings done in the
expressive figurative style of south-central Arnhem Land. As well as
producing a famous series of paintings on the arrival of Captain Cook in
Australia, he has explored the more recent history of Australia's involve-
ment in World War II from a somewhat tongue-in-cheek Rembarrnga
perspective. The bombing of Darwin by the Japanese in 1942 had
considerable impact on the white and Aboriginal people of northern
Australia. The event is commemorated in one of the most popular
dances of the Tiwi people from Melville and Bathurst Islands. In Paddy

38
Paddy Fordham Wainburranga,
How World War II Began,
1990.
Natural pigments on bark;
65 × 135 cm,
25⅝ × 53⅜ in.
National Gallery of Australia, Canberra

Fordham Wainburranga's version (38), the event was a consequence of a contretemps between Aboriginal people and Japanese pearlers over women. The bottom right panel shows an exchange involving Aboriginal women. Subsequently, the Japanese were expelled by the Australian authorities, only to return a year later with their bombers.

Aboriginal art thus provides a record of early – and later – contact with outsiders. We might imagine it as a passive reflection on an unfolding drama that was beyond their control and was to have a devastating effect on their lives. There may even have been an element of pleasure, an aesthetic challenge, in recording these new forms. But this may be adopting too European a view on art as representation. Painting was also a means of bringing objects under control, of incorporating them

within Aboriginal ways of understanding the world and making them part of an Aboriginal universe. I will never forget sitting with Jack Marrkarakara, a man from Groote Eylandt, beside a ground sculpture of a Macassan prau that had just been used in a purification ritual, and being firmly put in my place. I suggested that Aboriginal people had learnt the form of the ground sculpture from observing Macassan ships, implying that the ground sculpture had an origin outside their society. No, I was told, Aboriginal people had always had that ground sculpture, just as they had always had posts that today represent flagpoles and masts that represent the masts of Macassan praus. The ground sculpture came from the Dreaming (see Chapter 3) and had been passed on from generation to generation long before Macassans had visited the

shores of Arnhem Land. But, added Marrkarakara as a concession to my viewpoint, maybe it was only when the Macassans arrived that Aboriginal people knew that the ships were made of wood and that sails billowed from the masts and flags from the poles.

Paintings on rocks become a record of past lives that affect the present while the act of painting is a way of making things belong to oneself. And x-ray art, as will be seen later, is a way of seeing the inside, of looking beneath the surface and understanding the essence of things. The x-ray paintings of Macassan and European themes are an acceptance of change, of new things entering the world, but at the same time they are an attempt to claim that they were always there, prefigured in Aboriginal art and thought, not a final challenge from an irrevocably different and incompatible world but something else to add. Ironically, the additive nature of Aboriginal culture parallels the additive nature of European art: both worlds are accepting of other ideas as long as they fit in with their scheme of things. The power of European culture threatened at first to destroy the Aborigines, not by its intellectual or philosophical power, but through the force of arms and the appropriation of land. It was through their art that Aboriginal people maintained their sense of continuity with the land until circumstances changed so that they could hold on to it physically. And they hold on to it in a way that incorporates the outsiders – the Macassans, the Europeans with their boats and planes, cattle, horses and guns – into an Aboriginal world, rather than being themselves dissolved into the invaders' history.

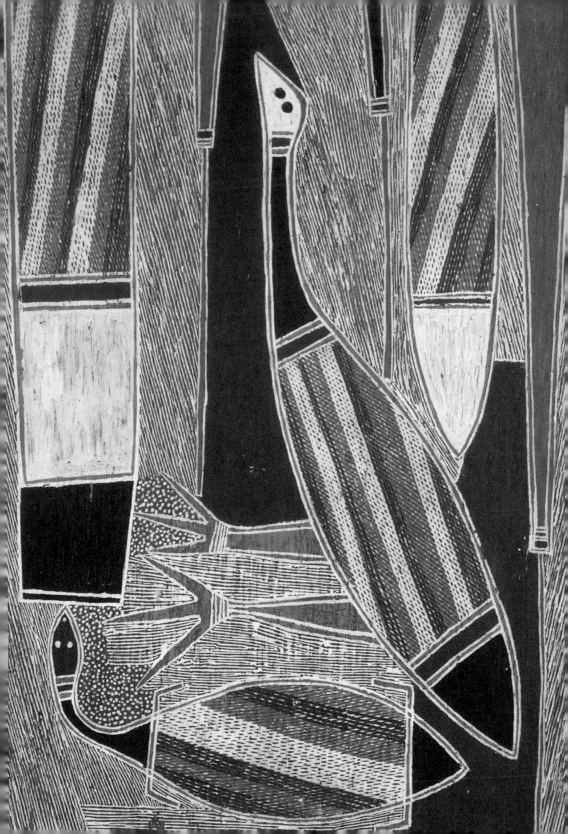

The Dreamtime, or the Dreaming, is crucial to the understanding of Aboriginal art. Art is a means of access to the Dreaming, a way of making contact with this spiritual dimension, and yet in turn it is the product of the Dreaming. In order to understand much Aboriginal art it is therefore necessary first to understand the concept of Dreaming.

Before European colonization there were more than two hundred Aboriginal languages, and many local dialects of those languages. Most Aboriginal people spoke more than one language, and in parts of central and northern Australia this is still true. But the spread of European colonialism resulted in the need to communicate across wider areas. This facilitated the spread of English and it also encouraged certain words to be adopted widely. Some words, such as 'boomerang', 'kangaroo' and 'woomera', came from Aboriginal languages; others such as 'totem' or 'clan' had their origin in non-Aboriginal languages. But in every case they described objects or ideas that were characteristic of Aboriginal societies but were not part of the contemporary European world. 'Dreamtime' and 'Dreaming' are such words.

The terms Dreamtime and Dreaming were first used in the late nineteenth century. They arose both out of attempts by early anthropologists to translate Aboriginal concepts into English and out of Aboriginal attempts to explain their religious values to European colonists. Increasingly, they were also used by Aboriginal people talking among themselves. They signify a concept that was of great significance in Aboriginal society but which was absent from European society and therefore had to be represented by the invention of a new term in English. Like all major religious concepts, the Dreamtime is not something that can be translated by a short phrase: it involves an exploration of Aboriginal ideas about the nature of the world.

Dreamtime corresponds to a word or set of words in many Aboriginal languages: the Yolngu word *wangarr*, the Warlpiri *djukurrpa* and the

39
Lipundja,
Djalambu
(detail of 46)

Arrernte (Aranda) *altyerrenge* are often given as examples. Indeed, it was in translating the Arrernte term that Baldwin Spencer and F J Gillen first used the word Dreamtime in a publication in 1896. They argued that the word *altyerrenge* was applied to events associated with ancestral beings in mythic times and to representations of those times. The word *altyerra* was also used for 'dream' and the suffix *-enge* signifies possession or belonging to. A literal translation might have been 'belonging to dreams' or 'of the dreams', but in order to differentiate the concept from everyday dreams, and to signify the connection to the ancestral past, Spencer and Gillen may have coined the phrase Dream Times. It would be wrong to see the word Dreamtime as a literal translation of an equivalent term in all Aboriginal languages. The word *wangarr*, for example, used by the Yolngu-speaking peoples of Eastern Arnhem Land, cannot be translated literally as Dreamtime, and indeed some Yolngu feel that the connotation of 'Dream' is inappropriate: *wangarr* is not a dream but a reality. So the words Dreaming and Dreamtime should not be understood in their ordinary English sense, but as words that refer to a unique and complex religious concept.

The Dreaming exists independently of the linear time of everyday life and the temporal sequence of historical events. Indeed, the Dreaming is as much a dimension of reality as a period of time. It gains its sense of time because it was there in the beginning, underlies the present and is a determinant of the future; it is time in the sense that once there was only Dreamtime. But the Dreamtime has never ceased to exist, and from the viewpoint of the present it is as much a feature of the future as it is of the past. And as we shall see, the Dreamtime is as concerned with space as with time – it refers to origins and powers that are located in places and things.

In most if not all Aboriginal belief systems there was a time of world creation before humans existed on earth. Often it is said that in the beginning the earth was a flat featureless plain. Ancestral beings emerged from within the earth and began to give shape to the world. The ancestral beings were complex forms capable of transforming their own bodies. Many were based on the shapes of creatures such as the kangaroo, emu, possum, caterpillar or witchetty grub; others on

inanimate objects such as rocks and trees; and others still on whole complexes of existence, such as bushfires or beehives and honey. However, whatever their form they were not subject to the constraints of everyday life. If they were boulders they could run, if they were trees they could walk, if they were fish they could move on land or dive beneath the surface of the earth. Frequently, an ancestral being transformed from animal, to human, to inanimate form, swimming like a fish or jumping like a kangaroo, walking like a person, singing songs or performing ceremonies, and transforming into a rock.

Every action of the ancestral beings had a consequence on the form of the landscape. The places where they emerged from the earth became waterholes or the entrances to caves; where they walked, watercourses flowed; and trees grew where they stuck their digging sticks in the ground. They lived as humans do today but on a grander scale, and their actions had grander consequences. Great battles occurred between groups of ancestral beings, and where they died hills formed in the shape of their bodies, or lakes formed from pools of their blood. Over time the features of the earth began to take shape, and as long as the ancestral beings lived on the surface of the earth they modified its form little by little. Where they cut down trees they left marks in a hillside; where they crossed a river they left behind a rocky bar; when they threw their boomerangs they pierced a hole through a cliff (40).

The landscape was not only formed as a byproduct of ancestral action; it was also a result of the transformation of ancestral beings' bodies

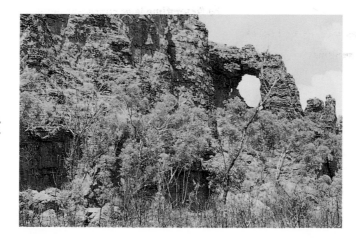

40
Boomerang
rock, Gadjiwok,
near Roper Bar,
Arnhem Land

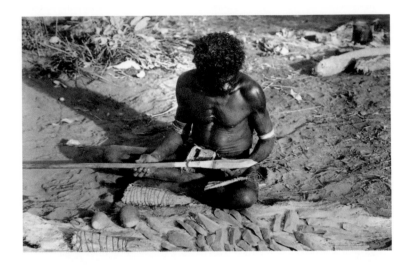

or bodily substances. Sources of ochre throughout Arnhem Land are formed from the blood or fat of ancestral beings. According to one story, the great stone spear quarry of Ngilipidji (41) on Blue Mud Bay, Eastern Arnhem Land, was formed from solidified blocks of honey that were driven deep into the ground when ancestral women cut down trees filled with honeycomb.

Ancestral beings may be incarnate in spectacular or unusual natural features or they may be part of mundane natural processes. The Wilton River in Ngalakan country in southern Arnhem Land, near its confluence with the Roper, is subject to both seasonal and daily fluctuations in the height and flow of its waters. During the wet season the river level rises until it covers the lower branches of the paperbark trees that line its banks. In the dry season the river rises and falls several feet each day as the tide ebbs and flows at the mouth of the Roper some 65 km (40 miles) away. At high tide in the dry season at a place called Yinbirriyunginy the river flows evenly, full and deep. But as the tide flows out rocks gradually appear across the river bed – craggy and jagged rocks cut by the endless flow of the river that eventually stand several feet tall against the flow of the current. These rocks are a manifestation of Djadukal, a group of ancestral plains kangaroos who crouched in the river to relieve themselves and were frozen for ever in that undignified position (42). The rocks are an expression of the kangaroos' presence in the land, but the kangaroos themselves moved on to create other places and things. Their spiritual force is thought to be permanently incarnate in the land. Earlier in their journey they fed on grass beside the Roper, where it is crossed by a rocky bar, and were transformed into coolibah trees (*motjo*) which stand beside the river. Over time the landscape changes, trees die and new ones grow up to take their place; the new trees take over the names of the old and continue as signs of the spiritual presence of the ancestral kangaroos.

Just as the changing lives of people and the succession of human generations are linked to the continuing influence of the ancestral past, so too is the seasonal cycle and the process of change in landscape anchored to the permanent presence of the ancestral beings in the land. Aboriginal religion is concerned with the continuities that lie behind

41
Making a spear using stone from blocks excavated at Ngilipidji, Eastern Arnhem Land. Photographed by Donald Thomson, 1935. Museum of Victoria

42
Rocks in the Wilton River at Yinbirriyunginy, Arnhem Land

dynamic processes and produce new lives, with stability in a world of acknowledged change. It is this accommodation of change and process that has enabled Aboriginal religion to maintain its relevance in a rapidly changing world.

Although their actions often appear to be violent, capricious or amoral, ancestral beings also instituted many of the rules by which humans subsequently lived. They invented ritual practices such as circumcision, originated the form of ceremonies, established marriage rules and lived according to the social divisions that characterize present human groups. They also created material culture objects such as stone spear-heads, boomerangs and string bags. Plants and animals that occurred in particular areas were named by the ancestral beings who spoke in the languages of the groups that eventually took over guardianship of the land. And they invented the songs, dances and paintings that commemorated the great acts of their life and their journeys. The mythological beings of the Dreamtime also created the human beings who were to succeed them on the earth.

The relationship between humans, animals and the Dreamtime beings differs from one part of Australia to another. In Arnhem Land mythology the creation of humans seems to have occurred quite late in the process of world creation, although from early on the ancestral beings them-selves had human attributes. The first humans came fully formed into the world, born out of the bodies of ancestral women. The ancestral women are often portrayed pregnant both with children and sacred objects, but needing some ritual act to unblock their vulvas so that they can give birth. In different places different agents come to their aid: a bird's beak, an emu's leg or a digging stick. Throughout Eastern and Central Arnhem Land children of the Dhuwa moiety were born from the Djang'kawu sisters.

The Djang'kawu sisters began their journey in the east, leaving the mythical island of Buralku in their canoes and reaching the coast of Arnhem Land as it was lit by the rays of the rising sun. In some versions of the myth the sisters were accompanied by their brother. When they reached land they pulled their canoe up on to the beach and began to make a camp for themselves. They used two digging sticks to support

them as they walked, holding them in either hand. When they made camp they dug a well in the ground with their digging sticks. Afterwards they planted the sticks beside the well and these became transformed into trees. They then spent much time exploring the landscape and naming places before they finally lay down beneath a *nganymara* mat, a large conical pandanus mat used for shade, and gave birth to numerous children and sacred objects. They then moved on to another place and repeated the sequence of events until, having peopled the landscape, they had finally completed their journey. Mawalan Marika's painting (43) magnificently conveys the creative powers of the ancestral women as children appear to cascade from their wombs, bringing abundance and fertility to the land.

In much of central Australia human beings seem to have been created earlier on, often appearing as partially formed 'found objects' in the landscape, and subsequently moulded or cut into shape by the actions of ancestral beings. These forms were intermediate between humans and animals and could be shaped into either. One myth from Lake Eyre in central Australia describes the first humans as coming partly formed out of a great hole in the ground at Lake Perigundi and lying in the sun to dry until they gained the strength to disperse across the landscape. A toa made by a Diyari man at the beginning of the twentieth century and now in the South Australian Museum illustrates this event. Toas were direction signs left behind at a camp to show people who followed where a group had moved to by representing mythologically significant features of a place. There has been some debate as to whether toas were used in pre-colonial contexts. My own assessment of the evidence is that they were used but that in some cases the form and the context of their use were influenced by European colonization of the region. The toa illustrated (44) shows the head of a human being emerging from the earth; the bands below the head represent the island that was created in the lake and the red dots the bushes that subsequently grew there. The whole represents the emergence of life.

Other myths tell of human encounters with particular ancestral beings who helped complete their transformation. In a Diyari myth from the Lake Eyre region the moon moulded two lizard-like creatures into

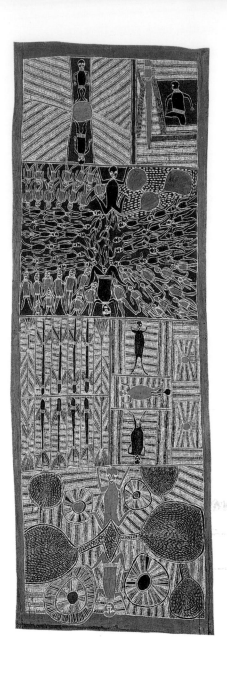
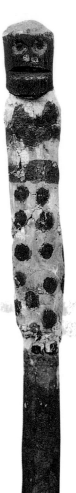

human shape by forming toes on their feet, then their noses, ears and mouths, and finally by cutting off their tails so that they could stand erect. A Yarawarka myth from the same region recounts how an ancestral being, Muramura Paralina, was out hunting for a kangaroo and saw four incomplete cowering beings. He smoothed out their bodies, cut fingers and toes, moulded mouths, noses and eyes and stuck ears on either side of their heads. He then blew hard through their ears so that they could hear, and finally made a sausage-shaped lump of hard clay which he forced down their mouths and out through their anuses to create their digestive systems.

In the mythology of the Arrernte, from the Alice Springs area of central Australia, human beings were similarly moulded out of more generalized forms. As Spencer and Gillen recorded, the earth was originally covered with salt water; after the water had retreated to the north, partly formed creatures called Inapertwa were left behind. In the sky two ancestral beings, Ungambikula ('ones who exist out of nothing'), saw the creatures and began to mould them into different groups of humans. 'These Inapertwa were in reality stages in the transformation of various animals and plants into human beings [and] each individual of necessity belonged to a totem of the name ... of the animal or plant of which he was a transformation.'

The ancestral beings often replicated themselves out of their own bodies. In an Anmatyerre story from the Harts Range in central Australia, Amungakunjakuna (the Jew-Lizard) reproduced by contemplating his own form, comparing himself in immense detail with the form of other animals. When finally he had differentiated himself from the rest of the world and established his own identity, another jew-lizard appeared out of his body; he stared at it and concluded that this was the same as looking at himself. He then travelled around showing other ancestral beings how to reproduce themselves.

Sometimes ancestral beings were involved in the process of simultaneously reproducing humans, animal species and sacred objects. In the great Arrernte myth of the bandicoot, Karora, the ancestor of all bandicoots, lay sleeping. He imagined a future world full of life where hunger was satisfied by plenty. He produced hundreds of bandicoots out of his

navel and from his armpits, and at dawn satisfied his hunger by cooking and eating two of them. Another night he felt a pain in his arm and from it emerged a bullroarer, a sacred wooden object attached to a piece of string that makes a roaring sound when whirled, which subsequently transformed into the shape of a man, his son, the first human of the bandicoot clan. The father sent the son out to catch bandicoots and in the evening they feasted together. Gradually more humans were born and bandicoots became scarcer. The humans searched for bandicoots without success, using the sacred objects as clubs, finally throwing them at a shape in the bush only to find that they injured their own bandicoot father. The bandicoot bodies were transformed into rocks near Alice Springs.

This world of human origins is one of partly formed embryos which have the potential to engender many different forms of life. The division between the ancestral and human world is ambiguous, as forms move from one state of being to another. Underlying the myths are the creative powers that are manifest in the development of particular forms. The ancestral forces emerge into an undifferentiated world and as their existence continues the world becomes more complex and more definite in its shape: the features of the landscape are formed, humans are differentiated from animals. The myths are concerned with the creation of something out of nothing. They are Aboriginal models of the Big Bang when the universe was created and set on its journey to the present. As the process is traced back in time the differences between things fade and the connections emerge; humans are not so different from animals after all, and the shapes of the mountains represent the imprint of time and the effect of action on the landscape. Totemism – the connection between human beings and animal species – is partly the expression of a belief in the common origin of things and the sharing of substance across the universe. These stories of creation are poetic accounts of the origins of people and society; they are concerned with the logic of similarity and difference, and with the projections of natural process and the certainties and uncertainties of the present onto the evolution of the world. They are stories of emergent physiologies but they are equally stories of emergent desires.

Human beings are also part of the continuing presence of ancestral beings on earth. When the ancestors left the surface of the earth and returned to that dimension of existence characterized as the Dreamtime, they left behind sources of spiritual power and expressions of self which continue to affect life on earth. Perhaps the most important connection to the ancestral world that an individual acquires is through spirit conception. In Aboriginal Australia sexual intercourse is not in itself considered to be sufficient to create new generations of humans. Conception requires the intervention of the spiritual domain, and it is conception spirits that give people their initial spiritual identity. In certain places ancestral beings left behind them reservoirs of spiritual power. These places are often marked by a powerful transformation of the ancestor into the landscape, in the form of a spring, cave or water-hole. Images of conception spirits vary across Australia, but in some form or other they are believed everywhere to be capable of entering a woman and initiating a pregnancy. Sometimes conception spirits can be summoned up by ceremonial performance, by ritual actions associated with certain fertility ceremonies. More often they wait in the waters of a well or stream or in the atmosphere surrounding a sacred site.

The conception spirit must be identified retrospectively by a form of spiritual diagnosis. A woman will report that she is pregnant and can feel the baby moving within her body. Her husband and other relatives will think of events that have occurred that may be a sign of the concep-tion. They may remember that the woman swam in a waterhole near a Dreaming site or that she participated vigorously in a ceremony. More often an unusual or dangerous event is recalled. The husband may have killed a kangaroo that proved to have a particularly large liver or the woman cooked a very fat goanna. The man may have been out in a canoe that was nearly overturned by a whale or his dog may have been seized from the river bank by a crocodile. Such events are taken as a sign that a particular ancestor – a kangaroo, a goanna, a whale or a crocodile – was responsible for the conception. After the child is born, people will examine it closely to find confirmatory signs, such as a scar where the dog was grabbed, a mark on the leg where the kangaroo was speared.

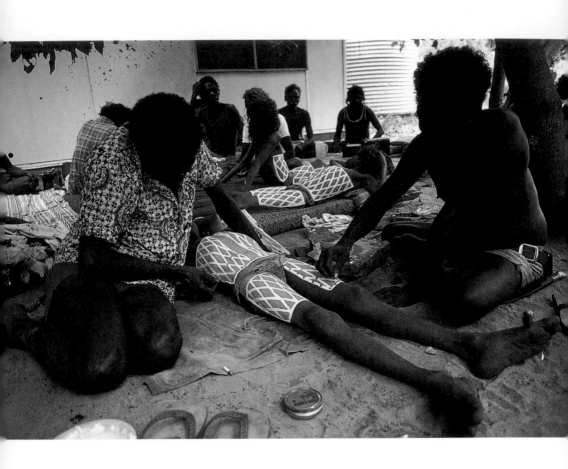

Spirit conception creates an initial link with the ancestral world which is then strengthened during a person's life. As people grow older they perform in more and more ceremonies and pass through different stages of initiation. At each stage they will have paintings placed on their bodies (45), be rubbed by sacred objects, see ceremonial sculptures and have songs sung over them. All these actions associate them with the ancestral beings and result in the accumulation of spiritual power. By the time they have reached old age they are thought increasingly to resemble the ancestral beings themselves; they have absorbed the substance of the ancestral past and are about to move once again into the dimension of the Dreaming. On a person's death it is necessary both for their own spiritual survival and for the continuity of the Dreaming for their spiritual power to become once again a part of the ancestral dimension. Part of the objective of mortuary rituals is to ensure that the soul returns to the ancestral past to rejoin those reservoirs of spiritual power whence it came. Once its journey has been completed, it becomes a source of spiritual power and many return as new conception spirits to initiate the birth of a new generation.

45
Preparation for
an initiation
ceremony,
Arnhem Land

This spiritual cycle exists across Australia, even if it varies considerably in its local detail. In some cases the process is linked with an almost explicit model of reincarnation. For the Arrernte, human beings originated by growing out of sacred objects, *tywerrenge* (*churinga*), which in turn came from the bodies of ancestral beings. Each person is today associated with a particular *tywerrenge*, an oval engraved stone sacred plaque, which represents the spiritual part of his or her life. On death the spirit returns to that ancestral being, and turns back into the ancestor, of which the sacred object is one manifestation. Subsequently, someone else will be born of that same ancestral spirit, will be identified with that same sacred object and will in a sense be the reincarnation of the person who existed before.

In Western Arnhem Land there is a somewhat looser relationship between a person's spiritual and individual identity and particular ancestral beings. Although there are still conception sites (*djang*) associated with manifestations of particular ancestral beings, a person's spiritual identity develops in a complex way during their life as they

travel from country to country and participate in the ceremonies of different ancestral beings. When they die their spirit still needs to be returned to the ancestral domain, but it does so in a way that replicates the journey of their life. The agency of many ancestral beings is invoked to reabsorb the spirit into the Dreaming. The spirit's journey in Eastern Arnhem Land is similarly complex. In many parts of Australia, as in Arnhem Land, the soul can be thought of as partible or as consisting of different dimensions of being, one aspect of which may, for example, return to the conception site but other aspects of which may go to a land of the dead or rise to join the stars of the Milky Way.

The Yolngu of Eastern Arnhem Land have many images of the journey of the souls of the dead, each of which complements the others. In some cases the soul returns to its destination borne on the swollen flood-waters of the wet-season rivers. As it is carried along in the water it has to avoid being speared as a fish, eaten by a bird or caught in a trap. The painting (39 and 46) by Lipundja (1912–68) draws on the ritual practice of his Gupapuyngu clan. In mortuary rituals the spirit is sometimes conceptualized as a catfish moving downstream to seek the sanctuary of shady waterholes. One of the hazards the catfish faces is the swooping figure of the diver bird as it plunges beneath the surface in search of food. Catfish, diver birds and the long-necked freshwater tortoises that are associated with them are sometimes painted on Yirritja moiety hollow-log coffins. And when the bones are placed in the coffin, dances are performed in which long bullroarers, representing diver birds in flight, are twirled above the participants' heads. Other dancers painted as catfish scatter in fright. The painting illustrates seven of the bullroarers spinning around the hollow-log coffin, which can in turn represent a catfish. The oblong figure to the left is the didgeridoo that accompanies the dancers. The catfish are also represented by the backbone design on the bullroarers, in effect consumed by the diver birds. The fishbones also refer to the bones of the deceased picked clean of flesh before being placed in the hollow-log coffin. The painting illustrates well the interplay of figurative and geometric designs in Yolngu art and the mediating role played by material objects in the artistic system. A diver bird and long-necked freshwater tortoise are shown moving in the water. The painting gains meaning through its relationship to ritual

46
Lipundja,
Djalambu,
1964.
Natural
pigments
on bark;
134·5 × 74·5 cm,
53 × 29¼ in.
National Gallery
of Victoria,
Melbourne

practice, by the fact that the catfish designs on the bullroarers also
occur on the bodies of the dancers and that they allude in turn to the
bones that are placed in the hollow-log coffin.

In another image the spirits of the dead reach an island in the sky by
climbing along lengths of feather string that resemble the rays of light
from the morning star (47). Once there, they live in a land of beauty and
happiness analogous to the Christian conception of heaven. In another
metaphor, the soul leaves the body as smoke rises from a fire. When it
reaches the sky, the smoke forms billowing clouds that drift across
Arnhem Land before bursting into rain and as the rain enters the ground
the soul returns to its conception site. Each of these images can be
acted out in ritual or expressed in song, each taps a different emotion or
presents a different idea – the difficulty of a spirit's journey, the desire
for eternal life, the reabsorption of the spirit within the Dreamtime.

Aboriginal conceptions of the spirit world are complex, as in most human societies. Myths and ritual practices represent ways of grasping at the problems posed by death and in their details are of necessity imprecise. As the Yolngu artist Dundiwuy Wanambi (c.1933–96) said to me: 'We will only find out when we die.' The apparent contradictions that exist in Aboriginal religion – conflicting theories of spiritual existence and the fate of the soul, how the soul of the dead can have more than one destination, how a person may or may not be a reincarnation of another, and how a person may reflect the identity of multiple Dreamtime ancestors or be the product of only one – reflect this uncertainty. Myths and ritual are metaphors of what might be the case, attempts to create concrete images of processes that only occur on the edges of the imagination and are never fully part of human experience.

The art historian Nigel Lendon has shown how in his paintings of Murayana, the Manharrngu artist David Malangi (b.1927), from Central Arnhem Land, conveys the world from the viewpoint of an interior spiritual existence. On the left of the painting illustrated here (48) is a representation of a hollow-log coffin, in which the bones of the dead are finally placed. Looming over the coffin is the figure of Murayana merging in with or growing out of the background forest. Murayana is a *mokuy*, a spirit being who provides company for the dead and moves between the world of the living and the spirit world that underlies it. Murayana is stretched out like a dead body covered with designs that represent the leaves of the Warri tree. The leaves of the body painting join the leaves of the trees in the jungle creating a continuous relationship between the present and the ancestral past, the living and the dead, the mundane and the spiritual. The transparency of the representation of Murayana and the interweaving of the leaves creates the sensation of movement through time and space, while the hollow coffin whose eyes stare luminously out of the background darkness of the forest reminds the viewer of the continual presence of death in life. Malangi's painting illustrates the dynamic nature of the traditions of Arnhem Land and the characteristic use of form to convey abstract and spiritual concepts. Designs from one of his paintings, originally borrowed without his permission, graced the first Australian dollar note.

47
**Mutitjpuy
Mununggurr,**
Morning Star,
1967.
Natural
pigments
on bark;
112 × 51 cm,
44 × 20 in.
National
Museum of
Australia,
Canberra

83 Art, Religion and the Dreaming

The great Australian anthropologist W E H Stanner wrote in 1965:

The idea of a sign is thoroughly Aboriginal ... Most of the choir and furniture of heaven and earth are regarded by Aborigines as a vast sign system ... The Aborigine moves, not in a landscape, but in a humanized realm saturated with meaning ... the ordering marvels of the Dream Time.

As we have seen, the most direct manifestations of the ancestral beings are the features of the landscape, and as people walk through that landscape they are reminded at every stage of the ancestral actions that created it. But the ancestral beings also left behind more explicit representations of themselves and their actions in the form of art. Although at times they acted capriciously, they also acted with deliberation, conscious that their actions would have an effect on the future. In particular, they were concerned that the humans who succeeded them on the earth would continue in their footsteps, would follow the rules of conduct that they had instituted and would commemorate their lives. As the ancestral beings journeyed across the earth they therefore made a record of their actions not only in the form of the landscape, but also in the songs, dances, paintings, ceremonies and sacred objects that they created on the way. These reflect on the lives of the ancestral beings and on the country that they travelled through, selecting as they went along certain interesting or characteristic features and recording them in word or design.

48
David Malangi,
Murayana,
1990.
Natural
pigments
on bark;
201 × 122 cm,
79¼ × 48 in.
Museum and
Art Gallery of
the Northern
Territory,
Darwin

The toas of the Lake Eyre tribes of central Australia provide excellent examples of the ways in which the journeys of the ancestral beings are encoded in art. A large collection of them was made by Pastor Johann Reuther, a Lutheran missionary who lived at Killalpaninna on Cooper's Creek between 1888 and 1906. Toas communicated their messages in a variety of ways but in most cases by using signs that represented the name of a place. For example, Tampangaraterkanani is a lake along Cooper's Creek. The name can be translated as 'where the pelicans stand', and it is represented by a carving of a pelican's head (49). Sometimes toas represented some other aspect of the mythology of the place that would be known to the interpreter. Let us illustrate this by following the route of one Muramura ancestor, Darana.

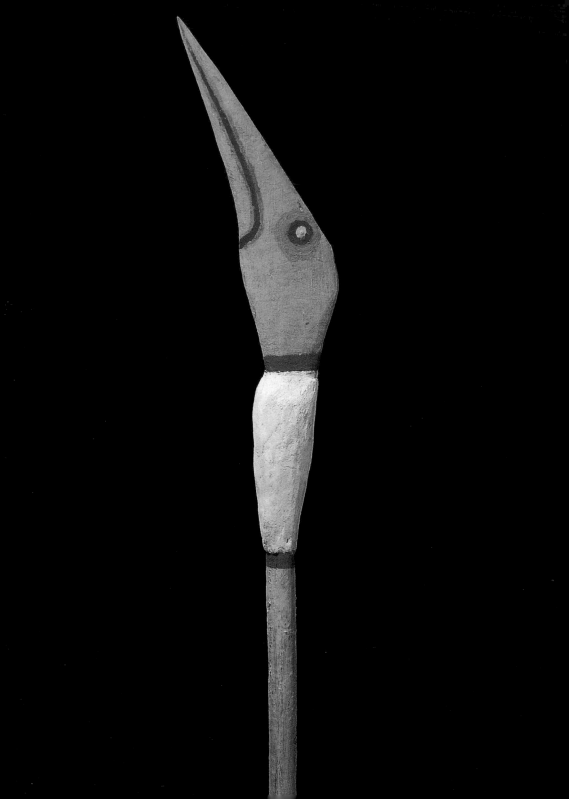

The story of Darana is a dramatic one associated with drought and flood. He emerged from the ground near Lake Hope (near Lake Eyre) painted and wearing his ceremonial headdress. At the time Darana arose from the earth with his followers the land was in the grip of a terrible drought and his songs described the parched landscape and the starvation that followed. Some of his followers died and most became crippled with malnourishment and crawled exhausted on their knees. At one place a number of his followers starved to death and their bones became transformed into marble columns. Darana later

49
Toa of a pelican head,
c.1904.
Natural pigments on wood;
h.52·5 cm, 20⅝ in.
South Australian Museum, Adelaide

50
Set of dogs,
c.1904.
Spinifex resin and ochre;
l. between 18·7 and 22 cm, 7⅜ and 8⅝ in.
South Australian Museum, Adelaide

returned and named the place after the bones he saw still lying there. The toa representing this place has pieces of bone inserted in the top (53). Darana was accompanied by dogs, one of whom is represented in the shape of the sand-dunes by Killalpaninna Mission on Cooper's Creek. The place is called after the name of the dog, Pirrilina ('white patch on the forehead'), since Darana noticed the resemblance to his dog. Reuther collected a unique set of painted spinifex resin sculptures of the dogs of the Muramura (50).

After years of drought, Darana brought rain to the country by per-
forming rain ceremonies and bringing rain to each place in turn.
One of the places where he taught his followers the ritual is called
Wimawolpawora ('the empty song place'), since, after he taught the
chants, they abandoned the place, leaving it empty of ancestral beings
(51). The toa represents the place by a visual pun, through the empty
space in its centre. The creeks filled and the country flooded and even-
tually Darana was up to his neck in water. As the waters subsided the
grass and bushes grew, and the country was transformed into a land
of plenty, although in places the banks of the rivers had been torn
away and the roots of the trees were left exposed (52). The Muramura
wandered from waterhole to waterhole leaving impressions of their feet
and hands in the rocks where they knelt to drink. The toas representing
the place show, respectively, the white impression of the hand that was

left when Darana lent on the rock (54) and his foot as he pressed it into
the ground (55). Darana instructed grubs and caterpillars to go out and
feast on the burgeoning vegetation. He collected the caterpillars and
ground them into two huge bags of flour, which he suspended in the
branches of a giant tree. These were eventually burst by two of his
followers, causing a scarlet sunset.

In Eastern Arnhem Land ceremonial songs are similarly concerned with
description of the environment and with the apparently mundane events
of the daily lives of the ancestral beings. The Djang'kawu sisters sang
songs that recounted their observations of the world as well as the
adventures that they had – the rhythm of the waves, the spray from the
rough sea, the animals they saw on land and in the sea. At Yalangbara
(Port Bradshaw), where they gave birth to the founding ancestors of the
Riratjingu clan, they noticed especially the goannas they saw playing
in the great sandhills and around the waterholes they had created on
the beach. A painting by Mawalan Marika (56) shows four goannas
stretched out on the sand poised to spring into action. The background
pattern of the painting represents patterns in the shifting sands of the
dune caught in the light of the evening sun. Ronald and Catherine
Berndt translated the songs of the sand goanna (djanda) at Yalangbara.
In the following extract, Waridj and Miralaidj are the Djang'kawu sisters
and Djang'kawu is their brother:

What is blocking us, Waridj, Djang'kawu?

It is a djanda goanna, Miralaidj.

We walk along swaying our hips, and singing.

A djanda goanna.

We leave it there crawling; making country, putting the sacred sandhill.

There with its body, its fat and its vertebrae!

We leave it behind, Waridj, Djang'kawu.

It has made tracks on the sandhill, crawling and making country.

We are clapping our sticks and singing watching it crawling.

We put it into the sacred well at the place of the Mawalan.

It splashed in the well, making foam like the sea.

It kicked in the sides and made foam as it dived.

We put it into the well at the place of the Mawalan,

it can stay there that djanda goanna.

56
**Mawalan
Marika,**
Goannas.
Ochre on bark;
94 × 40 cm,
29½ × 15¾ in.
Kluge-Ruhe
Aboriginal Art
Collection,
University of
Virginia

Many of the songs of the Djang'kawu sisters are lyrical descriptions of the environment at sunrise and sunset. They describe the light of the sun glistening on the sand and sea; the bright colours of the plumage of birds and the skin of people and animals are intensified by the rays of the sun. The words of the songs varied from country to country and subsequently became the languages of the human groups that they left behind in each place.

All ceremonies, paintings and songs are representations of the ancestral past, since they were created and used by the ancestral beings themselves. The songs and paintings of the Djang'kawu are evocations of the world as they saw and created it; as such they draw people closer to the creative times. Likeness with the ancestral beings is often the result of sharing characteristics with them, doing things as they did. The Muramura came out of the ground painted and decorated, and by painting and decorating themselves in the same way contemporary people can take on ancestral form. Spencer and Gillen's photographs of ceremonies in central Australia show just how transforming the body art of Australia is, and how easy it is to imagine that the dancers are manifestations of the ancestral beings as they were when they emerged from the earth (57). Similarly, the sacred poles used in the fire ceremony by the Arrernte are the poles that the ancestors themselves made and

the body paintings are the ones that they painted on their bodies. The painting *Three Corroboree Sticks* (58) by Nosepeg Tjupurrula (*c*.1925–93) conveys this sense of the sacred objects themselves strident in the landscape, glowing with their power, continually recreated in ceremonial performance.

Some designs are representations of the form of ancestral beings or other spirit beings. Sometimes the ancestors are represented in figurative form as a kangaroo, or as a rainbow serpent (59), or as with the Djang'kawu sisters, as human beings (see 43). In Cape York Peninsula, centred at Aurukun, there is a flourishing tradition of figurative sculpture representing the cult heroes. These carvings are used in mortuary

57
Dancers at a public ceremony, photographed by Baldwin Spencer, 1902

58
Nosepeg Tjupurrula, *Three Corroboree Sticks*, 1971. Acrylic on composition board; 56·2 × 70·7 cm, 22$^1_8$ × 27$^7_8$ in. National Gallery of Australia, Canberra

rituals and in other public re-enactments of ancestral events. The hero figures are associated with sites along the coast of Cape York Peninsula, sometimes connecting up with places in the Torres Strait Islands. The sculptures, which are made from wood painted in ochres and sometimes have features added in materials such as beeswax, feathers, horsehair and leather, are very expressive forms. Some represent engaging images of animal species: a kangaroo, attributed to George Ngallametta (b.1941), appears to be surprised by intruders, alert and ready to spring away (60). Others evoke images that cut across species boundaries: Saarra, the seagull hero, carved in 1962 by an unknown artist, seems to be halfway between man and bird, poised for flight like some eccentric aviator (61). Many of the sculptures have considerable emotional power.

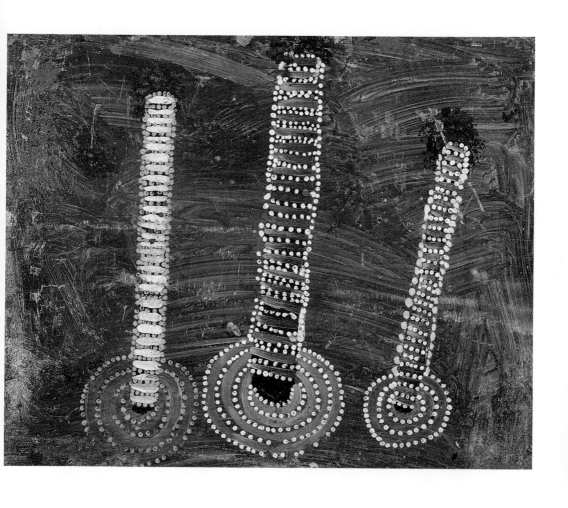

Crippled Boy of Thaa' puunt (62), by Jackson Woolla (1930–98), with his contorted arms, bared teeth and eyes red with pain or anger, evokes feelings of fear and sympathy. His knees are made out of small panels of wood nailed into the body of the sculpture, which adds to the feeling of pain and constriction. In ancestral times the little boy lived on the coast at Pupathun, on the lower Kendall River, and became crippled after entering a forbidden place.

Paintings occasionally represent scenes from the ancestral past, for example the Djang'kawu giving birth (see 43), or ancestral beings in human or animal form fighting. More often, ancestral beings are represented by an object associated with them – a digging stick or a breast girdle, a canoe or a paddle. But seldom can a single representation capture anything but a partial image of the ancestral being. We have seen that the ancestral beings have complex and transformational natures: they are sometimes human in form, sometimes animal; sometimes fixed in the form of rock, sometimes moving rapidly beneath the surface of the earth; sometimes singular, often plural (as with the herd of plains kangaroo on the Wilton River; see 42). It is difficult to imagine most ancestral beings as fixed in a single form. Their character is almost ineffable, grasped only for the moment. In their most concrete

59
John
Mawurndjul,
*The Rainbow
Serpent
Devouring the
Yawk Yawk
Girls*,
1984.
Ochres on bark;
123·5×74 cm,
48⅝×29⅛ in.
National Gallery
of Australia,
Canberra

60
Attributed to
George
Ngallametta,
Kangaroo,
1962.
Wood, ochre,
nails and resin;
68×11 cm,
26¾×4⅜ in.
National
Museum of
Australia,
Canberra

61
*Saarra, the
Seagull Hero*,
1962.
Wood, ochre,
charcoal, nails,
burlap and
leather;
132·5 × 46 cm,
52$^1$$_8$ × 18$^1$$_8$ in.
National
Museum of
Australia,
Canberra

62
Jackson Woolla,
*Crippled Boy of
Thaa' puunt*,
1962.
Wood, ochre,
nails, glass
beads, bone,
horsehair and
resin or
beeswax;
74·5 × 21·5 cm,
29$^3$$_8$ × 8$^1$$_2$ in.
National
Museum of
Australia,
Canberra

form they can be seen embodied in the form of the landscape and in the birth of a child, but the ancestor moves on and the child grows old and dies. They exist, in essence, as an idea, as a creative force that touches many different things and appears in many different manifestations, but which cannot be reduced to any one of them. It may be for this reason that ancestral beings are often portrayed not so much by figurative representations of objects that occur in the natural world as by more abstract geometric forms.

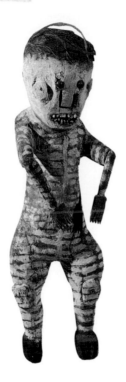

The sacred art of central Australia consists largely of patterns made up of geometric elements, and so it is with the clan designs of Eastern Arnhem Land and the marrayin patterns of Western Arnhem Land. As will be seen in later chapters, these designs can refer to concrete things, such as the topography of the landscape and the identity of the social group owning the design. But their most significant characteristic is that they have the capacity to encode a multiplicity of meanings.

The wild honey ancestor of one set of Yolngu clans is an example of the complex nature of ancestral beings and their associated designs. The ancestor refers to the whole complex of things to do with the wild honey

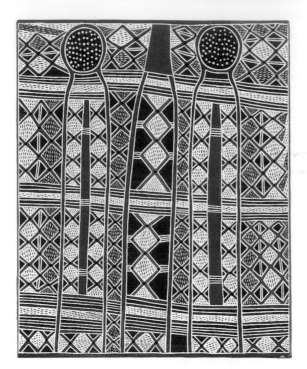

that comes from paperbark trees: the honey itself, the bees and the sounds that they make, the construction of the hives, the flowers and pollen of the paperbark trees, the swamps and the cycle of the seasons. The diamond pattern associated with the ancestral complex, when painted on an initiate's body, woven into the design of a sacred basket or engraved on to the form of sacred object, marks the presence of the wild honey ancestor. This design is the subject of a painting by Dula Ngurruwuthun (b.1936) of the Munyuku clan (63, 64).

The diamond design can be interpreted from a number of different perspectives, all of which contribute to the idea of 'wild honey'. It can represent the cells in the hive, with the white cross-hatching representing grubs, the red representing honey and the crossbars representing sticks which occur as part of the structure of the hive. The honey develops towards the end of the wet season and the diamonds also represent the flooded surface of the creek: here the white segments represent foam on the surface of the water, the red and red-and-white segments represent streamers of weed being dragged along in the current, and the crossbars represent logs of wood being carried along in the flood.

63
Dula
Ngurruwuthun,
*Yirritja Moiety
Wild Honey*,
1976.
Natural
pigments
on board;
64 × 50 cm,
25¼ × 19¾ in.
Private
collection

64
Diagram
showing (a)
entrances to
hive, (b) paper-
bark tree,
(c) background
pattern
representing,
respectively,
the beehive,
the floodwaters
and the bush-
fire, and (d)
paperbark
beater

The honey is ready to collect early in the dry season after the land has been burnt to allow easy access and the growth of new shoots. In this interpretation the diamond pattern represents the course of the fire: the red diamonds are the flames shooting up, the red-and-white cross-hatching represents sparks, the white is smoke, and the cross-bars represent blackened logs coloured on the surface with white ash. These encoded meanings build up a picture of wild honey and the seasonal cycle within which it is embedded. Each set of meanings can be seen as an expression of an aspect of the spiritual force that the wild honey ancestor represents. Taken up in song and dance these meanings can convey very particular connotations: the sound of the bees is the voice of the ancestral spirit as it retraces its journey, the fierceness of the fire is a force that purifies the ground, and so on.

Although the diamond design is the dominant pattern, the painting includes other representations associated with the ancestor. The cylindrical figures represent the trunks of paperbark trees. The circle is the mouth of the hive with the bees flying in and out. And beside the trees is a rolled paperbark beater which, when thumped on the ground, represents the distant sound of the ancestor. In this discussion of the painting we have only begun the process of decoding its meanings, and it will be looked at again in Chapter 5.

The boundary between 'natural' and 'cultural' representations of the ancestral past is not absolute. In Eastern Arnhem Land the same word, *miny'tji*, is used to describe paintings, writing on the side of a vehicle and the pattern inscribed by a beetle into the bark of the scribbly gum. In one myth of origin the diamond design resulted from the pattern created by an ancestral being folding sheets of paperbark. Red-coloured rocks may be the blood of ancestral beings where they entered a hill-side, and some paintings are thought to have been the result of ances-tral action or images left of ancestral beings as they went into the rock surface. In many parts of Australia rock engravings and early paintings are taken to be direct evidence of the activities of ancestral beings. And one of the explanations given today for the Mimi figures that character-ize an early phase of Western Arnhem Land rock art is that they were places where spirit beings were absorbed into the rock. There are many

Aboriginal equivalents of the image of Christ on the Turin Shroud: signs that mark an infinite presence on the surface of the earth.

The paintings, sacred objects, songs and dances are more than mere representations of the ancestral beings and their past. They are also thought of as manifestations of the ancestral past brought forward to the present; they are as concrete as the rocks and lakes that mark the passage of the ancestors across the surface of the earth. Some of the stone *tywerrenge* of central Australia were thought to have come out of the bodies of the ancestors and to have the power to change into human and animal forms. The distinction between the ancestral past and the present is in general merged in Aboriginal art. The paintings, body decorations and sacred objects were first used by the ancestors during their lifetime when they invented the ceremonies that commemorated their creative lives. When people paint themselves with these designs, they are engaged in the same actions that the ancestral beings were. When their bodies are finally decorated for ceremonial performances, they look just as the ancestors looked. Since the design of the painting is itself thought to have arisen out of ancestral activity, and since those living today have their origin in conception spirits from the ancestral dimension, art enables the Aboriginal people to participate directly in that world. Paintings and other manifestations of the ancestral past enable people not just to re-enact those events but to make them part of their present lives and to unite their experience of the world with that of the ancestral beings.

Through painting their own bodies and the rocks, and through making ground sculptures and ceremonial grounds, the Aboriginal people establish direct contact with the ancestral powers and thus can harness manifestations of those powers for human purposes. By keeping alive the presence of the ancestral beings, people ensure the regeneration of the landscape, the fertility of the land and the source of conception spirits. At a more individual level, they use art to make initiates closer to the ancestral spirits of their particular social or cult group, to renew their spiritual strength after recovering from illness or injury and to help a person's soul rejoin the spiritual dimension.

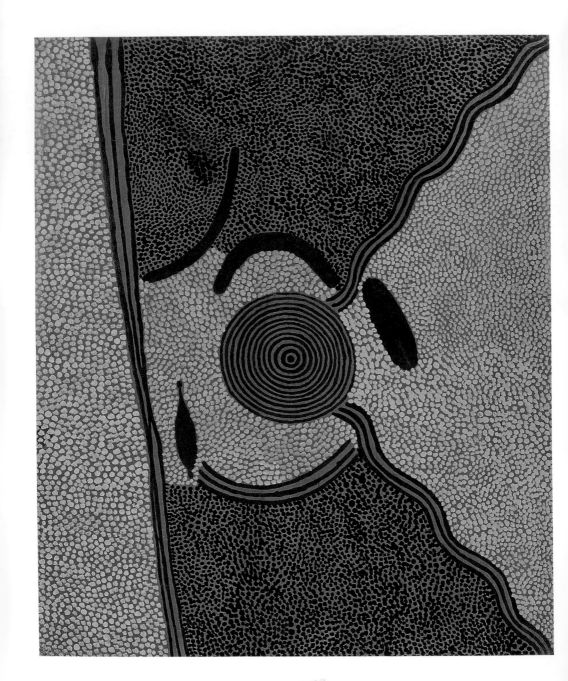

Aboriginal paintings are maps of land. It is necessary, however, to define precisely what is meant by a 'map' in this context. The danger is in transferring too literally a Western concept of topographical map on to Aboriginal cultural forms and making them into something they are not. Paintings are often discussed as if they were bird's-eye views of particular areas of land, as though reflecting an Aboriginal tradition of aerial photography. Seeing Aboriginal paintings from this perspective is superficially inviting because it provides a way in which people from another culture can find meaning in Aboriginal art. It is possible to relate nearly all Aboriginal art to landscape, and some paintings and designs do represent quite precisely the topographical relationship between different features of the landscape. But taken too far the analogy between Aboriginal art and maps can mislead because it oversimplifies and gives the wrong emphasis.

From an Aboriginal perspective the land itself is a sign system. The Dreamtime ancestors existed before the landscape took form; indeed, it is they who conceived of it and gave it meaning. Rather than being topographical representations of landforms, Aboriginal paintings are conceptual representations which influence the way in which landscape is understood. When Aboriginal paintings do represent features of the landscape, they depict them not in their topographical relations to one another but in relation to their mythological significance.

The mythological perspective on landscape, as reflected in Aboriginal art, is crucial, since it has a number of consequences for the form of paintings which make them very different from the conventional Western idea of a map. To begin with, there is no scale and no conventional compass orientation. Whereas there is a right way to view a map or a landscape painting in most European art – a top and bottom, left and right, or north and south – in Aboriginal art this is often not the case. Paintings are frequently produced on the ground, with the artist

65
Tim Leura
Tjapaltjarri,
*Possum
Dreaming at
Kurningka*,
1977.
Acrylic on
canvas board;
61×50·5 cm,
24×19⅞ in.
Flinders Art
Museum,
Flinders
University of
South Australia,
Adelaide

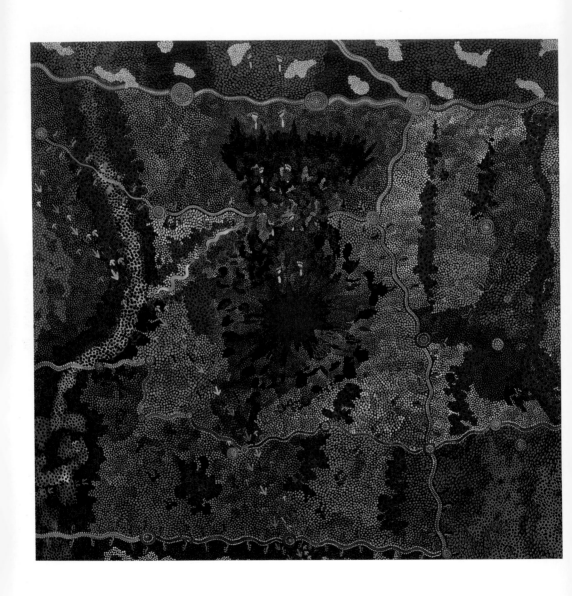

adding features from different sides as he or she moves around it, and each section of a painting may have its own geographical orientation. This way of painting means that in the completed work many features are no longer represented in their 'true' geographical relation and may appear out of place or out of proportion to one another. Paintings can involve detailed explorations of the mythological space of one tiny area and leave other features sketched in as a background reference point. There is often no single orientation for a painting, different views of the landscape may be superimposed on each other and the scale of features reflects their mythological proportions rather than their geographical relations. This applies in particular to many of the larger Western Desert canvases, such as *Warlugulong* (66) by Clifford Possum Tjapaltjarri (b.1932) and his brother Tim Leura Tjapaltjarri (1939–84). The painting has been analysed in detail by Vivien Johnson in her book on Clifford Possum and I follow her analysis here (67).

Warlugulong was painted in 1976, the first of a series of large canvases that the artists produced representing Dreaming tracks across vast areas of land in central Australia. The main theme of the painting is a

Art, Maps and People

66
Clifford Possum Tjapaltjarri and Tim Leura Tjapaltjarri, *Warlugulong*, 1976. Acrylic on canvas; 168·5 × 170·5 cm, 66⅜ × 67⅛ in. Art Gallery of New South Wales, Sydney

67
Diagram showing (a) Warlugulong, (b) track of the sons of the blue tongue lizard Lungkata trying to escape the fire, (c) travelling route of the great snake Yarapiri, and (d) track of the hare wallaby men, Mala

great bush fire, Warlugulong, that burst into being in the Dreamtime at a place of the same name. The fire was lit by the blue tongue lizard Lungkata to punish his sons for not sharing meat from a kangaroo they had killed. The fire had a catastrophic effect, as it chased his sons, who eventually perished in the flames. The bush fire, represented by the exploding figure in the centre of the painting (a), started at a place beyond the right edge of the painting. Most of the sites on the painting are to the east of Warlugulong, which suggests that it is oriented with south at the top. This might be confirmed by the footprints (b) which lead away from the fire towards the top of the painting: these represent the route taken by Lungkata's sons as they tried to escape the flames in the direction of Ernabella to the southwest. However, two of the major tracks that cross the painting contradict this geographical orientation. The serpentine line across the top of the painting (c) represents the great snake Yarapiri, and across the bottom can be seen the track (d) of the hare wallaby men, Mala. In both cases the overall direction of travel was from south to north, which turns the orientation of the painting through 90 degrees.

To understand this apparent contradiction all we have to do is to imagine that in painting the canvas the artists moved around it on several occasions, re-orienting the relationship between features according to their present position and focus. In the painting as a whole there are various twists in geographical perspective in order to incorporate mythological perspectives. Moreover, it is clear that certain long-distance geographical features, such as the track of Yarapiri, are represented in a conventional form which does not take into account the detailed contours of the route taken. They are there as a sign of the journey of the ancestor and the geographical connections with distant places and people rather than as an exact record of that journey. Details of the journey are encoded in the details of particular places and require a shift of scale. It is in the nature of such maps that multiple perspectives are superimposed on one another and that there are differences of scale across the painting. Aboriginal paintings can only be fully understood as maps once it is realized that the criterion for inclusion is not topographical but mythological and conceptual; paintings are thus representations of the totemic geography.

It is possible, however, to overstress the difference between Western maps and Aboriginal maps. The criteria may be mythological, but topographical order still influences how places are represented. And Aboriginal people certainly do produce maps that show the precise topographical relations between particular features of the landscape. Moreover, it is possible to find Western maps which share many of the characteristics of Aboriginal maps described above: which contain maps within maps; have differences of scale and orientation; draw features out of proportion to their actual size; and for which features are selected according to their historical significance.

All maps are full of conventions and distortions, which is why we need keys to read them. The maps we draw to show a friend how to get to our house, or how to negotiate a one-way system, usually lack any true scale or orientation. Like the route of Yarapiri, the main road or other feature that places the map in the wider world may be represented schematically, and the local details may contradict their compass orientations but still be easily interpreted. In order to understand our own maps we have to learn to read them, to know their biases and the viewpoint from which they are drawn, and often we need access to a key or to some specific information about the artist's intention which is not part of the map. We need to be told, for example, that the road between roundabouts is not drawn to scale or that the map only includes major roads. And in understanding the mapping aspects of Aboriginal paintings we likewise need to know the key to their interpretation, the criterion for the selection of features represented, and sometimes the purpose for which they were made.

Aboriginal representations of place and space are influenced by social factors as well as mythological conceptions. The relations between places involve the relations between groups as well as between ancestral beings, and features included in paintings can reflect both the social identity of the artist and the group to which he or she belongs. The ancestral beings gave knowledge of paintings to the people who inherited the land from them. Making paintings of country is exercising rights of inheritance and ritual authority, and often implies rights in the land itself. Every part of the landscape is associated with ancestral

beings, and people's rights vary according to the links they are acknowledged to have with these ancestral beings. The mythological map that a person produces of an area of land is not absolutely fixed but depends on his or her relationship to the land: on their rights to the land and knowledge of its spiritual and mythological significance.

The whole of creation, all of human life, is mapped on the landscape, to which ancestral beings are inextricably connected. Almost anything that exists has its place in the Dreamtime, whether it is an animal such as a kangaroo or emu; an object such as spearthrower, a stone spearhead or a ceremonial headdress; a ritual practice such as circumcision; or even an illness such as a cough or smallpox. And everything that has a place in the Dreamtime is likely to have a place associated with it on earth: a hill that is the transformed body of a kangaroo, stones coughed out of the body of the ancestral being and so on.

Marks and impressions on the ground or the person all have the potential to indicate ancestral presence. Some of the rock art of Western Arnhem Land shows where an ancestral being paused in the Dreaming, such as a stencil of an emu's foot at Kakadu National Park (68). The recent painting of a plains kangaroo at Mangalod on the Mann River marks a rock wall of a contemporary stone quarry associated with the ancestral kangaroo (see 27). In the foreground lies an actual block of stone broken off from the quarry from which stone knives have been made. Representations of rainbow serpents are often found around waterholes where they are thought to bask or caves where they are thought to dwell (see 115).

68
Emu foot
stencil,
Kakadu
National Park,
Arnhem Land

69
Welwi
Wanambi,
Rock Wallaby,
1974.
Natural
pigments
on board;
50 × 64 cm,
19¾ × 25¼ in.
Private
collection

Every representation can be linked with a place, or sets of places,
connected with the travels of the ancestral being associated with it.
A painting by Welwi Wanambi (*c.*1920–74) of a rock wallaby in Eastern
Arnhem Land is closely associated with the mythology of the Wagilak
(Wawilag) sisters (69). The hunting of wallaby with fire, spear and
spearthrower is a recurrent theme of the women's journey. In most
episodes of the story their hunting was unsuccessful – the wallaby got
away. Even when they caught it and prepared to eat by cooking it on the
fire, it eluded them by coming back to life and leaping out of the flames.

The painting shows the wallaby being hunted in the stone country to
the northwest of Blue Mud Bay. At first, little differentiates this painting
from any hunting scene. The hunter is seen moving through the forest,
the bands of red representing the fire lit to mask the smell of the hunter
and conceal him from the wallaby. The upturned trees are stringy-barks

cut down by the hunter searching for honey, and the square block in the foreground represents the stone over which the wallaby hops. But the painting is not of just any wallaby; when it is interpreted as a mythological landscape the hunter is recognized not as a male hunter of today but as one of the female ancestral beings. The painting must represent events that took place somewhere on her journey, and the fallen tree and the lump of rock take on connotations from the ancestral past. This does not mean that every representation is to be associated with one particular place, since ancestral beings are associated with long journeys that connect together vast stretches of land. Often a simple figurative representation does no more than refer to the journey as a whole, while some small detail of the painting may contain a more precise reference to a place. In this case the way the rock is represented suggests a place associated with the stone spear quarry of Ngilipidji in Wagilak country (see 41). The stone spear was invented by the ancestral wallaby as it was chased by hunter and fire through the inland forests; its feet hit the rocks heated by the fire and fragments flew off, cutting the hunter about her legs. The stone quarry itself consists of blocks of stone buried beneath the ground which are believed to have originated from pieces of honeycomb that became embedded in the earth when the stringy-bark tree was cut down.

Marks in the ground or on the person are never to be taken lightly. Galarrwuy Yunupingu, the son of the great Yolngu artist Munggurrawuy (c.1907–78), wrote of a childhood lesson:

When I was sixteen years old my father taught me to sing some songs that talk about the land ... One day, I was fishing with Dad. As I was walking along behind him I was dragging my spear on the beach which was leaving a long line behind me. He told me to stop doing that. He continued telling that if I made a mark or dug, with no reason at all, I have been hurting the bones of the traditional people for that land. We must only dig and make marks in the ground when we perform or gather food.

Ancestors' footprints are sometimes literally left behind as impressions in the landscape, as was seen with Darana (see Chapter 3), or in the pathway that they marked in the ground or in the engravings that are found in rock platforms and on boulders. Footprints are one of the

earliest and most widespread motifs in Australian rock art, and they continue today as a main sign of ancestral journeying. Lines of footprints, human or animal, are therefore one of the ways in which a place is shown in a painting. Place is marked simply by taking the footprint out of the land and putting it in a position in the painting or ground sculpture where it will be interpreted as the ancestor in the landscape. While some animals, such as emus, snakes and kangaroo, are associated, at least at a general level, with easily recognizable footprints or bodily impressions, other animals are represented by composite signs.

The anthropologist Nancy Munn has illustrated a number of designs that represent animal tracks used by men and women in sand drawings (70). She shows how the signs can be produced by using different parts of the hand and different combinations of the fingers to create

70
Designs
representing
animal tracks
used in sand
drawings
(after Nancy
Munn)

	Print	Technique
Kangaroo		Hind feet: drawn with index or with the tips of the index and middle finger crossed. Tail: impressed between hind feet with outer edge of hand. Front paws (when shown): claw prints dabbed in with finger tips
Opossum and Marsupial mouse		Tail: inner surface of index finger makes smooth, deliberate meander in sand. Paws: same as kangaroo
Snake		Same as Opossum tail
Dog		Thumb laid sideways in the sand makes pad print; finger tip or index or middle finger together make the toes
Emu		Thumb is held between middle and fourth finger; index is bent behind and resting against middle finger. Hand impressed so that back of index and middle finger, and pad of thumb make the print
Wild turkey		Drawn with index or impressed with side of hand. Claws are dabbed with finger tip. One style of emu print is is also made in this way and takes the same form as the turkey print
Eaglehawk		Large pad: impressed with side of thumb. Toes: impressions of index tips
Human		Fingers are clenched; hand held half closed. Footprint is made by impressing outer edge of hand in sand. Toe prints added by finger dabs

impressions in the sand. Very similar designs are produced in acrylic paintings, though these usually employ painting instruments rather than the hand directly. In *Warlugulong* (see 66) we can see a great variety of tracks marking ancestral journeys: the tracks of possum, hare wallaby and emu as well as different representations of human footprints and the sinuous tracks of snakes.

Nancy Munn has shown how various animal forms are represented as ancestors in Warlpiri art of central Australia and how distinctive designs are developed which distinguish one from another. Just as with the Munyuku wild honey ancestor (see Chapter 3), ancestral designs of this region often do not simply represent the ancestor as a single being but as a complex of forms, ideas and actions associated with the particular natural species. Each ancestral being is made up of a set of graphic elements organized in particular ways, the individual elements signifying parts of the ancestral being or the complex of items associated with the being. The Warlpiri honey ant ancestor (71), for example, consists of

71
Designs representing the Warlpiri honey ant ancestor (after Nancy Munn)

Features	Element combinations	Design examples
: :,)) = ant	((
/ = central passage (underground path) digging sticks of women	/ – : :	
)),)),≣ = side burrows	/ – ((≣ – ,,	
,, = (linked) vine ancestor U = woman digging	/ – ((((– ,,– U	
O = nest (hole)	O – / – ((((– : :	

elements such as curved lines and dots that represent the ants themselves, parallel lines that stand for the tunnels that link the separate chambers of the nests, circles that represent entrances to the nest and U-shaped signs and straight lines that can signify women using digging sticks to excavate the honey ants. Not all of these items are going to be present in every representation of a honey ant ancestor, and the fewer the elements that are included in the design the more ambiguous it can be, overlapping as it does with the possible designs for other ancestral beings. All of the separate elements can occur, with other meanings associated with them, as representations of other ancestral beings, but they will be ordered in different sequences and include different combinations. Some elements such as the meandering line are never part of the design for the honey ant, whereas they can be part of the rain, possum or rainbow snake ancestral beings, among others. In its most elaborated form the design of the honey ant is easily recognizable and unlikely to be confused with any other representation.

Aboriginal art uses several combinations of different representational systems, ranging from the geometric systems of central Australia to the elaborated figurative traditions of Western Arnhem Land. In most regions the representational systems include both figurative and geometric forms. Systems of representation are often employed in combination, one amplifying the meaning of the other. In the wallaby painting by Welwi Wanambi, for example, the geometric sign for the rock associates the figurative representation of the wallaby with a particular stage of the Wagilak sisters' journey (see 69).

In central Australia, as seen earlier, the basic form of paintings is made up from combinations of geometric shapes. There is a limited set of signs, which vary somewhat from place to place, each of which is associated with a wide range of meanings. Indeed, theoretically it must be possible to encode every meaning in the universe by using this small number of signs, which include linear, curvilinear and circular forms, U-shaped signs and various types of dotting and hatching. The meanings to be associated with the sign are indicated by the shape of the sign, so the sign most appropriate to the shape of the object is chosen. Things that are long and thin, such as a spear, are likely to be represented by

a straight line; things that are round, such as a fire or a ball, are likely to be indicated by a circle. The boundary between a geometric sign and a figurative representation can be narrow. Snakes, which could be shown by straight lines, are represented by curvilinear signs because of the way they move.

The way complex forms are represented depends in part on how they are viewed. A person seen from above can be indicated by a circle, a person seated by a U-shaped sign and someone standing by a straight line. Scale is also a factor. If a large area of land is being represented then a chain of waterholes in a creek bed may become a straight line, whereas each of them individually may be shown by a circle. This system inevitably creates ambiguities, for a circular form could represent things ranging from a rocky outcrop to an ancestral being or a campfire. Usually a full interpretation of a design requires additional information.

One of the most common contexts in which geometric forms are used is in stories drawn in the sand or on the ground. Although sand drawings are usually associated with central Australia, the practice is in fact widespread; someone in Arnhem Land or Cape York Peninsula is also quite likely to illustrate a story they are telling, or demonstrate a point, by drawing in the sand. The difference is that in central Australia the system is more conventionalized and has more of the characteristics of a formal visual language. In sand stories signs are used just as commonly to illustrate a myth or a daily event. Indeed, Nancy Munn quotes Warlpiri contrasting their mode of life with that of White Australians by remarking with pride, 'We Warlpiri live on the ground.' She comments: 'To accompany speech with explanatory sand markings is to "talk" in the Warlpiri manner.' The drawing (72) made to illustrate the following story is a typical example from central Australia.

Two women (a) are sitting in camp beneath dunes by a fire (b). They see a goanna (c) running into a hole (d). The women get up, grabbing a digging stick, and walk to where the goanna went into the hole. They dig up the goanna and bash it on the head. They walk back towards camp, taking the goanna in their carrying bowl (e). They walk through some dunes (f) and sit down again by the fire (back to b). They see their husband is still asleep (g). 'I'll soon wake that lazy man up for his dinner,'

one of them says. She throws the goanna on the fire, where it sizzles
and spits hot fat on to the lazy husband, waking him up.

This example illustrates the way in which signs can be used to repre-
sent spatial relations and how stories can be mapped on to landscape.
Although the events in this story concern everyday life, the events
of the Dreamtime are frequently everyday life writ large.

Many of the early Papunya acrylic paintings of central Australia (see
Chapter 8) of the early 1970s had characteristics of informal sand
drawings. *Emu Dreaming*, a painting by Long Jack Phillipus Tjakamarra
(b.*c*.1932), is a typical example (73). The top of the painting represents
the serpentine course of a river bed with sand hills shaped on either
side by the river in flood. Beneath it is the ancestral snake associated
with the creation of the lake, while in the centre is a waterhole out of
which an ancestral emu emerged. The emu's footprints can be seen
leaving the well and entering what is probably a U-shaped ceremonial
shelter. The painting shows some ritual objects and sites associated
with the increasing number of emus, symbolized by the footprints
which spread in all directions.

Clifford Possum Tjapaltjarri's *Yuutjutiyungu* (74) represents a later
development of Papunya acrylic painting where the underlying geomet-
ric structure has been masked or partly obscured beneath an extraordi-
nary and elaborately layered pattern of dots. The viewer is positioned
above the level of the clouds and yet the eye almost seems to penetrate
below the surface of the earth. The painting, representing the country
around Mount Allan in the Western Desert, to which the artist was

connected through his father, relates to an area of land some 65 × 50 km (40 × 30 miles). It contains within it a whole series of vignettes, stories concerning the lives of particular ancestors which centre on a series of campsites and are represented by a restricted set of geometric motifs.

The central feature represents the rocky outcrop of Yuutjutiyungu where two ancestral women sit manufacturing sacred boards. The main story associated with the site concerns a Kadatja man from the west on an avenging expedition who is seeking to steal sacred boards from the women. The women, represented by the black U-shaped signs, are sitting facing one another, the sacred boards pointing towards the circle in the centre. The footprints of the Kadatja man can be seen circling around the outcrop. On the northern edge of the outcrop, at a place called Kapatala, a man can be seen preparing a meal of caterpillars. He is represented in white, sitting beside a fire with his digging stick beside him; the bodies of the caterpillars seem to crawl all over the surface. To the south of the outcrop a man was hunting at Ngarritjaliti. He has set out from Tjunykurra, in the bottom left-hand corner of the painting, where a man is shown camped in the shade of a bough, represented by a thick white semicircle. On his journey to Ngarritjaliti he sees a strange cloud approaching from Lajamanu. He hides in a cave, but to no avail (concentric circles at centre bottom). Lightning strikes the cave and in the explosion the man's body is scattered across the countryside.

On the right of the painting another man, a goanna man, can be seen camped by a fire. He is the younger (goanna) brother, who rests exhausted after a hard day's travel. His elder brother goes out to find food for them but returns empty-handed and instead sets out to kill the younger brother. The footprints of the men shown on the right side of the painting record their exploits. At top right the elder brother's axe is lost, close to a rocky outcrop where harmony seems to have been restored and where ancestral goanna eggs can be seen transformed into a set of rounded boulders. In other versions the younger brother is killed by his pursuers (75).

On the left side of the painting, balancing the images of the goanna man, is a site associated with honey ants. Here we can see a characteristic elaboration of the honey ant design that was seen earlier (see 71).

73
Long Jack
Phillipus
Tjakamarra,
Emu Dreaming,
1972.
Acrylic on
composition
board;
64·7 × 62·6 cm,
25$\frac{1}{2}$ × 24$\frac{5}{8}$ in.
National Gallery
of Victoria,
Melbourne

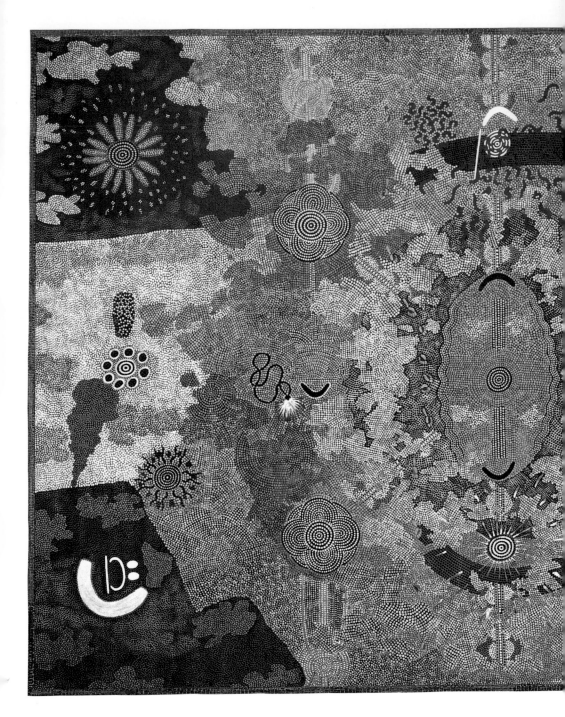

74
Clifford Possum Tjapaltjarri, *Yuutjutiyungu*, 1979. Acrylic on linen; 243·8 × 365·8 cm, 96 × 144 in. Kelton Foundation, Santa Monica

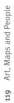

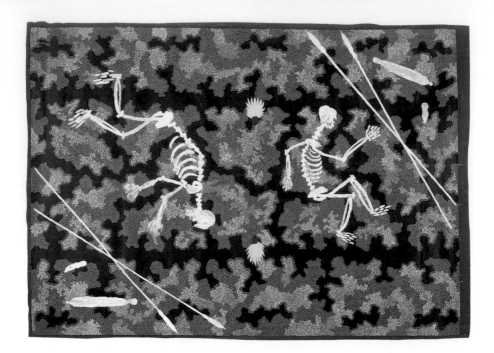

75
Clifford Possum
Tjapaltjarri,
*Blue Tongue
Lizard
Ancestor and
Two Sons at
Warrukulangu
(Warlugulong)*,
1978.
Acrylic on linen;
174·5 × 243 cm,
68¾ × 95⅝ in.
Gallery
Gabrielle Pizzi,
Melbourne

An ancestral woman arrives to dig for honey ants which live in chambered passages beneath the ground. The woman can be seen sitting on the ground with her digging stick in front of her, again represented by the U-shaped sign and (dotted) straight line. Beside her lies her discarded hair-string belt with its beautiful feather tassel. In front of her are the marks in the ground made as she sweeps her digging stick forward looking for the entrance to the honey ants' nest, which leads in turn to the hole into the ground and the chambered homes of the big fat honey ants. This design almost becomes a refrain for the left side of the painting where the circular motifs repeat themselves and are superimposed on one another, representing the spread of the honey ants' nests.

The painting is a superb illustration of the way in which perspective shifts in the representation of landscape in Western Desert paintings. The painting creates a structure of relationships in the landscape by repeating the same set of geometric elements – in this case, a circle, U-shaped sign and a straight line – to mark the presence of different ancestral beings at key sites in the landscape. As such, they act as a mnemonic for place. In each site the characters are drawn larger than their scale. Giants in the landscape seeming to shrink the space

between them. And in the case of the honey ant woman there is a further shift from a macro- to a micro-scale as the interpretation of the circular motifs moves from above the surface of the earth to the underground chambered passages of the honey ants. Floating above the surface, the broken circular motifs can be interpreted as broken clouds spreading out across the landscape from the site of the lightning strike. On the surface they represent the many sites around Mount Allan where the ancestral honey ants emerged from the ground. Below the surface they are the structure of the honey ants' nests. This switch of reference, which involves a change of scale, is one of the key characteristics of Aboriginal art. It has already been seen in paintings from another part of Australia, in the wild honey design of the Munyuku clan. From one perspective the Munyuku diamond design (see 63) stands for the structure of the wild bee hive, with each diamond representing a cell in it. From another perspective it represents the paperbark swamp itself, with floodwaters flowing through it and tall trees on either side.

By now it should be clear that one of the key motifs in central Australian desert art is that of the circle and line (76). The circle–line motif and the intricate patterns that are constructed out of it act both as a metaphor and as a representation. Nancy Munn refers to the linked circle–line as the site-path motif, and the author and elementary school teacher Geoffrey Bardon refers to it as the travelling sign, with the circles being resting places. 'Resting' here has the double meaning of places where the ancestral beings rested after their energy was spent and stopping places on a journey. Although the circle has the widest range of reference of any of the geometric elements, its core meanings often refer to places in the landscape that are important sites of ancestral action. Circles represent places where ancestral beings emerged from the ground, places where they camped and places where they performed ceremonies; in short, the identity of a named place. Straight lines and other linear motifs, such as meandering lines, are also multivalent, but when combined with circles or associated with footprints they usually refer to the track taken by Dreamtime beings. The line may be a notional line that represents the conceptual link between a series of places, or it may represent some action that connects two places – a line of footprints, the track of a snake or, at a micro-level, the path of a digging

76
Representative set of circle–line motifs, taken from central Australian paintings (after Peter Sutton)

stick thrust into the ground or the connecting passageways of the honey ants' chambers. The circle–line represents the connection between places and things both above and below the earth's surface. The line usually represents horizontal connections, but where the circle stands for a place where an ancestral being has emerged from the earth or re-entered it, the line can represent the process of emergence and return.

By extension, the circle–line motif also represents the connections between people – the marking of identities and the linkages between them. It represents the relationships between children and their parents, between one moiety and another, and between the different kin groups in a region. As a mnemonic the circle–line motif represents sets of named sites in sequence, or sets of people and their connections, and because of the close association between people and place the same painting refers to relations between people and places. In Clifford Possum Tjapaltjarri's *Yuutjutiyungu* (see 74) the different sites are associated with different subsections or kin groups, and the responsibility for managing the site varies accordingly. Thus the sites around Kapatala are associated with the Tjapangati subsection, as it was a Tjapangati man who gathered the caterpillars, whereas the main site of Yuutjutiyungu belongs to the Nangala.

The circle–line motif can occur in a number of different combinations. Sometimes there is a single central circle which may or may not have lines leading from it. In this case it is likely to represent the central theme of the painting, a particular waterhole, campsite, dance ground or sacred site, or some person, object, plant or animal that is the focus of attention. *Possum Dreaming at Kurningka* (see 65) by Tim Leura Tjapaltjarri has at its centre the representation of a small rock shelter at Kurruka, Napperby Station. The painting is a reflection on the lives of his father and father's father as hunters. The pink represents a camping area outside the shelter; the blue U-shaped sign stands for a wind break; the U-shaped sign opposite represents a man sitting beside the camp, with boomerang, shield and spearthrower lying on the ground beside him.

More often there are multiple circles either ordered in linear sequences or organized into symmetrical patterns, as can be seen in a painting (77)

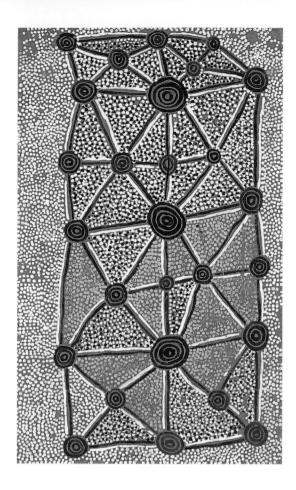

77
Pintubi George Tjangala,
Untitled,
*c.*1972.
Acrylic on
board;
68 × 41 cm,
26³⁄₄ × 16¹⁄₈ in.
Museum and
Art Gallery of
the Northern
Territory,
Darwin

by Pintubi George Tjangala (*c.*1925–89). Less frequently, circle–line combinations produce irregular and asymmetrical designs (78). Clifford Possum Tjapaltjarri's painting *Five Dreamings* shows a strong line of central circles connected by lines with a number of side links to other sites (79). The painting represents some of the sites already discussed in the two larger paintings, *Warlugulong* and *Yuutjutiyungu*, but in a somewhat more schematic form. The central track is a segment of the honey ant Dreaming, going from Yuendumu, represented by the bottom circle, to Mount Allan Station, represented by the upper one. The routes of other ancestral journeys are represented by distinctive sets of tracks: the hare wallaby travelling from right to left is on its journey from Warlugulong, the bushfire site, to Napperby Creek and the Tanami Desert; a second track running the length of the painting represents the dingo Maliki travelling through Pikilyi (Mount Doreen) and Ngarlu,

near Mount Allan, before continuing to the east. In this case the reference points in the painting cover a huge area of central Australia, positioning the settlement of Yuendumu in relation to the regional mythology associated with the artist.

It will be apparent by this point that the circle–line motif and the graph-like structures that are produced from it are as much conceptual markers of spaces and relationships as actual representations. Often the motif is replaced by other elements that mark the position of a place and its connections. Instead of lines there are animal tracks or footprints, and instead of circles there are figurative designs or more complex sets of geometric elements. In *Yuutjutiyungu*, for example,

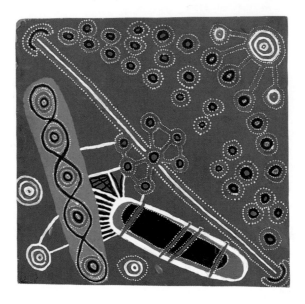

78
Uta Uta Tjangala, *Medicine Story,* 1972. Acrylic on board: 60×62 cm, 23⅝ × 24⅜ in. Museum and Art Gallery of the Northern Territory, Darwin

79
Clifford Possum Tjapaltjarri, *Five Dreamings,* 1976. Acrylic on board; 50×40 cm, 19¾ × 15¾ in. South Australian Museum, Adelaide

the places marked by the goanna eggs and the hair-string belt could easily be marked by a circle, and in each case the complex of circle, U-shaped sign and straight line could be replaced by a circle. Often, indeed, Western Desert paintings are composed of circle–line motifs representing an underlying structure of relations as opposed to a set of more complex visual motifs. The contrast between Clifford Possum Tjapaltjarri's *Five Dreamings* and his *Yuutjutiyungu* demonstrates the difference well, since they treat overlapping areas of land in apparently different ways.

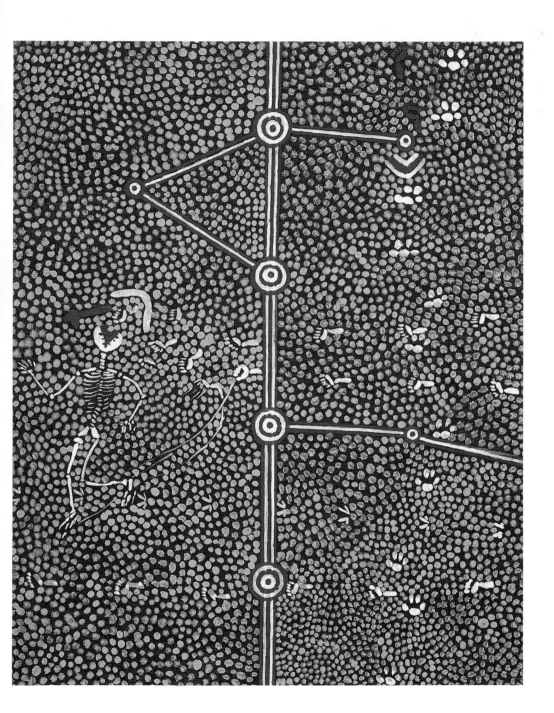

In *Five Dreamings* the honey ant sites are represented without any of the elaboration that can be seen in *Yuutjutiyungu*. The place Yuutjutiyungu is represented by a single concentric circle, as is each honey ant Dreaming site in turn. On the other hand, in *Five Dreamings* the story of the goanna brothers which occupied a small section of *Yuutjutiyungu* is elaborated and the painting includes a representation of the dead body of the younger brother, his head broken by the axe. Figurative elaborations in effect can create a painting within a painting or one painting superimposed on another, in which the figurative elements are out of scale with the geometric motifs. The killing of the goanna brother becomes the dominant surface theme of *Five Dreamings* and occupies a far greater area of the painting, as represented by the geometric motifs, than it would have done if places were represented in true topographical scale.

Yolngu paintings from Eastern Arnhem Land look very different from Western Desert acrylics but they work as maps in a similar way. The differences are slight. Arnhem Land maps tend to be a little more local, concerned with features of particular localities rather than vast areas of land, and there is as much focus on places as on the connections between places. This is partly because Arnhem Land, in particular coastal Arnhem Land, is more densely populated and people travel less in their daily lives. Song cycles such as that of the Djang'kawu are just as concerned with journeys over long distances, as in the Western Desert, but paintings tend to be centred more on individual places. The circle–line motif is used less in Arnhem Land paintings, perhaps again because the focus is on place rather than relations between places, though, as will be seen, spatial relations are represented in underlying geometric grids just as they are in the desert. Some of the differences may result from the way the art produced for sale to outsiders has developed in the respective cases. In Eastern Arnhem Land there has been an elaboration of symbolic themes associated with particular places, whereas the desert has seen the development of paintings which show a number of different Dreaming tracks. Much of the ritual art of the centre, however, and many early acrylic paintings, focus on single Dreamings tracks, and others are centred on particular places.

Although all Arnhem Land paintings can be associated with particular places, this does not make all paintings into maps. A painting by Dundiwuy Wanambi of the Marrakulu clan (80) is associated with the Djungguwan, a regional initiation ceremony, and the same design is painted on the chest of leading initiates. The mythology is connected with the Wagilak (Wawllag) sisters, the ones discussed earlier hunting wallaby inland from Blue Mud Bay. The Wagilak sisters went on a journey connecting many places, beginning somewhere in southern Arnhem Land and ending up at Mirrarmina on the coast near Milingimbi. There they encountered a great serpent who swallowed them. Paintings of this segment of the myth by artists including Yilkari (1891–1956), Dawidi (1921–70) and Paddy Dhatangu (1915–93), all members of the

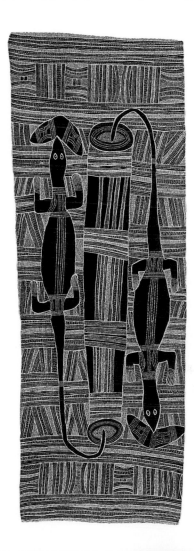

80
Dundiwuy
Wanambi,
*Two Water
Goannas*,
c.1982.
Natural
pigments
on bark;
128 × 43 cm,
50⅜ × 17 in.
Private
collection

Liyagalawumirr clan, featured in a major exhibition, *The Painters of the Wawilag Sisters' Story*, at the National Gallery of Australia in 1997, which was the first to attempt to exhibit a comprehensive set of Arnhem Land paintings connected by a particular ancestral track. The earlier stages of the journey inluded paintings by Welwi Wanambi (see 69) as well as Dundiwuy Wanambi.

The goannas, which refer to earlier episodes on the journey, lived in hollow trees and were one of the animals hunted by the women. In places they cut down trees with the goannas still inside, and as the trees cut a path to the sea the goannas travelled with them. Towards the end of the journey the goannas are associated with the carpet snake. The painting represents the goannas running in and out of a hollow log. However,

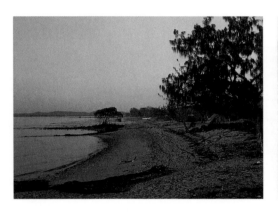
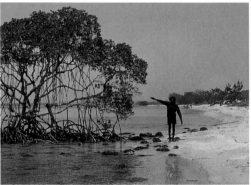

when the painting is interpreted in relation to different places, it can be connected to more specific episodes of the myth. Often particular characteristics of a painting key it into one locality rather than another.

Dundiwuy Wanambi interpreted his painting as a manifestation of the goannas on the beach at Trial Bay, near the settlement of Gurka'wuy. The story begins inland at the headwaters of the Gurka'wuy River where the Wagilak sisters were cutting down trees for honey. In one place a giant stringy-bark tree fell and crashed downhill towards the distant coast, gouging out the river bed. Inside the tree were two water goannas who lived off freshwater mussels, which can be seen gripped in their mouths. When the tree reached Trial Bay it spun out into the centre of the bay before disintegrating. Parts of the tree became islets in the

bay, but splinters from it impregnated the surrounding country with the spirit of the stringy-bark ancestor; the trees of different species that spring up along the coast are manifestations of it. The goannas ended up on the beach where they were transformed into rocky bars.

A mangrove tree on the beach at Trial Bay is one manifestation of the hollow log and close to it are the rocky bars that are the transformed bodies of the goannas (81, 82). The rocks are covered with white encrustations which represent the air bubbles that come from the goannas as they dive below the surface of the water. The topographical referents extend the interpretation of the painting and link it to Trial Bay. These referents differentiate it from similar paintings that are associated with the other places connected with the Wagilak sisters.

Some Yolngu paintings are much more map-like than this. This was brought home to me one day when I was at Yirrkala talking to Narritjin Maymuru about a visit he had just made to his clan lands of Djarrakpi on Cape Shield to begin clearing land for an airstrip and for building a settlement. While he had been away his son Banapana (1944–86) had made a number of paintings for me. Narritjin said that if I brought him the map of his country that Banapana had painted he would show me where he had travelled. It was the painting of the guwak's journey that he wanted (83). Banapana had already interpreted the painting to me, but as the story of events on the journey of the guwak from Donydji, inland in Ritarrngu country, to Djarrakpi on the coast.

According to Banapana, the painting represented the guwak, a Koel cuckoo, perched on top of a native cashew tree at the end of a hard day. The figures on either side represent the bodies of the guwak (the guwak is sometimes referred to in the singular and at other times in the plural), their heads pecking away at the fruits of a cashew tree. The guwak were accompanied by possums and emus. The emus provided water for the others. They would scratch the ground with their feet looking for water, and where they scratched wells would appear.

Once the guwak had fed then it instructed its friend, the possum, to go to work, spinning its fur into lengths of string. The possum would climb up and down the tree trunk spinning yards and yards of string that

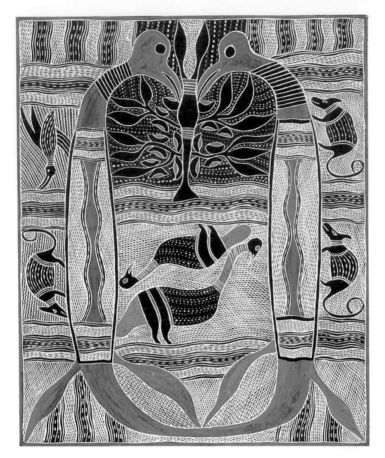

would then be handed out to the Aboriginal clans of the region for use in ceremonies. The figures at the side, as well as representing the bird's body, represent the trunk of the tree and the lengths of possum-fur string or *burrkun*. The following day the guwak continued its journey. It grabbed the end of a length of possum-fur string in its mouth and set off to a new destination. As it flew the string grew heavier and heavier until eventually it became too much to bear. The guwak then released it and let it fall down to the earth where it became transformed into features of the landscape.

When I handed the painting over to Narritjin he had quite a different interpretation (84, 85). He began in the bottom right-hand corner.

Here is where we arrived in our landrover (a). We drove up on the outside of the *burrkun*, the low gravel bank that marks the edge of the lake (b). We drove past the cashew trees where the guwak rested and on to the grove of wild plums where the possums feed (c). There we waited a day or two. We had not been to the country for a long time and we sang to the ancestors in the land, to the possum and the guwak and the emu, to say we were returning to our land. And we waited another day so that the missionary could come to bless the settlement that we were going to build. Then we drove on to the head of the lake and made the site of our settlement under the cashew tree beneath the sand-dunes where the guwak made his final home (d). We built the airstrip to the right of the painting (e). The lake water is sour: we can't drink that (f). We get our fresh water from the beach on the other side of the dunes which separate the lake from the sea (g). It is there that the emu threw his spear, and where it entered the beach just above the low tide point, there water bubbles up from underneath.

Narritjin's description shows how effectively the painting can serve as a map, but it does not contradict Banapana's interpretation of his painting; rather, it complements it. The painting is able to be a map precisely because it represents the transformation of mythic action into landforms. The guwak arrived from Donydji where Narritjin entered the painting, at the bottom right-hand corner. He fed on cashew nuts and instructed the possum to spin his fur. The land was featureless but it was not empty, as two women, the Nyapililngu, were there already

hiding from others, ashamed of their nakedness. The guwak laid down lengths of possum-fur string which became dunes and gullies at the entrance to the lake. The guwak then flew on to the next grove and finally, by way of the plum trees, to the casuarina tree that was to be his final destination. Along this inland side of the lake he laid down a great length of string, the *burrkun*, that was transformed into the gravel bank.

The Nyapililngu continued to hide on the far side of the lake. But they also observed. They learnt how to spin fur into lengths of string and saw that it would solve their problems: they would be able to make string bags to collect yams and wild plums; they could use the string to bind together the ends of spears and spearthrowers; and they would be able to make pubic coverings. They were so pleased with the discovery that they spun mountains of string which became the great sand-dunes that separate the lake from the sea shore (86). The emus meanwhile searched for water in the lake's bed, but only found slightly salty tasting water. In disgust they threw their spear-like legs over the dunes and on to the beach, where the fresh water bubbled up from below.

The Djarrakpi landscape is represented elsewhere in a far more schematic way, in which the places where ancestral transformations occurred are marked by geometric signs rather than figurative representations. Narritjin himself made a painting for the film-maker Ian Dunlop which represents the Djarrakpi landscape through a symmetrical structure based on three digging sticks (87). The digging sticks represent respectively the inland side of the lake, the lake itself and the sand-dunes. On the inland side the digging stick represents the body of the guwak and the trunk of the tree up which the possums climbed. In the lake it is the emu's legs and the spear that they threw to find water. On the dune side it is the digging stick that the Nyapililngu used to get wild yams and the walking stick they used to climb the sand-dunes. Squares on the digging stick mark significant positions in the landscape where events occurred. On the inland side the groves of cashew and wild plum trees are marked, and on the dune side the places where the ancestral women walked up and down the dunes. In central Australia the structure could well have been marked by circle–line motifs; the principles of representation are very similar in both cases.

Many distinctive traditions of representing landscape have developed in other parts of Australia which reflect different cultural backgrounds and the historical circumstances of the artists. In the late 1950s, encouraged in part by W E H Stanner, the Murinbata people of the Port Keats/Daly River region in Western Arnhem Land produced paintings on board and bark. Some of these paintings are notable for their detailed, almost pictographic, representations of segments of country along the Daly River. Nym Bunduk (1900–74) was the most prolific of the artists; his paintings show an interesting combination of features from desert, Arnhem Land and European styles. His painting of sites in Murinbata country (88) shows the meandering channels of the river as it crosses the flood

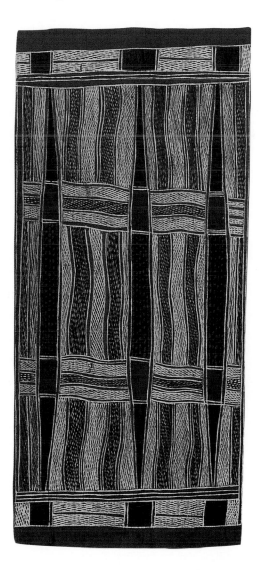

87
Narritjin
Maymuru,
*Three Digging
Sticks*,
*c.*1974.
Natural
pigments
on bark;
77 × 36 cm,
$30\frac{3}{8} \times 14\frac{1}{8}$ in.
Private
collection

**88 Overleaf
Nym Bunduk,**
*Sites in
Murinbata
Country*,
1959.
Ochre on
masonite;
89 × 156 cm,
$28\frac{3}{4} \times 61\frac{3}{8}$ in.
South
Australian
Museum,
Adelaide

plain, with dense vegetation represented on either side and fish and waterlilies in the creek beds. The influence of desert styles is clearly present in this work, in the form of the geometric representations, and other paintings by him seem to prefigure later developments in Western Desert acrylics.

Paintings done in the 1980s by Rover Thomas (1926–98), Paddy Jaminji (1912–86) and Queenie McKenzie (b.1930), and other artists associated with Turkey Creek, a settlement in the eastern Kimberleys, show some affinities with the Daly River paintings even though they have a different historical origin. The similarities, emphasized by an overlap in the range of colours employed, reflect both regional contact between the respective communities and common influences from the north and centre. The Turkey Creek paintings first appeared in the form of boards carried by dancers in regional ceremonies. One of these, the Krill Krill ceremony, came first of all to Rover Thomas in a dream (89).

The songs and paintings commemorate the death of an old woman in a car accident near Turkey Creek airstrip. Her injured body was taken by car and plane to Wyndham, and then to Perth, but she died before she arrived. The ceremony that Thomas dreamed is a commemoration of the woman, but it includes many other themes associated with the myth and history of the region. The paintings represent episodes in the myth of the land through which her body passed.

Many of the early Krill Krill paintings were painted by Rover Thomas's mother's brother, Paddy Jaminji, under his instructions, and quite often the two worked collaboratively. *The Dreaming Kangaroo at Elgee Cliff*

89
Krill Krill ceremony, Turkey Creek, Kimberley region, Western Australia, 1979

90
Paddy Jaminji and Rover Thomas, *The Dreaming Kangaroo at Elgee Cliff*, 1983. Natural pigments on plywood; 120 × 60 cm, 47¼ × 23⅝ in. National Gallery of Australia, Canberra

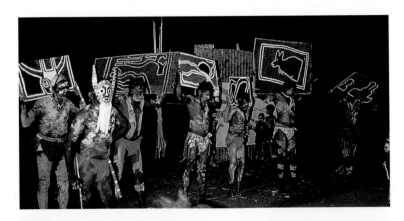

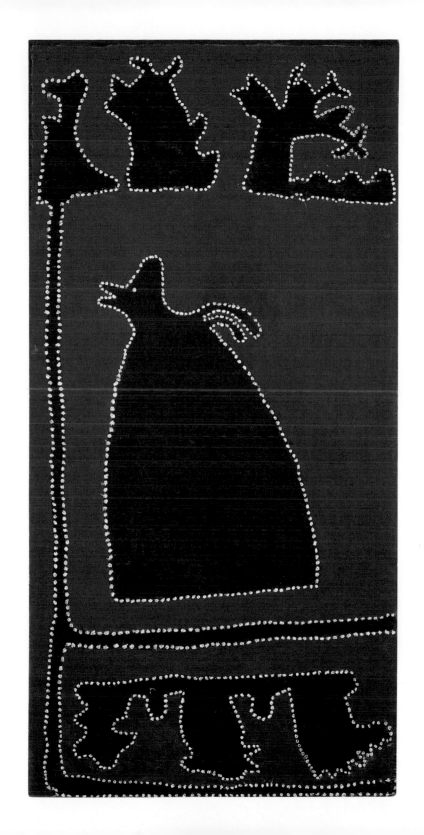

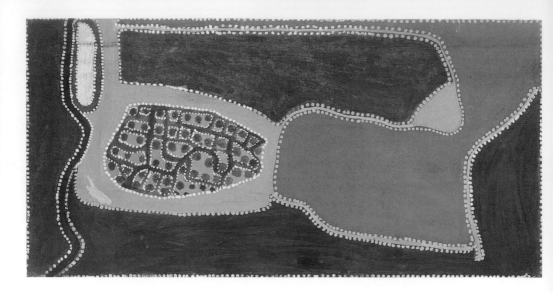

(90) is by both artists. The painting shows the woman's spirit approach-
ing a rock face on which the faded image of a kangaroo has been paint-
ed. The bottom part of the rock painting has been washed away leaving
half of the kangaroo's body on the top. The image conveys conceptual
aspects of the journey: the merging of ancestors and land, and the fleet-
ing images retained when moving rapidly through a landscape. The
kangaroo is seen in the distance, then suddenly confronts the viewer
and is just as quickly gone.

Landscapes at Kalumpiwarra, Yalmanta and Ngulalintji (91) represents
another place on the dead woman's spirit journey where she cannot
decide which way to go. It shows (92) Blackfellow Creek (a), the rock at

Ngarkarlin (b), the grass at Yalmanta (c), a wooded area with the trees shown in orange (d), and Ashburton Hill with the creek running through it that goes to the Bow River (e). Although Thomas's landscapes echo some contemporary Euro-American paintings in style, they come directly out of the art of the Kimberleys. And again the underlying theme is the spiritual value of the land and the connections between places.

The areas of solid colour that characterize Rover Thomas's paintings and that make them contrast strikingly with both Western Desert acrylics and Eastern Arnhem Land paintings are also found in another recent development in Aboriginal art, landscapes by Ginger Riley (Munduwalawala) (b.c.1937) and others from Ngukurr. However, the vibrant colours could hardly provide a more striking contrast. Ngukurr is a settlement on the Roper River to the south of Arnhem Land. It includes people of many different languages from the area of Katherine in the west to the Queensland border in the east, as well as strong links with communities in Western and Eastern Arnhem Land. The commercial painting tradition began to flourish in 1984, when people were encouraged to paint in acrylics on canvas. The art styles of the Ngukurr are eclectic and depend a great deal on the background of each artist. In contrast to Ginger Riley's expansive landscapes, artists such as Willie Gudubi (1916–96) and Gertie Huddleston (b.1933) paint more intricately detailed paintings, often in a compartmentalized narrative style.

Ginger Riley's painting (93) shows the country at the mouth of the Limmen Bight River where it flows into the southwest corner of the Gulf of Carpentaria, in land that belongs to people of the Mara language group. The painting shows the land stretching between a set of hills, the Four Archers, and the coast. A manifestation of the great snake Garimala can be seen creating waterholes as it chases a group of initiates who had disregarded restrictions placed on them. The youths are eventually consumed by the fiery breath of the monster serpent. The scene is watched over by the sea eagle Ngak Ngak, who created many sites along the coast. The painting is a highly innovative one in colour and form and shows many different influences; it is edged with a body painting design belonging to the artist which provides a frame through which the landscape is viewed.

91–92
Rover Thomas,
*Landscapes at
Kalumpiwarra,
Yalmanta and
Ngulalintji*,
1984.
Natual
pigments and
gum on board;
90×180 cm,
35³⁄₈ × 70⁷⁄₈ in.
National Gallery
of Australia,
Canberra
Below
Key

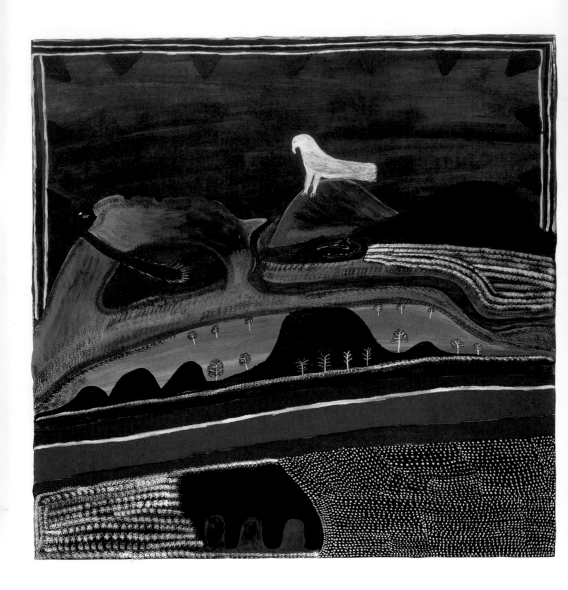

Ginger Riley comes from the mainland on the Gulf of Carpentaria south of Groote Eylandt and a relationship can be discerned between his paintings and some works from Groote Eylandt. Groote Eylandt artists have a long tradition of painting semi-diagrammatic maps of areas of country which show features of the coastline and interior pictographically. The paintings often have a black background which makes the colours of the design and Infill stand out brightly, and can give the design a fragile, almost floating, quality. The infill is often detailed and, in contrast to that of the mainland styles, tends to include more broken lines and dotted patterns.

Aboriginal art is inevitably associated with place since it involves the representation of ancestral beings who are themselves embodied in landscape. Most painting traditions establish a connection with the mythical past by using designs to represent the landscape that are themselves part of the time of world creation. The designs are ancestral designs in that they are thought of as having originated in the Dreaming; they are the ancestral beings own representations of the lands they created.

93
Ginger Riley
(Munduwalawala),
Mara Country,
1992.
Acrylic
on canvas;
240 × 240 cm,
94$\frac{1}{2}$ × 94$\frac{1}{2}$ in.
National Gallery
of Victoria,
Melbourne

The landscape paintings of Eastern Arnhem Land and the Western Desert come directly out of indigenous traditions. The representational tradition employed to produce acrylic paintings is an extension of that used to produce body paintings and sand paintings in ceremonial contexts throughout much of central Australia, and paintings identical in form to the Yolngu paintings already analysed could occur in ritual contexts in Eastern Arnhem Land today. The artists have certainly responded, however, to the new opportunities offered by the production of art for sale, and the contemporary context has become part of the dynamic of Yolngu and Western Desert art. It is meaningless to ask how painting would have developed without the intervention of colonialism, but in both cases the art came out of past practices, out of traditions of painting and systems of meaning that pre-existed colonialism.

The paintings of Rover Thomas and Nym Bunduk, and to an even greater extent Ginger Riley, might appear, in contrast, to come out of more recently invented iconographic traditions in which it is harder to see continuities with earlier styles. Nonetheless, we are only dealing with

degrees of difference, since on the one hand influences move rapidly across Australia and on the other local developments rapidly acquire their own vocabulary. Demographic disruption means that in some regions, such as the Kimberleys, cultural influences spread rapidly across a wide area where people travel 1600 km (1000 miles) to participate in ceremonies and cultural events. The Turkey Creek paintings crystallized out of the recent history of the eastern Kimberleys and are part of the continual process of establishing the relationships between people and land. Relationships are passed on in new forms, old forms take on new meanings, established myths find new expressions and the sources of influence are sometimes wider than they were before. Continuities and connections can be seen everywhere; the region of influence is broad and somewhat diffuse, and the boundaries are continually shifting.

Aboriginal people have always been concerned with connections across great distances as well as with the specificities of place. In central Australia similar systems of representation have been used across vast regions and people have shared influences and exchanged ceremonies and ideas without losing local identity. Sources of inspiration and artistic traditions and vocabularies differ regionally, yet nowhere are the traditions static. Each region has many ways in which the relationship between mythology, people and land can be represented, and Aboriginal artists are always inventing new ways of depicting that relationship. Everywhere paintings of the land can be brought into the same discourse over land, myth and history; it is this discourse over land that provides one of the unifying themes that can be applied to Aboriginal art across Australia.

Basically, you cannot label or categorize aboriginal paintings because they are layered w/ diff. meanings that need prior knowledge to decipher.

Aboriginal art is an integral part of the Dreaming – part of the constitution of the ancestral beings, part of their presence and part of their immortality. It is also part of the land itself and all other things that are thought to be creations of, and continue as manifestations of, Dreamtime ancestors. Whenever Aboriginal art is produced and wherever it is exhibited, it involves the exercise of rights that can ultimately be traced back to the Dreaming. Those rights are part of what makes it Aboriginal art, and locate it in the world of particular people and places. Without this reference back to the Dreaming art would be mere form – it would have lost its meaning.

94
Peter
Marralwanga,
Ngalyod, the Rainbow Serpent, at Manabinbala,
1980–1.
Natural pigments on bark;
154×93 cm,
60⅝×36⅝ in.
National Gallery of Australia,
Canberra

This does not mean, however, that human beings are merely passive actors slavishly reproducing some Dreamtime orthodoxy. The Dreaming should not simply be seen as the owner of all those things that are a manifestation of the ancestral past, including paintings and the landscape itself. This can result in the assertion that Aboriginal people, instead of owning the land, are owned by the land. The idea that people are the products of the Dreaming and as such have obligations to look after the land and other manifestations of the Dreaming is a thoroughly Aboriginal one, but to see them as owned by the Dreaming, or by the land, is misleading. On the contrary, there is a two-way relationship between people and the Dreaming. The ultimate authority lies in the realm of the sacred, but the sacred is a realm to which people have access and in which they participate.

People themselves are part of the Dreamtime: they are its creations. They are conceived of as ancestral spirits and they take on the clothing of the Dreaming in art and ritual. However, they also maintain contact with the Dreaming by exercising rights in land and the sacra (sacred possessions). Access to the Dreaming and the authority it gives to action are part of the politics of Aboriginal life. The Dreaming existed before individuals were born and will continue to exist after they have

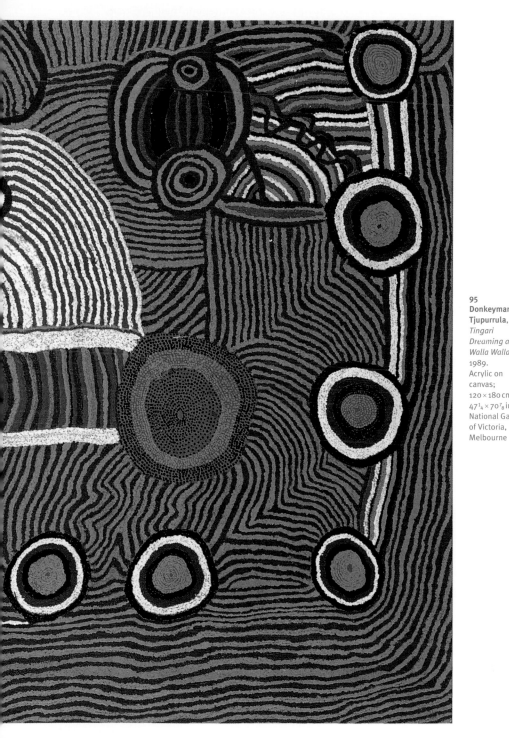

**95
Donkeyman Lee
Tjupurrula,**
*Tingari
Dreaming at
Walla Walla,*
1989.
Acrylic on
canvas;
120 × 180 cm,
47¼ × 70⅞ in.
National Gallery
of Victoria,
Melbourne

died; people play a role in keeping it alive and as a consequence are part of the process of its change and transformation. There are many ways in which the Dreaming adjusts to present circumstance and becomes a part of the politics of everyday life. Certain individuals become great ceremonial leaders and have an important influence on how the Dreamtime law is passed to the next generation. Rights in land and ceremony are validated on the basis of ancestral law and the law is adjusted to fit new circumstances, when for example a group or clan dies out and another has to take over its land. Groups that are formed around particular bodies of ancestral law change their membership as new people are brought in and others depart; the body of law brought together by networks of kinship changes accordingly over time. Divisions within society change as historical circumstances demand, the relationships between women and men may alter, as may those between the young and the old, and the distances over which alliances form may also change. Interpretations of the Dreaming and different understandings of the significance of ancestral law are part of that process of change.

The Dreaming is therefore a rich resource which can supply new inter-pretations. For example, myths provide images of alternative ways in which men and women could live. Throughout Australia there are female creator figures, such as the Wagilak sisters and the women who travelled with the Tingari (95), who in the past hunted as men do today and who held ritual authority over society as a whole. Such myths are a resource for figuring the changing and dynamic relationship between men and women, taking into account the effects of European colonial-ism, and ensuring that the Dreaming is relevant to present concerns.

While the underlying substance of the Dreaming is extremely durable, establishing long-term relationships between the lives of ancestral beings and the form of the landscape, the detailed construction of the Dreamtime changes to accord with circumstances. In this respect Aboriginal religion is no different from many others in that it belongs to the present rather than to the past, and as the present changes, as different things become relevant, it accommodates those changes. Aboriginal religion has also come to terms with the problem of free will

and human agency. The template provided by the Dreaming is a guiding structure rather than a determining one. For the Dreaming is partly the space in which people create their own identities. The Dreaming is a continual process of recreation as new generations of people establish their own selves in relation to landscape and history.

The ancestral beings gave the rights to occupy the land to the people that they left behind on condition that they continued to perform the ceremonies and produce the paintings that are a record of their creative powers. The first humans who occupied the land are thought of as the ancestors of the people who live in the country today. Knowledge of the form and content of paintings helps to establish the right to occupy land and the ability to maintain connections with the ancestral forces in that landscape. For this reason knowledge of paintings and the right to produce paintings is closely regulated, and paintings can only be produced by those who are acknowledged to have the right to do so. Although across Australia art is closely related to land and to the particular journeys of Dreamtime beings, the details of the way in which art is related to group identity and gender relations varies widely. In Eastern Arnhem Land and some of the more densely populated areas of central Australia, land, paintings and other manifestations of the Dreaming are the property of clans, groups of people connected primarily by descent, whereas in other regions the rights in paintings and land are more widely dispersed.

One of the striking things about the labels in exhibitions of Aboriginal art is that they often provide information about the social group or kin category that the artist belongs to. Just as the label of a painting by a European artist may include where and when it was painted, the nationality of the artist and the artist's dates, a painting by an Arnhem Land artist will include the person's clan, moiety and sometimes social category. Let us look at three paintings: one by Watjinbuy Marrawili (b.c.1944) of the Mardarrpa clan of the Yirritja moiety (96); one by Munggurrawuy Yunupingu and his brother Bununggu Yunupingu (c.1919–69) of the Gumatj clan, also of the Yirritja moiety (97); and one by Mawalan Marika of the Riratjingu clan of the Dhuwa moiety (see 56). In each case the artist is painting a design associated with his own clan

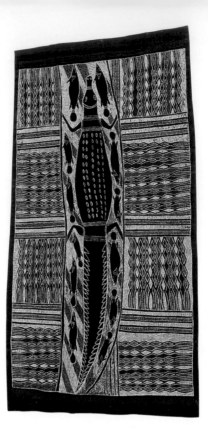

lands. The differences in the background designs of the paintings,
which in two cases consist of variations on a diamond pattern and in the
other comprises a pattern of intersecting oblongs, can be explained in
part by the clans to which the paintings belong. The Dhuwa moiety
Riratjingu clan painting belongs to the country of Yalangbara, and the
background designs represent the goanna that the Djang'kawu sisters
saw playing on the sand-dunes. The two paintings with the diamond
pattern both belong to clans of the Yirritja moiety and are associated
with the fire myth. We have already encountered the fire myth, in a
painting belonging to another Yirritja moiety clan, the Munyuku (see
63), which also has a background diamond pattern. The Mardarrpa and
Gumatj paintings refer to a later stage in the spread of fire for which
Baru, the crocodile ancestor, was responsible. Both paintings in fact
include a representation of Baru. The interpretation of these paintings
will be returned to after it has been established what kinds of groups
these clans and moieties are.

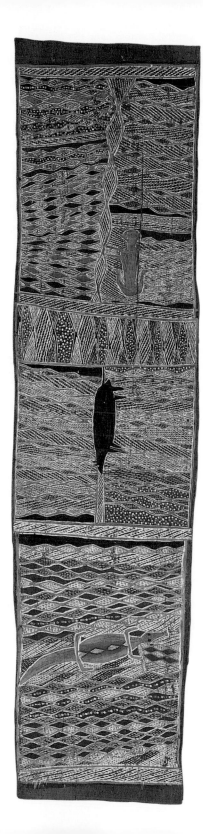

96
Watjinbuy
Marrawili,
Crocodile,
1976.
Natural
pigments
on bark;
147 × 75 cm,
$57\frac{7}{8} × 29\frac{1}{2}$ in.
Private
collection

97
Munggurrawuy
Yunupingu and
Bununggu
Yunuplngu,
Lany' tjung
Story No. 1,
1959.
Natural
pigments
on bark;
153·7 × 38·1 cm,
$60\frac{1}{2} × 15$ in.
Art Gallery of
New South
Wales, Sydney

In Northeast and Central Arnhem Land the primary land-holding group is a clan or a segment of a clan. People usually belong to the clan of their father (patrilineal descent), although in some cases individuals can become members of a clan by adoption. Both men and women belong to the clan of their father and on marriage they keep their own clan identity. The Gumatj, Mardarrpa, Munyuku and Riratjingu are all groups of this kind. The clans are exogamous, which means that a person must marry someone of a different clan to their own. The clan members have rights in the 'sacred law' – the paintings, ceremonies, sacred objects and songs – associated with their land. In Eastern Arnhem Land each clan speaks its own dialect of one of the Yolngu languages. The ancestral beings are said to have given the language to each place; the language or dialect is thus a sign of people's spiritual identity. Often the same word, such as Gumatj, Manggalili or Dhalwangu, can be used to refer to the clan and the language. Some of the dialects, for example Gumatj and Manggalili, are very similar to each other, whereas Riratjingu differs markedly from the other two.

In much of Arnhem Land clans are classed as belonging to one of two patrilineal moieties: the Dhuwa and the Yirritja. Moiety literally means a half and it refers to divisions of society into two categories of people. In Eastern Arnhem Land, for example, the Gumatj, Mardarrpa and Munyuku clans belong to the Yirritja moiety and the Riratjingu, Marrakulu and Djapu clans to the Dhuwa moiety. In Australia there are three main bases for dividing society into two groups: descent through the father, which creates patrilineal moieties; descent through the mother, which creates matrilineal moieties; and by grouping together people of alternate generations, which creates generational moieties – grandparents and grandchildren will be in the same moiety and parents will belong to the opposite moiety from their children. In many parts of Australia, such as among the Warlpiri and Aranda of central Australia, all three moiety divisions are important; but in Eastern and Central Arnhem Land the main moiety division is a patrilineal one.

In Eastern Arnhem Land, if a person's father is of the Dhuwa moiety then that person also will belong to the Dhuwa moiety. The moieties, like the clans, are exogamous. This means that a person of the Dhuwa moiety

must marry a person of the Yirritja moiety and vice-versa. People from the Gumatj clan cannot marry people from the Mardarrpa clan because they both belong to the same moiety, Yirritja, whereas a member of the Gumatj clan can marry a Riratjingu person since the clans belong to opposite moieties. Moieties are very important in the social and ceremonial life of Aboriginal people, since ceremonies and the roles people take in their performance reflect the moiety to which they belong. The division into moieties applies to the whole universe, so ancestral beings, plants and animals likewise belong to just one moiety. Ancestral beings created the landscape belonging to clans of one moiety only: Maarna the shark, for example, is associated with Dhuwa moiety land and Baru the crocodile, as we have seen, with Yirritja.

Myths act both to link clans to each other and to indicate their difference. The Gumatj, Mardarrpa and Munyuku clans are connected by the journey of fire (see 63), but only in the case of the latter two clans did Baru help carry it. The myth of Baru helps us interpret the paintings of Watjinbuy Marrawili, the Mardarrpa artist, and Munggurrawuy and Bununggu Yunupingu, the Gumatj artists, and shows how the clans had a shared ritual relationship.

In the Mardarrpa version of the myth Baru was a man; his wife was Dhamalingu (blue-tongued lizard). Baru made a bark hut to live in, while his wife went out to collect freshwater snails. His wife returned with a full dilly bag (a woven basket) to find Baru fast asleep in the bark hut. She wanted to talk to him and to sleep with him but he would not wake up. So his wife made a huge fire and cooked the snails. She cracked them open and threw scalding pieces on to his skin. But still Baru slept. Finally the pain was too severe and he woke up. He asked her why she threw snails at him. But Dhamalingu took no notice and kept throwing them.

Baru became extremely angry and rushed furiously at his wife, with sheets of bark sticking to his body. He began to act like a crocodile and yelled 'I am Baru, I am the fire, I am the Madarrpa [meaning original ancestor of the Mardarrpa]'. He seized his wife and together they rolled into the fire. He burnt her legs, which is why blue-tongued lizards today have short legs. Finally, his back bursting into flames, he dived into the

sea to try to put the fire out. He created a great rock beneath the surface of Blue Mud Bay where the fire continues burning today. In Watjinbuy Marrawili's painting (96), the serrated tail on the back of the crocodile is the bark house stuck to his back, the white marks on his back are the remains of the snail and the diamond pattern around the outside is the painting Baru does on his body. This is the painting that the people must paint on their bodies when they see the sacred objects belonging to him. The design represents the fire wrapped round his body; this fire is still burning at all the places he created.

Another crocodile (or perhaps it was the same one; stories differ) then carried fire around Cape Shield and on to Gumatj country in Caledon Bay. It is this crocodile that we can see in Munggurrawuy and Bununggu Yunupingu's painting (97), shown characteristically with short legs, as a result of being burnt escaping from the fire. The upper part of the painting is less directly associated with the crocodile, and more with the spread of the fire inland, where it burnt through a ceremonial ground, killing a number of participants. In the middle panel is a bandicoot which hid from the fire in a hollow log, marked by a vertical band. In the upper panel, a woman, Gurrurunga, is represented, who tried unsuccessfully to put out the fire.

Kinship identity is reflected in the form of paintings across Arnhem Land. Each clan has its own paintings which reflects the unique relationship it has with the ancestral beings who created the landscape. Sometimes this takes the form of combinations of figures that refer to myths associated with particular areas of land, or stages of the journey of a set of ancestral beings – the place where the crocodile was burnt, or where the Wagilak sisters encountered the snake. But kinship is also reflected in the geometric designs, discussed in Chapter 4, that are associated with particular places.

In Eastern and Central Arnhem Land there is an elaborate system of geometric clan designs which differentiates one place from another, one set of people from another. Major ancestral beings, such as the Djang'kawu sisters or fire/wild honey, travelled great distances and connect many different clans. The designs from each place along the ancestral track are similar but each also has unique features that

differentiate it from the rest. The journey of the fire/wild honey ancestor of the Yirritja moiety, as we have seen, is marked by a diamond pattern, which varies in its details from place to place, clan to clan. It is as if the landscape is clothed in a matrix of clan designs, each of which represents the unique identity of the people and the place.

Figure 98 shows diamond designs belonging to different Yirritja moiety clans, each of which is associated with a particular area of land and segment of myth. The differences between the designs are quite precise and easily recognizable. We have seen (Chapter 3) that the bold diamonds of the Munyuku clan are associated with the honey of the paperbark trees collected in the early dry season after the land has been fired. The adjacent Dhalwangu country is associated with the same inland rivers but its paintings are marked by sequences of smaller diamonds occasionally broken by oval forms (99). The Mardarrpa diamonds (96) associated with the coastal estuary are elongated just like the Gumatj ones (97), but unlike them frequently end in a shield-shaped form. And the Gumatj ones in turn differ according to which area of Gumatj land they belong to: the diamonds from Gururrnga,

98
Yirritja moiety clan designs, from top to bottom: Dhalwangu, Munyuku, Gumatj, Mardarrpa

99
Yangarriny Wunungmurra, *Ceremonial Ground*, 1976. Natural pigments on board; 50 × 64 cm, 19¾ × 25¼ in. Private collection

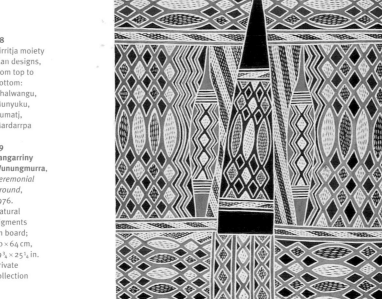

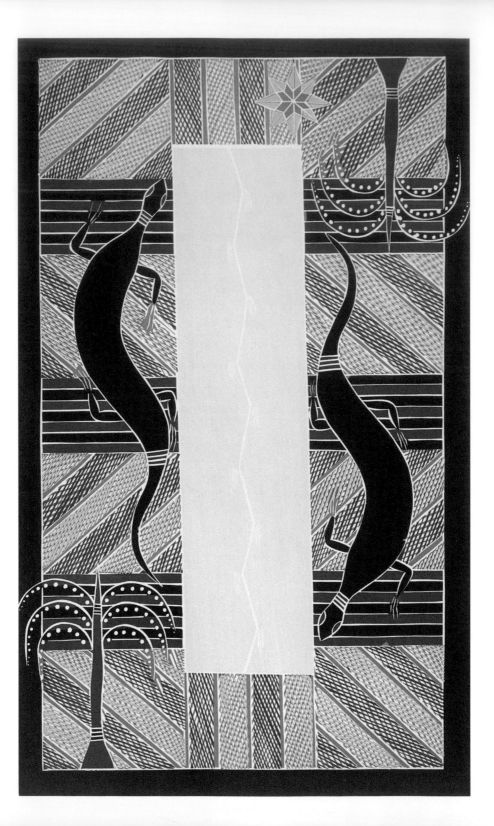

where the crocodile is seen, are more elongated than the ones from the Gumatj country inland.

Dhuwa moiety paintings, in contrast, never have background diamond patterns, but instead often comprise patterns of intersecting parallel lines or patterns that have an underlying rectilinear form. The Riratjingu sand goanna design (100), for example, contrasts with the related design from neighbouring Ngayimil country which is associated with a later stage of the Djang'kawu sisters' journey (101). The painting by Larrtjinga Ganambarr (b.c.1932) represents the country of Matjulwuy on the Gurrumuru River. The central panels of the painting represent plains

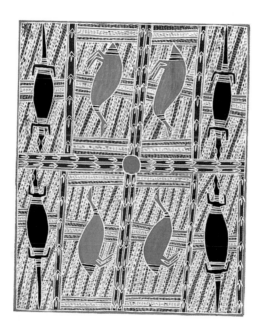

bustards the sisters saw drinking at a waterhole. The red and white dots in the background pattern represent ripe and unripe mundji berries. Bird tracks converge on the waterhole. The goannas in the outer panels are associated with the neighbouring site of Darawuy, a swampy place at the mouth of the Gurrumuru River completely covered with wild banana leaves. Djang'kawu sisters designs often include circle–line motifs within their overall structure, representing the route the women took and the waterholes they made with their digging sticks. A Liyagalawumirr ground sculpture, for example, uses a circle–line design to represent a still later stage of their journey when they

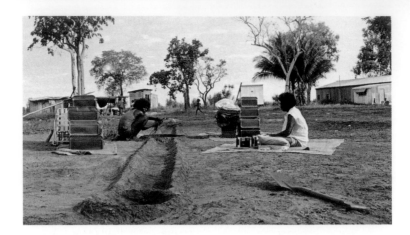

walked along the mud flats at Yawurryawurrngura collecting shellfish
(102). The design echoes the central motif of Larrtjinga's painting.

Aboriginal art is integrated within the framework of kinship. Kinship
terms can be applied alike to people, ancestors and land: people can
refer to their actual mother, their mother's country, or their mother the
ancestral being, by the same word, *ngaandi*. People's rights in paintings
and knowledge of paintings extend out from their own clan to those of
other clans on the basis of kinship and ritual links. People gain rights to
paintings of their mother's clan and of their mother's mother's clan, as
well as to paintings belonging to clans along the path of shared ances-
tral tracks. Kinship and clanship relations in Australia are classificatory,
so as well as a person's actual mother, certain other women will be
termed mother and certain other clans will also be counted as mother
clans. The rights that a person gains in another clan's paintings are
very important ones and require the person to exercise those rights on
behalf of the other clan by helping them in ceremonies or to come to
decisions about important matters. Throughout Arnhem Land people
are called upon to participate in the rituals of their mother's clans and
to help them in ceremonial preparation. In Eastern and Central Arnhem
Land people are referred to as the workers for their mother's clan,
though the role is one of considerable authority. The mother's mother's
clan belongs to the same moiety as a person's own clan and is spiritu-
ally very close; the extension of rights reflects this, although in the case
of mother's mother's clan paintings the rights are not often exercised.

102
Liyagalawumirr
ground
sculpture,
Milingimbi,
Arnhem Land,
1974

103
Dendroglyph,
New South
Wales,
photographed
c.1918

The Eastern Arnhem Land system of clan designs seems to be a little more formalized than in most other parts of Australia, and clan membership appears to play a more central role in people's rights to produce paintings. There is some evidence that similar systems existed in parts of southeast Australia but few detailed accounts exist. The geometric patterns on weapons and shields, possum skin cloaks and carved trees from New South Wales and Victoria may reflect the existence of such systems. The early ethnographies provide tantalizing hints of this. Robert Etheridge in his book on the dendroglyphs (carved trees) of New South Wales gathers some of the scattered early evidence together: he suggests that the designs on trees may represent individual or group identity. The carved trees were associated both with mortuary rituals (103) and initiation. Upwards of a dozen trees in an area surrounding

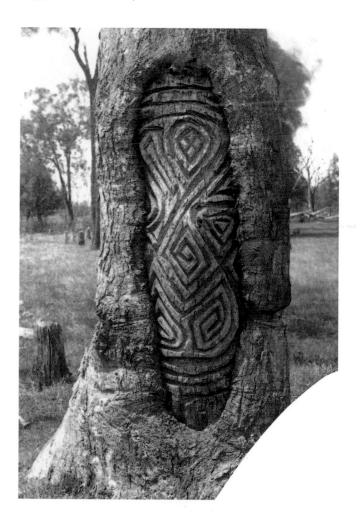

104
Detail showing
the design on
the inside of a
possum skin
cloak,
1872.
Possum skin
pelts, kangaroo
sinew and
pigment;
full cloak:
160 × 220 cm,
63 × 86¾ in.
Museum of
Victoria,
Melbourne

the grave of an important person would have a segment of the bark
removed and deeply carved motifs cut in the wood. Most frequently the
designs were geometric but figurative forms also sometimes occurred.
It seems probable that some of the designs represented the ancestral
identity of the deceased and that others commemorated events that
he or she took part in and relationships he or she had with members
of other groups. It has been suggested that the designs carved into
the trees replicated designs painted and incised on the inside surface
of possum skin cloaks (104). These cloaks were worn at intergroup
meetings and, according to the settler John Fraser, the designs on
them could be interpreted by the Kamilaruy people of north central
New South Wales to reveal the 'family' to which they belonged. But only
three such cloaks exist, and the evidence for the meaning of art in most
of southeastern Australia is thin indeed.

In contrast to Eastern Arnhem Land, in Western Arnhem Land, parts
of central Australia and Cape York Peninsula the relationship between
people and ancestral designs is more fluid, though the fluidity is a
matter of degree and emphasis rather than radical difference. In all

three areas there is still a close relationship between ancestors, art and land, and in each case groups form around these relationships. But in Western Arnhem Land individual leaders gain authority over the ceremony of a wide region, in parts of central Australia the basis for attachment to sites and sacra can be exceedingly wide, and in Cape York Peninsula rights are also regionally based.

The Kunwinjku of Western Arnhem Land exemplify these more regionally based societies. The Kunwinjku today live in settlements which spread from Maningrida in the east to Oenpelli in the west. The Kunwinjku are the largest language group in the region and intermarry on their boundaries, with speakers of Djawany and Ngalkbon, among others. Since European colonization the Kunwinjku have expanded, moving west to occupy the land of groups who suffered as a result of the Pine Creek gold rush of the 1880s and the encroachment of European settlement. Their art consists of a number of very distinct styles: the x-ray art first encountered in the rock art of the escarpment (see Chapter 2), the geometric marrayin designs associated with initiation rituals (105), Mimi stick figure paintings and sorcery figures (106). The same artist often produces paintings in all of these styles.

In Western Arnhem Land rights in paintings are more individual and less clan-based than in the east. There is a tremendous emphasis on exchange and mobility. Exchange ceremonies move rights and knowledge across the country, creating shared identities. Through marriage, kinship and residence individuals gradually accumulate authority and can end up as the senior people in areas of land that they are only distantly related to by descent. People can acquire rights in sets of paintings that belong to very different areas of country but that reflect the individual's life history. Although similarities are still apparent between the work of different artists, these similarities reflect not so much the patterns of clan membership, as in Eastern Arnhem Land, as the shared life histories and overlapping community membership of the people concerned. Peter Marralwanga (c.1916–87), for example, produced paintings of places that he became associated with through residence, kinship and ceremonial participation. Such factors differ from individual to individual. Although the pattern of rights in paintings may

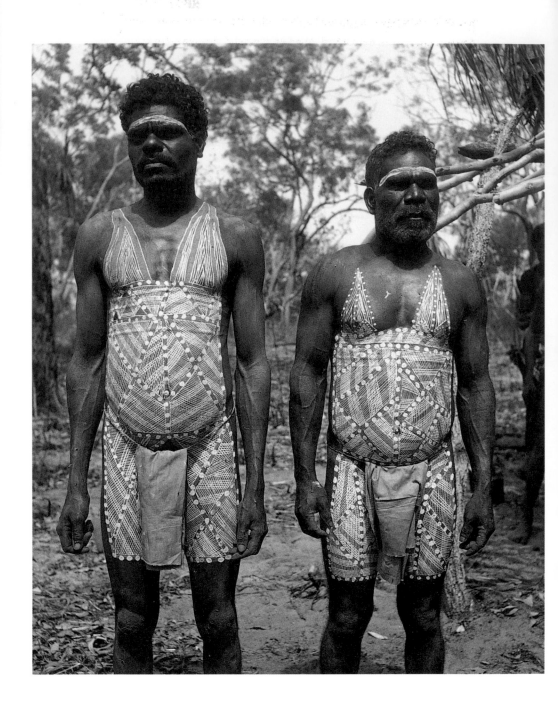

appear less clear-cut than is the case in Eastern Arnhem Land, they are nonetheless publicly acknowledged and enforced. People who produce paintings without authority or who stray into areas of ambiguity are likely to be reproached, fined or punished in some other way for their transgression. Kunwinjku artists are incorporated within a master–apprentice structure that receives the sanction of ancestral law and is integrated within the system of ritual authority.

105
BunduBundu and LamiLami returning to the public camp wearing *rarrk* body paintings after participation in a marrayin ceremony at the mouth of the Liverpool River, Central Arnhem Land, 1952

106
Jimmy MidjawMidjaw, *Sorcery Painting*, c.1947. Ochre on bark; 38 × 66 cm, 15 × 26 in. Berndt Museum of Anthropology, University of Western Australia, Nedlands

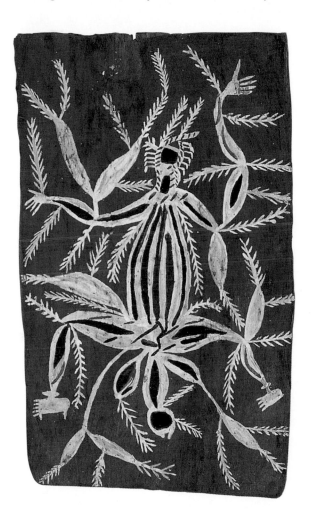

The anthropologist Luke Taylor has identified a number of contemporary schools of Kunwinjku art according to the style and content of the artists' works. The schools, comprising artists from groups of kin who live together, are usually associated with a particular region. One school he labels the Kunwinjku/Dangbon school, as the artists all

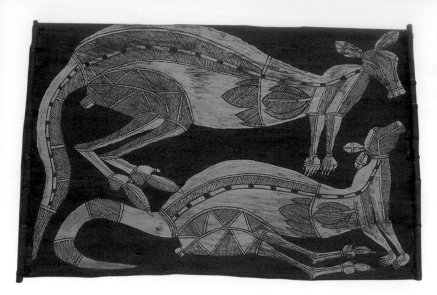
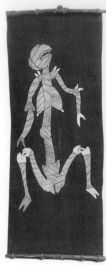

belong to Kunwinjku clans with strong links to Dangbon country to the south. The artists in this group, who are all associated with Oenpelli and the outstation of Manmoy near their own clan lands, include Dick Nguleingulei (1920–88; 107, 108), Lofty Bardayal Nadjamerrek (b.1926; 116, 117), Kalareya (b.1938) and Nabarlambarl (b.1930). The most striking feature of their work is the cross-hatching technique which employs very thin parallel lines. On close inspection these show a characteristic quiver; it is almost as if they had been painted with a shaky hand, and yet the consistency and fine definition of each line contradicts such an interpretation. The artists tend to use a single colour, in contrast to many other contemporary painters, and claim that the style is the one that used to characterize the rock art of the region. The artists often work together and share each others' pigments, which adds to the similarity of their paintings. Although the line work is in some respects austere, the outlines of the animal species are often forms of extraordinary elegance and naturalism, a high point of realism in Kunwinjku art. Nguleingulei's painting of plains kangaroos (107) conveys an extraordinary sense of being present in the Arnhem Land bush and seeing the relaxed but alert animals stretched out in the afternoon shade turning their heads towards the viewer.

Another school identified by Taylor is that of the Mumeka/Marrkolidban artists. It centres around Marralwanga, who in turn derived much of his

107
**Dick
Nguleingulei,**
Kangaroos,
c.1978.
Natural
pigments
on bark;
44 × 66 cm,
17³⁄₈ × 26 in.
Private
collection

108
**Dick
Nguleingulei,**
Spirit Woman,
1981.
Natural
pigments
on bark;
84 × 34 cm,
33 × 13³⁄₈ in.
Private
collection

109
**Jimmy
MidjawMidjaw,**
*Female Mimi
Spirit,*
c.1963.
Natural
pigments
on bark;
56 × 39 cm,
22 × 15³⁄₈ in.
National Gallery
of Australia,
Canberra

110
**Paddy Compass
Nambatbara,**
*Two Mimi
Spirits.*
Ochres on bark;
92 × 34·6 cm,
36¹⁄₄ × 13⁵⁄₈ in.
National
Museum of
Australia,
Canberra

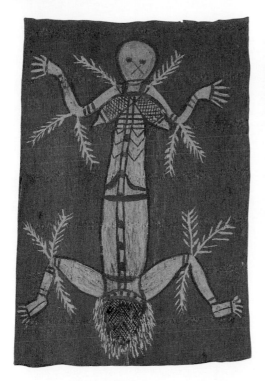

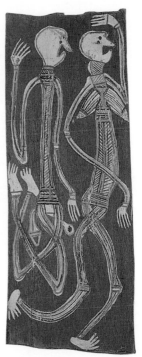

inspiration from Billy Yirawala (1894–1976). Yirawala was originally part of a school of artists based on Croker Island in the 1950s and early 1960s, and many of his early paintings are difficult to distinguish from those of other members of that school, such as Jimmy MidjawMidjaw (1897–c.1985; 109), Nangunyari Namiridali (1901–72) and Paddy Compass Nambatbara (1890–1973; 110). The paintings associated with the Croker Island school consist of very elaborate and contoured multi-limbed figurative representations of spirit beings as well as finely drawn x-ray figures. Later on Yirawala developed a style of complex infill within geometric segments which was loosely based on the form of marrayin designs. This resulted in the tapestry style of painting (111) in which the figures occupy a large expanse of the bark canvas, allowing room for the development of the intricate cross-hatched segments that so characterize the later Mumeka/Marrkolidban works.

Yirawala's paintings tend to be brighter than those of other members of the school, the strong yellow and red ochre lines emphasized by the white background he often used. The later Mumeka/Marrkolidban paintings are dense and deep in their effect and tend to draw the viewer

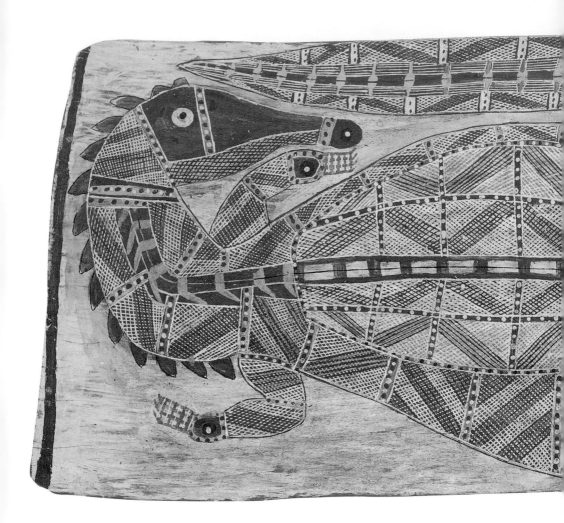

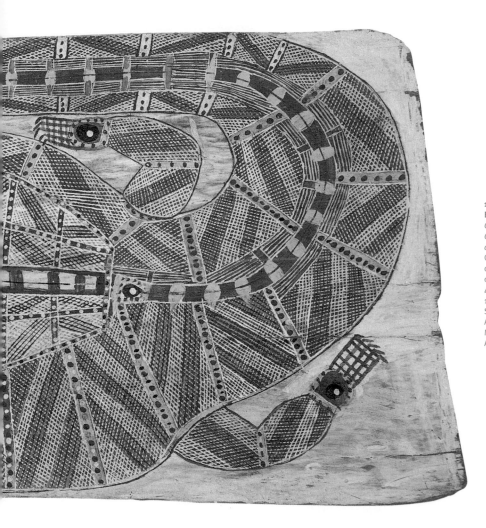

111
Billy Yirawala,
Ceremonial
Crocodile,
c.1970.
Ochre and
charcoal
on bark;
45 × 101 cm,
17¾ × 39¾ in.
South
Australian
Museum,
Adelaide

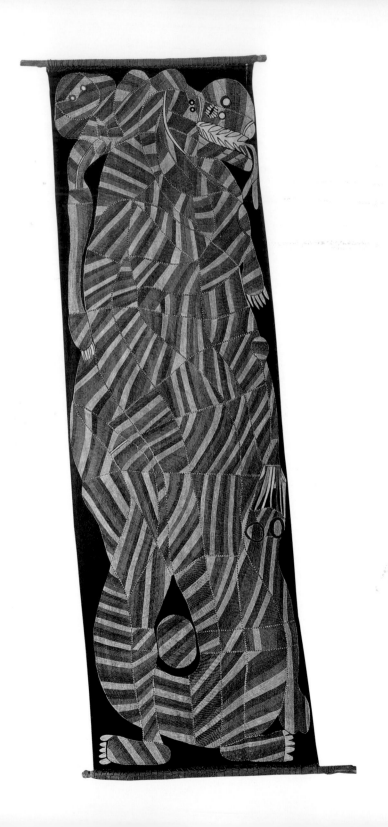

into the bark, whereas Yirawala's figures tend to leap out of the surface of the painting. Apart from Marralwanga (see 94), other members of the school include his son Namirrki (b.1924), and his sons-in-law Njimirnjima (b.1945) and John Mawurndjul (b.1952). The artists belong to the Kardbam and Kurulk clans respectively and have reciprocal responsibilities for each other's paintings. The aesthetic impact of the paintings owes much to the dense but often flowing nature of the forms, lightened by the tapestry of fine cross-hatched lines that seem just to scratch the surface of the painting. The cross-hatching is a constant source of variation; each segment often differs from the rest, setting off from its neighbours at divergent angles. Yet at the same time the effect can be one of extraordinary unity, with the segments blending together as a whole (112).

112
John
Mawurndjul,
*Ngalyod, the
Rainbow
Serpent*,
1988.
Natural
pigments
on bark;
245×78 cm,
96$\frac{1}{2}$×30$\frac{3}{4}$ in.
Museum and
Art Gallery of
the Northern
Territory,
Darwin

Although the two schools considered so far reflect both place and kinship networks, they are partly based on historical contingency and individual relations. Marralwanga deliberately set out to differentiate his paintings from those of Yirawala, his original teacher. One of Marralwanga's sons, Birriya Birriya (b.1945), belongs to a different school to that of his father. This is the Marrkolidban school, which followed the style of Mandaynjku (c.1910–82), who was joint leader of the out-station with Marralwanga, and David Milaybuma (b.1938; 113). The paintings of this school are again based on figurative paintings with infilled geometric segments. However, in contrast to Marralwanga's paintings, the artists produce broad bands of cross-hatching in regular colour sequences which create an overall pattern of striped bands across the surface of the figures. Birriya Birriya explicitly says that he follows Milaybuma's style, 'otherwise people will say I copy my father', which is an interesting reversal of the official position in Eastern Arnhem Land, where people follow their father's designs.

A final school of Kunwinjku artists is based to the west at Oenpelli and is centred on members of the Nganjmira family. The paintings show some similarities with the Marrkolidban artists in that the figures are infilled with alternating bands of single-coloured cross-hatching. However, whereas the Marrkolidban artists paint mainly single figures, the Nganjmiras, and in particular the youngest member of the family,

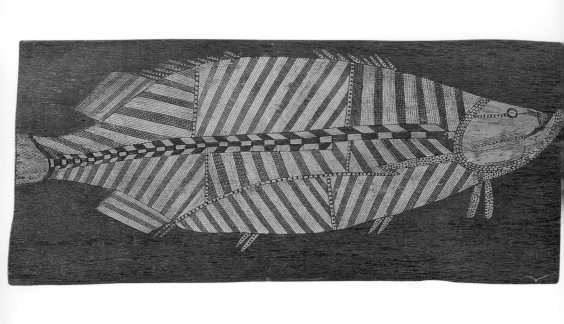

113
David
Milaybuma,
Barramundi,
c.1980.
Natural
pigments
on bark;
43 × 95 cm,
17 × 37¹⁄₂ in.
Museum and
Art Gallery of
the Northern
Territory,
Darwin

114
Robin
Nganjmira,
Mimi and
Namarodo
Spirits,
1985.
Ochres
on bark;
121 × 70 cm,
47⁵⁄₈ × 27¹⁄₂ in.
National Gallery
of Australia,
Canberra

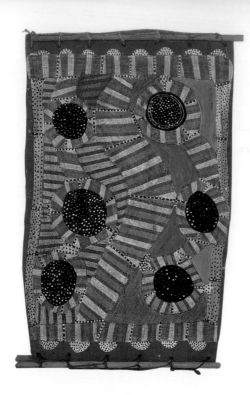

115
Mick Kubarrku,
Waterholes,
1980.
Natural
pigments
on bark;
93×55 cm,
36½ × 21¾ in.
Museum and
Art Gallery of
the Northern
Territory,
Darwin

Robin Nganjmira (b.1951), paint complex scenes in which Mimi hunters are combined with animal representations in energetic scenes (114).

It is possible to discern patterns in the themes that the Kunwinjku artists adopt that reflect both clan membership and individual authority within the regional ceremonial system. Young artists tend to produce themes associated with their father's clan first, then either the clan of their mother or mother's mother, before moving wider afield. Correlated with this is the fact that, as people gain in stature, so the range of themes represented in their art increases. Learning to paint is a long process in which the skill is only gained slowly, and through detailed instruction. Initial attempts to produce figurative forms are often clumsy, so younger artists are limited in the number of new forms they produce by the need to perfect the ones they have already acquired. Not only do they have to learn how to produce the features that distinguish the animal or fish represented, but they must also learn the elaborate techniques of cross-hatching that enhance the aesthetic effect of the painting. Some aspects of form, such as the divisions made in the body of a kangaroo, may be part of ancestral law; others, such as the

production of particular effects through cross-hatching, are much more subject to individual variation. In both cases, however, the technique of producing the form has to be learnt. An old man of ritual authority such as Yirawala or Marralwanga produces paintings from right across the Kunwinjku region. The limits to the set of paintings that an individual produces seem to be set by personal life history and rights gained during the person's lifetime.

Certain themes are more available than others. Thus x-ray paintings of familiar food species such as the kangaroo, crocodile or barramundi are produced by most artists. However, the ways in which these species can be represented may be more restricted. The ordinary x-ray style in which the backbone and internal organs are shown is among the most public forms of representation. Although such marks have complex symbolic meanings and refer to ancestral transformations, they are accessible to the public. Combined with certain other motifs or infilled with geometric patterns, however, they allude to the form of painting produced in the more restricted context of the marrayin ceremony, in which clan sacred objects are revealed. The marrayin designs consist of geometric patterns, often with dotted outlines (see 105), which echo in form the geometric art of central Australia. In the ceremony itself, the designs often occur in unbounded form independent of any figura-tive representation and are painted on initiates' bodies or on wooden ceremonial objects. Today, they occur as patterns within the confines of figurative representations, occupying the space that would otherwise be filled with x-ray features. Indeed, the geometric designs do signify the internal organs of ancestral beings and the features of the land-scape that were transformed out of their bodies. Painted in the body of a kangaroo or barramundi or catfish, the marrayin designs are a public expression of the more restricted art styles, and as such they are likely to be painted under the authority of senior ritual elders.

Mick Kubarrku (b.1922) is another senior Kunwinjku elder who has established his own distinct style, though one that relates quite closely to that of Mumeka/Marrkolidban artists. In Kubarrku's painting of waterholes (115) the artist has fused features of the landscape with those of the rainbow serpent by combining the geometric art of the

marrayin designs with heavily disguised figurative forms. The body of the rainbow serpent can be seen intertwined with the landforms in the centre of the painting. At the top and bottom, extensions of his body are shown combined with the serrated back of the crocodile, emphasizing its transformational power and strength. The black circles represent a series of deep waterholes into which the Mann River shrinks in the dry season, exposing tunnels that interconnect the pools. The tunnels were made by the rainbow serpent piercing the rock and are shown by the banks of cross-hatching connecting the circles.

Representations of major ancestral beings are likely to be painted more often by senior men and show variations of form according to the ritual affiliation of the artist. These include representations of Ngalyod, the rainbow serpent itself. Ngalyod is a universal being connected to clans of both moieties throughout the region. As the 'mother' of all ancestral beings (*djang*), containing within it the creative potential of all others, it can be connected to almost every ancestral site. It can therefore be as general or as specific as a particular artist wishes it to be. Although it is possible to represent Ngalyod in such a general way that it could be associated with any clan country, it is also possible to associate it with particular ancestral beings and places. This is achieved by combining features of a particular place or set of ancestral beings within the overall form of the rainbow serpent. Senior artists develop their own characteristic ways of combining features from other animals into the form of their own rainbow serpent, which then comes to be associated with them and their country and ceremony (116, 117).

Paintings associated with the culture hero Lumaluma, an all-consuming cannibal, or the Lorrkun ceremony, in which bones of the dead are placed in a hollow-log coffin, similarly allow senior artists to develop complex themes in their own individualistic ways. Senior artists also have access to a repertoire of paintings associated with the past ceremonial life of the region, in which certain ceremonies no longer performed were once common currency. Peter Marralwanga and Billy Yirawala, for example, painted themes from the Wubarr initiation ceremony which had last been performed when they were young men in their twenties and thirties.

116
Lofty Bardayal Nadjamerrek, *Rainbow Serpent* (combining crocodile, kangaroo, emu and barramundi, with waterlilies on back), 1981. Natural pigments on bark; 53 × 112 cm, 21 × 44$\frac{1}{8}$ in. Museum and Art Gallery of the Northern Territory, Darwin

117
Lofty Bardayal Nadjamerrek, *Rainbow Serpent* (combining crocodile and kangaroo), 1980. Natural pigments on bark; 52 × 151 cm, 20$\frac{1}{2}$ × 59$\frac{1}{2}$ in. Museum and Art Gallery of the Northern Territory, Darwin

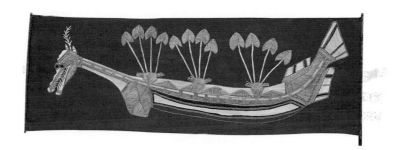

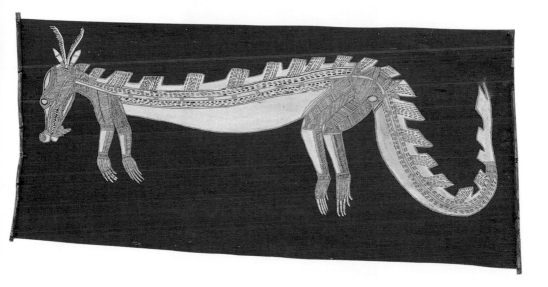

The neighbouring societies show a similar development of local styles often closely associated with the work of particular individuals. Mundarrg (1915–87), a Rembarrnga man who lived in the stone country to the south, inland from the Mann River, shared many themes with Kunwinjku artists to the west but painted in a different style. Using a harmonious range of pigments – almost brown ochres, a pale yellow, creamy whites – his paintings seem to blend in with the tonal qualities of the bark on which they are painted. He represents the stories of the arid stone country inland, sometimes macabre tales of trickster beings and their cannibal exploits, and on other occasions beautiful figurative representations of animals and plants that strongly evoke the feeling of the Central Arnhem Land bush (118).

118
Mundarrg,
*Waijara Spirit
with Wallaby
and Honey-
Collecting
Bags*,
1979.
Natural
pigments
on bark;
99 × 43.5 cm,
39 × 17⅛ in.
Museum and
Art Gallery of
the Northern
Territory,
Darwin

119
Echidna,
collected 1962.
Wood and
ochre;
l.43.5 cm,
17⅛ in.
National
Museum of
Australia,
Canberra

Variants of the relationships between people, art and land that we have seen in Eastern and Western Arnhem Land exist right across Australia. The close connections between groups based on descent, designs and land that we found in Eastern Arnhem Land occur in a somewhat more flexible form in the better-watered areas of central Australia, among groups such as the Katej and Aranda. Over much of central Australia, however, among people such as the Pintubi and Pitjantjatjara, groups that own paintings are formed on a much broader basis than by descent. Totemic cult groups associated with important sites and tracks in this region comprise people who are linked to the country through their father or their mother, whose conception Dreaming came from there, whose father and mother lived and died there or who have lived in the region for a long time. People are still recognized as having stronger rights to some areas of land than others, and rights in paintings and land are guarded just as closely as they are in areas where rights are primarily based on descent. Western Desert societies such as the Pintubi and Pitjantjatjara are therefore closer to those of Western Arnhem Land than those of Eastern Arnhem Land, although they lack the underlying framework of patrilineal clan territories.

The Western Cape York Peninsula represents yet another variation. The ritual art of the Wik-speaking peoples of the region of Aurukun still reflects the mythological events that are associated with particular sites. Elaborate carved and painted sculptures are used to represent events in the lives of mythic beings in initiation rituals and ceremonial events such as house openings. An echidna sculpture (119), collected in 1962, represents an ancestral echidna who died after a fight which broke out when he stole the wife of the ancestral taipan (venemous

snake), and it was used in a dance re-enacting the event. However, the right to produce the sculptures and body-painting designs associated with the regional cults is not vested in the membership of particular clans or totemic groups, nor does it imply proprietorial interest. Although senior owners of the site are likely to come to the fore in producing sculptures and singing songs associated with the mythology of a place, other people can use the songs and designs.

The anthropologist Peter Sutton has written extensively about one bark painting from Aurukun which illustrates how widely the rights to paint are spread. Bark paintings have only been produced in Aurukun since the 1970s, largely under the influence of people who moved there from Mornington Island in the Gulf of Carpentaria. The painting (120) by Angus Namponan (1930–94) was produced in 1976 and represents three mythic sites, which cover an area near Aurukun in the north to country south of Cape Keerweer. The top panel represents Walkaln-aw, a freshwater spring on the Small Archer River in country belonging to the Winchenem clan group. Ancestral fishermen are shown hunting for milkfish at night in the late dry season. A man stands poised holding a blazing torch in one hand and a spear and spearthrower in the other. (The hunting of milkfish is a major ritual theme; in 1962 the archaeologist Fred McCarthy collected an extraordinary sculpture of milkfish suspended on a frame; see 261.) In the bottom of the panel three men are shown performing a ceremony for the increase of animal species at the site. The pattern of half circles that divides the top and middle panel is associated with the Winchenem clan group and belongs to the dry country inland.

120
Angus Namponan, *Untitled*, 1976. Natural ochres and acrylic on bark; 55 × 35 cm, 21$\frac{5}{8}$ × 13$\frac{3}{4}$ in. Queensland Museum, Brisbane

The middle panel represents an ancestral shark hunt and is associated with the artist's own country on the estuary of the Kirke River inland from Cape Keerweer. The shark story concerns two young women in the form of quails who eventually turn into sharks. The women came from different sides of the Kirke River, belonging respectively to two clans speaking different languages. The shark story links the two clans by providing a common theme. The dotted pattern in the background represents the sparkling water at the turn of the dry season when the wet-season sediments have sunk to the bottom and the spring tides

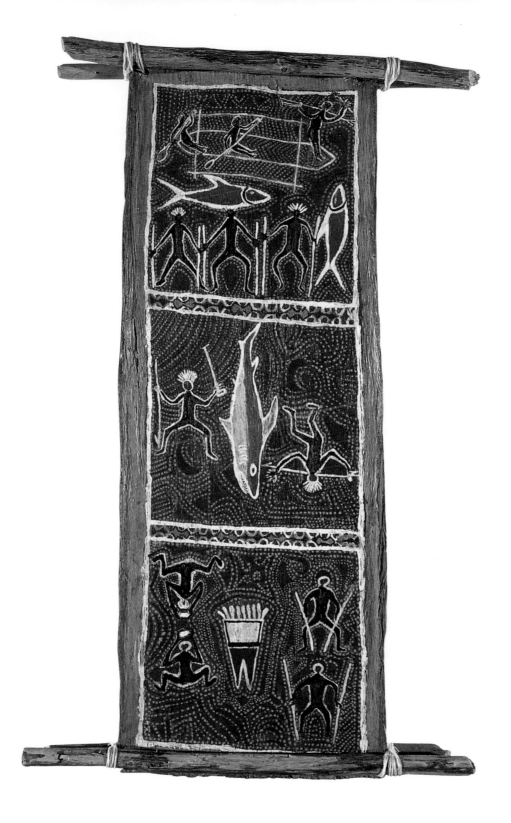

begin to rise. It is a time of abundance for hunters and gatherers in northern Australia and the design symbolizes the bounty of the land.

The bottom panel represents a dangerous place, Moolench, near the major camping ground of Thum-merriy south of the Kirke River. It shows two spirit images of men carrying ceremonial poles; they are spirits driven away from the place of death by mourning relatives. They encounter two beautiful women living beside a well, which is represented by the geometric figure in the centre. The women are squeezing the cooked flesh of stingray. The men ask the women for water and drink and continue asking and drinking until the well has nearly run dry, when the beautiful women depart the scene. This enigmatic myth relates both to departure from this world and to the ambiguity and dissolution of relations with place. The site is associated with a number of different clans, but is of particular importance to the northern Yunkaporta clan. The painting as a whole uses themes from different places belonging to different clans along the Wik coast of Cape York Peninsula to weave a story of seasonality, of relations between people and of the movement through life into death and the spirit world. The artist draws widely from the inventory of regional designs to create something that is essentially his own construction.

The ways in which the rights to paintings are owned, therefore, differ across Australia, but the differences are matters of degree rather than absolute. Everywhere designs and myths are linked to land, and this can be observed in paintings from the Western Desert, Western and Eastern Arnhem Land and Cape York Peninsula. The nature of the rights that human beings have in ancestral designs, the ways in which those rights are acquired and the ways in which they are associated with social groups varies in detail from place to place. Yet the similarities are easily recognized and it is possible to see how one system could be transformed into another with only minor changes.

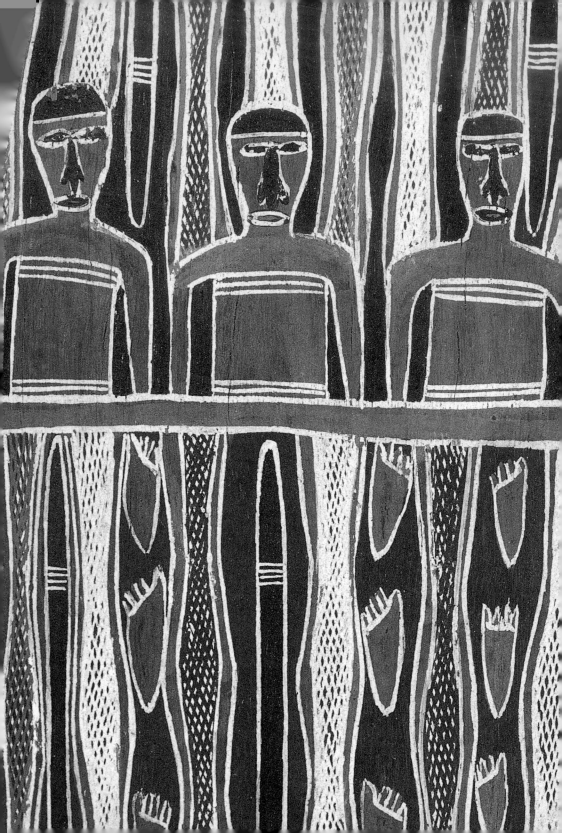

The New York theatre director Richard Schechner's definition of ritual as 'restored behaviour' is very appropriate for Aboriginal Australia. To Schechner ritual, like theatre, involves taking pre-existing forms – scripts, plots, choreographed sequences – and performing them in new contexts. Religious services such as marriage or baptism, and grand ceremonial events such as a coronation, the installation of an office holder or the state opening of parliament, all have set components and sequences of events that make each occasion a recognizable variation of its type. Although particular elements may vary each time the ritual is performed, the individual parts are likely to comprise pre-existing forms, such as hymns, prayers, readings from the Bible or music.

121
Yama
Munungiritj,
Yellow Ochre
of Quarry
(detail of 139)

Complex Aboriginal ritual performances are relatively infrequent occasions associated with mortuary practices, initiation or regional fertility ceremonies. They are often operatic in scale, involving the co-ordination of music, dance, painting, sculpture, action sequences and the incantation of sacred names. And every component is believed to have originated in the ancestral past, and to be associated with a partic-ular ancestral being who sang the song for the first time or painted the design on their body. The components of ritual arose almost literally out of actions in the past, and in ritual they are reproduced in the contexts of the present. In the excitement of ceremonial performance the pres-ence of the Dreamtime ancestors can be felt through the replication of acts that are thought to have originated with them. The ritual perform-ers embody ancestral form and in painting their skin and masking them-selves with elaborate headdresses and ceremonial regalia, they take on the identity of the ancestral beings. Rituals are thus a restoration of the Dreaming in the present, enabling the living to participate in its powers.

Rituals are surrounded by rules which prescribe the way in which events are performed and which acknowledge the authority of certain people to set the form of action and define the roles that different individuals can

122
Pearl shell
ornament,
Kimberley
region,
before 1973.
Shell l.18 cm,
7 in.
Berndt
Museum of
Anthropology,
University of
Western
Australia,
Nedlands

take. Each time a painting is produced in a secular context or a series of songs is sung in between rituals, people are expressing their rights in religious knowledge and have to obey the rules associated with the sacred law. Painting or singing in between ceremonies is a form of rehearsal but it is also a context in which people are instructed in the production of religious forms and the rules associated with them. People can only make the paintings that they are entitled to and must always be aware of the dangers of producing the 'wrong' painting – one that they do not have the right to produce or that has restrictions placed on its use. Paintings produced for sale to the market are no less constrained by rules than paintings made for ritual use.

Although the concept of ritual as restored behaviour provides a useful perspective on Aboriginal ritual it tells only half the story. For rituals are particular kinds of events in the present which have multiple purposes, motivations and effects. It is the present context that gives ritual its dynamic form, and makes it different each time it is performed. In this way it is connected to the emotions and aspirations of the partic- ipants as well as connecting them with aspects of their own history. Ancestral events are restored, not in the order the ancestral beings created them, but in an order designed to reflect present purposes: to guide the soul of the dead back to the spirit world, to express friendly relations between sets of people or to renew the spiritual strength of land and people. As well as being restorations, therefore, rituals are

also transformative events; they affect the individual and in doing so make the ancestral past conform to present realities and endow it with the force of contemporary emotions. As Spencer and Gillen were the first to point out, the excitement of ritual performance creates energies and emotions that in turn reinforce the power of the ancestors. The more successful a ritual is as a performance, the more alive the spirit of the Dreaming is thought to be. In this purposive and emotional process the aesthetic and semantic aspects of art play equally important roles.

Much Aboriginal art consists of objects whose surface appears to shine and simultaneously create the effect of movement. Natural phenomena that have these characteristics – rainbows, sparkling water, the rays of the rising or setting sun shining intense light on tree trunks or bringing out the colours in the surface of rocks – can be signs of the powers of ancestral forces in the land. Certain shiny natural forms, such as the engraved pearl shells from the Kimberleys (122) or naturally burnishing ochres, are traded widely across the continent. They end up as part of the content of bundles of ritually powerful items and are then released from the darkness of the 'inside' on ritual occasions to become part of a ceremonial costume or to be rubbed on the bodies of initiates. Part of the appeal of Western Desert acrylics or Eastern Arnhem Land bark paintings is that they simultaneously convey a sense of vibrant surface movement with clarity of form. The very techniques used – layering on the surface with thin cross-hatched lines in bright colour or the covering of the surface of the painting with gradations of dotted infill – seem designed to produce such an effect. Forms emerge with clarity but then shift with the movement of the eye, as can be seen in *The Spirit Djeritmingin in the Woolen River* (123) by the Djambarrpuyngu clan artist Bininuwuy (1928–82). The painting belongs to his mother's clan, the Gupapuyngu, and represents a river channel blocked by a stone bar that was broken in ancestral times to release the fresh water.

The effect achieved has many echoes in Western forms of painting, from the vibrant colours that once adorned Greek temples through the luminosity of Jan Vermeer (1632–75) to the Op Art of Bridget Riley (b.1931; 124) or the expressionism of Willem de Kooning (1904–97). But in the case of Aboriginal art this shimmering brilliance is thought to be of

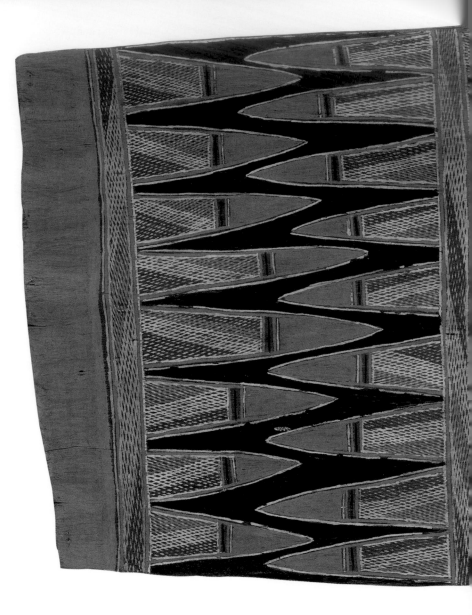

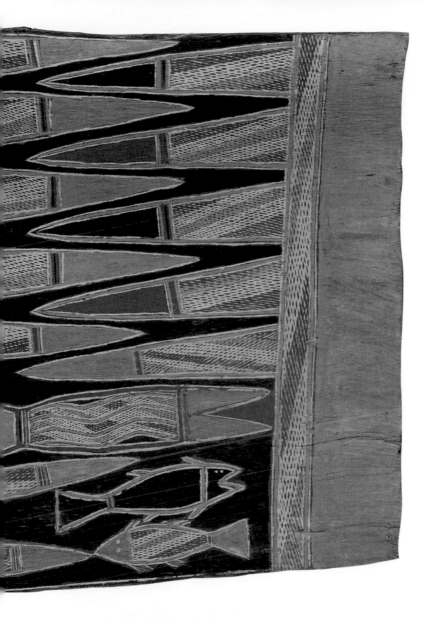

123
Bininuwuy,
*The Spirit
Djeritmingin in
the Woulen
River*,
c.1960.
Natural
pigments
on bark;
72·4 × 44·5 cm,
28½ × 17½ in.
Art Gallery of
New South
Wales, Sydney

124
Bridget Riley,
Cataract III,
1967.
Emulsion PVA
on linen;
221·9 × 222·9 cm,
87 × 87¾ in.
British Council
Collection,
London

ancestral origin: it is the presence of the ancestors in the art and land. Just as a rainbow is evidence of the great rainbow serpent rising from the waterholes where it resides, so too the brilliant surface of the paintings are evidence of the presence of ancestral forces within them.

In Eastern and Central Arnhem Land, painting is seen as a process of transforming a surface from a state of dullness to that of shimmering brilliance (*bir'yunhamirri*). The initial stages of making a painting can be completed quickly. First of all the surface is covered in a single colour wash, usually red ochre. The main design forms are then outlined in yellow and/or black (125), and the figurative representations are coloured in. At this stage the painting is referred to as 'rough' and 'dull'. Although setting the correct design is a skilled task usually carried out by a senior person, it is done quickly and little remains visible in the completed painting. The next stage involves covering the surface with cross-hatched infill. This is accomplished by using a special brush made from a short stick with a length of about 2·5 cm (1 in) of straight human hair bound to the end. This brush is dipped into pigment and then drawn across the surface of the painting, covering it with patterns made by sequences of parallel lines. Usually a second set of lines is painted at a transverse angle to the first, creating the characteristic cross-hatched effect of Arnhem Land art (126). Cross-hatching covers much of the surface of the painting, but most figurative representations and some geometric motifs remain in an overall uniform colour. The

125
Johnny BulunBulun painting a design in yellow, late 1970s

126
Narritjin Maymuru finishing the cross-hatching on a bark painting of a Yingapungapu ceremonial ground, 1978

final stage of the painting involves outlining the figures and cross-hatched areas in white to create a clear edge which defines their form (127). The artist Narritjin Maymuru explained to me one day how the process of painting was a risky one: you are never sure until a painting is complete whether or not it will look good. Indeed, he added, immediately before the final outlining of figures the painting can look an absolute mess and you can be most uncertain that all the effort put into the cross-hatching is going to pay off. But usually it turns out all right.

Narritjin's words show a concern with the technique of producing aesthetic effects that communicates to artists across cultures. Indeed, Narritjin was very conscious that he shared concerns with artists of other places and times. But in transforming a painting from a rough dull state to shimmering brilliance, Yolngu are not merely producing an aesthetic effect but moving the image towards the ancestral domain. The cross-hatched surface of the painting reflects the power of the ancestral beings it represents, the quality of shininess is the power of the ancestral beings incarnate in the object. The spiritual value attributed to cross-hatching explains in part the importance placed by the Kunwinjku artists from the various schools on elaborating and developing particular effects (128). The artist is in effect developing a qualitative understanding of the spiritual power of the ancestor. Painting is a form of contemplation and spiritual communion: the graded and layered effect of the infilling creates a depth of field for the Dreaming.

127
Tom Djumburrpurr outlining in white, 1988

128
Peter Maralwanga, *Ngalyod, the Rainbow Serpent*, at *Manabinbala*, detail of 94 showing cross-hatching

This general connotation of ancestral power is reinforced in particular cases by locating it in a specific attribute of the ancestral being. In Eastern Arnhem Land, for example, the ancestral shark Maarna is associated with a number of inland waterways. The shark was harpooned off Buckingham Bay on the north coast and in its agony drove into the land, gouging out the courses of rivers, tearing its teeth out as it smashed into the river bank. At one stage it was caught in a fish trap; eventually, seething with anger, it smashed the trap to pieces and continued on its way, bloody but unbowed. The painting (129) by Manydjarri Ganambarr (b.1948), in which the figurative representation of a shark almost dissolves into geometric form in the upper panel of the painting, brilliantly evokes the force of the ancestral shark Maarna as he crashes into the land and almost disintegrates in his death agony into an angry explosion of power. In the painting, his body is incorporated within the geometric design that surrounds him, signifying his transformation into a more generalized spiritual force. In the paintings of the shark the shimmering brilliance is the flash of pain and fury in the eye of the shark as it tries to escape from the hunter and lashes out in anger. Its fury is also reflected in the energetic steps of the dancers in ritual as they re-enact the stages of its journey. The brilliance of a design has gentler connotations in other contexts. In the case of the wild honey ancestor it may come from the light catching the flowers of the eucalypts in bloom or the glistening surface of the honey. These meanings are taken up in the songs that are sung to accompany paintings and the sacred names that belong to the ancestors.

129
Manydjarri
Ganambarr,
*Shark
(Djambarrpuyngu
Maarna)*,
1996.
Ochre on bark;
190 × 60 cm,
74¾ × 23½ in.
Kluge-Ruhe
Aboriginal Art
Collection,
University of
Virginia

The aesthetic effect of paintings is mediated through the way in which they are viewed and by the contexts in which they occur. In many cases paintings are seen at a distance or glimpsed out of the corner of the eye, rather than being subject to a prolonged gaze. They may be produced on a coffin lid which is painted under a shelter made of boughs and scarcely visible to anyone other than the painters. And when the coffin lid is completed, it is covered with cloth before being buried. Paintings on the bodies of dancers moving in the light of the fire are not fully seen. The same is true of paintings on the surface of sacred objects prepared in private and revealed to initiates for only moments at a time. In the past, cross-hatching was associated with the most restricted

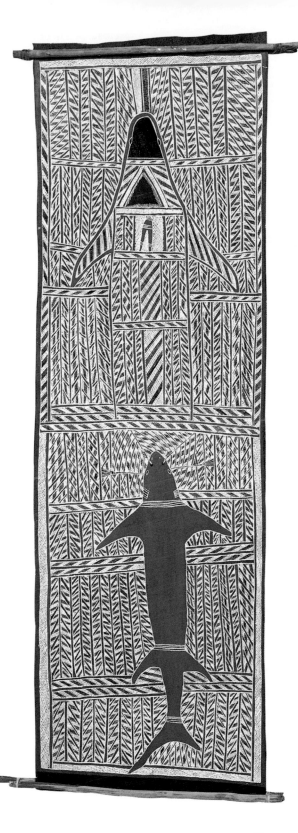

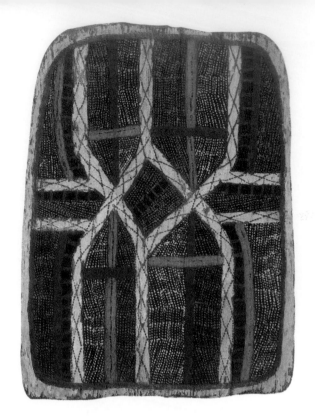

130
Kararunga Lame Toby, *Crocodile Painting*, 1965. Natural pigments on bark; 66 × 49 cm, 26 × 19¼ in. Museum and Art Gallery of the Northern Territory, Darwin

paintings, which were produced on the men's ceremonial ground and revealed in unmodified form only to selected people. The chest-paintings of boys undergoing circumcision, or of people who have had a sacred object revealed to them for the first time, used to be smudged out before they returned to the main camp. This smudging helped to obscure the form of the painting and reduced its brilliance, returning it to a duller state. Such action was thought necessary both to protect people from the power of the design and to maintain control over knowledge. The power of revelation, the impact of the moment of seeing, is thus enhanced by its rarity and the shortness of its duration.

The appearance of art amid the energy and movement of ritual also helps to obscure its form and reduce it to a flash of light. Even in the case of painted objects, such as memorial posts for the dead or hollow-log coffins, which remain visible until they rot away, the brightness quickly fades as the surface pigment is washed off and the post or coffin is eaten by the white ant and burnt by fire. Although elaborately cross-hatched paintings are on display today in craft stores and museums

to be gazed at for prolonged periods by the avid viewer, in indigenous contexts the conditions of seeing remain the same as always and are far removed from the context of the art gallery wall.

The fact that paintings are not produced to be hung on gallery walls does not mean, however, that aesthetic factors are unimportant in evaluating them. The art of the Tiwi from Melville and Bathurst Islands emphasizes originality, both in the sculptural art and in the bark paintings whose designs closely relate to it (130). The best-known art centres on mortuary rituals. The pukumani ceremony is the context for celebrating the life and renown of a person who has died. The ceremony involves the manufacture of carved and elaborately painted ironwood posts (132, 133), bark baskets that are broken over the head of the posts by the mourners, and armlets (131) and other decorations worn by the dancers. The posts take many weeks to prepare and their final positioning surrounding the grave is a great event. The carvers are commissioned by relatives of the dead to produce the finest poles they can and are provided with food and other supplies while they are making them. During the ceremony dancers will make payments to the carvers as a sign of their appreciation. The artists thrive on originality and anticipate the pleasure that the final appearance of the carvings will bring.

The surface of Tiwi paintings is richly encrusted with thickly painted friable ochres. Compared with Arnhem Land, the art appears to be abstract: it combines geometric forms with flowing abstract designs and there are very few figurative representations. Nonetheless, the art often refers to mythical themes. The painting (130) by Kararunga Lame Toby (c.1905–75) evokes rather than represents the ancestral crocodile and swordfish: the schematic animal forms seem to be entangled with each other to the point of disappearance. The white dots signify the passage of the crocodile and the yellow dots that of the swordfish. The coloured lines show their tracks along the muddy bottom and the red and black barred lines allude to the crocodile's teeth and perhaps the swordfish's serrated blade.

Europeans first became aware of the complexity of Aboriginal ritual performances through the writings of Spencer and Gillen at the turn of the twentieth century, and their photographs of dancers in ceremonial

131
Tiwi armlets.
Natural
pigments,
feathers
and bark;
l.20 cm, 7⁷⁄₈ in.
Tiwi pendant.
Painted seeds
set in beeswax,
human hair
and wood;
l.55cm, 21⁵⁄₈ in.
National
Museum of
Australia,
Canberra

132
Big Jack
painting one of
the pukumani
graveposts, with
Laurie Nelson
on the right,
Melville Island,
1958

133
**Laurie Nelson,
Big Jack, Bob
One, Big Don,
Charlie Quiet,
and an unknown
artist,**
Pukumani
graveposts,
1958.
Ironwood;
max. h.254 cm,
100 in.
Art Gallery of
New South
Wales, Sydney

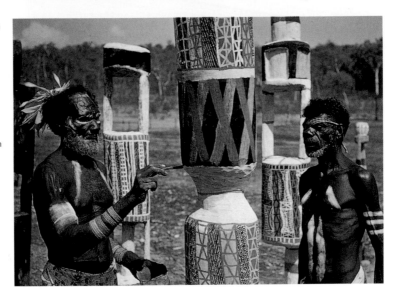

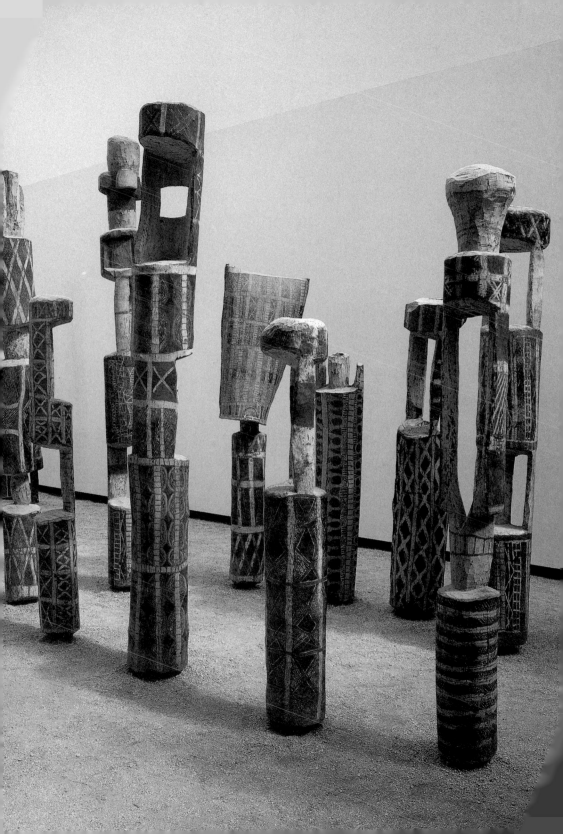

attire. Their description of an Aranda fire ceremony in which men hold-
ing burning brands (*wanmanmirri*) charge the group of participants
conveys something of the effect it had on the observers:

The excitement was growing gradually more and more intense … each of
the twelve men was handed one of the *wanmanmirri*; fires were made …
one of the men charging full tilt, holding his *wanmanmirri* like a bayonet,
and driving the blazing end into the midst of the group … the signal for
the commencement of a general melee … the men were leaping and
prancing about, the burning torches continually came crashing down
upon the heads and bodies of men, scattering lighted embers all around.

Such fire ceremonies are performed regularly across a wide area of
central Australia, and a film made in 1972 recorded the spectacle (134,
135). The ritual is one in which past grievances are brought out into
the open and resolved dramatically yet cathartically with the burning
brands. Over the years a fuller and more subtle understanding of
Aboriginal ritual has developed, and gradually people have begun to
take account of the role that aesthetics plays – a role that is signalled
in the form of many of the myths that are associated with the rituals.
Indeed, fire is itself a powerful component of the aesthetics of ritual. It
heats and it purifies through burning, it provides the light at night for
ritual performance and is integral to the aesthetics of viewing. Fire
gains symbolic power from the devastation that it can cause, and its
potential danger. It is an ideal symbolic medium for expressing anger
and resolving conflict through catharsis.

134
Warlpiri fire
ceremony
(*Ngajagula*),
Yuendumu,
central
Australia,
1972

The anthropologist Dianne Bell has provided a detailed account of
women's rituals from Warrabri in central Australia in which she draws
attention to their aesthetic content and motivation. Her most extended
account is of Yilpinji rituals, which focus on relations between the
sexes, on creating partnerships and dissolving or resolving existing
relationships. Because of this they are sometimes referred to as 'love
magic'. Although this gives the wrong emphasis, the rituals are indeed
concerned with sexual attraction and are expressions of desire as well
as attempts to provide a context for the enactment of the complexities
of gender relations. Yilpinji can be performed in order to bring people
together as lovers, but the case has to be argued in advance and the

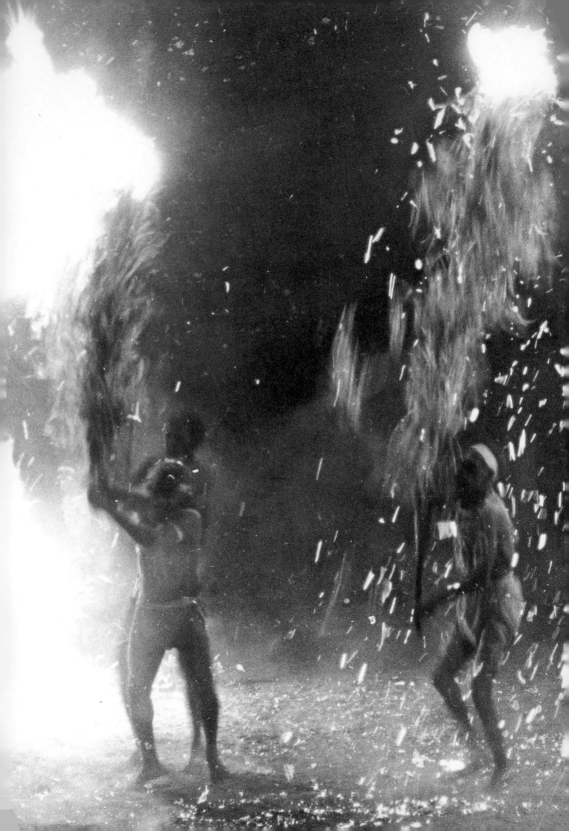

Intended relationship has to be considered a socially appropriate one. Since Yilpinji rituals require the performance of a number of women acting together they imply a degree of consensus about the objective.

Love magic can equally be used by men, and one of the main themes developed over the years by Clifford Possum Tjapaltjarri has been his *Ngarlu Love Story* paintings (136). The paintings refer to a mythic episode that took place near Mount Allan Station. A man fell in love with a woman of the wrong relationship group, with whom marriage and sexual relations were forbidden. The man decided to attract the woman by spinning for himself a beautiful pubic belt of hair string while singing powerful songs of love. The spinning created a sensation of elevation and that, combined with the overwhelming feelings of excitement as the woman approached attracted by his 'magic', caused him to lose concentration, and the hair string was caught up in a gust of wind and blew away. The tryst was successful, however, and a group of women gathered around their camp at night to guard the lovers as they consummated their desire. The painting shows the spindle whorl centred on the man's camp, the footprints of the lovers, and on the left and right the painted breasts of the women guardians. The brilliant rainbow colours of the painting evoke the sense of sexual attraction.

The Yilpinji that Bell describes belong to the Katej people and are associated in particular with relations in the Dreaming between two sets of ancestral beings, one female and the other male – the old woman Dreaming and the rain Dreaming. The Dreamings centre on Karlukarlu, the area that includes the famous Devil's Marbles. In the old woman Dreaming two elderly ancestral women are travelling the country. They are in possession of sacred songs and ritual objects. They are associated with swampy land, and as they travel from one swamp to the next they stab the ground with spear-like sticks. In a patch of tall spear trees near the Devil's Marbles they encounter a group of dancing boys. The boys dance around the women waving similar spears and the women stop to show them how to throw them. The young boys also carry sacred objects. The women are surprised, charmed, and suspicious of the boys. They wonder how ones so young can carry ritual paraphernalia, but nonetheless are persuaded to exchange knowledge of the contents of

135
Warlpiri fire ceremony (*Ngajagula*), Yuendumu, central Australia, 1972

**136
Clifford Possum
Tjapaltjarri,**
*Ngarlu Love
Story*,
1991.
Acrylic on
canvas;
240 × 130 cm,
94½ × 51⅛ in.
Art Gallery of
New South
Wales, Sydney

the packages. The women try to leave and the boys beg them to show them more. Suddenly the boys disappear into the bush and return as initiated men, wearing headbands and carrying the long spears of men. The women are amazed by the boys' easy assumption of initiated status and are ashamed of what they have revealed. They move on again. The young men plot to spear the women when they have finally mastered the art of spearthrowing. But the women leave, performing their rituals, and the men cannot catch them while they are on the women's ceremonial ground. The women are characterized as being powerful and transforming. As they travel they paint their bodies in red ochre and fat. They glisten and glow, taking on the colours of the desert around them and of the rocks at sunset.

In another version of the myth, after initiation the young men do catch up with the women away from the ceremonial ground and trap them. The women are out collecting witchetty grubs, digging in the ground at the roots of a shrub. One of the young men runs up to one woman and suggests that they dig for grubs together and travel on together. The woman is both shy and slightly ashamed since men do not usually behave with such brashness. The woman had left her country far behind and decides to return, but as she sets off the young man spears her and pins her to the ground. Unable to escape, she lies there naked while the young man paints himself and tries to make himself attractive to her, brings her gifts and wraps her in kangaroo skin. The woman is away from her country and feels that she has no choice but to remain with the man.

The second myth of the Katej Yilpinji is part of the *ngapa* (rain) story. It concerns Junkaji, the rain father, and his glamorous and adventurous sons who manifest themselves as rainbows. The rainbow sons make themselves irresistible by painting themselves with glorious colours, and go far away from their country in pursuit of young women. In many of the stories there is a hint of incest, of forbidden attraction between people. In some versions the women themselves are luring the men on by painting their bodies with Yilpinji designs. Against their father's advice the sons travel great distances from their homes. Eventually they catch up with the women and seduce them. Some of the episodes again

hint at violent capture with the spearing or crippling of the women. In others the women lose control of their ritual bundles, leaving them unguarded in the trees (as the Djang'kawu sisters did).

The main focus of the myth seems to be a battle of aesthetics, which often ends in a harmonious relationship. The brightness of the men's rainbow bodies is both a positive and a negative factor. While it can attract and dazzle the women, overpowering them, it can also overawe them and frighten them into retreat. Likewise, dullness is a weapon that can be used both by the men and by the women. The rainbow men can dull the sheen of their skin by rubbing themselves in an ant bed and the women can control the brightness of the men by throwing balls of slimy green weed at them. The mixture of dullness and brilliance can help to resolve their relationship. It can create an equality, an expression and dampening of desire, which leaves the couple united in love and in mutual support. In the end, however, the rainbow sons suffer for disobeying their father and for leaving their country behind. They are persuaded to return by their mother, who feigns ill health, and on their return they die.

As Bell herself cautions, however, these are myths constructed from a series of ritual episodes that are usually performed separately and never articulated as a whole. The myths clearly resonate strongly across cultures: they deal with universal themes of desire and control, of love and power, the relations between the generations, the heat of lust and the cooling of passion through the development of respect and love. And that is precisely why they are an appropriate source of inspiration for Yilpinji rituals, where different aspects can be teased out and developed according to the outcome desired by the partici-pants. They make moral points about the need to bear in mind correct relationships for affairs of the heart, or the need to control the violence of a spouse; they are also myths of seduction or desire which express feelings about male and female beauty and the relationship between spiritual and earthly powers.

The myth of the old women presents men as fairly unprepossessing individuals. It appears to emphasize the violent nature of male expres-sions of desire and emotion and the role of force in male–female

relations. However, the spearing of the women can be interpreted in other ways too. One theme that Bell draws attention to, which may not be obvious to a Western observer, is the link between women and country and the emotional loss and insecurity that is felt when women have to move away from the land of their birth on marriage. The spearing takes place away from their own country and leaves them as cripples in an unknown land. The crippling can be interpreted as a metaphor of loss of attachment to land, of a severing of connection with one's place of origin. Bell generalizes this theme so that it can apply equally to men and to women: it is a woman's perspective on a universal Katej problem. Men as well as women feel the potential loss of support and emotional attachment through marriage. Thus, while it reads on the surface as a myth of male dominance, it may also be considered a metaphor about loss. In the myth of the rainbow men the message is almost reversed, as the men are lured away from their country by women. In both myths the very attributes that attract others are shown to be potentially dangerous. The shiny ochred bodies of the women attract male lovers who violently remove them from their country and deprive them of their autonomy; the rainbow bodies of the men cause them to be attractive to women, who in turn draw them away from their land and away from the control of their father (137).

It is important to remember, however, that Aboriginal myths are generally not literal or descriptive statements about the world as it is but ways of thinking about a wide variety of general and perhaps universal

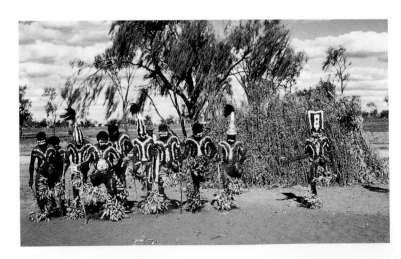

137
Warlpiri public men's dance, Amoonguna Community, Alice Springs, 1971

issues. An understanding of the aesthetic and social values embodied in the myths can be gained from their representation in Yilpinji rituals. In the rituals men and women paint and decorate themselves in the brilliant and colourful designs of the ancestral beings, their white headbands and feathered decorations complemented by the shining ochred bodies and the painted Yilpinji designs. Items such as watch-bands, buckles and brightly coloured headscarves can also be worn by the dancers for similar effect: to make themselves attractive to others and to represent the brilliance of the ancestral beings. The decorations of the dancers arise from an aesthetic in which colours of the landscape are selected, emphasized and reflected upon, just as in the songs of the Djang'kawu sisters in Arnhem Land. And at the height of the ritual the intensity of the action, combined with the brilliance of the dancers evoking the rainbow colours of the ancestral beings and the colours of the desert sands, creates a merging between ancestors, the living and the land that is almost dangerously powerful. Indeed, at the end of the dances the women mask the brilliance of the designs by rubbing them with dirt and removing their feathered decorations, thus quenching the heat of the ritual. Similarly, the green slime balls thrown by the mythi-cal women helped to control the fire of the rainbow men and to return the relations between men and women to more of a state of equilibrium.

The semantics or meaning of works of art plays as important a part in ritual as their aesthetic effect. In many cases it is semantics that explains why a particular painting is chosen or a particular dance is performed. The aesthetic impact of one painting or dance may be very similar to another, while its semantic value may differ significantly, although clearly in many cases a strict separation of the semantic from the aesthetic is impossible. The aesthetic effect of the rainbow dancers of the Katej myth is integral to their meaning.

Aboriginal ritual creates a symbolic world in order to accomplish particular objectives or forge particular identities or relationships. Performance involves selecting elements associated with different ancestral beings and places, and organizing them in sequences to accomplish certain ends. The objective may be to effect a change in the status of a group of youths undergoing circumcision by associating

them with a particular stage of cosmic change, such as the transfer of ritual power from the women to men; it may be to establish a relationship between a powerful individual and another set of people to create a framework for alliances between groups; or it may be to facilitate the journey of the soul from the place of death to its incorporation within the ancestral dimension at a conception site in its clan lands.

A Yolngu mortuary ritual, for example, has a number of complementary themes. The main ones concern the fate of the soul of the dead and the expression of support for the living. Two dimensions of a person's spirit are addressed in mortuary rituals, the *birrimbirr* (soul) and the *mokuy* (ghost). The *birrimbirr* spirit is conceived of as the positive dimension of the dead person connected to the ancestral spirits of the clan, and the objective in mortuary rituals is to return the *birrimbirr* back to the clan lands from which it came. In order to achieve the *birrimbirr* spirit's journey the ritual is structured in the form of a metaphorical journey. The physical route taken by the corpse from the place of death to the grave is used as a framework for acting out the spiritual journey that takes the *birrimbirr* from the place of death back to its spiritual home, where it will be reincorporated in the ancestral dimension. The *mokuy* spirit, on the other hand, is a malevolent ghost which comes back to haunt the living, to spread blame for the death and make demands on the living. Much ritual energy is directed to driving the *mokuy* spirit away to areas of the forest distant from habitation sites where it can linger until memory fades.

An infant died when I was staying at Gurka'wuy on Trial Bay, Eastern Arnhem Land, in the country of the Gumatj and Marrakulu clans. The child's spirit home was in its own Mardarrpa clan country at Gunmurruytjpi some 100 km (60 miles) away. The objective of the ritual was to move the spirit from Gurka'wuy to Gunmurruytjpi. The journey was accomplished by calling on the ancestral beings that created areas of land between the two. Each place is associated with a particular set of ancestral beings and their songs, dances and paintings. These form the 'restored behaviour' of ritual, the symbolic resources upon which people can draw. Participants in the ritual therefore have to select elements from particular places on the journey and organize them in a

sequence to move the 'body' from a to b. A dance will be performed from one place, a series of songs from another, a painting will be made from a third, a ground sculpture from a fourth and so on. Many alternative routes could be taken. In the case of the Mardarrpa child the participants discussed whether to take him along the coast or over the inland route on which they finally settled. People base such decisions on many different factors: to whom the dead person is related, who offers to take part in the ceremony, which groups decide to stay away. A ritual is thus an affirmation of friendship and trust since it involves using one's own spiritual powers and restricted knowledge on behalf of others.

For the Mardarrpa child the journey began with a dance led by Yama Munungiritj (b.*c*.1920) that represented the yellow ochre ancestors

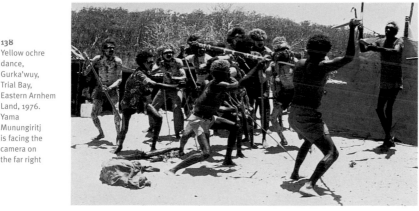

138
Yellow ochre dance, Gurka'wuy, Trial Bay, Eastern Arnhem Land, 1976. Yama Munungiritj is facing the camera on the far right

from Yarrwidi Gumatj country nearby at Gururrnga in Caledon Bay (138). Gururrnga is the site of a big yellow ochre quarry associated with a number of clans of the Yirritja moiety, including the child's own clan, the Mardarrpa. The ancestors were portrayed walking along the beach searching for the yellow ochre deposits. They dragged their digging sticks behind them and held sacred woven-string dilly bags gripped between their teeth. Every so often the dancers stopped to thrust their digging sticks in the ground, representing the ancestors as they levered up bits of ochre. They tested the quality of the ochre by rubbing it under their arms and across their chests before moving on. Eventually they 'found' ochre of the finest quality immediately in front of the shade where the child's body lay; through the enactment of this episode the

ancestors found the child's spirit, which would then begin its journey. The dance allowed the expression of the anger and pain felt at the child's death. The dilly bag gripped tightly in the mouth was not simply for collecting the ochre; it contained the anger and anguish of the bereaved.

Each stage of the funeral was marked by analogous ritual events, each taking the journey one stage further. A key component was provided by the coffin-lid painting. The yellow ochre ancestors could have been represented by a painting such as one by Yama Munungiritj that shows the beach at Gururrnga with footprints of the ochre hunters in the beach (139). The ochre hunters are shown in the centre of the painting. In the bottom panel their footprints can be seen walking up and down the beach as they search for yellow ochre. Their digging sticks lie in the sand between the rows of footprints. The upper panel shows the quarry itself in the cliffs above. The background clan design represents striations in the quarry where lumps of ochre have been removed, and digging sticks are again depicted. However, in this case the painting chosen for the coffin lid belonged to another Yirritja moiety clan and comes from Gaarngarn, a place almost half way on the spirit's journey. The painting represents a place on the Gaarngarn River where the waters flood in the wet season and where a fish trap is set up by blocking off the stream. The painting (140) by Yangarriny Wunungmurra (b.1932) is similar to the one on the coffin lid and represents the fish trap at Gaarngarn: the diamond pattern signifies the raging torrent of the wet-season floodwaters over the site of the fish trap; streamers of weeds extend from the limbs of the freshwater tortoise and mark patterns in its shell. In songs and dances the participants referred to the floodwaters carrying the coffin on its journey downstream and to the great snake who swallowed it and took it on to the coast. This was the snake whose ribs, in turn, were used to make the fish trap in the ancestral past. The final stage of the journey took place at the graveside when dancers acting as crocodiles 'buried' the child in the crocodile's nest, for it was from the crocodile at Gunmurruytjpi that the child's conception spirit had come (141). Each element of the ritual was woven in a complex way into the whole, yet each existed independent of its context to resonate in the minds and memories of those taking part.

139
Yama
Munungiritj,
*Yellow Ochre
of Quarry*,
Ochre on bark;
69.8 × 30.5 cm,
27$\frac{1}{2}$ × 12 in.
Kluge-Ruhe
Aboriginal Art
Collection,
University of
West Virginia

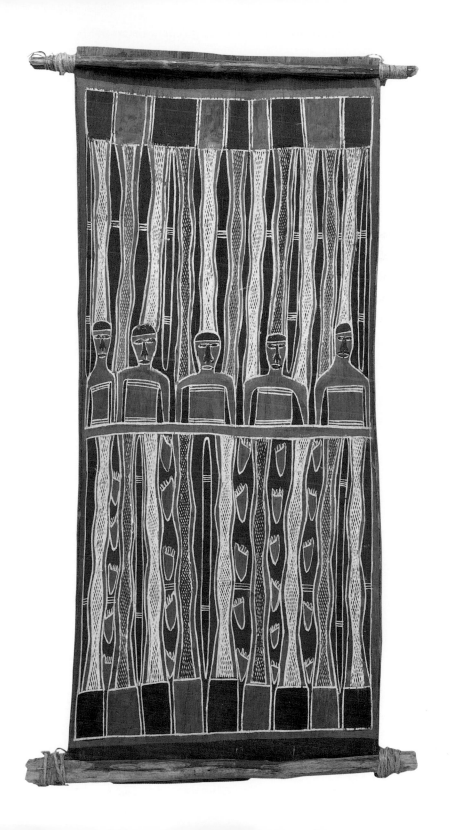

Many rituals involve the construction of a ground sculpture which provides the spatial framework for ritual action. There are many different forms of ground sculpture, linked to social groups, particular ceremonies and places, but together they are a key form of Aboriginal art. Ground sculptures represent and recreate the ceremonial grounds that the ancestral beings themselves made and are the locus of the re-enactment of the events of their lives. As with other art forms, the shape of the ground sculpture sometimes arose through an ancestral event which

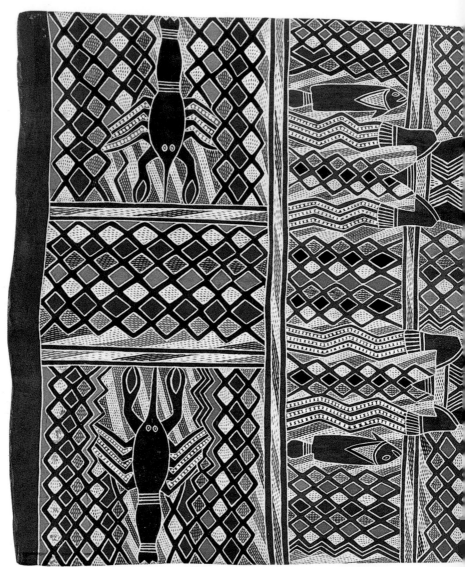

140
Yangarriny
Wunungmurra,
Fish Trap,
1976.
Ochre on bark;
65 × 126 cm,
25⅝ in × 48⅛ in.
Collection
Department of
Archaeology and
Anthropology,
Australian
National
University,
Canberra

resulted in the form being impressed in the ground. The triangular shape of the ceremonial ground used in the Djungguwan ceremony (Chapter 4) was created when a great stringy-bark tree was cut down and left its impression in the ground. In such cases the results of the original act are still visible in the form of the contemporary landscape. The ground sculpture is usually only one manifestation of that form. Often the shape of the outline provides the framework for clan paintings or is a basic component of a clan design. Particular ground sculptures

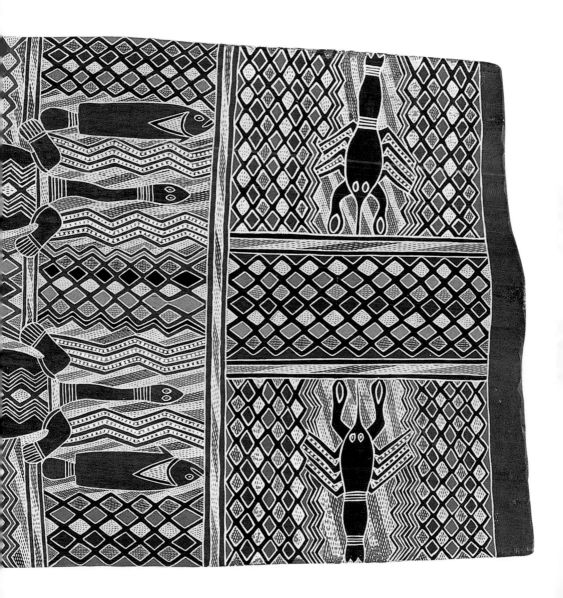

141
Crocodile
dance, Trial
Bay, Eastern
Arnhem Land,
1976

are usually associated with a number of different places along the route of an ancestral being's journey and represent a number of different occasions upon which the same event was repeated – the tree was cut down, the digging sticks were dug into the ground and so on – and each manifestation of the design may belong to a different group. Often the design will show minor variations that enable it to be associated with a particular group or place. The ground sculpture is not so much a representation of a particular place as an icon of ancestral action that has one of its manifestations in that place. But the ceremonies in which the icon is made, the conceptual track along which the ancestor journeyed, and even the group of people connected to it, are equally its representations, since ancestral thought and law underlies each of them.

Let us now explore the meaning of one ground sculpture in the context of ritual, focusing in particular on the ways in which such a form both creates the framework for ritual and acquires meaning through its use in ritual performance. This ground sculpture was made for a rag ceremony in Eastern Arnhem Land held in conjunction with a house opening some six months after the death there of Narritjin Maymuru's eldest son. The aim of the ceremony was to clear the house of the pollution associated with the death and return the site to everyday use. The rag ceremony is structurally analogous to the secondary and tertiary stages of burial, when the bones were exhumed six months after death, cleaned of flesh and then carried around by close relatives in a bark container for several years before burial in a hollow-log coffin. These two stages ceased to be widely practised after the establishment of mission stations in the area.

Today the rag ceremony provides the context for destroying and burying some of the dead person's possessions, for re-enacting some of the themes of the primary burial ceremony and for establishing a state of normality after the death. It marks the end of intense mourning and it is the time when people are freed from the taboos and prohibitions associated with death. In this particular case the ceremony was also a house opening. The house outside which it was held had been closed since Mandjilnga had died; now was the time to restore it to occupancy. The main structure of the ceremony showed similarities to the funeral at Gurka'wuy described above. The main themes of the ceremony were to drive away the last manifestations of the *mokuy*, or ghost, that may still have been in the neighbourhood, and to restate symbolically the journey of the *birrimbirr* soul back to the clan lands, which in this case were at Djarrakpi, some 160 km (100 miles) to the south. The ground sculpture (142) played a pivotal role in both these events. It represents another Yarrwidi Gumatj place, Gulungurra on the sea at Port Bradshaw.

The Yarrwidi Gumatj were the mother's mother's (*maari*) clan to the dead man. The sculpture marks a stage on the journey of the dead man's *birrimbirr*. The movement of the *birrimbirr* is a collaborative venture requiring the co-operation of members of a number of clans of the same moiety as the dead man. The sculpture is associated with the ancestors of the Macassans, the people from south Sulawesi in Indonesia who, until the early twentieth century, visited the coast of Arnhem Land each year. It represents an ancestral house on stilts, consisting of just two rooms, a kitchen and a bathroom, which collapsed following a great storm. The house was of gigantic proportions and

142
Ground sculpture, representing an ancestral house at Gulungurra, Port Bradshaw, made for a ceremony at Yirrkala, Eastern Arnhem Land, 1976

where it fell onto the ground it formed features of the landscape. The stilts (represented by the parallel lines) were transformed into lines of mangrove trees and the rooms became two connected shallow lagoons behind the mangroves.

After the sculpture was constructed a series of dances was performed, which continued into the following day, representing events in the life of the Macassans. One represented a Macassan drunk on arak (143); another Macassans hunting flying foxes with a rifle (144). A hole was dug in the kitchen to represent the hearth (145). At this stage the hole was called *Milnguya* (Milky Way), which symbolizes the afterlife. The Milky Way is one of the homes for spirits of the dead, which are said to ascend to the Milky Way up a rope of possum-fur string from a sacred well in Mangalili country. After the hole had been dug there followed a dance in which the door of the actual house was opened by a Macassan sword, or *kriss*. In the night a guwak (koel cuckoo) ceremony was performed: Narritjin climbed into the tree above the ground sculpture and summoned people with the cry of the guwak. A great length of possum-fur string, the *burrkun*, was uncoiled and strung through each room of the actual house, then out through the door to be tied to a tree above the ground sculpture. The string was then attached to a spear which was fixed into the side of the 'hearth' (146).

The following day relatives were able to enter the house accompanied by singing and the crying of sacred names (147). The dead man's possessions were removed and placed in the 'bathroom'. Any belongings that were intimately linked to the dead person, such as eating utensils, items of clothing, his mattress and his gun butt were broken up and placed in the 'hearth' (148). Other things were smoked by beating them with smouldering ironwood branches and returned to use. When the material had been sorted into these two categories, the objects left in the 'hearth' were set on fire and the front of the house became engulfed in a cloud of thick black smoke (149). The following day the ground sculpture was raked flat and the remains of the fire were buried beneath the surface.

Finally, dances were performed that referred to the departure of the Macassan fleet. First came the mast dance, during which a painted pole

The House Opening, 1976

143–145
Top row l to r:

Dance representing drunken Macassan;

Dance representing Macassans hunting flying foxes;

Hole representing the 'hearth'

146–148
Middle row l to r:

Possum fur string attached to spear in the 'hearth';

Relatives enter the house;

Possessions being planted in the 'hearth'

149–151
Bottom row l to r:

The fire;

The mast dance;

The farewell

surmounted by a flag representing the Macassan site of Multara, an island in Caledon Bay further to the south, was erected at the head of where the ground sculpture had been (150). The mast became the focus of the final dance of the ceremony in which dancers crouched, representing Macassan sailors on the prow of the ship looking out to the horizon, in a farewell gesture to their dead relative, the flag fluttering above their heads (151).

The Macassans were not the only group referred to in the iconography of the ceremony. The names that were cried out while the dead man's possessions were being broken up before being thrown into the 'hearth' had dual reference. At one level they evoked the sounds and events associated with the manufacture of iron by the Macassans – the heating of metal in the fire, hot metal and hammering the metal; at another level they had analogues in the Western world with which the Yolngu people were becoming increasingly familiar. The power names referred not only to the forging of iron but also to the bulldozers moving into action at the neighbouring mine site – the puff of smoke from the exhaust when the engine is cold early in the morning, the sparks that fly when the blade hits hard rocks, and so on. Thus the mythology updates itself to take account of contemporary experiences.

The ritual's main themes can be described briefly. The *mokuy* spirit is subject to violent action, the drunken Macassans fight it, the flying fox hunters shoot at it, and the flames and the noise drive it away into the forest. The *birrimbirr* soul, on the other hand, is led more gently on its journey. The length of possum-fur string, the *burrkun*, that touches the places where the man has sat during his life marks the soul's journey, the ancestral house embraces his body, and the grieving relatives bid his soul farewell. Many images can be interpreted in more than one way. For example, the great fire that consumed the dead man's possessions both drives away the *mokuy* spirit and provides a moving image of the fate of the *birrimbirr* soul. The column of smoke billows upwards to the sky where it combines with the early wet-season clouds. These drift across the sky and come down in the form of rain which filters into the ground to return to the surface in due course as spring water, just as the soul of the dead goes back to the clan lands before

returning as a spiritual resource for new generations. And the *burrkun*, as well as representing the journey of the *birrimbirr* overland, also alludes to the spirit rope connecting the earth with the Milky Way.

The ground sculpture was an integral part of the ceremonial action. Its full significance can only be uncovered by linking it to the variety of themes that are imminent in the performance as a whole, including kinship and inter-clan relations; here we can only outline its spatio-temporal connections and transformations.

The sculpture transforms the area outside the dead man's house into the ancestral landscape of Port Bradshaw. But it presents it in a dynamic form linked to contemporary relations of clanship and connected in mythological space to other places and times. The sculpture provides both a spatial referent for the journey of the soul and a spatial framework for dividing up and sorting out the possessions of the dead. This in turn provides a means of separating different dimensions of the spirit of the dead which have different spatial and temporal destinies. The *mokuy* spirit is driven away so that it can disappear from people's memories. The *birrimbirr* soul is returned to the landscape to become incorporated in precisely the same kind of body of ancestral 'law' that the ground sculpture itself represents. The grounding in the sculpture of the memories that the living hold of the dead person involves the sedimenting of contemporary meaning, redolent with the emotions of loss, onto an ancestral icon. At the end of the ceremony the ground sculpture in effect becomes a representation of a second Macassan place on the spirit's journey, this time an island off Caledon Bay. The ship whose image is invoked in the mast dance is a symbol of farewell as well as the means by which the soul is transported on the next stage of its journey. As we have seen, place is the means by which people are moved across the landscape.

In temporal terms the ground sculpture allows a collapsing of time. Temporally separate events become juxtaposed through their location in the same forms. Thus the ground sculpture provides an ethnographic account of the lives of the Macassan visitors projected back into the ancestral past. The account is updated by being integrated into this particular ritual performance, which links it to a conception of 'house'

that seems more Western than Macassan. The Macassan house has a kitchen (where the possessions are burnt) and a bathroom (where the possessions are 'cleaned') just as the settlement houses have. And later on we see an analogy drawn between the forging of iron and the work of the builders in the mining town. The soul of the dead person is reincorporated within the ancestral past, but through a symbolic process that includes journeying through the recent history of the region.

Ritual provides the main context for learning about the meaning of art, and shows that the construction of meaning is an active process. Some instruction is given to people when they are seated at the men's ceremonial ground, or when they are making paintings for commercial purposes or being shown how to do a painting by a relative. However, the main context for learning is through participation in ceremony, where people learn how to perform songs and dances and how to do paintings. People observe who produces which paintings and the context in which they are used; they learn to do the yellow ochre dance when it is being performed for a particular purpose, and they see how a ground sculpture is used in a particular way. Meaning is built up over time, and what is learnt in one context about an object can quickly be applied to other contexts and objects. It is possible to learn about paintings as maps by walking around the landscape; it is equally possible to learn of the significance of particular features of a painting or a landform by seeing them danced out, sung about or enacted in some other way. Aboriginal art is learned behaviour that comes alive and gains a purpose in the context of the present. And in this way ancestral experience is incorporated in present experience while simultaneously underpinning it.

Engaging the Other Art and the Survival of Aboriginal Society

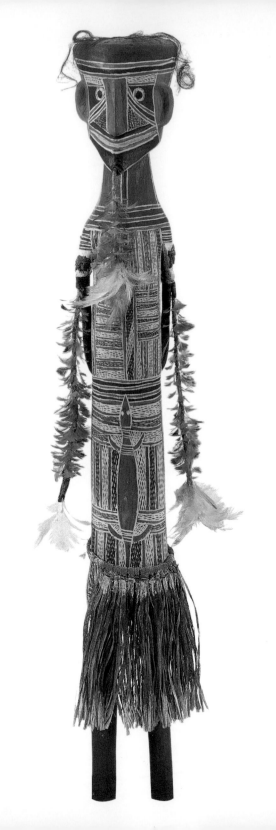

Within Aboriginal society the value and meaning of art changes with each generation: it becomes associated with new people who experience it in different ways and make it part of the world in which they live. Designs that previously belonged to one group can be taken over by another on its extinction, or they can be passed on from one group to another as evidence of newly formed relationships. As always, the ancestral powers are believed to lie behind the changes and to sanction them. The main focus of this chapter is the way in which art has been used by the people of Eastern Arnhem Land to promote the value of their culture and way of life to Europeans. However, it is necessary to begin by looking more generally at the ways in which Arnhem Land art has played a part in the relationships established with outsiders.

The Macassan mythology of the Yolngu people of Eastern and Central Arnhem Land shows just how readily Aboriginal society responded to outside influences and incorporated change without destroying the existing order. The Macassan mythology was one of the means by which Aboriginal people came to terms with the Macassans, and examining the era of Macassan contact, 1600–1900, provides insights into the ways in which Aboriginal people were able to establish relationships with outsiders. These encounters show how Aboriginal Australians might have accommodated Europeans in the long term if Europeans had been interested in developing a relationship with the indigenous population rather than appropriating their land.

The Macassans are enshrined in the oral history of Arnhem Land and their annual visits, generally friendly though potentially violent, are remembered as a time of excitement and adventure. Paintings show the interior construction of Macassan praus, the ranking of the men aboard ship, the techniques for preparing sea cucumbers (trepang) and details of Macassan technology and agriculture. A Warndiliyaka rock painting from Groote Eylandt (153), for example, shows a Macassan prau in full

152
Mawalan
Marika,
Figure of an
ancestral being
of the Dhuwa
moiety,
1960.
Wood, hair,
bark fibre and
feathers;
h.74.3 cm,
29¼ in.
Art Gallery of
New South
Wales, Sydney

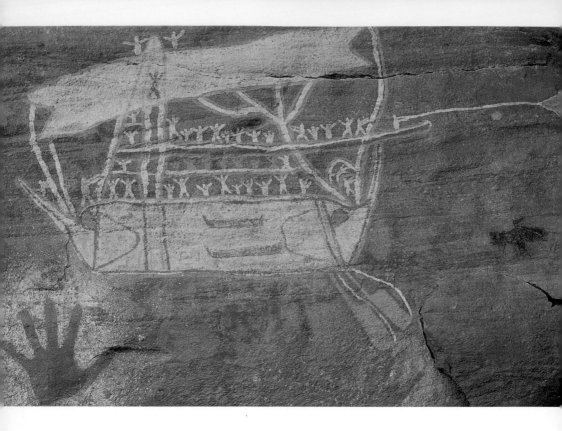

sail, with the crew linined up along the deck, the platform above and in the rigging. Two dugout canoes can be seen in the hull and a large porpoise appears to have been harpooned from the stern.

Over the years coastal Aboriginal groups established long-term relations with particular Macassan traders who continued to return to the same places to exchange goods with the local population. Some Aboriginal people joined the crews of Macassan ships and visited Indonesia, spending several months or even years there. The technology of Arnhem Land was also influenced by these visits: the dugout canoe, metal axes and spearheads were introduced, as well as other trade goods. The painting (154) by the Galpu artist Mithinari Gurruwiwi (1929–76) shows a dugout canoe and Yolngu receiving metal axes from Macassan spirit people. The interaction between the two populations was quite close and may have involved a degree of participation in each other's ritual affairs. The large number of Macassan words in Arnhem Land languages suggests close contact, as does the widespread

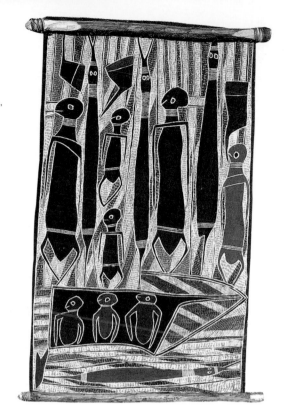

153
Macassan prau,
c.1700–1800.
Ayuwawa,
Groote Eylandt

**154
Mithinari
Gurruwiwi,**
Steel Axes,
1976.
Natural
pigments
on bark;
100 × 46 cm,
39⅝ × 18⅛ in.
Australian
Institute of
Aboriginal and
Torres Strait
Islander
Studies,
Canberra

occurrence of Indonesian names in Aboriginal naming systems for
people and places. Some Aboriginal groups also include people
descended from the Indonesian visitors.

The Macassans were eventually incorporated within the Aboriginal
universe as insiders rather than outsiders. Just as the natural world,
the seasonal cycle, the rules of social life and the very form of the land-
scape itself were incorporated in the Aboriginal cosmos through being
part of the Dreamtime, so too were the Macassans. Aboriginal art
provides a means of understanding and controlling the world through
reproducing it in the form of representations which have a place in
Aboriginal society. Thus different elements of Macassan life and the
different places associated with them are owned by specific clans who
have the responsibility to look after them. In this way the Macassans
are taken out of their own world and reordered and 'controlled' as part
of an Aboriginal world. Aboriginal people decide who will have a partic-
ular Macassan-derived name, who will have the right to produce a

painting of a Macassan ship and whether or not to use a Macassan ground sculpture in a ceremony.

In their visits to the coast of northern Australia at the end of the nineteenth century the Macassans existed for the Aboriginal people in two distinct ways. They were visitors who came each year, who traded and worked, drank, fought and loved; who established relationships with particular Aboriginal groups and were incorporated in a network of relationships and obligations. At the same time the Macassans had a pre-existence as part of the Dreamtime, as something that always had been, that belonged to the people of Eastern Arnhem Land. Incorporation of the Macassans into the Dreamtime creation, far from signalling a conservative ideology that took no account of change, was a means of adjusting to changing circumstances while at the same time ensuring that new information about the world was incorporated within traditional frameworks of knowledge. Change was accommodated in such a way that it did not disrupt the core relationship between people and land. The Macassans became part of an Aboriginal history of place rather than imposing their own history and identity on Arnhem Land.

Let us first examine how Aboriginal people incorporated the Macassans into their system of relationships with place. While the Macassans were in Arnhem Land they were affiliated to moieties and clans and given a place in the kinship system. That is what happens to anybody who establishes long-term relationships with Aboriginal people. The outsiders quickly find that they have a set of relatives – brothers, sisters and cousins – and that relatedness entails obligations and privileges: there are categories of people who expect to receive gifts, places where the incorporated person can feel at home, ceremonies to which they will be invited, times when they will have to mourn. Although not all outsiders take these obligations equally seriously, Aboriginal people continue to apply them today, persistently referring to a person by their clan or moiety even if that person has no desire to belong to it. The Macassans would have been included in precisely such a network of etiquette and obligation which would have been one of the requirements of peacefully visiting the land each year. In order to trade Macassans were expected to learn the law of the land and to respect

155
Johnny
BulunBulun,
*Marrukundja
Manikay Cycle*,
1993–4.
Ochres on
canvas;
116 × 226 cm,
45 5/8 × 89 in.
The Holmes
à Court
Collection,
Heytesbury,
Western
Australia

it. How appropriate that the Macassans would discover that they were part of the law they had to learn. Some stories about the Macassans, for example, include accounts of occasions when they failed to follow the rules of the game and interrupted ceremonial performances, or took favours without permission, and it was on occasions such as these that the generally friendly relationship was disrupted by outbreaks of hostility and violence.

Although the last visit by the Macassan fleet took place in 1906, memory of the Macassans has been kept alive through ritual (see Chapter 6). In 1992–3 the Ganalpuyngu artist Johnny BulunBulun (b.1946) of the Yirritja moiety produced a magnificent set of canvases exploring the Macassan mythology. In the painting illustrated (155) images representing the life and ritual of the Ganalpuyngu of Central Arnhem Land can be seen, as well as themes associated with the Macassan voyages. On the right, geese, fish and long-necked fresh-water tortoises represent the abundance of wildlife in the inland swamps and waterholes. To the left are material objects from the Macassans – knives, guns, pots, lengths of rope and people climbing in the mast and rigging of the prau. The painting combines figurative with geometric forms, the geometric forms often bringing elements of both cultures together in a single form. The triangular pattern is a clan design of the Yirritja moiety, but here it also represents the clouds and

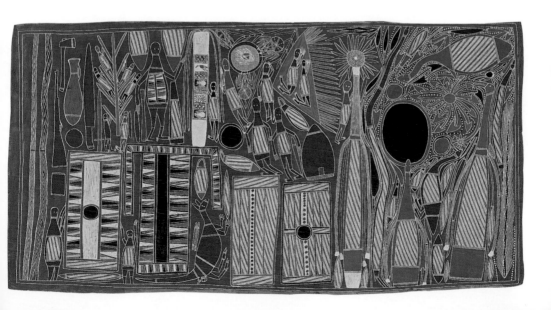

wind of the wet season that filled the sails of the Macassan ships and brought them to the Arnhem Land shores. The painting, with its attention to detail, colour balance and exquisite vibrating cross-hatching, is characteristic of BulunBulun's style.

The case of the Macassans shows how outsiders can become insiders through incorporation within mythology: by becoming part of the Dreamtime. However, outsiders can become insiders in a more direct way by entering into all kinds of relationships of exchange. Aboriginal society is in many ways outward looking; its members are keen to enter into relations with other people, to expand the universe of political relations, so long as the outsiders recognize existing rights and accept the conditions of exchange. The motivation comes partly from the Aboriginal belief that there are things of great value at the core of their way of life, represented by the sacred objects that are associated with places and people.

156–157
Goyulan
(Morning Star)
Rom pole, 1995.
Wood,
vegetable fibre
string, human
hair, feathers
and ochres;
h.c.274 cm,
108 in.
Australian
Institute of
Aboriginal and
Torres Strait
Islander
Studies,
Canberra

In Arnhem Land certain ceremonies, such as the Rom or Maradjirri, exist primarily to establish connections between people, both known and unknown. These ceremonies, which the anthropologist Les Hiatt called 'rituals of diplomacy', can be the occasion of trade, or used to cement alliances, commemorate dead relatives or celebrate the coming of age of members of the society. They nearly always involve the participation of people from a number of different groups who are joined together by their sharing of the same ceremony. On occasion, relationships can be extended further by passing the ceremonies to neighbouring or even distant groups. Similar ceremonies exist in the central desert regions; almost certainly they once occurred throughout the whole of Australia.

One of the major ceremonies of this kind is the Morning Star (*barnumbirr*), in which the focal point of the event is the making of beautifully painted and decorated poles (156, 157). This emblem has lengths of string attached to it in a form reminiscent of the European maypole, representing the strings that are said to be used by the spiritual beings who pull the star into the dawning sky from its home in Buralku, over the horizon to the east. The Morning Star is associated with mortuary rituals and ceremonial exchange. Most clans of the Dhuwa moiety have their own version of the ceremony and details of

the myth vary, but there are a number of themes in common. The paint-ing (see 47) by Mutitjpuy Mununggurr (1932–93) belongs to the Djapu clan and represents its Morning Star pole. During the day the star is kept in a woven dilly bag (shown at the bottom of the pole) and each night it is let out from the bag. The star is held by a piece of string which slowly releases it into the sky but never allows it to escape. At dawn the string is pulled in and the star returns to the bag.

The Morning Star moves from place to place on its journey, pausing to hover over a pandanus tree in each clan's country. Each of the clan's places is associated with ancestral spirits belonging to the Morning Star who performed dances and made the original commemorative emblems. The strings of the emblem also represent the groups that are joined together in the alliance by the journey of the star.

158
Jack Wunuwun,
*Barnumbirr, the
Morning Star*,
1987.
Natural
pigments
on bark;
178×125 cm,
70×49¼ in.
National Gallery
of Australia,
Canberra

Buralku, the land of the Morning Star, is the main Dhuwa moiety land of the dead. One dimension of the *birrimbirr* spirits of the dead go there (the other returns to sacred places in the country of the dead man). The songs that accompany the ceremony are redolent with images of the afterworld, which is pictured as a land of great beauty and joy, full of butterflies and flowers and plentiful supplies of honey. The mythol-ogy is associated with the seasonal cycle and with images of growth and regeneration, appropriate themes for mortuary ceremonies.

The magnificent painting (158) by Jack Wunuwun (b.1930) emphasizes these themes. In the centre two Morning Star poles are shown with dancing spirits pulling on their strings, performing the ceremonial dances. The panel on the viewer's right illustrates yams growing in the forest at the end of the wet season. The cross-hatched tubers represent new growth and the spotted ones old and withered yams. The climbing vines of the yams are analogous to the strings that pull the Morning Star, and the yams themselves, like the souls of the dead and the Morning Star itself, are collected in dilly bags. The basketry fish-trap in the panel on the viewer's left likewise alludes to the Morning Star and the souls of the dead. The fish-trap is set up as the wet-season floodwaters begin to subside. Fish in their abundance are seen as symbols of fertility and regeneration. The journey of the human soul after death is seen as analogous to the journey of the fish down the

flooded river and the fish-trap represents the kind of hazard it is likely to meet on the way.

Mortuary rituals throughout Australia form the context for exchange ceremonies which both celebrate the passing of the dead into the ancestral domain and at the same time renew or extend relationships among the living. The Morning Star ceremony is well adapted to this purpose. The journey of the star connects sets of clans together and focuses on their unity as members of the same moiety. The lengths of string that extend from it represent the journey of the Morning Star to each clan's territory and the feathered tassel at the end stands for each Morning Star place in turn. The fact that the strings are all joined together and bound into a central string that is wound around the pole emphasizes the clan's unity and interconnection. The Morning Star itself is likened to the dilly bag, collecting within it a set of related clans. The Morning Star ceremony affirms the existing alliance between two clans after the potential disruption caused by a death. The ceremony can even be used to extend the network outwards. Groups who have been given a Morning Star emblem in previous years can perform the ceremony for a group that has not previously had the rights to produce it.

Like others of its kind, the Morning Star ceremony is also associated with trade and exchange. One reason for establishing connections and alliances is to create opportunities for trade and smooth the passage of trade goods. People coming to a ceremony will bring with them as a matter of courtesy food and raw materials, such as feather string and ochres, that will be needed by those taking part. However, ceremonies also provide the context for trade in goods from regional centres. In the past, stone axes or spearheads from the great quarry of Ngilipidji would have been brought and traded for ochres, string, spearshafts and imported goods such as cloth, blankets, tobacco or iron brought by people from other areas. A painting (159) by Djardi Ashley (b.1950) of the Ganalpuyngu clan of Central Arnhem Land illustrates stone spears from the quarry at Ngilipidji (see 41). The dense scattering of triangular points represents the stone spears traded in bundles across Arnhem Land and associated with the mythology of the Wagilak sisters. The

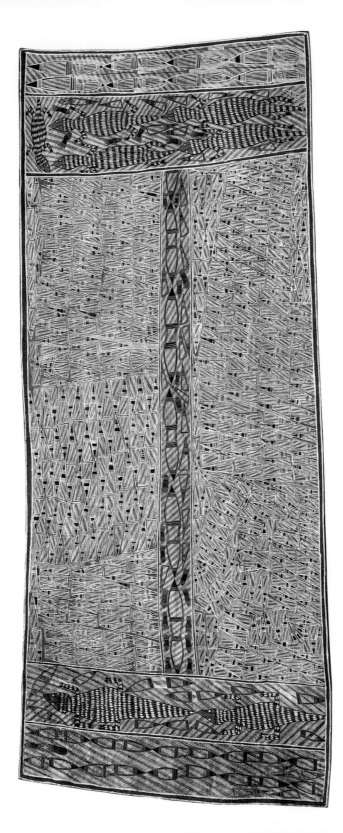

59
jardi Ashley,
*gambi Stone
pears*,
990.
chre on bark;
27 × 100 cm,
9¹₂ × 39¹₂ in.
luge-Ruhe
boriginal Art
ollection,
niversity of
irginia

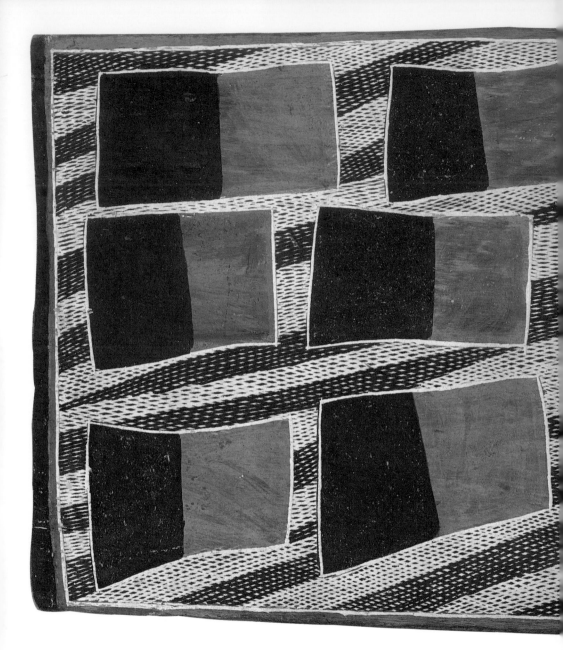

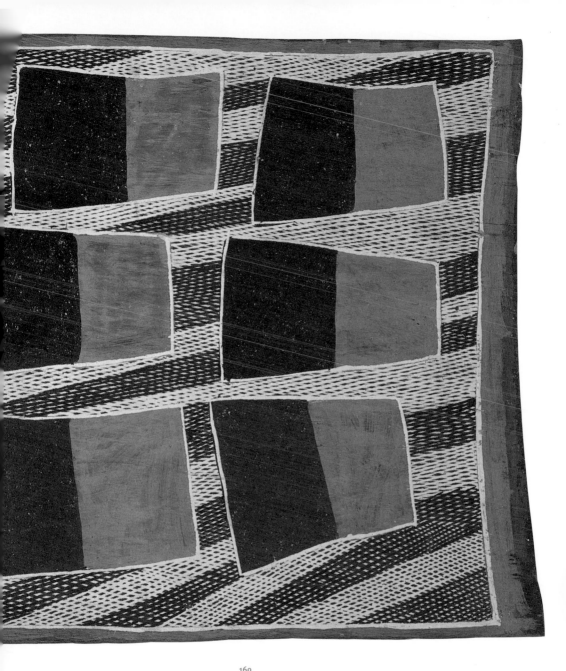

160
Mithinari
Gurruwiwi,
Stone Axes,
before 1993.
Ochre on bark;
40·6 × 78·7 cm,
16 × 31 in.
Kluge-Ruhe
Aboriginal Art
Collection,
University of
Virginia

sisters came from the region of the quarry in the south and are linked with both the invention of stone spears and their ceremonial exchange. Mithinari Gurruwiwi's painting (160) shows stone axes associated with a mythical being who lived on the beach at Caledon Bay. The painting is characteristic of Mithinari's work in that it develops themes from Galpu clan mythology but expresses them in an individualistic way with great fluency and boldness of design. His works exemplify certain features of Eastern Arnhem Land art that resonated strongly with modernist aesthetics – the boldness of the geometric shapes, the balance and vibrancy of the colours.

So far this chapter has considered ways in which the Yolngu people of Eastern and Central Arnhem Land had, over centuries, established working relationships with both Aboriginal and non-Aboriginal out-siders, incorporating them within their local symbolic universe and simultaneously engaging in trade with them. It is likely that from their first contact with Europeans, Aborigines throughout Australia similarly tried to engage the Europeans' interest, develop their understanding, exchange values with them and ensure respect for each others' rights. For much of white Australia's history, however, the invaders were in too much of a hurry, had no interest in anything Aboriginal people might have had to offer, decimated Aboriginal populations and appropriated their land and resources. Unlike the Macassans or neighbouring Aboriginal groups, most Europeans showed little interest in developing long-term relationships with Aboriginal people.

161
William Westall, Body of an Aborigine shot on Morgan's Island, Blue Mud Bay, 1802. Pencil and watercolour on paper. Royal Commonwealth Society Collection, Cambridge University Library

Eastern Arnhem Land provides a lesson in what might have happened across Australia if the circumstances of colonization had been different. Here European colonization was a long-drawn-out process. There was time for people to learn, for exchanges to develop and for persuasion to have its effect. The final imposition of European rule also occurred at a time when conquest by force was less acceptable, when the possibility and will to control the spread of disease was greater, when voices in defence of Aboriginal society began to compete with those who failed even to see the presence of fellow human beings.

The initial encounters with Europeans in the area were no less violent than elsewhere. In 1802 an Aboriginal person from Eastern Arnhem

Land was shot and killed on Morgan's Island in Blue Mud Bay. He was shot by a member of the navigator Matthew Flinders's crew, though against Flinders's instructions, in reprisal for the spearing of one of the ship's officers, Mr Whitewood. The Aboriginal party had set out for Morgan's Island from neighbouring Woodah Island. (Following the encounter a seaman called Morgan died of sunstroke, hence the name of the island.) The next day the body of the Aborigine was washed up on the beach and William Westall (1781–1850), the ship's artist, took the opportunity to sketch it for 'anatomical' purposes (161). Flinders was surprised by the attack on his crew: 'I can account for this unusual conduct only by supposing that they might have had differences with, and entertained no respectful opinion of, the Asiatic visitors of whom we found so many traces.'

Although other unrecorded, violent encounters may have occurred over the next hundred years, Eastern Arnhem Land remained beyond the frontier. The most serious massacre of post-contact times took place around 1910. A punitive expedition was sent by the police to find the 'missing' geologist Major Stuart Love, which resulted in the deaths of many Yolngu at Trial Bay and other places further inland. (Love eventually returned unharmed.) It was not until the 1930s that colonial rule was finally imposed, and again Woodah Island played a part. Mounted Constable McColl, a member of a police patrol, was speared to death at Woodah Island in 1932. The following year the crew of a Japanese pearling lugger were killed on Caledon Bay, and the Australian

government made plans to intervene. Although they had originally intended to send a police expeditionary force, sympathies in the southern states had now shifted more towards the indigenous population. Instead the government sent an anthropologist, Donald Thomson, to enquire into the situation; it also supported the Methodist Church in establishing a mission station at Yirrkala.

While Donald Thomson based himself at Caledon Bay, in 1935 the Reverend Wilbur Chaseling established the missionary settlement of Yirrkala further to the north. Both Thomson and Chaseling encouraged Eastern Arnhem Landers to produce paintings for them. Within a short time of his arrival Chaseling was collecting and shipping bark paintings, hollow-log coffins and other artefacts to museums in the southern states. As part of his research, Thomson also made huge collections,

162
Wonggu Mununggurr, Wet-season painting, collected 1942. Natural pigments on bark; 188 × 110 cm, 74 × 43³⁄₈ in. Donald Thomson Collection, University of Melbourne, on loan to the Museum of Victoria, Melbourne

which largely remained hidden in his rooms at Melbourne University until after his death in 1970. One painting (162) collected by him is a precursor of the large barks representing clan mythology that were produced at intervals from the late 1950s. The painting was made by Wonggu Mununggurr (*c.*1880–1959), the leader of the Djapu clan, assisted by several of his sons, who had played a role in killing the Japanese in 1933. It was Wonggu who had eventually decided to estab-lish peaceful relations with the encroaching Europeans, and when the painting was done in 1942 his sons were part of a special reconnais-sance unit, headed by Thomson, set up as a coastal patrol to monitor Japanese military operations. The painting represents land associated with Djapu clan country inland from Caledon Bay and illustrates a number of totemic animals and plants that provide the themes of the wet-season song cycles. The background pattern of squares represents the wet-season cloudscape with the rays of the sun penetrating them: 'the scintillating light of the sun at sunset'. The human figures repre-sent Djambawul the thunder man who creates lightning by throwing his spear across the skies, which can be seen in the form of shooting stars.

Chaseling's primary motivation was to earn money to provide tobacco and other supplies that would encourage Yolngu to move to the settle-ment. He was carrying out a policy that had been developed earlier at Milingimbi in Central Arnhem Land by the Reverend T T Webb. This policy had the dual purpose of ensuring self-sufficiency and instilling a Protestant work ethic through the introduction of agriculture and by encouraging craft production. However, both Chaseling and Webb also admired the artefacts that the Yolngu produced, and saw their sale to museums as a way of demonstrating the skills of Aboriginal people and, in Chaseling's case, of gaining support from congregations in the south.

Yolngu too painted mainly for economic return. Munggurrawuy Yunupingu, who was one of the first artists to paint for Chaseling, referred to the works he produced as 'anyhow' paintings. He told me that Chaseling asked them to paint 'anyhow', and that was what they did since it was only for tobacco. This may explain some of the differ-ences between the paintings collected by Chaseling and those collected at the same time by Thomson. Chaseling's paintings include themes of

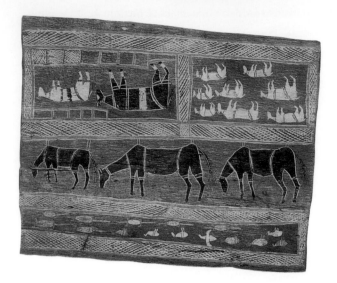

163
Horses in
the mission
stockyard,
collected 1938.
Ochres on bark;
55 × 70 cm,
21³⁄₄ × 27¹⁄₂ in.
Australian
Museum,
Sydney

settlement life, horses in the mission stockyard (163), and images of
aeroplanes and mission boats. Many paintings consisted of groups of
animals or fish and were referred to as 'hunting stories', and relatively
few of them included the clan designs that are characteristic of
Aboriginal religious art. These paintings also tended to be of roughly
the same size, produced on sheets of bark measuring 90–120 x 60 cm
(3–4 x 2 ft). Thomson, on the other hand, collected few 'hunting stories'
but many complex clan-owned paintings. Some artists produced works
for both collectors, and from the beginning Yolngu motivations in
selling paintings included both economic return and furtherance of
cultural understanding.

The connection between art, advocacy and cultural understanding that
was established by these initial transactions developed over the years
and influenced both the form of Yolngu bark paintings and the contexts
of their use. From 1935 onwards a market for Yolngu art developed.
Museums and anthropologists were the most prominent collectors but
many paintings were sold to mission staff and, during World War II, to
members of the armed forces based at the flying-boat station on Gove
Peninsula. In the late 1940s two sets of anthropologists made major
collections of Arnhem Land art. Between 1944 and 1947 Ronald and
Catherine Berndt lived in Western and Eastern Arnhem Land communi-
ties and made the significant documented collections that are now in

the Anthropology Museum of the University of Western Australia. In 1948 the National Geographic Society and the Australian government sponsored the American–Australian Scientific Expedition to Arnhem Land, which made collections from Groote Eylandt, Yirrkala and Oenpelli. The works ended up being divided between the major state art galleries in Australia and the Smithsonian in Washington, DC.

The effect of such collecting was twofold: it began to spread knowledge of Arnhem Land art in the southern states of Australia and beyond, and it resulted in a dialogue between Yolngu and Europeans in which art was used as a means of asserting and exchanging value. Because art was so central to the religious and political life of Aborigines it was an excellent medium for education. Moreover, the Yolngu quickly realized that art was something valued by European society, even if the basis upon which Europeans valued art differed from its value to Aboriginal society. Although it was remote from the rest of Australia, a few people from Arnhem Land began to visit the southern states. Narritjin Maymuru, for example, was greatly impressed by the Art Gallery of New South Wales which he visited c.1960 when he was touring the southern capitals as a member of a dance group. He saw the respect in which paintings were held by Europeans and determined that his own paintings should be similarly treated.

164
Elcho Island
Memorial,
photographed
by Ronald
Berndt, 1958

Until the 1960s, however, the main place of interaction remained the mission stations of the Arnhem Land coast – Milingimbi, Galiwin'ku (Elcho Island) and Yirrkala. The most significant event was the creation of what came to be known as the Elcho Island Memorial. In 1957, after several months of preparation, a set of carved and painted sacred objects, together with some bark paintings, were erected in a public place beside the church (164). The impact of this memorial is hard to imagine today. Many of the objects displayed had previously been restricted to the secrecy of the men's ceremonial ground. In Yolngu practice and belief only one or two of these objects at a time would have been revealed in the context of clan-based ceremonial performances, and they would never have been seen by women and uninitiated men, on pain of death. And yet here they were, all displayed for public gaze. In other places and at other times this might have been a sign of the effectiveness of the mission, of the overthrow of traditional authority, in which the chimera of secrecy was shattered by exposing the objects to public gaze. But this was neither the intention of Burramura and Badanga, the leaders of the movement whose members created the memorial, nor the effect. The movement had both internal and external objectives. One aim was to modify the form of society by bringing all of the clans together, and to create unity by displaying all of the sacred objects together in public. It was argued by some that the separation of the clans, centred on and symbolized by the sacred objects that they held, made it difficult to create a united front for negotiating with Europeans. Another concern was the strain that the mission context imposed on the traditional system of marriage. Paintings and sacred objects are seen to sanction marriage alliances and their public display was thought by some to create the possibility of a more flexible and less gerontocratic system. The lifting of the veil of secrecy may also have been a recognition of the increasingly important role of women in public affairs.

The memorial was at least as much directed towards European Australians as an internal audience. It was accompanied by a manifesto aimed at the government and the missionaries. The intention was to set up an exchange relation with Europeans: by showing Europeans their most sacred and valuable possessions they hoped to get in return better

education, employment, control over access to their lands and more influence in their own affairs. The memorial was both a bid for autonomy and, in the anthropologist Ken Maddock's insightful phrase, a 'remodelling of society'. Some remodelling was an inevitable consequence of colonialism. Aboriginal people had no option but to get their rights recognized in the wider institutional context of the Australian state, to adjust their way of life to living in larger communities and to develop an economy that was adapted to the new circumstances. But if they were to do so in their own terms, the value of their way of life and cultural traditions had to be recognized and the solutions to problems had to be developed from within rather than imposed from outside.

The memorial was able to have such an impact on White Australian attitudes mainly because Yolngu and missionaries had long been part of a spiritual discourse in which both sides were prepared to listen. Both missionaries and anthropologists had been interested in Aboriginal culture and the spiritual side of their life. The Methodist Overseas Mission in Arnhem Land had from the start taken a positive attitude to Aboriginal culture, not simply by encouraging the production of bark paintings for sale, but also by allowing traditional practices to continue, and in some cases encouraging them to develop where they did not conflict with Christian values. In the 1950s stained-glass windows with Aboriginal designs were commissioned for the church at Milingimbi, and later on the Reverend Edgar Wells encouraged panels of sacred designs to be erected beside the altar of the church at Yirrkala. An environment had been created such that Yolngu could reasonably expect that in displaying sacred objects in public they were offering something that would be perceived to have considerable value.

The Elcho Island Memorial formalized a process that had been in effect since the 1930s, in which Aborigines offered Europeans access to things that Europeans valued in exchange for things that Aborigines wanted, whether it was tobacco, money or more control over their land. Moreover, it was a process over which Aborigines maintained a tight grip. They released paintings selectively and for particular purposes, and they never intended to give up any influence over their use or to transfer any rights that were vested in them. The Elcho Island Memorial

did not result in a flood of reproductions of the objects revealed, nor did it lessen the control that people exercised over them, or reduce the power that they were thought to contain. As far as the Yolngu were concerned the value of the objects and designs lay in their ancestral origins, not in secrecy *per se*.

Yolngu continued to use paintings and, to a lesser extent, sacred objects in their relations with Europeans as a means of asserting the value of their culture and the importance of their relationship to land. Paintings formed the basis of local exchanges with missionaries; they were also produced for national audiences and for explicitly political action. The use of paintings as a medium of exchange resulted in some significant changes in the form and content of Arnhem Land art. These developments were not so much the result of direct outside influences on the form of the art; rather, the changes were internal developments in response to the new contexts in which art was being used and the new possibilities that were opening up.

From the 1930s to the 1950s the form and context of the paintings made for sale altered. Paintings based on clan mythology and including the sacred geometric patterns associated with particular ancestral beings and places were increasingly produced. Other paintings reproduced ceremonial events such as the Morning Star ritual or burial ceremonies, and included representations of associated sacred objects. These changes were partly a response to aesthetic preferences of the buyers, but they also signalled a change of intent on the part of Yolngu. These paintings were seen as a means of educating Europeans about Yolngu religious life and the relationship between paintings and land.

Thus while many of the people who bought the paintings may at first have had little interest in the meaning of the art, the changing form and content reflected both Yolngu concerns and the interests of Europeans who became involved in the trade. Missionaries and anthropologists initially provided a significant local audience; Yolngu then found that paintings were a useful tool in getting their message across to a wider community. As Burramura said in a sermon in the Walramiri language at the time of the Elcho Island Memorial:

I am taking this opportunity to explain the duty of anthropologists. They come around in order to find out the meaning of our dances, songs [and paintings]. They stand for this and that is their duty. This means that they are holding the world firm. And they are holding up the government too.

While greatly overestimating the power of anthropologists, this statement reflects clearly the educational objectives of Yolngu and their attempt to use art as a means of spreading understanding.

In this period, European purchasers of Aboriginal art, in particular institutional buyers, began to understand the clan-based nature of the art and its status as an ancestral inheritance which reflected the journeys of the Dreamtime creator beings. This emphasis on the religious dimension of art not only influenced the content of the paintings, but may also have contributed indirectly to changes in their scale and composition. In ritual, paintings are part of a whole complex of actions which reproduce the Dreaming or ancestral dimension. Some objects, such as hollow-log coffins, provide a large canvas, but most paintings are produced on small surfaces, such as the human body. The significance of paintings depends on their place in a particular ritual, and their meaning is derived partly from the knowledge held by the participants. In ritual contexts they do not have to illustrate a whole myth or a ceremonial performance. Paintings produced for outsiders, on the other hand, do not travel as part of a ceremony but have to convey their meaning independently of that context. The Yolngu responded to this problem by producing larger paintings to fill in the story of a myth, by combining a number of different paintings on one large sheet of bark and by illustrating ceremonies or myths in narrative sequences.

The collection made by Stuart Scougall and Tony Tuckson in 1959 was a significant move in this direction. Scougall was an orthopaedic surgeon from Sydney and a major donor to the Art Gallery of New South Wales. In 1958, after more than a decade spent collecting works of Aboriginal art, he visited Melville Island where he commissioned a set of pukumani mortuary poles for the gallery (see 132, 133). In 1959 he visited Yirrkala with the artist and curator Tony Tuckson, the potter and author Margaret Tuckson and his secretary Dorothy Bennett. They brought back a set of large bark paintings specifically produced for

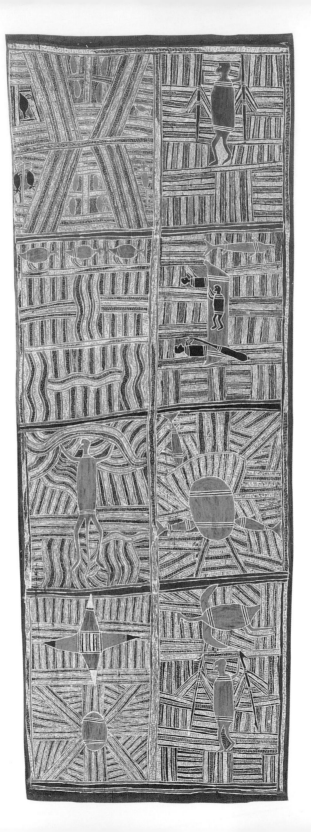

165
**Mawalan,
Mathaman
and Wandjuk
Marika,**
*Djang' kawu
Myth No. 1,*
1959.
Natural
pigments
on bark;
191·8 × 69·8 cm,
75½ × 27½ in.
Art Gallery of
New South
Wales, Sydney

them which illustrated the mythology of the clans living at Yirrkala. Mawalan's painting of the Djang'kawu sisters giving birth was one (see 43). Another painting, produced jointly by Mawalan, his brother Mathaman (1920–70) and his eldest son Wandjuk, illustrated the journey of the Djang'kawu from Buralku to Riratjingu country and the events that occurred on the way (165).

In addition to bark paintings Scougall also collected a significant number of carvings from Yirrkala. Munggurrawuy Yunupingu's carving of the Yirritja moity ancestral being Garaginja was seen earlier (see 16). Mawalan Marika's carving (152) represents a figure associated with the Djang'kawu sisters mythology. The body of the figure is painted with the designs associated with the sand-dunes at Yalangbara (see 56, 100 and 165) and the streamers of rainbow loraqueet feathers represent the armbands that the sisters wore. The feathers allude to the tassels of the sacred dilly bags that they hung on the tree beside the waterhole they had created. Such carvings have a history that links them with Macassan contact and with subsequent interaction with Europeans as well as to the indigenous artistic system. The anthropologist Ronald Berndt, who made the first significant collections of wood carvings from Eastern Arnhem Land, traced the origin of the carvings back to Wuramu gravepost figures that may in turn have been influenced by Macassan mortuary practices. The vertical post-like form of the figures with their arms close to the body suggested the possible link. The flying-boat station built on the Gove Peninsula during World War II is thought to have stimulated the carving tradition by providing a local market for wood carvings and encouraged the development of more figurative and less abstract forms, culminating in the elaborate carvings of Lumaluma II (1941–85) and Djambawa Marrawili (b.1953). But the objects equally come out of the religious iconography of Yolngu clans and were firmly incorporated within the ceremonial system.

The idea of producing paintings that covered many episodes of a myth was developed further in the two panels of paintings made for the new church at Yirrkala which were mentioned earlier. It was decided that each panel should represent the paintings of one of the two moieties, Dhuwa and Yirritja, into which the clans were divided. The leading

artists from the clans of the respective moieties worked together on different sections to create a painting that would be representative of the region as a whole. The paintings were to be a sign of the spirituality of the land and Yolngu relations with it, as well as of the compatibility of Yolngu beliefs with those of Christianity. Like the Elcho Island Memorial, the paintings illustrated the underlying unity of the clans while revealing that each had a unique inheritance.

At the same time as large composite clan paintings were being developed some artists introduced 'story paintings' which illustrated mythological themes in a narrative fashion. Narritjin Maymuru and his brother Nanyin (c.1912–69) respectively developed paintings of the Djert and Bamabama stories. These stories are moral tales told to children and 'performed' for entertainment; although they are associated with particular places they are not represented by sacred paintings.

The Bamabama story is a tale of incest and its consequences (166–167). Bamabama, a trickster ancestral being, was sent to collect young men for a ceremony. He went to a neighbouring settlement (a) but asked for young girls instead of boys. He knew one of the girls was a fast runner; she was a beautiful girl but his classificatory sister. He challenged the girls to a race, saying that only the fastest one would be selected for the ceremony (b). The girl raced ahead of all the rest and eventually she and Bamabama were alone. They rested by a lake and Bamabama sent her to collect firewood while he fished. While she was away he stuck a fish bone into his foot and when she returned explained that they would have to camp for the night because he was lame. They built a hut with a fire at the centre (d), and settled down on either side of the fire. In the night Bamabama threw cycad nuts on to the roof and frightened the girl by saying that it was the sound made by a sorcerer. He moved over to her side of the fire, ostensibly to protect her, but he then raped her and killed her with his large penis. He hid her body in a bark container and returned to her camp (c and d). When people found out what had happened they started to beat him (a). He became wild and started throwing spears about: he speared dogs (e), cycad bread and vegetables (c). After a while everything began to change. The cycad changed back into a palm, and all the people turned into the animal species that

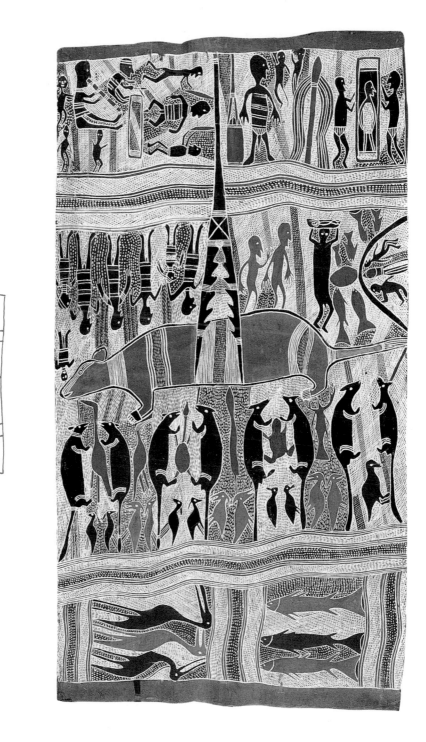

were the totems of their clan (f and g), and returned to their own clan territories. Finally, a great flood came and covered the area where the events had taken place.

Just as the Elcho Island Memorial was directed to internal as well as external issues, so too were the changes that occurred in the form, content and execution of bark paintings. In the settlements bark painting increasingly became a means of teaching about the sacred life and passing on knowledge of design forms to young people. The groups of young artists working and learning together effectively amounted to a Yolngu art school. The 1960s saw another development: the greater involvement of women in painting. Sacred paintings made for sale had tended at first to be produced in seclusion away from women, just as in ritual contexts. The paintings collected by Scougall were produced inside a circle marked out on the ground to prevent women and uninitiated men from getting too close. Gradually, however, women began to take an increasingly prominent role in producing paintings as social and economic circumstances changed, first by assisting their fathers, and later by being allowed to do paintings themselves. Mawalan Marika and Narritjin Maymuru taught their daughters as well as their sons to paint: today Banduk Marika (b.1954) and Naminapu Maymuru (b.1952) are recognized as major artists. Banduk's print (see 100) shows the ancestral goannas at Yalangbara that were the subject of her father Mawalan's painting (see 56). She deliberately chose a sequence of colour printing that would highlight the brilliance of the white in order to convey the spirit of Yolngu aesthetics. Naminapu's print (168) represents the Manggalili ancestress Nyapalingu (Nyapililngu) at Djarrakpi, a theme that she has developed in a number of different media. This emphasis on portraiture is unusual in Yolngu art but follows developments initiated by her father, Narritjin. By the 1970s women were beginning to produce paintings in ritual contexts previously restricted to men.

The topics chosen for painting were intended to educate Europeans about the relationship between art and land, but they also provided knowledge to rising generations of Yolngu themselves. Narritjin explained to me that he had learned much of the mythological significance of his distant land at Djarrakpi from paintings by his

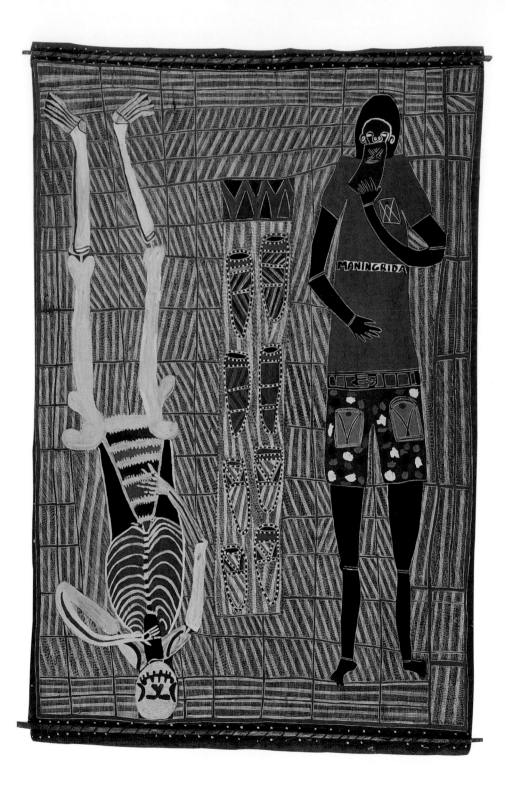

classificatory grandfather, Birrikitji, while he was living at Yirrkala Mission. The themes developed for the new story paintings were often relevant to current concerns. The Bamabama story is particularly appropriate for the period since the 1940s as it refers to a time of chaos in which the world was turned upside down as a consequence of people breaking the rules and failing to follow traditional norms of behaviour. I heard Narritjin tell the story for the first time as a reproach to one of his sons, who had accidentally knocked his mother over while playing football. On other occasions he said to me that he felt that the time of Bamabama was here again, with the coming of the mining town and the effect of alcohol on people's behaviour.

Other artists represented the themes of contact more directly, as in Maningrida artist Les Midikuria's painting of the petrol sniffer (169). Midikuria (1932–96) takes up the traditional theme of a mortuary ritual associated with his clan's dilly bag designs and incorporates a petrol sniffer as a warning of the possible consequences of the practice.

The themes of these paintings and the context of their production do not represent a radical break with past practices. Paintings had always incorporated change in the form of new themes, and had always been a medium for educating young Yolngu. Just as one generation had to come to terms with the Macassans and the introduction of arak and firearms, so too later generations have had to deal with petrol sniffing, mining towns and threats to their land and autonomy. The response of Arnhem Land artists is by no means uniform. George Milpurrurru (b.1934), the Ganalpuyngu artist, talking to the curator Djon Mundine emphasized the conservatism of the themes he paints in contrast to Les Midikuria, whose work he knew well.

Some people have painted things like [Missionary Aviation Fellowship] planes and Europeans with [radio] telephones. They paint these things on bark; that's different from my thinking. For my part, I couldn't paint such things in that way because they're not my Dreaming.

Nonetheless, in this interview, referring to his magpie geese paintings (170), Milpurrurru stressed both their continuity with the artistic traditions of his clan and the new compositional elements they contained:

169
Les Midikuria,
Petrol Sniffer,
1988.
Natural
pigments
on bark;
165 × 107 cm,
65 × 42$\frac{1}{8}$ in.
The Holmes
à Court
Collection,
Heytesbury,
Western
Australia

I was taught to paint by my father Ngulmarmar on sheets of bark. Some paintings I do very much the way my father did. The pictures I paint are based on the ones I have been taught, but I also think of making my own pictures like the magpie goose paintings. My father taught me to paint but I paint differently from him. I teach others to paint and sometimes they paint differently to me. My father also taught my sister, Dorothy Djukulul, to paint. Now there are many Yolngu women bark painters; and men don't try to stop them.

The increasing role that women have taken in the art is likewise part of a continuing process of adjustment to new circumstances and a response to new opportunities. The crowded conditions of settlement life also required adjustments to ritual performance in order to take account of the close proximity of men to women, and young to old, just as the coming together of many different clans encouraged a broadening of knowledge through the Elcho Island Memorial. The increased participation of women was viewed by Yolngu as an enrichment of community life and a recognition of the important role played by women in holding the community together in times of social stress. These changes have not lessened the value of the paintings, nor have they been imposed on Yolngu from outside. Rather, they reflect choices, sometimes individual choices, made in response to circumstances. As we shall see, other communities have taken a different direction.

It is tempting to interpret the long series of exchanges with Europeans and adjustments within Aboriginal society as part of a long-term strategy that prepared Aboriginal people for their crucial battle with the Australian government over their right to title to their land. The gifts and sale of paintings were acts of persuasion that involved increasingly large numbers of outsiders. Their involvement in these transactions also allowed Aborigines to familiarize themselves with the European world that was enveloping them and the hierarchies and institutions that they had to deal with. Yolngu had learned a great deal about European society by the time they confronted the greatest threat to their autonomy.

During the 1950s Arnhem Land remained remote from the rest of Australia. The activities of the missionaries apparently posed no direct

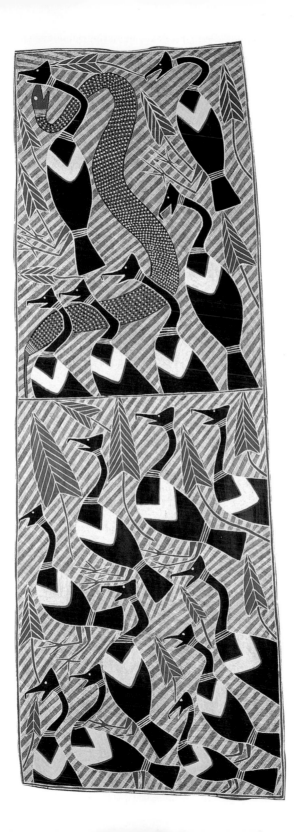

170
George
Milpurrurru,
Magpie
Geese/Water
Python,
1988.
Natural
pigments
on bark;
237 × 78 cm,
93³⁄₈ × 30³⁄₄ in.
Museum of
Mankind,
London

threat to Yolngu land tenure. For many centuries outsiders had come
in and engaged in trade, entered into negotiations, used some of the
resources of the land with permission and moved on. As far as the
Yolngu were concerned the missionaries were there with their permis-
sion. It was they who had decided as a gesture of conciliation and a bid
for peace to allow Chaseling to set up Yirrkala Mission. The European
perspective was very different: the missionaries were present because
under Australian law Yolngu were assumed to possess no title to their
land. The fact that the Yolngu had not been conquered, had not surren-
dered sovereignty, and the fact that Europeans had apparently not
as yet attempted any developments on their land was irrelevant.
Permission was not required because under the legal fiction of *terra
nullius* the Yolngu in effect did not exist as people with rights. In the
late 1950s and early 1960s Yolngu discovered prospectors from a French
mining company on their land and heard that great reserves of bauxite
had been found; they later discovered that an application was going to
be made to excise their land from the Arnhem Land Reserve in order to
develop the deposits. It was at that point, in 1963, that they petitioned
the House of Representatives in Canberra.

The petition was written in English and Gumatj, one of the Yolngu
languages. It drew attention to the significance of the land to the
Aboriginal people, pointed out that some five hundred people lived
in the area of the proposed mine and used it for hunting and gathering,
and asked that they should be consulted before any decision was made
to excise the area from the lease. It concluded that the 'petitioners as
in duty bound will ever pray God to help you and us'. An eminently
reasonable petition, and one that would doubtless have been quietly
filed away in an office drawer had the petitioners not, through an act
of perspicacity, sent it in the form of two bark paintings (171, 172). Two
copies of the actual petition were made and then each was pasted to
sheets of bark around the borders of which were painted designs of
the Dhuwa and Yirritja moieties respectively. The genius of the bark
petition was that it introduced Aboriginal symbolism into parliamentary
discourse, making it harder for Europeans to respond in terms of their
own cultural categories. Petitions framed in parliamentary language
can be dealt with through parliamentary procedures. Petitions framed

in bark add a new element. The bark petition emphasized the difference between 'Aborigines' and other petitioners, and it did so in a way that was likely to be taken up by the media.

The considerable press coverage was one of the factors that led to the setting up of a Parliamentary Select Committee to investigate the grievances of the petitioners. When the Australian government still decided to go ahead with the excision, the people of Yirrkala took the government to court in 1968, a case that they were eventually to lose in Mr Justice Blackburn's judgement of 1971. By that stage the judgement was so out of sympathy with the climate of the times that all-party support was eventually given to the Aboriginal Land Rights (Northern Territory) Act of 1976. This provided the means to give Aboriginal people title to the lands that had been reserved for them and the possibility of claiming unalienated Crown land throughout the Northern Territory. Although the bauxite reserves were still leased to the mining company Nabalco, the Yolngu gained secure title to most of their remaining land.

The bark petition was important because it received national attention and introduced a form of evidence – sacred paintings as title deeds to land – that argued for new solutions. As far as Yolngu were concerned it was not the first step but just one stage in the process of gaining cultural recognition and acknowledgement of their rights. Had paintings not been released over the years, had there been no Elcho Island Memorial or paintings in Yirrkala church, had there been no interest from outsiders in Yolngu art and culture, then bark paintings could not have emerged as an appropriate symbol in the early 1960s.

Art and ritual have continued to play a significant role in Aboriginal political action. In 1988 a meeting in the Northern Territory of Aboriginal landowners produced the Barunga Statement (173). The statement echoed the bark petition but included paintings from central Australia as well as Arnhem Land and reflected a shift in the political agenda to a more national focus.

Sometimes events establish more localized connections. In 1982 the Anbarra community of the Liverpool River in Central Arnhem Land decided to widen the basis of their ceremonial exchanges by holding a

171–172
Various artists,
The Yirrkala
Bark Petition,
1963.
Ochres on bark
and paper.
59·1 × 34 cm,
23¼ × 13⅜ in.
Parliament
House,
Canberra

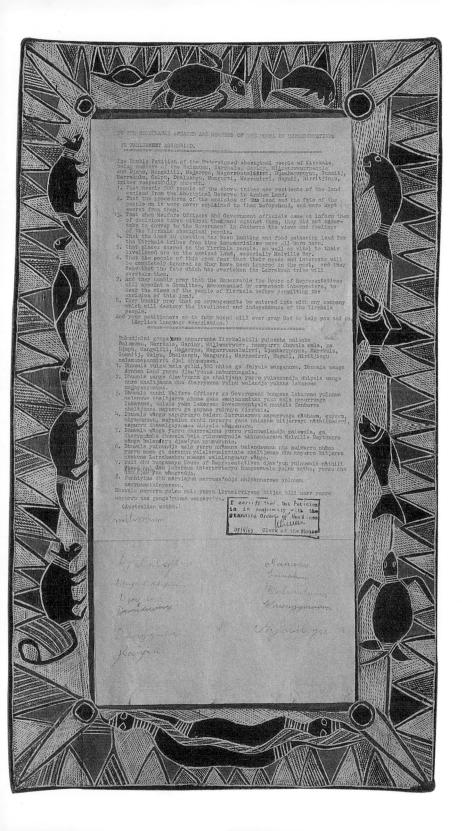

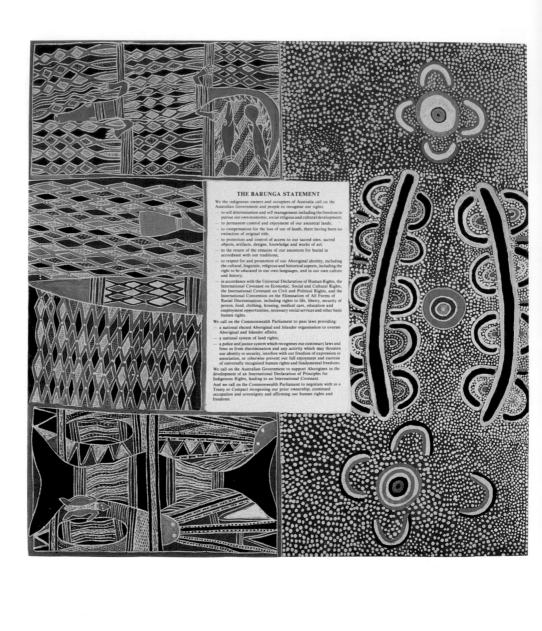

Rom ceremony (174), which included the manufacture of a Morning Star pole, at the Institute of Aboriginal Studies in Canberra. The aim of the performance was to cement relations with the institute which was seen to play a significant role in recording Aboriginal culture and in making politicians and other 'important' people aware of Aboriginal concerns. The Anbarra saw it as a way of introducing Aboriginal cultural practices to what was perceived as the centre of Australian political power, and thereby continuing the Arnhem Land agenda of spreading understanding through sharing knowledge.

173
Various artists,
The Barunga
Statement,
1988.
Ochres on
composition
board with
collage of
printed text
on paper;
122 × 120 cm,
48 × 47¼ in.
Parliament
House,
Canberra

174
Rom ceremony,
Canberra, 1982

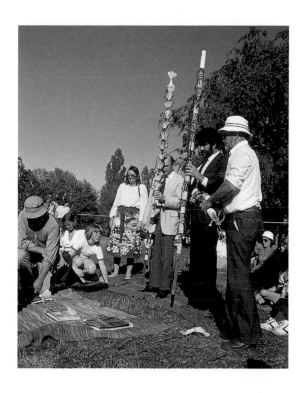

Rituals are both a way of involving other Australians in the values of Aboriginal society and paradoxically of allowing Aboriginals to exercise control and gain access to resources outside their local areas. While the economic value of Aboriginal land to Europeans is unquestionable, until recently Europeans saw little of value in Aboriginal culture. The growing interest of Europeans in Aboriginal culture has extended the range of Aboriginal intervention in Australian society. The Anbarra who organized the Rom ceremony set conditions for how it was to be viewed, who would receive the objects produced and how they would be

disposed of. The exercise of control cannot be taken for granted, and it has to be argued for. But in the case of cultural products, at least, if not in the case of land, Aboriginal people retain the option of refusing to release them if Europeans disregard their interests.

There are strong incentives, apart from political necessity, for Aboriginal people to participate in national arenas. By participating in the wider Australian context they ensure that some of the economic resources devoted by the state to cultural activities will be directed to Aboriginal concerns and that the resulting activities will be the product of Aboriginal creativity.

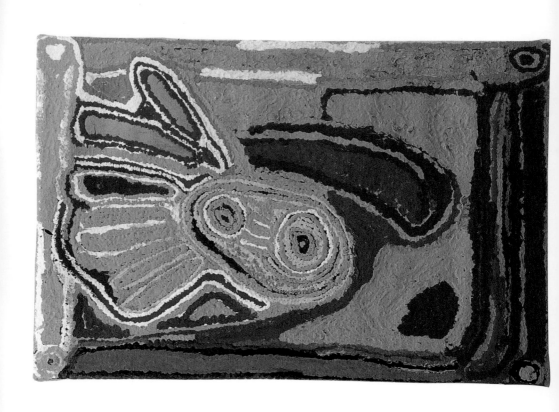

In central Australia the development of Aboriginal art has taken a different course from that in Arnhem Land. In the desert environment most art forms were, until European colonization, impermanent structures sculpted out of sand, painted on bodies or woven into the form of sacred objects. The more permanent forms were often secret and, although highly sought after by dealers in primitive art, were by their very nature difficult to incorporate into a public art and craft industry. By the end of the nineteenth century, however, major collections of artefacts and ceremonial objects had been made by anthropologists such as Baldwin Spencer and F J Gillen, and by missionaries such as Carl Strehlow and Johann Reuther. Although aesthetic factors motivated the collection and display of the objects, they were largely classified as ethnographic items whose significance lay in the cultural information they contained. However, the boundary between interest in objects as ethnographic specimens and a more general interest in the objects as collectable items is a narrow one, and a trade in boomerangs (176), shields (177), spears and other artefacts rapidly developed in central Australia. The trade in turn influenced the form of some of the artefacts collected. In some cases, for example, the decoration became more elaborated and figurative elements began to be introduced.

It has been argued by the historian and curator Philip Jones that the toas, the sculptures from the Lake Eyre region discussed in Chapter 3, developed in part as a result of their production for sale in the first decade of the twentieth century. The figurative nature of some of the toas may indeed have been influenced by interaction with Europeans, although the extent of any influence is still open to question. In the case of some other artists working in central Australia at the same time, the influence of European art forms is unquestionable. Jim Kite (Erlikiliaka) (b.c.1865), an Arrernte man, produced figurative carvings (178, 179) for sale that created widespread interest. Little is known about him, although in his youth, unusually for the time, he travelled to both Sydney and Darwin. For most of his life he lived at Charlotte

175
Eubena
Nampitjinpa,
*Women's Law
Dreaming*,
1995.
Acrylic on
canvas;
60×90 cm,
23⅝×35½ in.
Rebecca
Hossack
Gallery,
London

176
Boomerangs,
central
Australia and
the Northern
Territory,
19th century.
Wood;
l. between
71 and 74.3 cm,
28 and 29¼ in.
National
Museum of
Australia,
Canberra

177
Shield,
Nullagine,
Western
Australia,
before 1898.
Natural
pigments
on wood;
h.107 cm,
42⅛ in.
Pitt Rivers
Museum,
University
of Oxford

178
Jim Kite
(Erlikiliaka),
Possum,
collected 1934.
Clay;
l.14 cm, 5½ in.
National
Museum of
Australia,
Canberra

179
Jim Kite
(Erlikiliaka),
Grasshopper,
collected 1934.
Clay;
l.7 cm, 2¾ in.
National
Museum of
Australia,
Canberra

Waters, and worked in the Overland Telegraph station and possibly as an assistant police tracker. In 1901 he accompanied Spencer and Gillen in their year-long research expedition across central Australia (see 5), during which time he contributed numerous drawings to Gillen's notebook. Later he became renowned for his Meerschaum pipes that he sold to people passing through the region. An article in the *Adelaide Register* on 13 July 1913 by a special correspondent discussed his work and placed a strong emphasis on its realistic nature:

In the upstairs room of the Selbourne Hotel I saw the triumph of the Aborigine's handiwork. They ought surely to be purchased for the national collection. The table was spread with perhaps a score of valuable and diversified creations of the black's extraordinary talent. I saw marsupial rats with life so realistically suggested that they appeared to be scampering away among the undergrowth or poised tense for attack. Jim Kite's graphic knife had carved birds with such delicacy of form and such a superb sense of rhythm that they might have been perhaps caught in flight and imprisoned in kaolin.

The reaction is perhaps a precursor to the reception of Albert Namatjira's watercolour paintings, the first art works to make a major impact on the southern art market.

The Arrernte artist Albert Namatjira first started painting in 1936. His paintings (180), which were produced in a European medium following

closely the style of his teacher, Rex Battarbee (1893–1973), gave rise
to the term, 'Hermannsburg school'. Hermannsburg watercolours were
interpreted for a long time as a symbol of assimilation and of the subor-
dination of Aboriginal traditions to introduced forms. In the 1970s a
new tradition of Western Desert art developed at Papunya, northwest
of Alice Springs, which involved the reproduction of traditional body
painting and ground sculpture designs in acrylic paints on canvas.
Although initially the response to this new art was muted, within a
decade Western Desert acrylics had become among the best-selling
contemporary art in Australia. In the 1980s and 1990s Western Desert
art moved on to the world stage with important exhibitions in New York,
London, Paris and Tokyo. Private galleries specializing in Aboriginal
art were established in major capitals around the world. Ironically, the
changed political climate and the success of Western Desert acrylics
brought about a re-evaluation of Hermannsburg watercolours. They
were now seen as evidence of a tradition of resistance that represented
an Aboriginal perspective on the landscape of central Australia, albeit
through a European medium.

If we compare the Arrernte watercolour tradition which began in the
1930s with the Western Desert acrylics that were first produced some
forty years later, we are presented with one of those interesting appar-
ent reversals of time that the postmodernists delight in. Both appear
to be, in some respects, borrowed traditions – movements that are

products of colonialism and the incorporation of the Australian Aborigines within a market economy. At first sight it seems that the watercolourists, painting in an introduced medium and genre, and initially following quite closely the style of their teacher Rex Battarbee, are archetypal victims of colonialism, their skills devoted to the production of other people's art. The Western Desert artists, on the other hand, produce paintings in acrylic on canvas for sale to Europeans, using as their inspiration religious designs that had previously been produced as ground sculptures, body paintings and on sacred objects. The real surprise is that the European landscapes precede the traditional designs as the subject matter of the paintings. The evolutionist's logic is reversed, and this may provide a clue to another interpretation. Far from being considered signs of colonial domination, both movements can equally be seen as expressions of Aboriginal identity and of a determination to maintain autonomy in post-colonial Australia.

In Chapter 7 it was argued that the history of the European colonization of Australia has also been a history of Aboriginal attempts to assert the equality of value of their culture and way of life against the economic and political objectives of the invaders. The colonial process has been a battle not only between different economies but between different ways of relating people to land, and since aesthetics has been close to the heart of Aboriginal relationships with land, colonialism has also been a struggle over the aesthetics of the Australian landscape. The acrylic paintings of today, whose form and design have begun to influence contemporary Australian art in fundamental ways, are unequivocally the work of what the anthropologist Bob Tonkinson has referred to as 'the Aboriginal Victors of the Desert Crusade'. By contrast, the meaning of the Arrernte watercolour paintings has changed very significantly since they first started to be produced.

In the patchwork history of European colonialism, the Arrernte people of the Alice Springs region were surprisingly early victims. To some extent the landscape of central Australia was resistant to European economic enterprises: European colonists perceived the desert as a harsh and barren wasteland. They colonized the region in a sporadic fashion: after a few seasons of above average rainfall, cattle and sheep stations

180
Albert Namatjira, *Palm Valley*, late 1940s. Watercolour on paper; 37 × 54 cm, 14½ × 21¼ in. Art Gallery of New South Wales, Sydney

would be established on Aboriginal land; later the rains would fail and the properties would be abandoned. But by then the local population had often been devastated by murder and disease, and forced to retreat to the newly established mission stations or outback towns. Aboriginal groups living as far north as Lake Eyre had been decimated and dispersed by the end of the nineteenth century.

The building of the Overland Telegraph in 1872 was perhaps as significant an event as the establishment of cattle stations. It created a route for further colonization as well as the necessity for permanent European settlements at intervals along the line from Adelaide to Darwin, since repeater stations were needed to relay messages and to ensure that the line was kept in good repair. Mission stations and government settlements became the focal point of Aboriginal settlement. Alice Springs, close to the geographical centre of Australia, became the inland headquarters of the Overland Telegraph in central Australia. Shortly afterwards, in 1877, the Lutheran Church established the mission station of Hermannsburg some 125 km (80 miles) to the south. Arrernte country had now been occupied along much of its length. It was here, some sixty years later, that the Arrernte school of watercolourists had its origins.

The orthodox version of the origins of the school is provided by Rex Battarbee himself. In the 1930s he used the Lutheran mission station of Hermannsburg as the base for his painting trips to central Australia, sometimes accompanied by his friend and fellow artist John Gardner (1906–87). After an exhibition of paintings by Battarbee and Gardner at Hermannsburg, Battarbee was approached by Pastor Albrecht, the mission superintendent, who said that one of his community, Albert Namatjira, had expressed a desire to learn to paint. Battarbee returned to central Australia in 1936 and arranged to go out on a painting expedition to Palm Valley with Albert Namatjira as his guide. In exchange, Battarbee was to teach him his method of watercolour painting. 'After we had been out for two weeks,' Battarbee wrote, 'Albert brought along a painting of the Amphitheatre to which I had not even seen him put a brush – I felt that he had done the job so well that he had no more to learn from me about colour.'

Namatjira's paintings have to be understood in the context of the Hermannsburg of the time, the constraints placed on Aboriginal life, the lack of autonomy and the cultural environment in which people found themselves. The Lutheran Church in central Australia had as its goal the salvation of souls and the saving of Aboriginal lives. Unlike the newly established Methodist settlements of coastal Arnhem Land, the Lutheran Church was not oriented towards syncretism and tolerance of Aboriginal religious practice. Indeed, the 1930s and 1940s was a time of consolidation of Christianity at Hermannsburg, with the opening up of Aboriginal sacred sites and the handing over of sacred objects. Philip Jones has argued that Namatjira was himself part of this movement. He certainly responded to the opportunities made available by the missionaries. He was a person of initiative and enterprise, a highly skilled craftsman who also worked as a stockman on Hermannsburg and neighbouring cattle properties. He was proud of his ability and

sought to maximize his income. Namatjira had been exposed through-out his life to European images, both in the form of Lutheran Bible illustrations and, later on, through the increasing number of visits of many artists apart from Battarbee. He produced artworks in a number of different styles, including pencil drawings for visiting researchers and pokerwork engravings on artefacts made for sale. Hermannsburg had a well-established craft industry and Namatjira was one of the leading makers of artefacts. He subsequently combined traditional craft practice and watercolours during World War II by producing for sale boomerangs and spearthrowers illustrated with watercolour scenes (181).

Namatjira's paintings quite rapidly achieved widespread acclaim. They were first exhibited in 1937 at the Lutheran Synod at Nuriootpa, near Adelaide; in 1939 his first one-man show was held at the Atheneum

Gallery in Melbourne, and in the same year there was an exhibition of his paintings at the Royal South Australian Society for the Arts in Adelaide. A painting, *Haasts Bluff*, from this second exhibition was purchased by the Art Gallery of South Australia: this was the first work of art by an Aborigine bought by an art gallery as opposed to an ethnographic museum.

The Hermannsburg watercolour tradition continued after the war, when Namatjira's fame increased. In 1954 he was flown to Canberra to meet Queen Elizabeth II on her first state visit to Australia. However, his success brought with it considerable personal problems, compounded by the general constraints imposed at the time on Aborigines in central Australia. Aboriginal people were not citizens of Australia and did not have the freedom of movement enjoyed by other Australians. They were not allowed to purchase alcohol and attempts were made to keep them in the settlements away from Alice Springs. As a reward for his success, Namatjira was granted citizenship in 1957; the associated rights applied to him alone, however, and were not extended to other members of his family. As a consequence he was arrested and charged with supplying alcohol to his relatives and spent time in jail, although his sentence was eventually modified on appeal to spending two months on the settlement of Papunya. The strains of his situation combined with illness brought about his premature death at Alice Springs on 8 August 1959.

The success of Albert Namatjira's work was by any standards quite exceptional. Within a few years of beginning to paint he had developed an international reputation. His works were selling for more than those of Battarbee and the exhibitions of his paintings throughout Australia were triumphs. Part of the explanation for his success must be sought in the racial attitudes of the times. His paintings were undoubtedly appreciated because of their aesthetic appeal, but they were at the same time a curiosity and a sign that Aborigines could be 'civilized'. The linguist and anthropologist Ted Strehlow wrote in 1951 that the acclaim accorded Namatjira's paintings was 'a grudging admission that a member of a race which had been regarded without scientific grounds for over one hundred and fifty years as genetically incapable of learning European techniques had unexpectedly acquired mastery of one of

these techniques to such an amazing degree that his work had become virtually indistinguishable from that of a white artist'.

This view of Namatjira's art as an icon of assimilation provided only a fragile long-term basis for its acceptance. Once the curiosity value of his paintings had waned, the art world's interest in them diminished. The very fact that the greatest acclaim was for their imitative qualities, that they were 'indistinguishable from' the works of his teacher, became problematic, especially since his teacher produced unfashionable if popular works. Naturalistic watercolour landscapes were hardly at the forefront of the Western avant-garde, and after their initial purchases by art galleries, Namatjira's paintings began to be seen as mid-twentieth-century 'artificial curiosities'.

At the time that Namatjira's work began to gain renown, the avant-garde in European–Australian art, still firmly entrenched in the modernist aesthetic, was ironically beginning to show a belated interest in traditional Aboriginal designs. Margaret Preston was urging White Australians to appreciate Aboriginal art and incorporating elements of the traditional art of central Australia in her work. As interest in Aboriginal art developed after the war and White Australians became even more exposed to it through exhibitions, design and publications, interest in the work of Namatjira and others painting in the watercolour tradition diminished. The works of art produced in Arnhem Land, by contrast, were placed in the classic pigeonhole of 'primitive art' – art uninfluenced by European colonialism and produced for internal purposes by anonymous artists.

As already seen, however, Arnhem Land artists were fully engaged in a discourse with European society from the beginnings of their contact with Europeans, and what they produced was influenced by that context. How similar is Namatjira's case? Like the artists of Arnhem Land he was seeking both economic opportunities and recognition of his skills as an artist, though there is less direct evidence that he was asserting his traditional relationship to the land, and there are less obvious continuities in form between his paintings and 'indigenous' Arrernte art. Indeed, continuity with Arrernte values appears to be denied by the very art that he was renowned for producing. Whereas in Elcho Island the opening up of traditional designs went hand in hand with asserting

their value to Europeans, in Namatjira's case it appears that he was celebrating the artistic values introduced by Europeans. It is thus possible to interpret Namatjira's paintings, as the anthropologist and curator Nelson Graburn does, as signs of the successful assimilation of introduced values. But this assimilationist interpretation of Namatjira's art is problematic: it reduces artistic values to formal similarities, and very general ones at that. In this interpretation Namatjira's paintings look like Battarbee's, therefore they are a kind of European art. But influence should not be conflated with identity: there is a difference between being influenced by European art and being an imitation of European art. Battarbee himself challenged this assumption when he wrote in 1944, 'The white man could study any art in the world. Why not the black man? Australian painters could paint in the French style without any criticism. Albert Namatjira was able to paint in the European style.'

The assimilationist position has been strongly challenged in recent years, partly as our concept of culture has widened. We no longer have to remain within a narrow Western art-historical framework and view Namatjira's art either as part of a European tradition or as the product of Aboriginal tradition. Rather, Arrernte watercolours can now be understood in relation to the particular circumstances of their own history and the motivations of the artists. In this view Aboriginality is not restricted to a narrow set of signs: it reflects complex political processes and relates to people's lives in their entirety. Namatjira's Aboriginality has been defined through his socialization as an Arrernte person at a particular point in the history of central Australia, when Aboriginal people were still denied citizenship, when Christianity was a strong influence in people's lives, when much of the country they occupied had been transformed by the pastoral industry, and when they had for decades been subject to the assimilationist policies of the mission settlements. The paintings he produced and their particular characteristics can be best understood when they are placed in that context.

Although Namatjira's paintings were a response to Battarbee's exhibition and the European watercolour tradition, the vision of central Australia in his paintings is at least as much the result of his inspiration, and of his life as an Arrernte person, as his teacher's technique.

Namatjira and the other Arrernte artists conveyed qualities of light and colour in their central Australian landscapes that delighted and surprised their viewers. While Aboriginal people were absent from the landscape, so too was evidence of the pastoral industry and, for the most part, colonial settlements. Although some would interpret the paintings as the imposition of a European picturesque genre on to the landscape of central Australia, they can equally be seen as Aboriginal representations of land that challenged both European occupation and European preconceptions of the centre as an arid wasteland. The paintings cut across the dominant dialectic of Australian art: that between a domesticated pastoral vision of landscape and a harsh, barren and at times surreal interior. The very fact that the paintings have continued to be part of the 'tourist' image of central Australia can be seen as a sign of their success in representing qualities of landscape across cultural boundaries, conveying Aboriginal delight in the beauty of their landscape to an audience that was largely unaware of it. Without further research, however, too many presumptions cannot be made about how Aboriginal people saw the paintings they produced and what drew them to that particular watercolour tradition.

The art historian Ian Burn and curator Ann Stephen have shown how Namatjira's paintings differ in their structure from those of contemporary White Australian artists. The paintings often lack a fixed point of focus and give different parts of the painting equal emphasis. In contrast to the central focus of landscape paintings by Hans Heysen (1877–1968) or Battarbee himself (182), Namatjira's paintings are often most detailed around the edges. In Namatjira's *The Western MacDonnell Ranges, Central Australia* (183), for example, Burn and Stephen note that 'the visual emphasis on the edges holds the composition in balance without either a dominance of forms near the centre or any hierarchy of forms.' The same authors have also observed that, while there is an underlying symmetrical structure behind many of Namatjira's paintings, asymmetrically placed foreground features such as trees often seem to lie on top of the landscape, creating unexpected juxtapositions, as if the artist has combined two distinct compositional techniques. Other significant features include the very high horizon in many Hermannsburg paintings and the emphasis placed on the

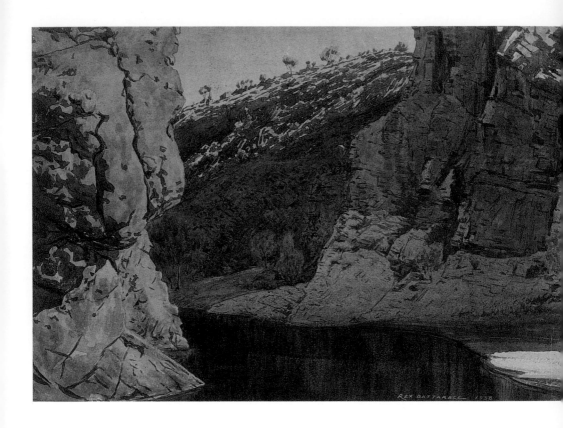

182
Rex Battarbee,
*Finke River
Gorge,
MacDonnell
Ranges, Central
Australia,*
1938.
Watercolour
on paper;
39·4 × 56·9 cm,
15$\frac{1}{2}$ × 22$\frac{3}{8}$ in.
Art Gallery of
South Australia,
Adelaide

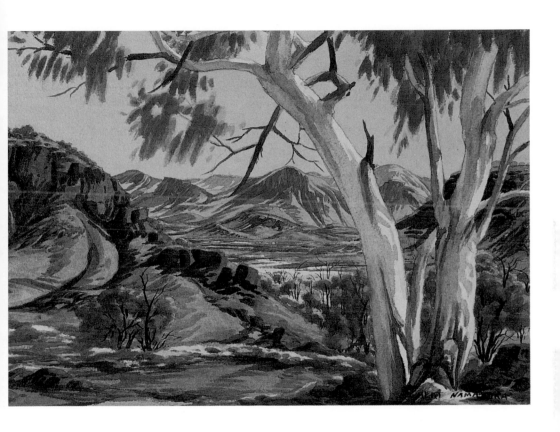

183
**Albert
Namatjira,**
*The Western
MacDonnell
Ranges, Central
Australia,*
c.1957.
Watercolour and
pencil on paper;
25.2 × 35.8 cm,
9⅞ × 14⅛ in.
National Gallery
of Australia,
Canberra

different textures of the landforms: 'the textures are emphasized by different treatments and surface markings building up a pattern of decorative effects … almost in patches.' This interesting comment links Namatjira's art with the later Western Desert acrylic tradition.

Namatjira's traditional affiliations influenced both the subject matter of his paintings and his social relations as an artist. He painted areas of land to which he could trace linkages through kinship and marriage and which were associated with the religious life of his people. Battarbee noted that the Hermannsburg artists' paintings were influenced by their own 'tribal mythology'. Philip Jones, however, while acknowledging that Namatjira painted mainly religious sites, argues that he 'chose land-scapes to paint primarily according to their potential as watercolour subjects'. The extent and nature of his influences remain a matter for future research.

We are on much less controversial ground when we look at the social obligations he accrued as a successful Arrernte artist: not only was he expected to share the proceeds of his paintings with close kin, he also had an obligation to teach them his art. For example, Albert was a 'close uncle' to Walter Ebatarinja (1915–68), and when Walter expressed inter-est in becoming a painter Namatjira had a duty to teach and support him. Because of the network of kinship obligations many of the next generation of artists were close kin of Namatjira's. Once the initial influence on Namatjira had occurred, watercolour painting became incorporated as a local Aboriginal tradition.

184
Edwin
Pareroultja,
Untitled,
before 1970.
Watercolour
on paper;
35 × 53 cm,
13¾ × 21 in.
Museum and
Art Gallery of
the Northern
Territory,
Darwin

The expectation in Western professional art, at least under modernism, is that each generation of artists will form their own tradition. This ideology stems from European concepts of individual creativity and authenticity. Fine art styles of the 1930s were not expected to persist into the 1960s except as pastiche or in fakes. In treating Hermannsburg art as if it were a form of European art, the artists' adherence to a partic-ular style is negatively valued; hence the label 'tourist art' is often applied in a pejorative sense to contemporary Arrernte watercolours. However, Namatjira was not positioned as a mid-twentieth-century urban Australian when he began to produce his watercolours, and the society he belonged to carried forward the new tradition according to its

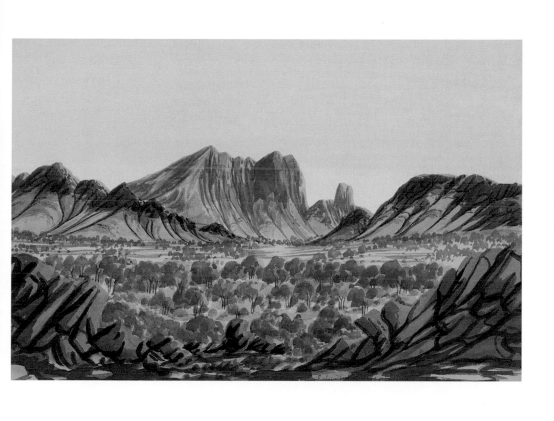

own rules and in relation to the context of life in central Australia. Watercolour painting became associated with a particular segment of the Aboriginal population and traditional systems of obligation and tutelage ensured that it was passed on through a network of kin.

Namatjira's successors worked through the canon in their own way. Although the centre of artistic activity was focused on the art world of the Arrernte, there was considerable individuality in the paintings of the different artists, and their styles developed over time. Edwin Pareroultja (1918–86), whose works date from 1943, painted from the first in a more abstract style than Namatjira, often using bold bands of colour to create symbolic representations of the landscape (184). Over the years he and Namatjira were joined by others such as Reuben (b.1915) and Otto Pareroultja (1914–73; 185), and Enos (1920–66) and Oscar Namatjira (b.1922), and the tradition continued into the 1990s through the works of such artists as Wenten Rubuntja (b.1926; 186), former chairman of the Central Land Council, and Doug Abbot (b.1948). The compositional structure favoured by different artists varied, as did their use of colour and technique of infilling forms. However, the works of the other artists in the school never received such widespread recognition as Namatjira and also failed to engage the long-term interest of the fine-art world. The more recent works have often been condemned for being derivative: to the casual observer they appear to replicate earlier works. Although the earlier paintings of the Hermannsburg school began to be viewed more positively during the 1980s, the strong market interest in Western Desert acrylics led many watercolour artists to change their style. Nevertheless, the Arrernte watercolour tradition has continued to be popular with the art-buying public in Alice Springs, maintaining a status somewhere between tourist art and popular art.

An interesting recent development in Hermannsberg art has been the transference of the landscape painting tradition to pottery design. Pottery quickly became established following the appointment of the potter Naomi Sharp as an adviser in 1990. The lids of the pots usually consist of moulded animal figures with their bodies providing a comple-mentary landscape. The pot (187) by Beryl Ngala Entata (b.1960) is

surmounted by two galahs which are reproduced in painted form, almost as reflections, in the landscape below. The combination of painting and sculpture conveys the scale of the central Australian landscape, and allows the viewer to look into the landscape from the viewpoint of the sculpted figure which appears simultaneously to be both inside and outside the scene. Some of the first pots produced were painted in the dot style of Western Desert acrylics, and this influence can still be seen in some of the works produced. *Tekentyarre (Red Headed Lizard)* by Virginia Mpitjana Rontji (b.1942) uses a combination of figurative and dot painting very effectively to convey the colour and texture of the lizard and to show the way it merges with the landscape (188). Pottery provides an apt means of evoking the process of ancestral transformation, because it is itself the result of a transformation – of clay.

Just as Hermannsburg art has its orthodox version of its origin, so too do Western Desert acrylic paintings. In central Australia there had also been a long-established craft industry which depended on the production of material culture objects such as boomerangs, shields (189, 190) and spearthrowers. Often these objects would be painted in red ochre, and sometimes shields would have designs painted on them. On the

187
eryl Ngala
ntata,
*lintja (Pink
alahs)*,
995.
eramic;
1 × 19 cm,
2¹⁄₄ × 7¹⁄₂ in.
luseum and
rt Gallery of
he Northern
erritory,
arwin

188
irginia
Mpitjana
ontji,
*ekentyarre
Red Headed
izard)*,
996.
eramic;
6 × 21 cm,
5¹⁄₄ × 8¹⁄₄ in.
trehlow
esearch
ollection,
lice Springs

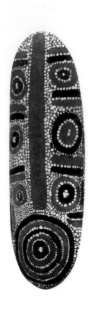
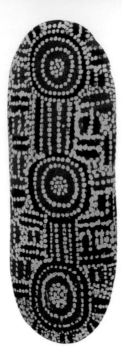

Aboriginal Art

189
Charlie
Jampijinpa
Gallagher,
Warlpiri shield,
c.1980.
Natural
pigments
on wood;
h.68 cm,
26¾ in.
Whitlam
Collection,
Australian
National
University,
Canberra

190
Tim Japangardi
Langdon,
Warlpiri shield,
c.1980.
Natural
pigments
on wood;
h.80 cm,
31½ in.
Whitlam
Collection,
Australian
National
University,
Canberra

191
Billy Stockman
Tjapaltjarri,
Long Jack
Phillipus
Tjakamarra,
Kaapa Mbitjana
Tjampitjinpa,
Old Mick
Tjakamarra and
other artists,
*Honey Ant
Dreaming*,
1971.
Mural (now
destroyed) at
Papunya school

whole, however, the rich ceremonial art of central Australia occurred in restricted contexts, inaccessible to the outside world. In 1971, at the settlement of Papunya, all this was to change.

In contrast to the Arrernte, whose land had been subject to colonization for over a hundred years, many of the people to the west, such as the Pitjantjatjara and the Pintubi, remained relatively isolated from direct European contact until the 1950s and 1960s. In the 1950s those who remained in the desert were encouraged to move to settlements, such as Papunya, in conformity with government policy. Partly they came because they had begun to feel increasingly isolated: many of their relatives had moved in before them.

In 1971 Geoffrey Bardon was teaching art and craft at Papunya school. He was interested in ways of including traditional art in the school curriculum and he encouraged some of the community's elders to paint murals on the school walls. The first designs were painted by Long Jack Phillipus Tjakamarra and Billy Stockman Tjapaltjarri (b.c.1927) who were employed as school groundsmen. The project captured the interest of other members of the community and soon more elders became involved. Once the murals had been completed

(191), the artists wanted to continue painting; they therefore asked Bardon to provide them with painting boards and pigments. Some of the paintings were sold to cover the costs of materials, and it was not long before they began to be exhibited and marketed throughout Australia.

While the role that Geoffrey Bardon played in the acrylic art movement is crucial, the story is more complex. The paintings on the school walls were in fact only one event among many in which Europeans who were interested in Aboriginal art encouraged people to reproduce traditional central Australian designs in an introduced medium. The many hundreds of drawings collected by anthropologists such as Nancy Munn (192) and Norman Tindale and the photographer Charles Mountford, and drawings in crayon collected by schoolteachers, represent earlier examples of transferring sacred and non-sacred designs to new media. The willingness of the artists to produce paintings at the school and their facility in producing designs on different surfaces is thus not as surprising a break with past practice as it may seem at first to be. However, what was required in each case was people with an interest in and sensitivity to Aboriginal culture. Bardon himself explored Aboriginal designs with the artists and his sympathetic encouragement established a positive environment for them to work.

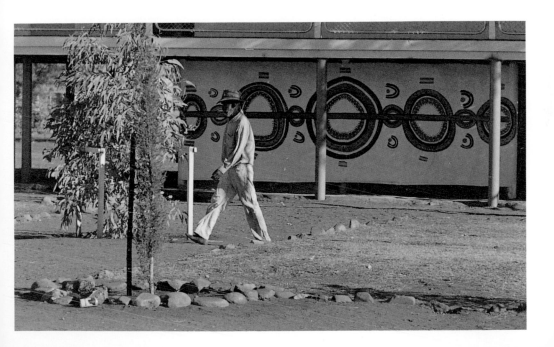

Gunawai yoh Beenley women.

There had been fifty years or more of craft production in the region and many innovative traditions preceded acrylic paintings in central Australia. I have already referred to the pokerwork designs produced by Namatjira and other Hermannsburg artists. The pokerwork technique, which used hot wire to etch out shapes on the smooth surface of wooden artefacts, developed in many parts of Australia from the early years of European colonization and even earlier. In many central Australian communities, particularly those associated with Pitjantjatjara people such as Areyonga, Docker River, Mutitjulu and Ernabella, a tradition of fine pokerwork carvings has developed. Although carvings are primarily for the tourist market, some of the larger examples must be included in the category of fine art (193). The market definition of the art form as 'tourist art' has failed to do justice to the aesthetic power of some of the best works.

192
Drawing of an ancestral design by a Warlpiri man, 1957. Pencil crayon on paper; 19 × 28·1 cm, 7$\frac{1}{2}$ × 11 in. Private collection

193
Perentie lizard, collected 1988. Pokerwork on wood; l.43·9 cm, 17$\frac{1}{4}$ in. Museum of Victoria, Melbourne

The Ernabella community, aided by the entrepreneurial craft adviser Winifred Hilliard, produced an exceptional range of artworks from the 1950s onwards. From a base of artefact production, there developed a women's tradition of painting and print-making based on decorative abstract designs. These were carried over into rug-making, using wool produced by the mission settlement, and finally transferred to batiks. It is useful to compare Ernabella batiks with Hermannsburg paintings. Both may have suffered because they represent art forms – textiles and watercolours respectively – that are relatively unfashionable in the fine art world, and because they appear to emphasize introduced forms. Ernabella batiks also had the disadvantage of being classifiable as a 'women's craft' at a time when such works were undervalued. Indeed, artworks from the centre were in general rarely accepted as fine art. Woodcarvings, like batiks, straddled the art/craft divide, and some

items, such as boomerangs and spearthrowers, were classified as ethnographic artefacts. It is quite conceivable that the batiks will eventually have a renaissance compared to the one enjoyed by Arrernte watercolours. The high-point of batik production coincided with the growth of interest in the acrylic paintings and the works have perhaps been underestimated as result. Nonetheless, many Ernabella batiks have been acquired by national collections (194). Certainly their vibrant colours and energetic compositions are reminiscent of later developments in painting at Utopia, Balgo and other Western Desert communities. Indeed, at Utopia the acrylic painting tradition followed the introduction of batik production.

The history of the influence of introduced art forms across Aboriginal communities has been neglected by researchers. While the introduction of a new technique or form was often facilitated by a craft adviser or art teacher from outside, the subsequent development of the tradition and its spread to other Aboriginal communities has often been as a result of Aboriginal initiatives. People from Yirrkala, for example, were inspired to learn the technique of batik making through the work of Ernabella women, and artists such as Naminapu Maymuru visited the community to learn how to produce them. Pokerwork carvings have spread across the Pitjantjatjara region as people have moved from one community to the next, as have acrylic paintings. People throughout the area have grown up with the idea that art and craft production is a meaningful form of practice.

194
Angkuna
Graham
(Kuyluru),
Batik,
1984.
Silk twill
and dyes;
93 × 376 cm,
36⅝ × 148 in.
National Gallery
of Australia,
Canberra

Thus by the early 1970s, when the Papunya artists began to paint, central Australia already had a long history of the production of commercial art and craft production. A number of other factors came together in the 1970s and 1980s to underpin the development of Western Desert acrylics. The early 1970s saw the evolution of the outstation movement in northern Australia, in which small groups moved out from main settlements to establish homes on their own land. Craft production was one source of income for such communities, and the return to the land provided a spiritual stimulus to artistic activity. Political pressure by Aboriginal people in the south of Australia and the land rights movement in northern Australia also resulted in better resourcing for

Aboriginal matters. One consequence of this was the formation of the Aboriginal Arts Board of the Australia Council and support for a federally funded marketing organization for Aboriginal arts. Moreover, during the 1970s and 1980s Aboriginal art gradually emerged as a symbol of more general significance to the wider Australian society. As a consequence it became increasingly visible as a component of design and marketing for a range of different products. Corporations and public bodies began to acquire Aboriginal art for the walls of the conference room and to use it to illustrate the front of their brochures. Most importantly, it was in the 1970s that the major state art galleries, in particular the Museum and Art Gallery of the Northern Territory in Darwin, began a systematic process of acquisition. All these factors, in retrospect, made it an opportune moment to launch a new desert art movement.

There was more discontinuity between the indigenous arts of central Australia produced for internal consumption and the works produced for sale than was evident in Arnhem Land. Whereas in Arnhem Land paintings produced for sale were often indistinguishable in form from paintings produced in ceremonial contexts, many objects manufactured in the centre – Hermannsburg watercolours, Ernabella batiks and poker-work carvings – had no place in indigenous ritual. The sacred art of central Australia remained separate from the mass market, partly because much of it was highly secret. Although sacred objects such as *tywer-renge* were made for sale up until the 1960s, they were never a popular art form and their sale was subsequently restricted. But the main reason may simply have been that in the societies of central Australia most sacred art was not in the form of paintings. Since painting has had such a dominant place in the value structure of the fine arts during the nineteenth and twentieth centuries, cultures that did not have painted forms found that the marketability of their work was limited.

Developing the right medium for the production of desert art for sale was not simply a matter of finding the appropriate raw materials for the artists to use. Had that been the case, then Western Desert artists would long have been producing art for sale. But the market demanded authenticity, and in part vested that authenticity in the raw materials

and techniques used as well as in the forms and design. Whereas artists in Arnhem Land apparently had a pre-existing medium – bark – for producing 'flat' paintings suitable for sale, desert communities did not. In the 1970s there was no sudden discovery of an indigenous medium that fitted commercial purposes; rather, the market changed its criteria. Geoffrey Bardon's great contribution was twofold: he seized on a medium that made the forms of desert art available to a wide external audience and helped to develop a market for the paintings that were produced; but just as important, he did so at the right moment.

The first Papunya paintings were quite successful in finding a market. Paintings were bought by Europeans working in the community and batches were sent by Bardon to the Stuart Art Centre in Alice Springs. Between July 1971 and August 1972, 620 paintings were put on sale there, and many more paintings were produced but remained unsold at the time. One painting, by Kaapa Mbitjana Tjampitjinpa (1920–89) won the prestigious Alice Springs Caltex Art Prize in 1972. These early paintings were produced on a variety of materials, including artist's board, plywood, linoleum and door panels.

Bardon has explained that 'the art movement from 1971 to August 1972 was not at first an acrylic paint movement.' He introduced acrylic paint in June/July 1972 as it was suitable to a type of pre-sealed masonite board that had been introduced by the Outpost Administration. However, 'during the early years of 1971/2 and during my further residency in 1973, paintings were completed using natural ochres, commercial house paints, high quality poster paint of the Plaka brand and PVA (Poly Vinyl Acetate) Bondcrete.' He encouraged artists to mix their own pigments to allow their paintings greater tonal subtlety and emotional responsiveness in the colours used (195). From 1973 onwards acrylic paints have tended to dominate.

Although they generated considerable interest, Western Desert paintings were not as immediate a success as the Arrernte watercolours had been, perhaps because in their form they remained true to the cultural traditions of the artists, perhaps because doubts were felt about their authenticity. The works were unlikely to be described, as Namatjira's had been, as 'indistinguishable from a White artist's', since they were

unlike anything that White artists had produced until then. But at the same time, they were made with introduced materials and explicitly for sale. They were ambiguous objects, located in the space between cultures. They had no obvious Western precursor – there was no Rex Battarbee to foreshadow them – yet they appealed to a modernist aesthetic. They had no obvious place in the history of Western art, yet in formal terms they could have represented a movement of the Western avant-garde. As objects they had no place in indigenous cultural practice, yet in their forms and designs, and in the constraints imposed on their production, they were unquestionably Aboriginal artworks. The paradoxical nature of Papunya art has worked to its long-term advantage, yet early on it caused resistance.

It was not until the 1980s that the artists of the Western Desert were accorded enough recognition for a few artists to begin to earn a living from their work. The decade of incubation was probably beneficial. It gave the Aboriginal people time to sort out the political implications of the sale of their designs and to ensure that the art retained its internal ritual value at the same time that its beauty was beginning to be appreciated by others. Although sales remained slow during the 1980s, artists continued to produce paintings and knowledge of the art form began to spread to wider European audiences. One of the Aboriginal Arts Board's initiatives was to encourage the appointment of craft advisers at different Aboriginal communities, not so much to advise on the production of art as to assist with marketing and management. After Bardon left Papunya in 1972, a series of craft advisers – including Dick Kimber, John Kean, Andrew Crocker and Daphne Williams – played a significant role in developing the market and increasing appreciation of the art. The Papunya artists themselves formed a cooperative, Papunya Tula Arts, which has continued to represent the artists and to market their works. A measure of their success is that by 1988 Papunya Tula had an annual turnover of one million dollars. Although the income has fluctuated greatly since then, income from painting continues to be a major component of the community's economy.

We must now consider the styles of Western Desert art in more detail. The painting tradition at Papunya has developed in complex ways over

195
Kaapa Mbitjana
Tjampitjinpa,
Untitled,
c.1972.
Acrylic on
board;
92 × 60 cm,
36¼ × 23⅝ in.
Museum and
Art Gallery of
the Northern
Territory,
Darwin

time. Early paintings show an enormous diversity of form, technique and composition. Many are quite stark in their form, comprising outline geometric figures closely related to ground sculpture or body painting design. Although the acrylic paintings were soon to be popularly characterized as 'dot painting', many of the early works had no dotted infill, or had dotting restricted to certain areas (see 78). Some of the early paintings included concentric patterns of dots outlining the geometric forms but combined them with other dotted motifs (196). They often included representations of sacred objects (197), human figures and animals. Nearly all were produced on small surfaces, not more than 60–120 cm (2–4 ft) square. Although the artists used most of the colours

196
John
Tjakamarra,
*Initiation
Ceremony*,
*c.*1974.
Acrylic on
canvas;
57 × 56 cm,
32$\frac{1}{2}$ × 22 in.
Museum and
Art Gallery of
the Northern
Territory,
Darwin

197
Johnny
Warrangula
Tjupurrula,
*Wild Potato
Dreaming*,
1972.
Acrylic and
ochre on board;
65 × 30 cm,
25$\frac{1}{2}$ × 12 in.
Private
collection

available to them, so that their paintings were often multicoloured, or even quite wild in their colour combinations, some painters used restricted palettes and developed colour preferences: for example, Johnny Warrangula Tjupurrula (b.*c.*1925) produced a number of boards using predominantly cream and pink (198), although on other occasions he used a kaleidoscope of colours. A popular range of colours – red, yellow, black and white – was similar to that employed in Arnhem Land bark paintings and perhaps reflected the colours used in indigenous ritual.

In the decade following the initial burst of creativity the tradition developed in a number of different directions. A narrower range of colours was used and many artists standardized the structure of their paintings. For a while the figurative element in paintings was greatly reduced: sacred objects ceased to be represented for internal political reasons, and representations of humans and animals became even rarer. There was an emphasis on paintings of classic simplicity based on interlinked concentric circles and U-shaped signs outlined with parallel lines of dots that filled in the whole surface of the painting. The paintings took on an appearance of abstraction and there was more concern with evenness of finish and fineness of execution. With the introduction of good-quality canvas boards the size of the paintings began to increase. By 1976 huge canvases were being produced, such as Clifford Possum Tjapaltjarri's outstanding *Warlugulong* series with Tim Leura Tjapaltjarri (see Chapter 4).

While the work of some artists became somewhat predictable, other artists continued to innovate. Clifford Possum Tjapaltjarri never ceased to include material culture objects and human and animal representations in his paintings. As the sociologist Vivien Johnson has shown, his paintings developed through a series of stylistic modes focusing at different times on different potentialities of the artistic tradition. In his early paintings he developed a number of representational schema for myth episodes; in his middle period he produced complex representa-

198
Johnny Warrangula Tjupurrula, *Water Dreaming*, c.1972. Acrylic on board; 50 × 50 cm, 19³⁄₄ × 19³⁄₄ in. Museum and Art Gallery of the Northern Territory, Darwin

199
Johnny Warrangula Tjupurrula, *Nintaka and the Mala Men*, 1973. Acrylic on board; 69.5 × 65.3 cm, 27³⁄₈ × 25³⁄₄ in. National Gallery of Victoria, Melbourne

tions of the relationship between landscape and ancestral track; and later still he placed more emphasis on the decorative effect of the techniques of infilling and formalized some of his compositions.

Johnny Warrangula Tjupurrula created an extraordinary layered effect – occasionally present in other artists' works, but perfected in his – by using patches of infill and sometimes by superpositioning one pattern on another (199). His infill seldom followed the contours of the main geometric figures for long, and different segments of the background showed different infilling techniques. The overall effect, at least to European eyes, was a multi-layered vision of the landscape in which

200
**Uta Uta
Tjangala,**
*The Old Man's
Dreaming,*
1983.
Acrylic on
canvas;
242 × 362 cm,
95¼ × 142½ in.
Art Gallery of
South Australia,
Adelaide

201
Turkey Tolson
Tjupurrula,
Straightening
Spears at
Ilyingaungau,
1990.
Acrylic on
canvas;
181·5 × 243·5 cm,
71¹₂ × 95⁷₈ in.
Art Gallery of
South Australia,
Adelaide

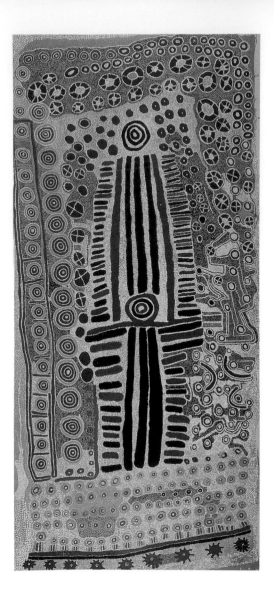

202
Paddy Jupurrurla
Nelson, Paddy
Tjapaltjarri
Sims,
Larry Jungarrayi
Spencer,
*Yanjilypiri
Jukurrpa,*
(*Star Dreaming*),
1985.
Acrylic on
canvas;
372×171·4 cm,
146½×67½ in.
National Gallery
of Australia,
Canberra

one saw through the clouds and the distributed features of the land-
scape to the ancestral world below. The development of these tech-
niques reached a very high level of complexity as early as 1973.

The paintings of Uta Uta Tjangala (*c*.1920–90) also have a distinct style,
characterized by the boldness and replication of the circle–line motif
associated with the Yumari myth (the motif represents rock holes and
camp sites linked to the journey of an old man who was punished after
having sexual intercourse with his mother-in-law), the restricted range
of his palette, the even quality combined with dynamism of form (200).

The diversity of Papunya art is extraordinary, yet at the same time the paintings are the product of an artistic practice that imposes constraints on what particular individuals can paint. The strictly controlled distribution of rights to produce certain designs means that the works of different artists are often related. People can only produce the Yumari paintings if they have the right to do so, and although their individual versions of the myth and landscape may differ, paintings from Yumari form a recognizable set. Many Papunya pictures are clearly built up on an underlying geometric framework that represents ancestral journeys and landscape features, but this is not true of all. *Straightening Spears at Ilyingaungau* (201) by Turkey Tolson Tjupurrula (b.*c*.1938), for example, consists of sequences of parallel lines, and the *Fire Story* paintings of Maxie Tjampatjimba (1945–97) appear to be purely expressive, with patterns of dots grading into one another to create a vibrant surface.

Papunya artists were joined later in the 1980s by artists from other communities in central Australia, notably Yuendumu, Lajamanu, Utopia and Balgo. This 'new' tradition of the Western Desert even spread to the Arrernte watercolour artists, some of whom, for example Wenten Rubuntja, began to paint in both styles. Each community has its own history, which is reflected both in the style and the organization of the art. Yuendumu is a long-established community northwest of Alice Springs with a predominantly Warlpiri-speaking population. Many of the early Papunya artists were Warlpiri (202), and there had always been considerable movement of people between the communities encircling Alice Springs. In the early 1980s a painting movement became established at Yuendumu, encouraged by the anthropologist Françoise Dussart among others. The movement was initiated by women artists who wanted to save money so that they could visit Adelaide. It was not until six months later that men joined them in making paintings for sale. The following year, 1983, in an episode reminiscent of the creation of the Papunya school murals, senior men were asked by the principal to paint designs on the doors of the new community school. In 1985 the co-operative Warlukurlangu Artists Aboriginal Association was formed.

The early paintings from Yuendumu had much of the vibrancy of the early Papunya art. They were characterized by the use of vivid colours

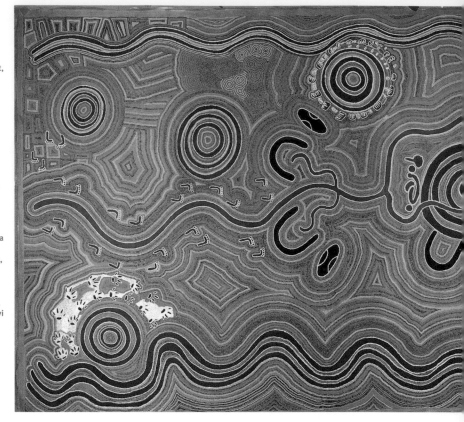

203
Jack Jakamarra
Ross, Darby
Jampijinpa Ross,
Paddy Jupurrurla
Nelson, Paddy
Japaljarri Stewart,
Harley Jupurrula
Nelson, Dolly
Nampijinpa
Daniells, Uni
Nampijinpa
Martin, Molly
Nampijinpa
Langdon, Lucky
Nampijinpa
Langdon, Bessie
Nakamarra Sims,
Jillie Nakamarra
Spencer, Long
Maggie White
Nakamarra,
Connie Nakamarra
White, Joanne
Nakamarra White,
Andrea
Nungarrary
Martin, Sheila
Napaljarri Brown,
Wendy Nungarrayi
Brown, Daisy
Napanangka
Nelson, Mariette
Naparrula Ross,
Joma Naparrula
Nelson, Maggie
Napaljarri Ross,
Rosie Nangala
Fleming, Ruby
Nampijinpa
Forrest, Pansy
Nakamarra
Stewart, Beryl
Napangardi
Robertson, Judy
Napangardi
Watson, Queenie
Nungarray
Stewart, Rhonda
Nakamarra
Spencer, Judy
Nampijinpa
Granites, Tilo
Nangala Jurra,
Liddy Napanangka
Walker, Biddy
Napanangka
Hutchinson, Vera
Napangardi
Marshal, Aileen
Napanangka
Nelson,
Karrku Jukurrpa,
1996.
Acrylic on canvas;
280 × 680 cm,
110 × 267½ in.
Kluge-Ruhe
Aboriginal Art
Collection,
University of
Virginia

and often by asymmetrical forms. They developed differently, however, in part because of the way the cooperative organized art production. Yuendumu paintings have been centred on the mythology of landscape, and the movement has always been more group oriented. Whereas the Papunya Tula artists cooperative has often been effective marketing the work of individuals, the Yuendumu organization is more active on behalf of groups of artists. One result has been the production in the late 1990s of major large-scale commissioned works with groups of artists collaborating on the same canvas. These projects begin with a visit to the site to be depicted in the painting and are deliberately organized as a means of keeping people in touch with their land and of passing on knowledge of places, designs and songs to the next generation. Young and old work together on paintings – even quite small children are encouraged to participate. Each commission focuses on a different site as part of a system of community education.

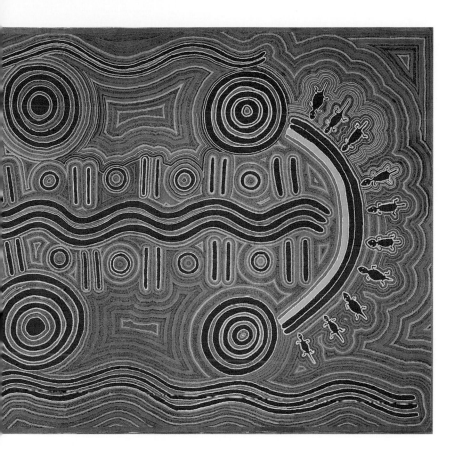

In effect these commissions exploit the opportunities created by a global interest in Aboriginal art to reinforce continuing cultural practices. Yuendumu artists must ensure that these gigantic collaborative canvases succeed as works of art. They have to encourage institutions to commission them in advance, since the costs of producing them would otherwise be prohibitive. Although the paintings depend on the market, their form and scale are not market driven, but reflect the artists' determination to maintain control over their production.

Karrku Jukurrpa (203) was commissioned in 1996 for the collection of John Kluge. Twenty-nine women and five men contributed to the canvas which was documented by Susan Congreve, the arts adviser of Warlukurlangu arts, and interpreted for me by Françoise Dussart. The painting is oriented from top to bottom in a north–south direction. In the southwest corner we can see the footprints of the anthropomorphic dogs who gather at Windijarru. The painting represents a wide range of

mythological elements some of which are only tangentially related to the main story. The painting is centred on the ochre mine inside the mountain at Karrku in the Campbell Ranges west of Yuendumu, which is represented by the set of concentric circles in the centre of the canvas. The mine is associated with the mythical ochre bearer, who travels from east to west looking for a place to deposit the great store of ochre that he carries with him. The ochre man is associated with two ancestral women, sisters with whom he had a lusty encounter. By the time he approaches the mountain at Karrku he is handicapped with his burden

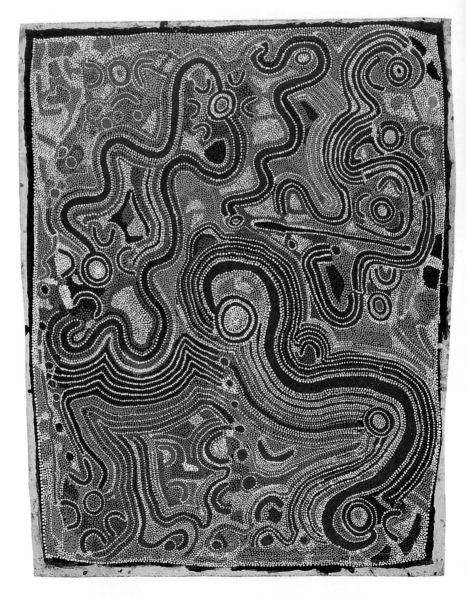

204
Paddy Tjapaltjarri Sims, *Witchetty Grub Dreaming at Kunajarrayi*, 1986. Acrylic on canvas; 136 × 108 cm, 53$\frac{1}{2}$ × 42$\frac{1}{2}$ in. South Australian Museum, Adelaide

and carries it on top of his head. He hears the *ngappa* (rain) Dreaming approaching. The rain passes over the country. The great arc represents a rainbow that appeared a number of times during breaks in the storm. The eight small concentric circles running between Karrku mountain and the rainbow represent clouds and the parallel lines on either side lightning. In the face of the storm the ochre man retreats into the mountain shelter. The mountain itself appears to grow. In one version of the myth the old man makes a lasso of hair-string, represented by the green line in the painting, with which he reins in the mountain. In a second version a snake vine is used by the two sisters for the same purpose. The two sisters had travelled from the west, the pathway shown by the footprints following the vine, searching for rain. At last they find a waterhole, drink and fall asleep, the two semicircles representing the women. While they sleep the ochre man has inter-course with them. The women awake and return from where they came, following the rainclouds. They perform ceremonies on their journey, hoping all the time for rain but it never falls and the two women perish in the desert. Their bodies are represented by the concentric circles in the northwest quadrant of the canvas.

Yuendumu artists also produce individual works, and just as with the Papunya Tula, many artists' works can be identified on stylistic grounds. The elaborately coloured and intricately composed asym-metric designs of Paddy Tjapaltjarri Sims (b.*c*.1916), with their charac-teristic combination of reds, greens, pinks and yellows, are easily recognizable (204). In contrast, the paintings of Jeannie Nungarrayi Egan (b.1948) tend to be much more tapestry-like in their patterns, with a balance of colours chosen from a more restricted palette (205).

The other painting communities of Lajamanu, Balgo and Utopia also show stylistic differences reflecting their local cultural traditions and the nature of their contemporary communities. Lajamanu (Hooker Creek) provides an interesting contrast to Yuendumu, especially as the community is also predominantly Warlpiri-speaking and many people living there moved from Yuendumu in the 1950s. It is associated with stark paintings using the same basic design elements as occur at Yuendumu but with predominantly white dotted background infill (206).

205 Overleaf
Jeannie
Nungarrayi
Egan,
*Jangampa
Jukurrpa
(Possum
Dreaming)*,
1996.
Acrylic
on canvas;
76 × 180 cm,
30 × 70⅞ in.
Private
collection

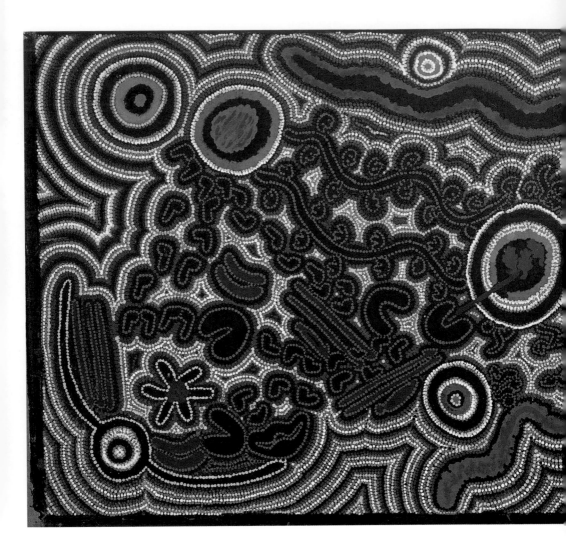

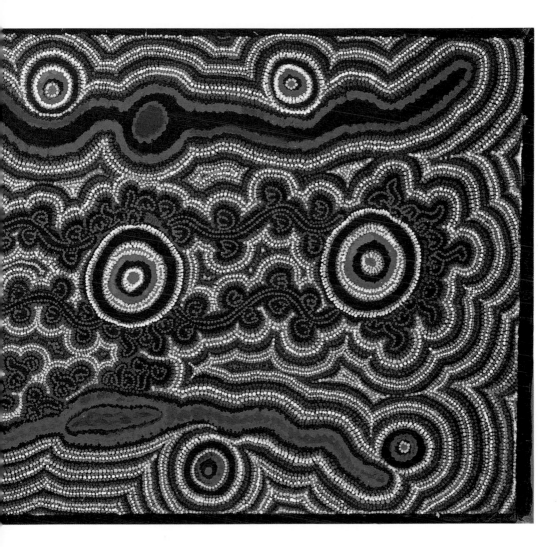

Balgo is situated on the edge of the Great Sandy Desert in Western Australia, a considerable distance from most of the other art-producing desert communities. Nonetheless, the ceremonial links between Balgo and the communities further to the south are very strong. Thus Balgo people were certainly familiar with the developments that occurred at Papunya and Yuendumu. However, Balgo also has strong links with groups in the Kimberleys to the north and eastwards into the Northern Territory, a factor which helps to explain the diversity of styles within the community. The first exhibition of Balgo work produced for sale was not until 1986. Balgo artworks have been produced from the beginning by both men and women; many of the paintings have underlying geometric designs of landscape and the journeys of the ancestors across them, but they are less constrained by the particularities of group affiliations than either Papunya or Yuendumu art. This reflects both the more flexible structure of society in the least densely populated regions of the Western Desert and the diversity of groups represented at Balgo.

The use of colours at Balgo is as eclectic as at Yuendumu, with an emphasis on brilliant colour effects. Artists employ very different effects of infill: some use broad washes of colour similar to the Turkey

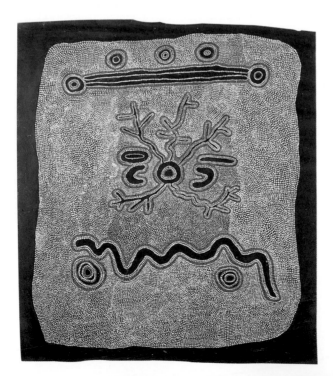

206
Louisa Napaljarri Lawson, *Witchetty Grub Jukurrpa,* 1989.
Acrylic on canvas; 162·6 × 137·2 cm, 64 × 54 in.
Private collection

Creek paintings, others use various dotting techniques. Donkeyman Lee Tjupurrula (c.1921–93) built up ridges of colour that gave his paintings an extraordinarily textured effect (207). By the late 1990s many of the artists had developed very individualistic styles. Eubena Nampitjinpa (b.c.1930) with her husband Wimmitji Tjapangati (b.c.1925) began by producing delicate, almost filigree-like, paintings of waterholes, soaks and dunescapes characterized by minute but dense patterns of dots (208). By 1996 Eubena's paintings had become more abstract, so that it was harder to discern the underlying structure of watercourses and hills. The dots that had overlapped in some of the earlier paintings began to merge with each other to produce densely worked surfaces. Her paintings of the later 1990s employ bright colours – yellow, red and orange, with occasional features in black or bark brown – which tend to merge into each other in a fashion strongly reminiscent of Abstract Expressionism (see 175).

North of Alice Springs, Utopia was established as an Aboriginal community for Alyawerre and Anmatyerre people in 1977, when they took over a former cattle station. Utopia first became renowned in the 1970s and 1980s for its batiks, which were produced both as artworks and as textiles for clothes. Many Utopia batiks consisted of repetitive floral or

207
Donkeyman Lee
Tjupurrula,
Tingari at
Tarkun,
1990.
Acrylic on
canvas;
180 × 120 cm,
70½ × 47 in.
Kluge-Ruhe
Aboriginal Art
Collection,
University of
Virginia

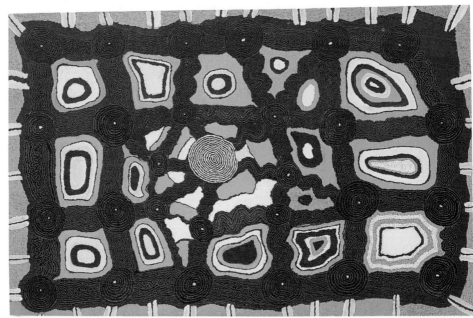

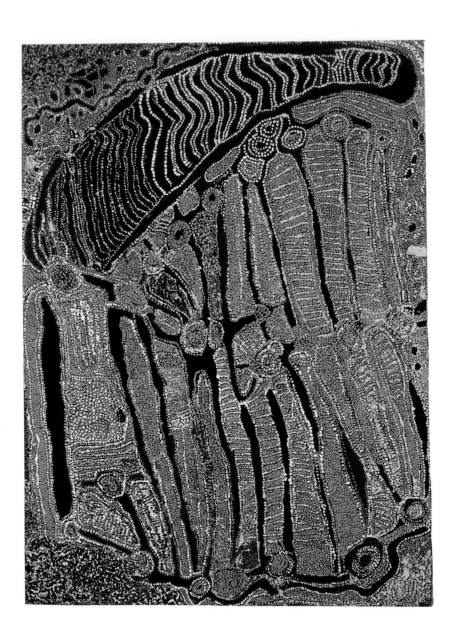

decorative motifs; however, in contrast to the Ernabella tradition, the artists of Utopia also based their works on traditional stories. Indeed, some batiks look remarkably similar to acrylic paintings from other communities because of their reference to landscape. It was not surprising, therefore, that by the late 1980s many women had begun to paint instead of making batiks. A number of men also began to produce paintings, but the best-known artists from Utopia are a group of women who include Emily Kame Kngwarreye (*c*.1910–96), Gloria Petyarre (b.1938), Kathleen Petyarre (b.*c*.1930) and Ada Bird Petyarre (b.*c*.1930). Kathleen Petyarre's painting (209) won the 1996 Telstra National Aboriginal and Torres Strait Islander Art Award and was subsequently embroiled in controversy when her non-Aboriginal former *de facto* husband, Ray Beamish, claimed authorship of it. However, an official enquiry established Petyarre as owner of the design and creator of the work, although it was not disputed that Beamish had assisted Petyarre, which is consistent with the collaborative nature of Aboriginal art. The controversy nonetheless poses interesting questions about the bounded nature of Aboriginal art, issues that will be taken up in Chapter 11.

The paintings of these women show considerable continuities with Utopia batiks and often have the feeling of textiles about them. Gloria and Kathleen Petyarre's paintings are characterized by a meticulous dotting technique which creates a moving surface where patterns emerge and blend in with each other. The optical effects created are reminiscent of Op Art, a characteristic shared with paintings from other regions of Australia. The underlying geometric structures of their paintings are similar to those of the earlier work of Emily Kame Kngwarreye.

Emily Kame Kngwarreye began to paint only in her late seventies, but her work had an immediate impact. Her first paintings consisted of an underlying structure of geometric forms, often including plant and animal representations, which were then overpainted with lines of dots which followed and overlapped the contours of the outlines (210). As she developed this style of painting, the underlying figures became almost submerged beneath the surface pattern of dots. In contrast to the classic forms of Papunya and Yuendumu art, these did not follow the contours of the designs but sometimes even contradicted them.

208
Wimmitji
Tjapangati,
Artist's Father's Country,
1990.
Acrylic on canvas;
120 × 90 cm,
47$\frac{1}{2}$ × 35$\frac{1}{2}$ in.
Gallery Gabrielle Pizzi, Melbourne

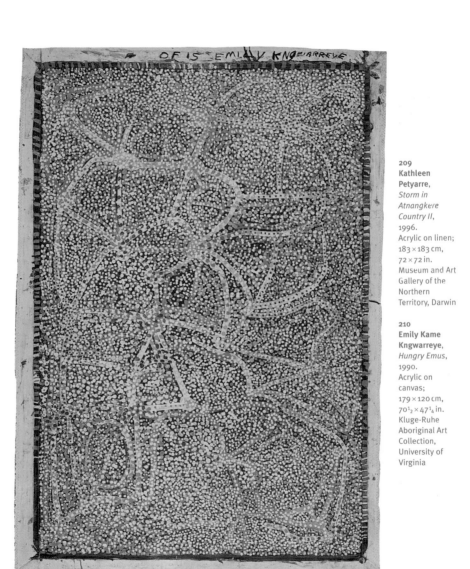

209
Kathleen Petyarre, *Storm in Atnangkere Country II*, 1996. Acrylic on linen; 183 × 183 cm, 72 × 72 in. Museum and Art Gallery of the Northern Territory, Darwin

210
Emily Kame Kngwarreye, *Hungry Emus*, 1990. Acrylic on canvas; 179 × 120 cm, 70½ × 47¼ in. Kluge-Ruhe Aboriginal Art Collection, University of Virginia

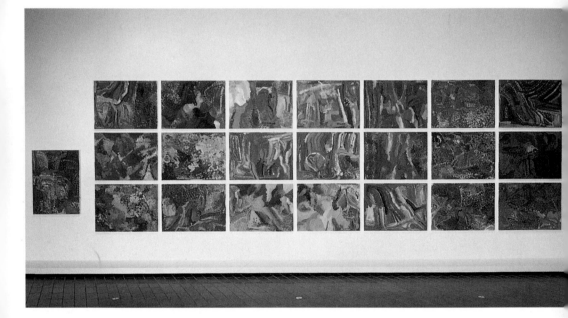

211
Emily Kame
Kngwarreye,
Alhalkere Suite,
1993.
Acrylic on
canvas;
22 panels, each
panel:
90 × 120 cm,
35½ × 47¼ in.
National Gallery
of Australia,
Canberra
Opposite
Detail showing
one of the
panels

Sometimes patches of different tones reflect the existence of underlying patterns without directly reproducing them; such paintings are reminiscent of the background in some of Johnny Warrangula Tjupurrula's work. Kngwarreye later developed a painting style which was all surface form, with a flowing pattern of dots of different colours and varying sizes. She changed her style frequently. In 1995 she produced an extraordinary many-panelled painting using bold purples and pinks for the National Gallery of Australia which has a strongly expressionist feel (211). Later still she produced a series of stark bichrome linear designs based on body-painting designs; these were exhibited posthumously at the 1997 Venice Biennale (212).

Emily Kame Kngwarreye's paintings have an enormous appeal because they echo so many themes in the recent history of European art, they are executed with painterly fluency, and they exhibit such richly textured colour effects. As her style has also appeared to change systematically yet in unexpected ways over time, her works fit well the criteria and expectations of a modernist aesthetic. Yet it is also possible to see echoes of each of her styles In the work of other Western Desert artists – the background effects of Johnny Warrangula Tjupurrula, or the scattered dots of Maxie Tjampatjimba – and the aesthetic effect of her paintings, along with much of the art of central Australia, is that of works that shimmer and vibrate, that create an illusion of movement.

Western Desert acrylic paintings have achieved an extraordinarily widespread reputation since they were first produced in the early 1970s. Unlike much non-European art, Papunya paintings were never art by metamorphosis: objects that began life with some other purpose but were converted by the European market into works of art. The paintings missed out the stage of being primitive art altogether and became almost overnight part of Australian contemporary art. They were produced by their makers as art for sale and from the beginning were as likely to be bought for an art gallery as a museum. However, they have also remained slightly ambiguous objects that could be placed in any number of different categories according to emphasis.

Eventually, when a detailed history of the process of recognition comes to be written, it will reveal a complex and at times contradictory story.

The first sets of paintings sold to the Stuart Art Centre in Alice Springs sold reasonably well, but had very little wider impact. But instead of dying, the tradition carried on, supported in part by the Aboriginal Arts Board, which underwrote the costs of a craft adviser and provided a market for the paintings in exhibitions and as gifts to institutions.

The paintings changed and developed, and by the time interest in the market had begun many of the paintings were very different from the ones that had been first produced. These later paintings were the first to achieve high prices. But then in the 1980s and 1990s the early paintings were rediscovered and collectors began competing for them. It is unclear if this is the result of a historically sensitive market trying to acquire the precursors of a contemporary tradition or an exercise in 're-primitivization' by metamorphosing the paintings back into primitive art and attributing authenticity to the earliest ones produced! If the latter is the case, it is unlikely to succeed, since the art continually reasserts its contemporary nature. The first acrylic paintings appeared after one hundred years of European colonization in central Australia, and forty years after Albert Namatjira first began painting in watercolours. To Clifford Possum Tjapaltjarri, Namatjira's watercolours are as much part of his heritage as an artist as the designs of desert ground sculptures or body painting art. Batik designs were part of Emily Kame Kngwarreye's heritage as much as the body designs that influenced her later paintings. Western Desert art, in common with the art from Arnhem Land and elsewhere, is a dialogue between the present and the past in the context of the ever widening world in which people live.

Settler Australia The Survival of Art in Adversity

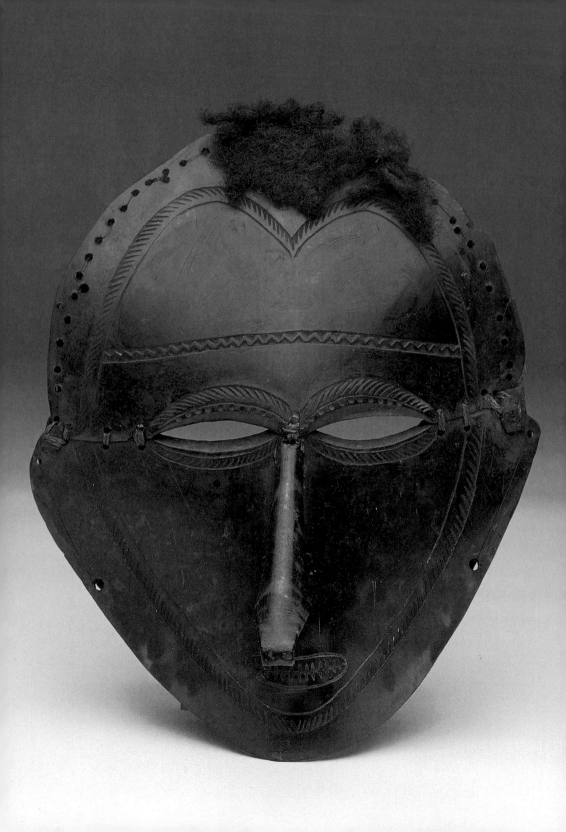

In some parts of Australia Aboriginal art almost lost contact with the Dreaming for more than a century. Aboriginal people as victims of colonialism, deprived of their land, decimated by disease, murdered and dispersed, often forcibly separated from their children, found it difficult to continue their ceremonial life. Indeed, it was taken for granted by the wider society that Aboriginal art had disappeared from the southeast by the end of the nineteenth century. Aborigines entered a period of invisibility when they were no longer thought of as a presence in the land. They had no place in the received history of southern Australia between the middle of the nineteenth century and the re-emergence of 'Kooris' (as some Aborigines of southeast Australia refer to themselves) as a political and cultural force in the second half of the twentieth century. European 'vision' and political practice separated Aboriginal people in the southeast from their past and imposed a discontinuity between the 'real' Aborigines of the past and the 'less real' ones of the present.

Aboriginal art from the southeast, as the Europeans came to understand it, was constituted not beyond the frontier, nor on the frontier, but after the frontier had long since passed. The great nineteenth-century collector of artefacts in Victoria, R E Johns, whose acquisitions formed the basis of the Bourke Museum collection in Beechworth, Victoria and who contributed significantly to many others, may never have known any Aborigines (though in his capacity as a police magistrate it seems likely he would have had some involvement with them). Certainly, his collection came second hand from other collectors, friends and relatives, and from salerooms. It was part of a distancing process that separated Aboriginal people from their culture.

However, the collections made by Johns and others, together with the artefacts and paintings from central and northern Australia, formed the basis from the 1940s onwards for the recognition of Aboriginal art. This recognition occurred initially within the paradigm of 'primitive art'.

213
Ceremonial mask from Torres Strait Islands, c.1890. Turtle shell and human hair; h.28 cm, 11 in. Cambridge University Museum of Archaeology and Anthropology

Aboriginal art was 'discovered' as a traditional form independent of European art and uncontaminated by contact with European cultural forms. In a colonial state such a paradigm is essentially conservative: 'primitive art' is recognized so long as it remains unchanged. Aboriginal art and its relationship to the world was defined and mediated through the European world-view. This caused problems for Aboriginal people throughout the south of Australia, surrounded as they were by European cultural forms and educated in European institutions. The uncontaminated 'primitive art' of southeast Australia was produced in the early years of European colonization by people several generations removed from the 'present' of the 1940s. Art that Aboriginal people had subsequently produced was influenced by their colonial experiences, incorporating recognizably European forms and techniques, and as such not seen as Aboriginal art. The label 'Aboriginal' thus designated precolonial art rather than the more inclusive category of art produced by Aboriginal people. 'Authentic' Aboriginal art was thought to have been produced by an imagined population belonging to the past, while living Aboriginal people were thought to produce an inauthentic assimilated art, imitative of European forms.

For most of Australia's history government policy was assimilationist: its aim was to absorb Aborigines into the wider population, to eliminate signs of difference. So while 'traditional' Aboriginal art of the nineteenth century began to gain in recognition, value did not accrue to those artists who continued to show its influence. Artists who painted in contemporary Western styles also largely went unrecognized and their work was not considered to be Aboriginal art.

As Aboriginal people in southeast Australia became a political force through their civil rights campaigns of the 1960s, the art they produced again became visible. A question emerged: 'How could it be that authentic Aborigines did not produce authentic Aboriginal art?' Exclusion from the category of 'Aboriginal art producers' (a category in which the people of Arnhem Land and the desert were allowed to exist) came to be interpreted as a sign of the denial of Aboriginality, and the development of a more inclusive concept of Aboriginal art became a political issue. The use of the term 'Koori' rather than 'Aborigine' is a

sign of people asserting their own identity and moving away from an externally imposed definition of Aboriginality. It is a sign of autonomy and continuity, of integration rather than assimilation. 'Koori' had long been used by Aboriginal people of New South Wales and Victoria among themselves, but it finally became a public label in the 1960s.

Since the 1960s the position of Aborigines in southeast Australia has changed in ways that have brought continuities with the past back into the open. Kooris have reconnected themselves to their history. Late nineteenth-century artists, such as William Barak (1824–1903), have gained in stature, and continuities in craft production over time have also been recognized. At the same time the fundamental contradictions underpinning the primitive art market have been exposed and challenged. It is now acknowledged that most of the 'traditional' Aboriginal art to be found in Western institutions was produced for sale by Aboriginal people who had been affected by colonial processes, and that from the beginning of the colonial era Aboriginal art has been linked to the politics of survival. The work of contemporary Koori artists such as Trevor Nickolls (b.1949), Lin Onus (1948–96) and Robert Campbell junior (1944–93) is now recognized as being an expression of their Aboriginality, a product of their particular history and a symbol of the survival of their Koori identity.

Let us look at the history of colonial southeast Australia in more detail. The initial contacts in the region between Europeans and Aborigines give little warning of things to come. The early voyagers sought knowledge of *Terra Australis* and its inhabitants, while always bearing in mind its economic potential. Their instructions from home were usually to respect the life and rights of the people they encountered and to establish friendly relations, to retreat rather than to engage, and to avoid conflict. On the whole they did avoid conflict, perhaps because Aboriginal people largely avoided them, although we have seen how even in the case of the well intentioned, such as Flinders, things did not always turn out for the best.

It was on these early voyages that Aboriginal art was recorded by Europeans for the first time, and in this process we can often see the shape of things to come. The bark art of Tasmania is known largely from

the visit of the French explorer Nicholas Baudin's expedition to Maria Island off the east coast. On 19 February 1802 Jean-Baptiste Lescenault, the expedition's botanist, came across two 'unusually well-made huts joined together'.

I saw another one that appeared to be knocked down. I was struck by the length and thickness of the bark and went nearer to examine it. I then realized that what I had taken for a shelter was a carefully arranged mass of bark covering a hemispherical mound. Turning over the pieces of bark, I discovered that they were covered with lines deliberately made, which resembled the tattooing of these people.

This was no ordinary mound but a burial place: pieces of bone were found buried in a pit in the middle (214). On departure the visitor 'restored as much of it as I was able in the same arrangement as I

found it'. On the same day the expedition's geographer, Françoise Péron, found a similar hut on the opposite side of the island at Oyster Cove. It too covered a burial.

During the four days spent on the island, the voyagers encountered the same group of Aboriginal people on several occasions, and described them as being somewhat depressed. As Ed Ruhe, an American collector of Aboriginal art and a professor of English, speculates, this was probably a burial party from the mainland and the group must have included relatives of the dead. However carefully the bones were reburied and the slabs replaced, this 'discovery' of Tasmanian art involved the disturbance of a grave, and would undoubtedly have caused anxiety to the local population.

During the next twenty-five years of Tasmania's European history there were no more reports of Aboriginal art, and during this time the population was decimated and dispossessed of its land. It was only towards the end of this period, when the Aboriginal people were finally to be driven away from their land into exile, that other reports of bark shelter art begin to appear. In 1827 the surveyor Henry Hellyer reported finding huts in northern Tasmania covered with charcoal drawings of animals and symbols, and later George Augustus Robinson, who travelled through the interior rounding up Aborigines for incarceration on Flinders Island settlement, provided similar descriptions. Rather than stimulating interest in Aboriginal culture, however, these reports gave rise to a new and somewhat bizarre instrument of control. Surveyor-General George Frankland wrote to Governor Arthur on 4 February 1829:

I have lately had the opportunity of ascertaining that the Aboriginals of Van Diemen's Land [Tasmania] are in the habit of representing events by drawing on the barks of trees, and that the march of certain Europeans over a country before unfrequented by us, was found by us a short time after drawn with charcoal on a piece of bark. The carts, the bullocks, the men, were distinctly represented, according to the exact number that really existed.

This revealed to Frankland 'a newly discovered faculty' which in turn could be used to communicate the government's wishes to the Aboriginal people. The result was the famous 'Proclamation of Governor Arthur to the Aborigines' (215). In a form of European naïve art the proclamation depicted the consequences of violence and the neutrality of the law, with the death of an Aborigine at the hands of a European and the death of a European at the hands of an Aborigine resulting in the same mortal punishment. The proclamation had little time to achieve its educative effect, for within four years the remaining Aboriginal population had been removed from the island. The deaths of so many had gone unavenged.

Although there are a number of descriptions of Tasmanian art, little of it is extant and few illustrations were made. The fragments of evidence suggest an art as abundant and diverse as elsewhere on the continent, with figurative and geometric forms and a significant role in mortuary

rituals. We know of the technical skill of the Tasmanians from the weapons, models and woven bags produced in the years of incarceration on Flinders Island and subsequently at Oyster Cove. And we know something of the aesthetics of body decoration and ornament from the portraits (216) of the Tasmanian artist Thomas Bock (1790–1855) and the shell necklaces that continue to be made. Bock's portraits convey a gentle beauty that belies the horrendous recent history of the Tasmanians and contradicts the subsequent stereotypes of Tasmanian society that made them into archetypal representatives of primitive society. The shimmering brilliance and delicacy of the necklaces connect the aesthetics of Tasmanian society with that of their mainland neighbours.

Despite the terrible history of colonialism, Tasmanians continue to produce artworks. There are items that connect with the past technologies – fibrework, basketry and the long-stranded shell necklace (217) – and items that use new technologies — the photographs of Ricky Maynard (b.1953), the mixed media works of Julie Gough (b.1965) and the ceramic works of Jennie Gorringe. Ricky Maynard's *Moonbird* series illustrates the life and environment of the mutton-birders of Cape Barren Island (218). His intention is to create a collaborative photography in which the subjects are involved in the enterprise and not only give their consent to the images being taken but influence the form the photograph takes. In this way Maynard, through his artistic practice, challenges the positioning of Tasmanian Aboriginal people by outsiders and highlights the lack of consent that has characterized their treatment by Europeans since the invasion of their lands.

Tasmania represents in microcosm events that were occurring all over southeastern Australia. In Tasmania the colonial process was speeded up, and the consequence for the indigenous population was, if possible, more disastrous than elsewhere, and the record of the local culture was more fragmentary. But for much of southeastern Australia the difference is only a matter of degree.

In 1788 the leaders of the First Fleet, too, came with good intentions. Arthur Phillip was determined to avoid conflict with Aborigines, to develop a cooperative venture and not to interfere too much with their

215
Proclamation of Governor Arthur to the Aborigines, c.1829.
Oil on pine;
35.7 × 22.6 cm,
14 × 8⅞ in.
Mitchell Library, State Library of New South Wales, Sydney.
At the top right the petition has been misattributed to Governor Thomas Davey (1758–1823) by a later archivist

216
Thomas Bock,
Manalargenna carrying a fire-stick,
1834.
Watercolour on paper;
29.3 × 22 cm,
11¹⁄₂ × 8³⁄₄ in.
Pitt Rivers Museum, University of Oxford

217
Three shell necklets, Tasmania, outer two collected *c*.1900–10, inner one collected before 1865.
l.118 cm × 46¹⁄₂ in, 94 cm × 37 in, 37 cm × 14¹⁄₂ in.
Pitt Rivers Museum, University of Oxford

218
Ricky Maynard,
Jason Thomas, Terry Maynard and David Maluga gathering the dead birds ready to be put on the spit,
image from the *Moonbird People Project*,
1985.
Australian Institute of Aboriginal and Torres Strait Islander Studies, Canberra

lives. But as W E H Stanner has shown, this was doomed from the start. Phillip wanted the relationship on his own terms. He saw Aborigines as providing a service, assisting with hunting and divulging their knowledge of the land and its resources. He distributed gifts as a gesture of goodwill before a relationship formed, and with no idea of how the gifts might be interpreted – he gave them not as a sign of a relationship but as a sign of power. He envisaged using Aborigines to help develop the resources of the land, but he never considered that they might see the resources as their own and his seizing of them as an unwanted invasion.

Many of the early conflicts were over resources. The Europeans caught large numbers of fish and thought their act of handing a few over to the Aborigines was a generous one. They were surprised when Aboriginal people treated the resource as if it were their own and took more. Phillip could not set up a meaningful exchange because he failed to acknowledge the values of the Aboriginal people of the Sydney region, as well as to recognize their rights and the importance of what they knew and controlled. For the Aborigines it must have seemed that the world, which had been regulated and meaningful, had become a lawless one almost overnight.

The Dharuk and other peoples of the Sydney region attempted the same process of persuasion that occurred later in other parts of Australia. The European invaders of Sydney Cove were introduced to the religious life

of Aboriginal people, and there are many early accounts of Europeans attending ceremonial performances, some of which may have been organized specifically for their entertainment and enlightenment (219). Governor Hunter describes one such event in 1893:

When they were all prepared we walked down to the place appointed, after dark, for they prefer taking their amusement by firelight ... The dancers being ready we were placed in a circle by Bana-lang and Co-al-by, who seemed to have the chief authority and direction ... their dancing was wild and savage, yet in many parts, there appeared order and regularity.

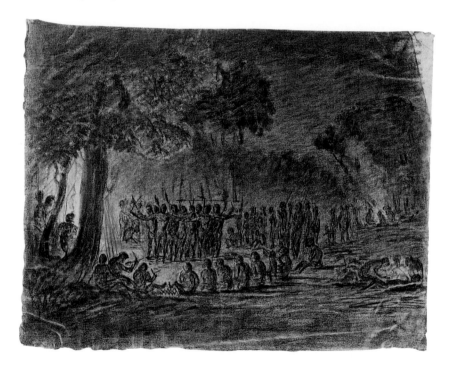

Thus Aboriginal culture and society contradicted European preconceptions, and Europeans found themselves entertained by Aboriginal performances. But the invaders were reluctant to acknowledge this.

In the southeast Aboriginal people were soon removed from areas of European settlement to a restricted life on reserves and mission stations. Appreciation of Aboriginal culture waned and caricature of Aboriginal people gained ascendance. In the state of Victoria Aboriginal culture was repressed and ceremonial performances banned. In 1887

the newly appointed governor of Victoria, Sir Henry Loch, requested a corroboree be put on for his benefit. But even as a form of entertainment for a high political figure, corroborees, representative of Aboriginal religion and culture, were considered too dangerous to be sanctioned. None of the mission or government authorities would allow Aborigines to perform their traditional rituals. The gift of a painting by William Barak of Aboriginal dancers was substituted. Nonetheless, Aboriginal dance performances were sometimes put on as public exhibitions at mission stations such as Coranderrk.

As the nineteenth century moved into the twentieth the situation for Aborigines in southeast Australia deteriorated. They had been driven from their lands to be contained in mission stations and government settlements, but even this was considered to give them too great a presence. Colonists competed for the tiny areas of lands reserved for Aborigines, and they were dispossessed from most of them. Coranderrk Aboriginal Station in Victoria, for example, which had been a successful and well-managed self-sufficient Aboriginal farming community, was disbanded in 1917 and the land handed over to European interests. Aborigines were moved on, forced to live in ever smaller groups or concentrated at the government settlement of Lake Tyers. Their children were often taken away from them and placed in homes or fostered out. The process of dispersal, begun with the gun in the initial stages of colonization, continued into the mid-twentieth century through administrative edict and general harassment.

There are nineteenth-century parallels for most of the events that were to occur in Arnhem Land and central Australia in the twentieth century. But whereas in Arnhem Land it is possible to weave events into a story that appears to go somewhere, that heads towards a greater understanding of Aboriginal people and some recognition of Aboriginal rights, it is harder to see any pattern in the events of the nineteenth century. We have seen that Aboriginal people in southeast Australia tried very similar strategies to those pursued later in the north and the centre. They tried to persuade Europeans of the value of their culture, they tried to involve them in exchange relations, they were happy to put on ceremonies for them and they continued to petition for recognition of

219
Charles-
Alexandre
Lesueur,
Corroboree,
c.1802.
Charcoal
on paper;
19.5 × 25 cm,
7⅝ × 9⅞ in.
Musée
d'Histoire
Naturelle,
Le Havre

their rights. But the majority of White Australians were utterly uninterested in developing a dialogue and had no wish to understand or share values with Aboriginal Australians. Their petitions continually fell on deaf ears.

The objects that remain from this time become signs not of the transactions of which they were a part, nor of the lives of people who were struggling to exist in conditions of adversity, but of a distanced Aboriginal past that preceded the process of destruction. They become signs of the 'disappearance' of Aboriginal people, not of their continued struggle for existence. As signs that their producers no longer exist, these objects collude with the very processes that their makers were trying to slow down or even reverse.

In the southeast of Australia the narratives are about the dispersal of the Aboriginal population and their near-extinction. The objects become signs of a particular version of the past; events that suggest a different course are obscured or become difficult to interpret. It is the responsibility of the historian to reconnect those objects as signs with the real events that produced them. And it is in this process of reinterpretation that the nature of Aboriginal agency and motivation becomes clearer.

There was a keen trade in artefacts from the earliest encounters. David Collins, one of the First Fleet officials, wrote that: 'most of us have made collections of their spears, throwing sticks etc. as opportunities have occurred'. It is likely that even at this early stage many of these weapons were made specifically for trade, and trade quickly became a part of ongoing tradition. The authorities saw no need to ban the manufacture of material culture objects; indeed, it was encouraged at many of the government settlements and mission stations. The emphasis in the early collections from the southeast on shields, boomerangs, spears and spearthrowers reflects a general nineteenth-century European interest in weaponry. It also reflects the aesthetics of their forms.

Many of the weapons of southeast Australia are elaborately decorated with engraving and earth pigments. Their intricately carved patterns, in which geometric forms outlined with sequences of incised parallel designs flow into one another, cover the surface of the object (220).

Sometimes the design includes a central figurative motif (221). The aesthetic effect that results is characteristic of weapons from New South Wales and Victoria. The rich colours of the burnished wood contrast with the sharply ribbed surface effect of the engraving, adding a texture and variety that alters according to conditions of light and angle of viewing. However, it is important to remember that we are not viewing the objects as they originally looked. In many cases the incised patterns were infilled with clays and ochres and the raised surface of the central motifs was painted in the same or contrasting colours (222). From the few that are still in near pristine condition we can see that the effect is stunning. But most examples that survive in museum collections have become pigmentless with age and handling – they gain an austere beauty, a worn and patinated elegance reminiscent of antique furniture, but they lose their original vibrancy. Not all weapons were decorated in such elaborate ways. Some remain largely unembellished; others have single outline patterns and figure compositions either engraved or burnt into the surface. Over time there was a move away from intricately carved and painted forms.

The manufacture of weapons for sale continued until the beginning of the twentieth century. William Barak and Tommy McRae (c.1830s–1901), both better known today for their drawings and paintings (see Chapter 10), were skilled craftsmen who produced a range of artefacts for sale. Aboriginal involvement in artefact manufacture, particularly of boomerangs, continues to the present in parts of the southeast, but the weaponry collected and exhibited as art belongs primarily to the nineteenth century.

These artefacts entered a global exchange system, prefiguring events a hundred years later in Arnhem Land. But the chain of exchange was discontinuous and the objects lost their identity in the process. Like the people, they were dispersed and scattered. For the nineteenth and early twentieth centuries the connection between the object and the societies that produced them is weak; not even the most basic information survives. In all but a few cases it is not known who made an object, who used it, where and when it was made and what it was used for. Nothing about the cultural context and meaning remains, nor any first-hand

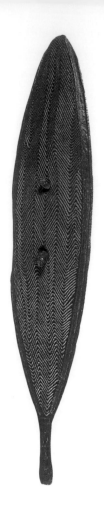
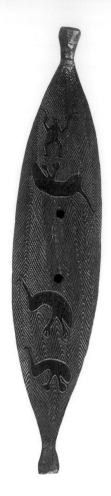

information about the methods of manufacture, the raw materials used
and what their significance might be. It is possible in many cases that
this information has been lost for ever. The rate of attrition for documen-
tation in museum collections has until recently been devastating. Old
labels wear out and the information on them is not copied. Each transfer
of ownership is a source of danger, an opportunity for the loss of docu-
mentation. The early collectors had little interest in acquiring informa-
tion about objects and were not even interested in their previous sale
history. They wanted to acquire them as forms, as examples of a type
of object that had a particular place in an evolutionary sequence.
Such works were viewed as examples of what Aborigines used to
produce, and their authenticity may even have been put into question
by a surfeit of information.

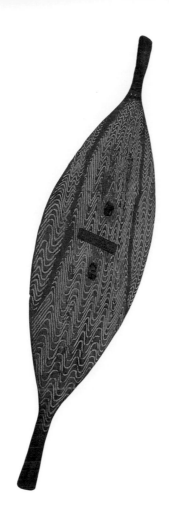

Figure 223 illustrates 'boomerang clubs' from various parts of New South Wales that have all eventually found a home in the National Museum of Australia. The very label boomerang club testifies to the lack of knowledge about them: a boomerang in shape but probably too heavy and therefore better classified as a club. The documentation on the clubs is thin. The top club was collected by the author Katherine Langloh Parker in the vicinity of Bangate Station on the Narran River, New South Wales. The Langloh Parker family bought the property in 1878 and left in the mid-1890s. Based on her experiences there Mrs Langloh Parker wrote *Australian Legendary Tales* (1896). In the case of the second club we know nothing except that it was transferred from Sydney University to the Institute of Anatomy in Canberra in 1957 at the time the university's anthropology department dispersed most of its

ethnographic collection to other institutions. The third club was acquired by the geologist and antiquarian Stan Mitchell (1881–1963) from the pastoralist Lindsay Black. Mitchell's main interest in Aborigines was to uncover earlier evolutionary stages of human society. More is known about the fourth than any of the others. Almost uniquely, we have the maker's name, Jack Shepherd (d.1916), a Nyimpaa man of Byrock, New South Wales. He made it and many other implements for the collector and New South Wales railways administrator Edmund Milne. We even know that it was called a *burrgal*. All these clubs are beautiful objects with fragments of historical context linking them more closely to the history of collections and collectors than to the Aboriginal people who made them.

Although so little information survives, the possibility of recovering more through analysis of the objects is considerable. This research is in its infancy. The first task is to collect together all the fragments of information about context and meaning, relate them together and reconnect them to the objects themselves. This attempt at reconnection is made easier by the knowledge that now exists about the art and artefacts of neighbouring societies to the north whose histories are better known. But it is most important to connect artefacts to the historical processes of which they are a part, to the Aboriginal people who are the descendants of their makers and who provide avenues to understanding. The information they hold helps in the reconstruction of past patterns and also serves to incorporate the objects into the present.

Eventually much will be learnt by carrying out such research and from the form of the objects; at present it is possible only to glimpse their significance, to grasp intuitively the ordered worlds they were once part of and to reflect on the aesthetic effect they may have had. The art of southeast Australia fits with what is known from elsewhere, and although there are problems with an approach that relies on analogy from other times and other places, and although what is known must always be kept separate from interpretation, nonetheless the similarities between Aboriginal societies and the fact that Aboriginal people exchanged ideas across vast distances makes such analogies fruitful.

The design forms typical of Victoria and New South Wales suggest a close relationship between design and social group. The geometric patterns of the carved trees and the patterns on possum skin cloaks echo those on weapons, body paintings and ground sculptures. There are hints that the designs are connected to religious rites and by their relationship to totemic group organization. David Collins, who arrived with the First Fleet, provides one of the few early accounts that suggest that art and material culture were symbols of identity, as in northern and central Australia:

It must be observed that the principal tribes have their peculiar weapons … on showing them to our Sydney friends, they have told us that such a one was used by the people who lived to the southward of Botany Bay; that another belonged to the tribe of the Cam-er-ay … they extended this peculiarity even to their songs and their dialects.

As a general statement this is consonant with the pattern known from elsewhere in Australia, but we have seen in chapters 5 and 6 the variety of cultural forms that fit within such a general framework. And south-east Australia is such a vast area that there must have been great diversity within the region. It is known that supreme ancestral beings in human form such as Daramalan and Baiami were held in awe over a wide region; representations of Daramalan were a central feature of Bora initiation ceremonies. Some descriptions of the ceremonies themselves exist, and the famous series of photographs taken by Charles Kerry (1858–1928) of the Burbong ceremony held at Quambone Station on the Macquarie River in New South Wales in 1898 show the richness of the ceremonial iconography (224). Representations included raised ground sculptures of Baiami, an immense snake, an emu, a bullock and a constructed eaglehawk's nest. Geometric motifs were carved into the ground, elaborate body decorations were worn and carved trees surrounded the ceremonial ground. It is known that the ceremony included representations of the mythological events associated with the region and that these events were re-enacted as part of an initiation ritual, but we have no more detailed information.

In some areas there is evidence, albeit fragmentary and inconclusive, that the different geometric patterns that occurred in body painting

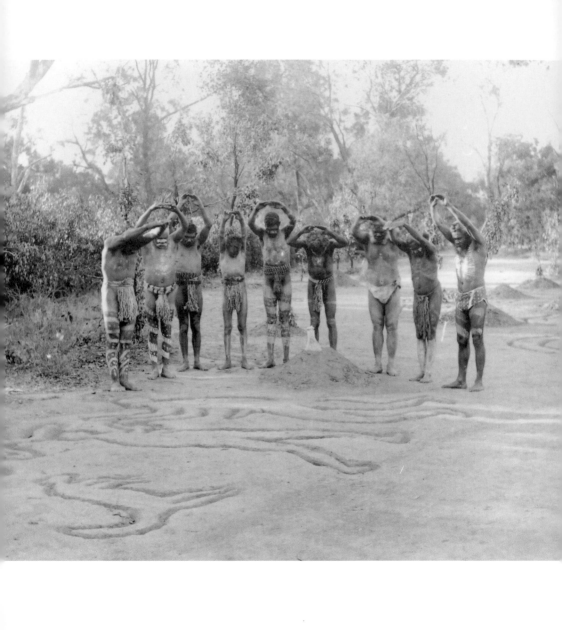

were associated with particular social groups. The 'protector' of Aborigines, George Augustus Robinson, recorded that in the Western District of Victoria different body painting designs were associated with different clans in the Keilambate region. There is also a suggestion that the notorious Batman Treaty of 1835 involved the use of clan designs by the elders. Batman had negotiated a treaty with Aboriginal leaders on behalf of the Port Phillip Company which in effect resulted in the colony of Victoria. He asked them to sign by making their mark on the trunk of a tree, which he then copied on to paper. The nature of social organization over much of the region is poorly understood, however, and there is a long way to go before it can be convincingly connected to the art that has survived. Information is lacking on most other aspects of the meaning of designs. It is tempting to assume that the geometric art encoded the same condensed representations of place as occurs elsewhere in Australia. The civil servant and mining engineer Brough Smyth, indeed, discussed the meaning of designs on a club from the Ovens River in 1878, recording that it represented a lagoon on a branch of the Broken River and areas of the owner's country. He said that it was possible to gain similar information in other cases, but sadly did not record more.

The art of southeast Australia contains a wide range of representational systems. The geometric element is predominant, with diamond patterns and curvilinear forms interspersed with oblongs, squares and oval features. The circle–line motifs that characterize much of the art of central Australia are largely absent, although the art of the southeast shares in common with the art of the centre the repeated outlining of the form of the central features. From elsewhere in Australia we know that the details of the infilling of designs has significance, and the variety of infill in the southeast suggests a similar elaboration of meaning. There is also a considerable figurative component in the art; representations of animals and humans occur across all forms – on weapons, carved trees, as body paintings, ground sculptures and on possum skin cloaks. In some ceremonies animal figures, which almost certainly represented ancestral beings, were carved out of bark, suspended from trees or used by dancers in mimetic performances. Geometric and figurative forms were frequently combined in the same object, and it is likely that the meaning of the art, as constructed from the combined use

of different representational systems, was associated with systems of restricted knowledge, as in the north.

The aesthetics of southeastern art can also be linked with art from elsewhere in Australia. Representations of Aboriginal ritual in European artworks emphasize the brilliance of the body painting designs brought out by the light from the fires. It is easy to imagine the striking effect of the angled and flickering light from the flames on the deeply incised designs of the carved trees and on the incised patterns of the shields and spearthrowers. The white and red patterns painted on the shields would have been equally striking in daylight or at night time.

Little is known about the functions of designs on weapons. Were the more elaborately decorated weapons special items used largely in ceremonial contexts? Were they a marker of status or were they in daily use by all categories of people? The designs on shields and weapons may have been a sign of identity, a heraldic mark linking the individual with the group, showing membership of a clan. The designs may have been connected to the religious life of the clan, sanctioning the warrior's action and perhaps even imparting power to the object and helping him in battle. The aesthetic effect may have been intended to dazzle the opponent or distract him. As the anthropologist S J Hemming writes: 'The painted designs seem to act as a visual deflector, focussing the eye of the attacker away from the shield.' All are plausible suggestions, but the evidence for any of them is slender. We are left with a partial and fragmentary record of art that only partly reveals the richness of the Aboriginal cultural heritage of the region.

Elsewhere, in those parts of Australia that were 'settled' by Europeans by the mid-nineteenth century, similar patterns can be observed. In southwestern Australia, in Queensland and the Torres Strait Islands colonial practices disrupted indigenous arts, threatened people's relationships with land, and separated children from their parents by housing them in segregated dormitories or removing them from their homes for adoption or placement in institutions. The arts of the early colonial period were highly valued as museum pieces or as an inspiration for Western artists, but often distanced from the present, viewed as belonging to a time long since passed. In spite of the adverse circumstances

for cultural transmission, art continued to be produced and provided an ongoing link with past lives. The Torres Strait Islanders to the north of Cape York Peninsula were among the earliest peoples of northern Australia to be caught up in the colonial encounter.

Like many small island communities off the mainland of New Guinea, the Torres Strait Islanders had a mixed economy in which trade played a central role. To varying degrees the people of different islands practised agriculture and hunting and gathering. In all cases fishing was a significant economic and cultural activity. The main orientation of trade relations was with the more densely populated societies of mainland New Guinea to the north, though complementary trade relations existed with the Aboriginal societies to the south. Torres Strait Islanders traded raw materials and weapons with the people from Cape York Peninsula, and the trade routes and the journeys of the mythical beings of the hero cults of Cape York Peninsula extend northwards to the islands. The cultural orientation of Torres Strait is at least as much towards Melanesia as it is to Australia, but politically and economically it has long been part of Australia. Torres Strait Islanders have been heavily involved in the post-European-colonial economy, working in the pearling industry and on inter-island and regional trading vessels. More recently, they have been migrant labourers, working in Queensland sugar plantations, for example. The London Missionary Society established a major presence in the 1870s and Christianity has played an important role in Torres Strait Islander life.

Knowledge of the meaning and context of Torres Strait Island art has lagged behind appreciation of its form. As early as 1606 the Spanish explorer Luis de Torres noted the spectacular turtle-shell masks worn in ceremonial dances (see 213). The art of the Torres Strait had some influence on modernism and in particular inspired European Surrealists. The art seems to come out of the sea and the islands: the raw materials include turtle shell, pearl shell, fibre-string and hair, and wood. The intricate engravings that cover and embellish the surface of indigenous artefacts can be seen to reflect a desire to use all available space.

Contemporary works often show continuities with past forms while setting off in new directions, in both the use of raw materials and the

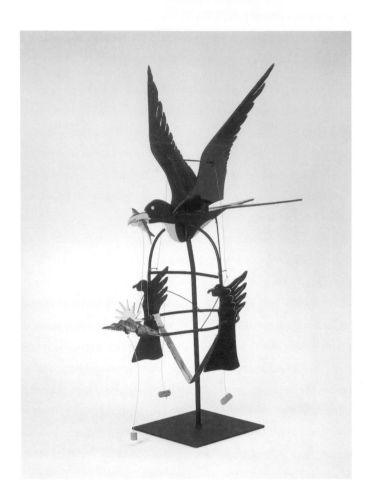

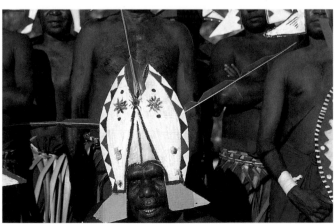

225
Ken Thaiday,
Whoumerr,
frigate bird
dance mask,
1991.
Plywood, wire,
rubber, fishing
line, string,
enamel paint
and plastic;
h.50 cm, 19¾ in.
National Gallery
of Australia,
Canberra

226
Masked dancer
from the Torres
Strait Islands,
photographed
on Groote
Eylandt,
late 1970s

themes that are developed. The sculptures (225) of Ken Thaiday (b.1950) continue the tradition of dance masks (226) but use introduced materials and techniques. The masks are mechanical sculptures, portable mobiles that spring into life when the strings are pulled or the dancer's body moves. The frigate bird looming over the land evokes many themes of island life, it conveys the sense of space and alludes to the importance of journeying and connection while evoking the importance of home. The sculpture combines a sense of delicacy combined with strength that characterizes much Torres Strait art. Other contemporary artists such as the printmakers Alik Tipoti (b.1973) and Brian Robinson (b.1974) have applied the techniques and forms of wood engraving to new media and often use them to illustrate themes from Torres Strait mythology and island life.

Torres Strait Islanders have shared the recent battle for land rights and cultural autonomy with Aboriginal people and this has in turn been reflected in their art. One of the most significant legal cases in recent Australian history was the Mabo judgement, in which a Torres Strait Islander, Eddie Mabo of Mer Island, gained recognition for native title (the recognition of the prior ownership of the land by its indigenous inhabitants). This was taken up by another Islander artist, Ellen Jose (b.1951), long resident in the south of Australia. Her sculpture *RIP Terra Nullius* (227) takes up the theme of 'native title' by celebrating the death of the idea that Australia was a *terra nullius*. The sculpture refers to the contemporary islander practice of erecting a tombstone in memory of the deceased a few years after the death. In addition to its political message it has a strongly Christian iconography.

In much of Queensland, the state to the south of the Torres Strait Islands, colonial rule was also established early on and was at least as unsympathetic to Aboriginal culture as was the case elsewhere. Coastal Queensland and the Atherton Tablelands were the site of some of the most violent confrontations between Aboriginal people and pastoralists and the Native Police. The violence extended well into the twentieth century. Control of the Aboriginal population was if anything more restrictive than elsewhere. The dormitory system in which young people were separated from old, male from female, was

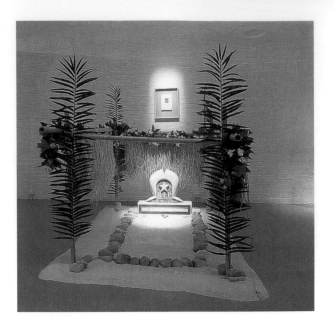

227
Ellen Jose,
RIP Terra Nullius 26 June 1788 – 3 June 1992,
1996.
Marble, sand, stones, bamboo, shell, raffia, silk, plastic flowers, satin ribbon. Tandanya National Aboriginal Cultural Institute, Adelaide, and William Mora Galleries, Melbourne

228
Stencils, Carnarvon Gorge, Queensland

229
Quinkan rock paintings, Laura, Queensland

instituted in mission stations and government settlements throughout Queensland. It was designed as a harsh instrument of assimilation and had a negative effect on cultural transmission, as forced separation made it difflcult to teach the young. In addition, there was a policy of continual dispersal in which children were removed from their families, for adoption or residence in institutions. Members of the community who were considered disruptive were removed to Cherbourg in the south of the state, or to Palm Island, where they were in effect imprisoned.

Despite these adverse circumstances, much of the richness and diversity of Aboriginal art throughout Queensland has survived. Some forms of art are today restricted mainly to museum collections or to the natural archives of rock art, others are still produced in continuity with past traditions, while some artists have developed new cultural forms reflecting the present circumstances of their lives.

In Laura, in central Cape York Peninsula (229), and in the Carnarvon region of central Queensland (228) are two of the great rock-art traditions of the world. The artists continued to paint until well after European colonization, since there is evidence of introduced themes, cattle, horses, people and possible images of the Native Police. The population of the Laura region was subject to years of harassment

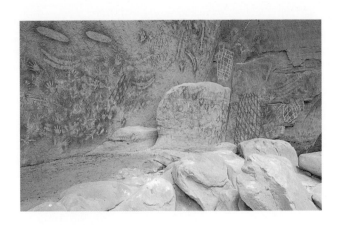

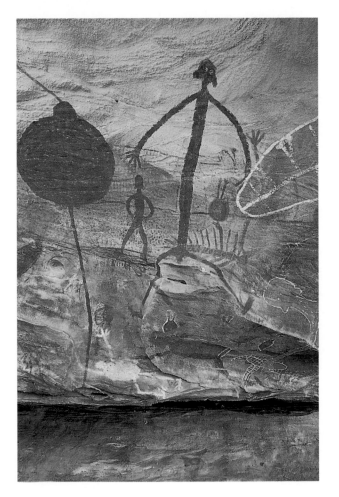

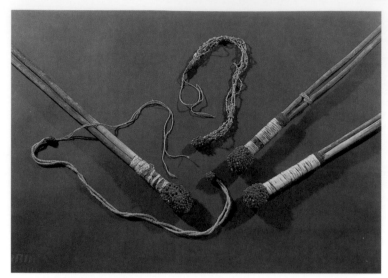

230
Firesticks and
chestbands,
Queensland.
Firesticks,
collected 1927.
Wood, fibre,
resin and abrus
seeds; l to r:
l.203 cm, 80 in,
185 cm, 72$\frac{7}{8}$ in,
107.5 cm,
67$\frac{1}{8}$ in.
Chestbands.
Plant fibre,
resin and abrus
seeds;
l to r: l.111 cm,
43$\frac{3}{4}$ in.,
56 cm, 22 in.
National
Museum of
Australia,
Canberra

and eventually the people who were left moved to coastal settlements.
Some paintings are known to have been produced as sorcery paintings;
others, according to people from neighbouring areas, were produced
during long stays at wet-season camps. They were often painted for
pleasure, though some may have represented ancestral beings. The
painting tradition was labelled Quinkan by the rock-art specialist Percy
Trezise, who has done much to make the paintings better known. The
word applies to the representation of spirit beings, human in form,
which appear to be similar to the Mimi spirits of the Kakadu region. The
rock art of the Carnarvon Gorge area is characterized by an elaborate
stencil tradition in which weapons and body parts – hands and arms in
particular – are stencilled in red on the rock surface.

The art of much of Cape York Peninsula and the Gulf country over
towards the Northern Territory border has been disrupted less by
colonization than elsewhere in Queensland, simply because the impact
of the pastoral industry was later and relatively less devastating.
The sculptural tradition from Aurukun has already been considered
in Chapter 3. From Aurukun south along the coast to Kowanyama on
the Mitchell River the cultures are renowned for their beautifully
constructed firesticks and body ornaments (230), and spearthrowers
decorated with the brilliant black and red abrus seeds embedded
in beeswax. Fine painted and decorated shields were also made.

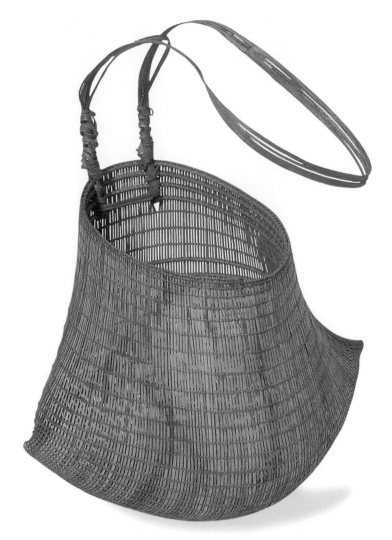

231
Two-cornered
basket,
Queensland,
before 1893.
Lawyer cane;
h.24 cm, 9½ in.
Pitt Rivers
Museum,
University
of Oxford

Some of the best-known artworks from the region – rainforest shields
and associated weapons and complex basketry – come from the oppo-
site side of Cape York Peninsula, from Cairns and Yarrabah. The two-
cornerned baskets made from lawyer cane are striking and elegant
objects (231). The mouth of the basket is circular; the body opens out
with curved sides ending in sharply pointed corners. The form seems
to be the architectural projection of a mathematical formula combining
strength with flexibility, a highly complex form based on simple princi-
ples. Painted in earth pigments these rare objects epitomize the rich
basketry traditions that exist throughout Australia, wherever the raw
materials are available.

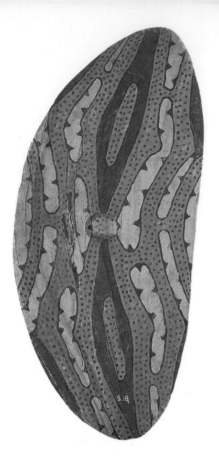

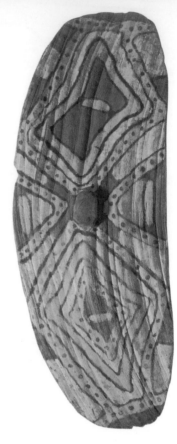

232
Rainforest
shield,
Queensland,
collected 1897.
Ochres on
soft wood;
h.91 cm, 35 $^7/_8$ in.
Australian
Museum,
Sydney

233–234
Rainforest
shield,
Queensland,
before 1890.
Natural
pigments
on wood;
h.81·5 cm, 32 in.
Pitt Rivers
Museum,
University
of Oxford
Right
Detail

The rainforest shields made by the Kukuyandji and other groups of
the coastal region were one of the inspirations for Margaret Preston's
modernism. They are occasionally produced for sale today, although
information on the original significance of many of the designs and
the context of use of the shields is fairly limited. The shields gain their
characteristic asymmetrical shape (232, 233) from the root of the native
fig from which they are made. They were used in ritual combat and
many of the ones collected at the end of the nineteenth century, and
now in museums, show signs of such use. The shields attracted atten-
tion because of the boldness of their designs and the richness of the
pigmentation. Many of the designs appear to be abstract, though some
figurative representations occur, usually of animals but sometimes of
material culture objects.

However, the research of Ursula McConnel in the 1930s established that
the abstract forms are in fact representational, signifying totemic

animals associated with particular clans. The designs associate the shields with regional myths and in turn with features of the landscape in the region of Cairns. Although the evidence suggests that they may have been part of a design system analogous to that of Eastern Arnhem Land, it remains sketchy. The missions discouraged ritual practice, and the land that the designs referred to was taken away and turned into farmland. Despite this, the richness of the art remains. The abstract designs, the textured surface thick with pigment, the purity of the ochres all contribute to its appeal to a modernist aesthetic (234).

One important contemporary development of art in Cape York Peninsula has been the work of the potter Thancoupie (b.1937). Thancoupie comes from the township of Weipa, north of Aurukun, and is one of Australia's leading ceramicists. She developed her skills in pottery in Sydney but has practised as a potter for many years in north Queensland. The circular forms of her pots are said to relate to the fire-hardened clay balls that were used to conserve and trade pigments for use in ritual. Her pots, with their deeply incised designs, draw on traditional mythological themes from her Thanaquith culture. *Corrup the Kangaroo and Chinjarl the Wallaby* (235) represents a myth of world creation with the animal species dancing for joy.

235
Thancoupie,
Corrup the Kangaroo and Chinjarl the Wallaby,
1994.
Ceramic stoneware decorated with slip and oxide; h.25 cm, 9⁷⁄₈ in.
Private collection

To the west of Cape York Peninsula in the Gulf of Carpentaria is Mornington Island. It too has a long history of missionization, but because of its geographical position it has a recent history of linkage around the Gulf from Arnhem Land to Cape York Peninsula. Despite its geographical isolation it has developed at times a thriving craft industry, including the manufacture of a characteristic form of conical headdress. The best-known artist from Mornington Island, however, was the Lardil artist Dick Roughsey (Goobalathaldin) (1924–85), the first chairman of the Aboriginal Arts Board in the early 1970s (236). He painted in two different genres and used different media, bark paintings and acrylics, both of which were introduced to the area in the 1960s. He first produced bark paintings for sale to tourists, which comprised figurative and decorative motifs that have tended to be treated as curiosities. He subsequently developed a very different style of painting to illustrate children's books, often written collaboratively

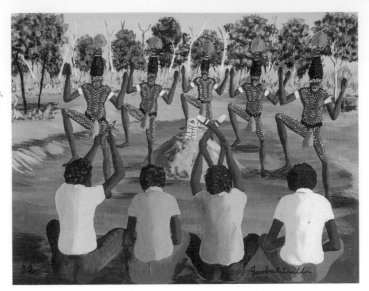

236
**Dick Roughsey
(Goobalathaldin)**,
*Rainbow Serpent
Dance, Thwiathu
Dance,
Mornington
Island*,
1972.
Acrylic on
cardboard;
47·7 × 57·4 cm,
18¾ × 22⅝ in.
National Gallery
of Australia,
Canberra

with his friend Percy Trezise. The painting styles share few elements in common, but in both cases he drew on themes from traditional life, hunting and gathering, and ceremonial performance. The ceremonial representations are particularly interesting in that they record head-dresses and body painting designs for rituals that Roughsey himself was partly responsible for reviving, following many years of suppression. In making representations of Aboriginal life for outside consumption, Roughsey shares something with two artists working in Victoria nearly a hundred years earlier, William Barak and Tommy McRae.

10

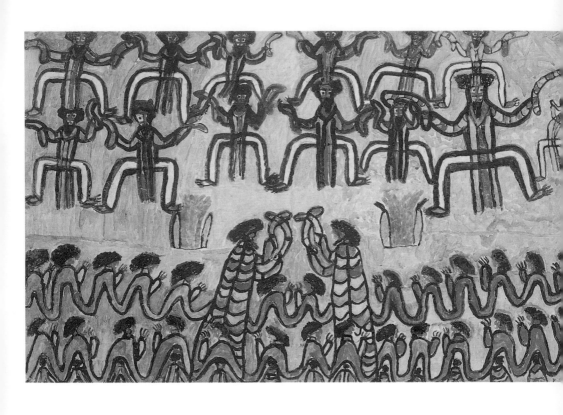

In recent years two Aboriginal artists from the southeast have been recognized as major figures of nineteenth-century Australian art: William Barak and Tommy McRae. The artworks of both were, in their different ways, strongly influenced by the post-colonial context in which they worked and made use of introduced forms and materials. In the past these artists might have been placed together in a lumpen category that included Albert Namatjira, Jim Kite and Dick Roughsey: Aboriginal people of different times and places who produced what the anthropologist Nelson Graburn labelled as assimilated fine art. However, as was seen in Chapter 8 with Namatjira, the whole concept of assimilated fine arts is problematic. It has no regard for the specificities of place and time and it makes it too easy to neglect continuities with indigenous forms which explain particular characteristics of the work. The works of Barak and McRae, while showing formal differences from much of the indigenous art of Victoria, in particular the engraved weapons and painted-body designs, also clearly come out of the Aboriginal societies of late nineteenth-century Victoria. The drawings of Barak and McRae are far from being as unique as recent history has made them appear, and the works of other artists working around the same time, such as 'Mickey' (*c*.1820–91) of Ulladulla on the south coast of New South Wales, have recently been uncovered. The recognition of the significance of the work of William Barak and Tommy McRae is acting as a catalyst for the re-examination of the works that survive from the colonial period in archives and collections and the reassessment of them both as sources of historical understanding and as works of art in their own right.

William Barak was born some years before the Batman Treaty of 1835 brought about the intense European colonization of Victoria. By the time he died in 1903 he had witnessed the transformation of his land and the destruction of most of his people. He was born in 1824 into the Wureundjeri clan of the Woiworung people whose country lay in the

237
William Barak,
Corroboree,
*c.*1880s.
Earth pigments,
wash and pencil
traces on
paper;
56·8 × 80·9 cm,
22³⁄₈ × 31⁷⁄₈ in.
National Gallery
of Victoria,
Melbourne

region between Heidelberg, now a suburb of Melbourne, and Mount Baw Baw in the Victorian Alps. A leader of his people at a time when Europeans were unconcerned with Aboriginal rights and political compromise, he was a member of the Native Police force in the Melbourne area, perhaps until it was disbanded in 1853. In the 1860s he moved to the Aboriginal reserve at Coranderrk where he was to remain for the rest of his life.

William Barak began painting soon after he settled at Coranderrk, although most of his extant paintings date from the 1880s and 1890s. This seems to have been the period of his greatest productivity. Coranderrk was established as a farming community and produced much of its own food. Craft production was one of the main sources of income, enabling people to purchase goods such as tobacco, ammunition and clothes; many of the weapons and much of the basketry in museum collections were manufactured there. Introduced items such as woven hats were manufactured for sale but Barak was the only person to produce drawings and paintings on a regular basis.

Barak's style shows considerable continuity with the indigenous art forms of the region, combining geometric with figurative forms, and creating decorative patterns through repeated sequences of the same elements. His paintings are simultaneously documentary and decorative. Many of them are illustrations of ceremonial performances (237): these show rows of dancers with painted bodies performing around blazing fires, with groups of figures seated in the foreground singing and clapping boomerangs together in rhythmic accompaniment. They evoke the feeling of ceremonial performance rather than the particularities: the rows of dancers are frozen in their synchronized movement, yet alive with pent-up energy. Sometimes the paintings include animals apparently moving amid the dancers. These may signify the theme of the dance, or they may represent mimetic dancers. Sadly, little is known of the detailed meaning of the paintings. They teem with life and show multitudes gathered together for ritual occasions. It is known, however, that Barak was producing images from the past rather than illustrating current performances: non-Christian religious performances were banned throughout Victoria by the time he began his paintings.

Another common theme of Barak's paintings is groups of people in possum skin cloaks. Sometimes the figures are represented standing in rows; the figures provide a graceful balance as they seem to respond to each other's presence (238). In other paintings the seated figures wrapped in possum skin cloaks are reduced to triangular icons surmounted by bearded heads (239).

Barak painted on sheets of paper and cardboard, sometimes backed with linen. He made extensive use of natural pigments, ochres and charcoal, but also incorporated European watercolours. In each painting he used a limited range of colours, frequently infilling figures with alternating bands or stripes of colour which create a harmonious and rhythmic effect. The details of the individual figures are subordinate to an overall pattern. Clearly his paintings were a development of the aesthetic practice and formal elements of Indigenous Victorian art. It is tempting to draw an analogy between his work and that of later artists, such as Namatjira or the desert acrylic artists, who likewise combined Aboriginal and European influences in their art. But whereas Namatjirra adopted a specific style of European watercolour painting and desert artists arguably fitted well the aesthetics of modernism, Barak's paintings cannot so easily be related to the European art worlds of his time.

Certainly Barak's work attracted considerable interest. But although he had his local sponsors, such as the de Pury family, and many of his paintings ended up in museums in Australia and overseas, they tended to be purchased as curiosities, as relics of 'a passing race'. The art historian Andrew Sayers summarizes the position well when he writes of the motivations of the purchasers: 'There was always, for them, an inescapable consciousness of Barak as "the last of his tribe". Such collectors, who dutifully sent drawings back to their various mother countries, saw Barak's life as a kind of closure, and his art for them was a reminder of this fatalism.'

We may have some understanding of why Europeans bought his art but we remain a long way from understanding how Barak himself saw it. It may indeed be that his motivations were quite similar to Namatjira's and the land-right petitioners of Yirrkala, although he was working in even more difficult circumstances. He was always willing to explain

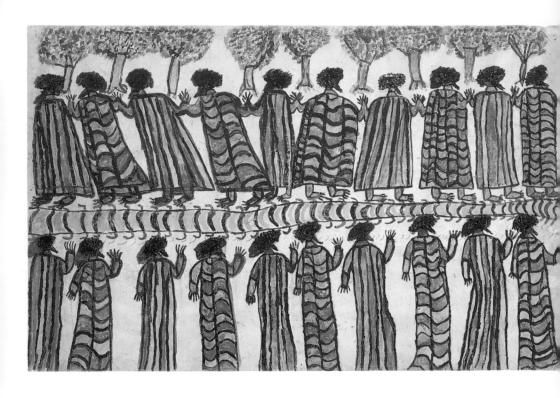

238
William Barak,
Figures in Possum Skin Cloaks,
c.1880s.
Earth pigments, wash and pencil traces on paper; 56·8 × 80·9 cm, $22\frac{3}{8} × 31\frac{7}{8}$ in. National Gallery of Victoria, Melbourne

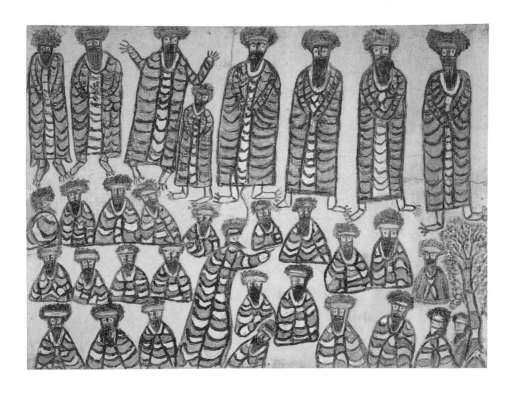

239
William Barak,
Corroboree
(*Figures in*
Possum Skin
Cloaks),
c.1885.
Natural ochres,
charcoal on
paperboard;
56 × 75 cm,
22 × 29½ in.
National Gallery
of Australia,
Canberra

Aboriginal culture to Europeans, and his paintings were undoubtedly a way of passing on knowledge to his children in the missions. He was generally interested in art and interacted with visiting European artists, and he used the reputation he gained as an artist to petition for improved conditions for his people. All this we can surmise, but we do not have his word for it. Indeed, for three-quarters of a century following his death Barak's paintings were neglected, and it was not until 1981, when they were shown in a major touring exhibition, *Aboriginal Australia*, that interest in his art revived.

Although Tommy McRae's art appears at first sight to be further removed from the traditional art of the region, it is nonetheless possible to see continuities with it. His life has interesting parallels with William Barak's. He was born in the area of Wahgunyah on the Victorian/New South Wales border in the 1830s around the time the European invasion was beginning to take hold. He lived his life in that region, his movements gradually restricted to ever smaller domains as his lands were taken over by pastoralists and miners. In his youth he worked as a stockman on some of the stations established in the region, and in the 1860s he settled at an Aboriginal reserve on Lake Moodemere, where he and his family subsisted by growing produce for the nearby town, making artefacts and, in McRae's case, making drawings.

McRae's drawings consist of silhouette figures illustrating themes from daily life and contact history. Some of his paintings, like Barak's, illustrate Aboriginal rituals and others show scenes from town life. He adopted a historical perspective in his later paintings, recording not only themes of an Aboriginal life that had long since passed (240) but also a European world that had rapidly been overtaken by change. He painted the squatters as they stood in their arrogance in the early years of colonization, representing them in the long-tailed coats and top hats of 'the old times'. He drew the Chinese who were attracted to the goldfields and who subsequently worked as gardeners for local pastoralists. In addition, he produced a series of 'history drawings' representing Buckley, an escaped convict who lived with the Aboriginal people of Port Phillip Bay for thirty-two years until he surrendered to surveyors who accompanied John Batman's 1835 expedition.

240
Tommy McRae,
Hunting emu
in trees,
c.1870.
Pen and ink
on paper;
25 × 30 cm,
$9^7_8 \times 11^7_8$ in.
La Trobe Picture
Collection,
State Library
of Victoria,
Melbourne

241
Tommy McRae,
Lachlan war
dancing,
c.1865.
Pen and ink
on paper;
21·7 × 28·1 cm,
$8^1_2 \times 11$ in.
La Trobe Picture
Collection,
State Library
of Victoria,
Melbourne

Sydney Tribe in olden times

His drawings are often titled with a brief description that helps with their interpretation, although it is often very cryptic in form. When and by whom the titles were added is not known but some were almost certainly contemporaneous with the drawings. Although his drawings were usually in silhouette, they are more detailed than William Barak's and they are as much descriptive as decorative. His drawings of ceremonies show dancers in poses similar to those in Barak's paintings, but his sometimes show details of individual body painting designs. They are labelled as representing the ceremonies of different regions and details of the ceremonial attire tend to correspond to some local affiliation. Dancers from the Melbourne area are shown holding flag-like objects, whereas those from the Lachlan River show interesting hair ornaments (241), and those from the Echuca area are represented with bunches of leaves tied around their calves.

Many of his hunting scenes are captivating, demonstrating in considerable detail various hunting techniques. The impact of contact is shown in the use of guns by Aborigines, although more often spears and spearthrowers are the weapons employed. In one beautiful drawing three hunters are seen moving towards a flock of birds, screening themselves behind branches held in one hand (242). One hunter is armed with a stick, a second with a boomerang and the third with a rifle. The composition is characteristic of McRae's work: significant features are sketched in separately on the page and the ground between is left blank. The three hunters are separated from the birds they are advancing towards by a vignette that possibly represents the scene from a different perspective: the birds swimming in the lake masked by rushes along the lake shore. In his drawings the page is often composed in parts rather than as a whole, sometimes with an implicit dividing-line between scenes occupying different parts of the page.

This style of composition, with connected and unconnected scenes sharing the same space, is very reminiscent of the way art develops on rock surfaces. It also shows continuity with the tradition represented by one of the few remaining bark drawings from Victoria. The drawings engraved into the blackened surface of the famous bark from Lake Tyrell (243) in Victoria echo the compositional qualities and the mixture of

themes evident in McRae's drawings. Although the style of representation differs, the scale and perspective employed are very similar. The bark was collected in the Mallee district prior to 1874. It appears to represent in a realistic style scenes from daily life in the post-colonial context, with the European 'squatter's' house in the foreground. Above the house are dancing figures, possibly engaged in a mortuary ritual since there is some evidence of warfare in the section above. The picture lends itself to narrative and allegorical interpretations, as the scene seems to shift from the Garden of Eden at the top through Aboriginal occupation to colonial appropriation. But in truth we know frustratingly little about the artist's intention or what kind of work the Lake Tyrrell bark represents.

McRae's drawings were well known in the region where he lived. His main sponsor was a local station-owner and wine-maker named Roderick Kilborn. McRae drew in pen and ink either on separate sheets of paper or on the pages of a notebook. He would be commissioned to produce a notebook full of drawings for a customer who would be expected to provide the raw materials as well as paying for the finished product. Two of McRae's early drawings appeared in Brough Smyth's *Aborigines of Victoria* (1878), but his work became most widely known through the illustrations to Mrs Langloh Parker's *Australian Legendary Tales* of 1896. McRae may not have been aware that his drawings appeared in the book until after it was published. The drawings were unattributed, cited as the works of an anonymous native artist, and it is therefore unlikely that McRae received any reward or recognition during his lifetime. The illustrations came originally from a sketchbook in the possession of the social theorist Andrew Lang, which he had received in turn from his brother who lived in Corowa, near McRae's settlement.

McRae had good contacts in the European community and a growing reputation. He was teetotal and was the head of a self-sufficient community at Lake Moodemere. None of this protected him from the policies of the Victorian government. His applications for government grants to improve his housing were turned down, and his children were taken away from him and placed in state institutions, even though he was supported by powerful representatives of the local

White community. As Andrew Sayers points out, the analogy with the treatment of Namatjira is irresistible.

The circumstances of Aboriginal people in southeast Australia under European colonization could hardly have been worse, and they did not improve until the mid-twentieth century. And yet, as the artist Lin Onus poignantly wrote, 'For Aboriginal people life went on.' The populations of New South Wales and Victoria declined catastrophically as a result of killings, introduced disease and appalling living conditions. By the end of the nineteenth century most of the land had been alienated and Aborigines were restricted to reserves and pastoral properties. There then began a long process of harassment. Reserves were degazeted,

242
Tommy McRae, Hunting ducks with stick, boomerang and rifle, c.1880. Pen and ink on paper; 24 × 34 cm, 9½ × 13⅜ in. Private collection

243
Lake Tyrrel bark, before 1874. Etching on smoked bark; 85 × 46 cm, 33½ × 18⅛ in. Museum of Victoria, Melbourne

people were forced to move on, their children were taken away from them and institutionalized. Aboriginal culture was utterly devalued. The objects that remained in museums became signs of a culture that had once been. Aborigines were denied citizenship and forced to exist in the interstices of Australian society. The ideology of assimilation gave them no option: they had to disappear either by becoming non-Aboriginal through absorption or by remaining Aboriginal and therefore literally not counted. And yet we have seen that from the beginning Aboriginal people tried to engage, and to create spaces for themselves, in the society that was being created around them.

365 The Art of William Barak and Tommy McRae

William Barak worked for the Native Police, became a leading member of the Coranderrk community, supported the church, assisted the anthropologist Alfred Howitt to understand the culture and ceremonial life of the region, made artefacts for sale and gained a reputation as an artist in what is now recognized as an innovative style. McRae, likewise, participated fully in the life of his times, working as a stockman, becoming the centre of a self-sufficient community and achieving widespread recognition as an artist and recorder of early colonial life. Both tried to carve a niche for themselves as Aboriginal people in the wider Australian society.

The generations that followed them faced an enormous task. If William Barak and Tommy McRae were being written into history as the last of the 'tribal' Aborigines of Victoria, their descendants were simultaneously being written out. Removed from their families, their ceremonies banned, pushed from place to place, it is hardly surprising that their connection with the past was disrupted. Yet throughout the first half of the twentieth century, a time when Aboriginal people disappeared from the official face of southeast Australia, they managed to survive and their population grew. And they continued to maintain a distinctive culture with its own set of values, even if those values were not regarded by the outside world.

During the period between the wars craft production continued to be an important source of income for some Aboriginal people in southeast Australia. The artefacts were produced primarily for sale to tourists and included indigenous, introduced and innovative craft objects. The objects were often unfashionable in art world terms, straddling the division between popular art and tourist souvenir. Products included carved emu eggs (244), decorative feather flowers and appliqué bark pictures. Other crafts, such as basketry and boomerang manufacture, have their origins in traditional practices, but were now directed towards the tourist and souvenir trade. A few artists, such as Revel Cooper (1933–83), a Nyungah artist from Western Australia, and Ronald Bull (1942–79) from Victoria, painted in a European style (245), using European-introduced media, and were subject to the same kind of ambiguous response as Namatjira. But since they were from 'urban'

areas in the west and south it was assumed, of course, that they had lost their Aboriginal culture.

While the Aboriginal people themselves were given little recognition in the public culture of southeast Australia, aspects of Aboriginal heritage became important symbols of Australian identity overall. Aboriginal art began to influence Australian modernism in the 1920s and 1930s and inspired movements such as the Jindyworrubuks with artists such as Margaret Preston, which aimed to develop a uniquely Australian art.

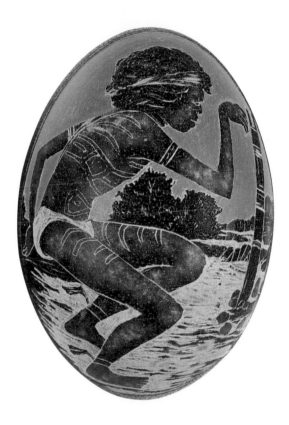

244
Esther Kirby,
Carved emu
egg showing
a hunter,
c.1985.
h.13 cm, 5 ¹⁄₈ in.
Museum of
Victoria,
Melbourne

Just as significantly, Aboriginal elements were firmly incorporated into Australian popular culture. Boomerangs in particular became internationally known, although, as the art historian Sylvia Kleinert has shown, in the local context such things as bush tucker (food) and fire making became symbols of the exotic in Australia's heritage. Artefacts for the tourist market were sometimes manufactured by non-Aboriginal groups, but Aboriginal people were aware of this appropriation, which may have reinforced their pride in the material forms as expressions of

245
Revel Cooper,
Black Boys,
1964.
Watercolour
on paper;
96·5 × 144·8 cm,
38 × 57 in.
Berndt Museum
of Anthropology,
University of
Western
Australia,
Nedlands

Aboriginal identity. Aborigines continued to produce crafts for sale and were willing to put on performances for tourists. The Gunai (Kurnai) people of the Lake Tyers settlement, for example, have been continuously associated with the manufacture and sale of boomerangs from the mid-nineteenth century into the twentieth century, and have continued to put on performances for visitors.

Participation in the tourist economy has often been misrepresented as the manipulation of Aboriginal culture by outside entrepreneurs. It should be viewed as the product of Aboriginal agency and an expression of Aboriginal people's continual attachment to their culture. Indeed, as Kleinert has shown, such activities were often carried on in the face of opposition from the authorities who saw them as potentially disruptive, running counter to the assimilation policy and outside their direct control. It was this resistance to incorporation within the mainstream of Australian society, combined with the flexible approach to new forms and practices, that set the background for the apparent rebirth of Aboriginal art and revival of Aboriginal culture in New South Wales and Victoria in the 1980s. From the perspective of Aboriginal people it was a resurgence, not a rebirth: for them there had always been a Koori art.

Contemporary Developments Aboriginal Art and the Avant-Garde

11

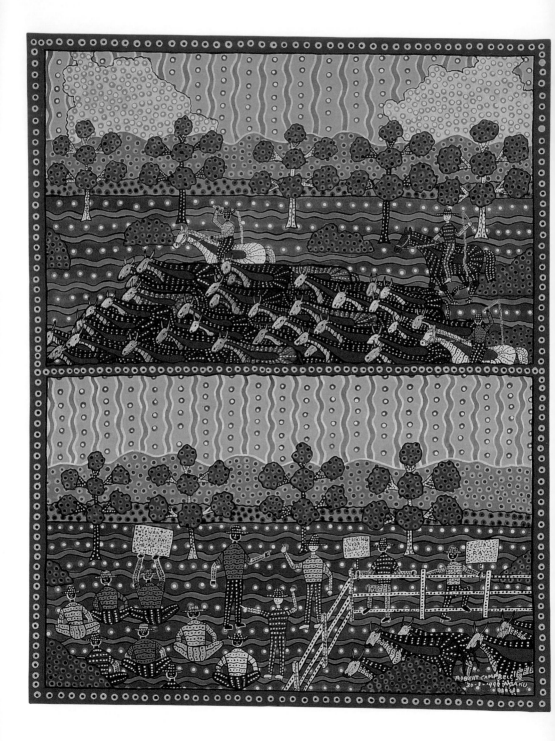

The recent acceptance of Aboriginal art into the fine art category by the Western art world has interesting implications for the Western concept of contemporary art. It also reflects a change in the concept of primitive art since the turn of the twentieth century, when African, Oceanic and Native American art provided such an inspiration to the avant-garde of the time. In the 1930s Aboriginal art, if it was anything, was 'primitive art'. The way primitive art was defined was both a misrepresentation and a distancing mechanism. The category was the product of an evolutionary model in which the societies of Europe were thought to represent the more evolved forms of civilization. The catalogue cover (247) by Percy Leason (1889–1959) for the 1929 exhibition in Melbourne, *Australian Aboriginal Art*, conveys these sentiments well. The bark painter is shown in an almost ape-like posture painting a design on a rough and raw-edged piece of bark apparently torn rather than cut from a tree. The very word 'primitive' connoted something that was less sophisticated and logically prior. It also had positive connotations, of course; it was seen as somehow underlying, basic and closer to the emotions. But these connotations were equally a result of false history, more a projection of the Western imagination than a reflection of the nature of art in non-Western cultures.

As 'primitive art', Aboriginal art entered the art galleries in the space assigned to it in Western art history. It was placed in relation to an avant-garde motivated by the idea of progression: art was deemed to be continuously in a state of progress in which new forms succeeded old. The European avant-garde of the early twentieth century drew inspiration from the arts of other cultures and other times to free itself from the constraints of 'tradition'. Australian Aboriginal art has played such a role in the development of Western art practice, although its influence came later than that of African art. From Margaret Preston onwards Australian artists have been influenced by the forms of Aboriginal art, using it as an inspiration for their own work.

246
Robert Campbell junior, *Striking for Equal Pay, Wattie Creek*, 1990. Acrylic on canvas; 109 × 92 cm, 43 × 36¼ in. Museum and Art Gallery of the Northern Territory, Darwin

247
Percy Leason,
Cover design for
the exhibition
catalogue
*Australian
Aboriginal Art*,
Melbourne,
1929

The two dominant paradigms employed until recently for exhibiting
primitive art in art galleries reflected the way in which non-European
arts have been incorporated within Western art worlds: the objects were
either exhibited so that they could be appreciated in the same way as
Western artworks, or they were exhibited in terms of their supposed
influence on Western art. The former type of exhibition was the most
common. The works were exhibited in ethnic or stylistic sets purely as
aesthetic objects to be appreciated on the basis of their form: African
art, Yoruba art, Aboriginal art, Western Desert art. The objects were
selected according to criteria of authenticity established by the
European art market. One of these criteria was that they represented
the type of object that could have influenced the Western artists who
first recognized their aesthetic power. In other words, they were retro-
spectively selected to pre-date the European avant-garde; they were
by definition not contemporary. And as the curator Jean-Hubert Martin
writes, 'The hierarchies of stylistic periods will always be suspect
because they essentially derive from the necessity to justify historically
the tastes of the present day. They are therefore of a mythical nature.'

The second type of exhibition reflected more explicitly the criteria
underlying the first. We can label it the 'primitivism in modern art'

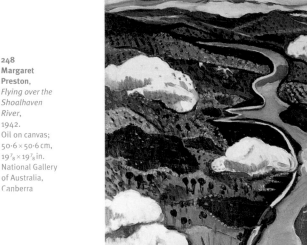

perspective after Robert Goldwater's famous 1938 book of the same title. As an exhibition format it was rarely realized in practice, although it reflected a dominant theme of Western thinking about non-Western art. The most famous exhibition of the type, William Rubin's *Primitivism in Twentieth Century Art* at the Museum of Modern Art in New York, was held in 1984 when the paradigm was under challenge. At around the same time, in 1983, the paradigm also provided the basis for the inclusion of Aboriginal art within the founding exhibitions at the newly opened Australian National Gallery in Canberra, where an Aboriginal painting was exhibited in proximity to one of Margaret Preston's paintings, *Flying over the Shoalhaven* (248). There was no attempt to show the specificity of influence, since Preston was unlikely to have seen the painting. Rather, Preston was known to have been influenced by Aboriginal art and her work thereby provided the imprimatur for allowing Aboriginal works into the gallery. Aboriginal art could only be hung in the Australian National Gallery on European art pegs.

Neither of these exhibition paradigms took account of indigenous meanings or the significance of the artworks to their original producers, nor were the artists involved in their planning and organization. 'Primitive art' was incorporated as a footnote to European art, to be

viewed through European eyes from the perspective of European art history. Rather than being a means to educate Western audiences into Aboriginal aesthetics, to endorse the values of Aboriginal culture, these exhibitions were a means of denying their relevance to the appreciation of the works as 'art'. The meaning of Aboriginal art to Aboriginal people was the province of ethnography and hence part of the discourse associated with ethnographic museums rather than art galleries. To be viewed as art Aboriginal works had to be subordinated to a universalistic concept of the aesthetic that had its roots in the comparatively recent history of European art. Ironically, this conceptualization of art excluded works of Aboriginal art that were thought to be contaminated by European contact, such as works of art that were made for sale. Even contemporary bark paintings from Arnhem Land were treated with suspicion since they had always been made for sale and hence were not authentic 'primitive' art. This was why the British Museum's ethnography department delayed buying any bark paintings until the late 1980s and why Australian galleries and museums have such poor collections of early to mid-twentieth-century bark art. Aboriginal art as 'primitive art' was interpreted as something associated with a past way of life, with 'otherness'. And if Aboriginal people were not sufficiently 'other', then they no longer produced 'true' Aboriginal art.

This conceptualization of Aboriginal art, moulded and controlled by the primitivism paradigm, was increasingly challenged after World War II. By the 1970s it was breaking down and the primitivism model was beginning to be viewed with disfavour. There was an attempt to develop ways of looking more inclusively at global arts, freeing them from the pigeonholes defined by Western art history. The *Magiciens de la terre* exhibition which opened in Paris in 1989 provided a major challenge to the primitivist paradigm. It was organized by Jean-Hubert Martin, partly in opposition to the values underlying the 1984 *Primitivism* exhibition. *Magiciens de la terre* showed the work of fifty artists from the West alongside the work of a similar number of artists working in non-Western traditions. The exhibition's main achievements were to challenge both the temporal ordering of Western art history and the criterion of authenticity imposed by the primitive art market. Whereas the *Primitivism* exhibition included works that were logically and in

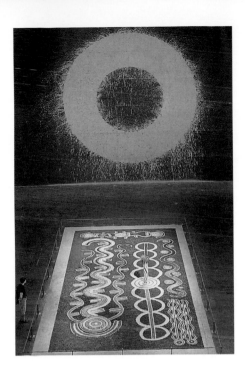

249
Paddy Jupurrurla
Nelson, Paddy
Tjapaltjarri
Sims, Paddy
Cookie
Tjapaltjarri
Stewart, Neville
Japangardi
Poulson, Francis
Jupurrurla Kelly
and Frank
Bronson
Jakamarra
Nelson,
Yarla,
ground
sculpture,
(with Richard
Long's *Mud
Circle* on
the wall),
as installed
in Le Halle
de la Villette,
Paris, for the
*Magiciens de
la terre*
exhibition,
1989

almost every case chronologically prior to the European artworks, *Magiciens de la terre* celebrated continuing traditions and all the artists exhibited were presented as contemporary. The exhibition included the work of artists from Yuendumu and Arnhem Land as well as many other Third World and indigenous artists whose works showed evidence of change as well as continuity of form (249). A Yuendumu ground sculpture was juxtaposed with a work by the British artist Richard Long (b.1945) consisting of a huge circle painted in mud on the adjacent wall. Western and non-Western art were positioned as contemporary to one another: the fiction of the evolutionary paradigm was being exposed and exploded.

The second theme captured in the exhibition's title was more problematic. It came from the assumption that art in non-Western societies was predominantly religious and magical and that this contrasted with the gradual loss of spirituality in Western art. It achieved its desired effect as a rhetorical device by providing a less Western-centric universal theme than 'the role of primitivism in twentieth-century art'. But it ran the risk of bolstering the stereotyped view of non-Western art as exclusively magico-religious.

'Contemporary Aboriginal art' emerged as a category in Australia during the 1970s and 1980s. Initially it included paintings which challenged the 'primitive art' label because of the living nature of the art and the artists. Previously the only slot allocated to such work was the devalued category of 'tourist art'. The new category included art from all regions of Australia, with the proviso that the works were in continuity with Aboriginal traditions, and thus part of a trajectory that stretched backwards to the pre-colonial era. It included the art of Arnhem Land, an art whose genesis was independent of European traditions. The category came into being partly because Aborigines asserted the contemporary nature of their art in the Australian context. It was their contemporary art, it influenced White Australian art and in turn was influenced by the post-colonial context of its production. Aboriginal art, too, represented dynamic and diverse traditions, and for those who were prepared to listen it was an avowedly political art. The category also came to include the acrylic art of the Western Desert.

The *Aboriginal Australia* exhibition of 1981, which travelled to the state art galleries of Victoria, Western Australia and Queensland, was a major expression of this new and more inclusive category. In addition to bark paintings, Western Desert acrylic paintings and sculptures from Cape York Peninsula and Melville and Bathurst Islands, it included decorated artefacts from all over Australia. It also found a place for string bags and basketwork which straddled the accepted division between art and craft. Most innovatively, perhaps, it included the watercolours by Albert Namatjira, paintings by William Barak and drawings by Tommy McRae.

The extensive *Dreamings* exhibition that toured the USA in 1988–9, before returning to its home gallery in Adelaide, was in direct continuity with *Aboriginal Australia*, although its agenda to show the works as contemporary Aboriginal art was even more explicitly articulated. *Dreamings* emphasized the commercial context of much of the art and drew attention, especially in the catalogue, to indigenous perceptions of the art as opposed to Western aesthetics. It also included a far greater proportion of works from the Western Desert than *Aboriginal Australia*, reflecting the degree to which that art was beginning to attract global interest. The exhibition of Western Desert acrylics and

bark paintings from Arnhem Land together as equal members of the contemporary Aboriginal art category was potentially very challenging to the conceptualization of the avant-garde. Western Desert paintings were a newly developed art form employing European materials, and they apparently changed rapidly over time; these paintings thus became unproblematically avant-garde. Bark paintings, which used materials and techniques that were independent of European art, had been accepted into the old category of primitive art. Yet as art objects they and Western Desert acrylics occupied an almost identical position, and both were related directly to indigenous iconographic traditions. Aboriginal art seemed to be simultaneously 'primitive' and 'avant-garde' art. As Jean-Hubert Martin pointed out, 'If [contemporary] Aboriginal artists do produce work of recognized value then our institutions are in dire need of revision.'

The development of 'contemporary Aboriginal art' as a category rescued some Aboriginal art from being marginalized or devalued, but it sowed the seeds for a different kind of marginalization. In the 1970s, when the art of the north and the centre was beginning to achieve recognition, the Aboriginal art of southeast Australia was still unrecognized (see Chapter 9). There the illusion that Aboriginal art belonged to a past that was separated from contemporary life was easy to maintain. It was simply a facet of the continuing invisibility of Aboriginal people from the south in the consciousness of most White Australians until the mid-twentieth century. Aboriginal art had gone, just as Aboriginal people were 'fading away'. The near-prehistoric art of the early to mid-nineteenth century gained some acceptance, but the art of the twentieth century and contemporary Koori art remained unrecognized, hidden as part of what W E H Stanner called 'the great Australian silence'.

As we have seen, however, Aborigines in southeast Australia had continued to produce art and craftworks, and a few such as Ronald Bull gained a limited reputation as artists. But they were in a difficult position, like Namatjira only more so. They found themselves positioned either as producers of tourist art, which was negatively viewed as a contaminated form of primitive art, or if their art was influenced by, or indistinguishable in formal terms from, contemporary Western art, then what they

produced was taken as a sign of their assimilation. *Aboriginal Australia* pushed at the boundaries of these categories by including works by William Barak and Tommy McRae. But more significantly the emergence of the category 'contemporary Aboriginal art' and the positioning of Arnhem Land bark paintings and Western Desert acrylics within it brought the contradictions of exclusion and Martin's 'need for revision' closer to home. This was implicitly recognized in the *Dreamings* exhibition. Even so, the catalogue included reference to the contemporary art of southeast Australia while the exhibition itself did not.

The situation was finally remedied in 1993 by the exhibition *Aratjara*, which toured a number of venues in Europe including the Hayward Gallery in London. The exhibition was curated by the artist and curator Bernard Lüthi and initiated by the Kunstsammlung Nordrhein-Westfalen in Düsseldorf. It had a dual agenda to present Aboriginal art as fine art, and to adopt a broad conception of the category Aboriginal art. Indeed, within Australia itself, as the art historian Ian McLean notes, 'not until 1990 were there signs of an institutional shift towards the inclusion of urban Aboriginal artists'.

In the 1970s and 1980s many Aboriginal people in southeast Australia began to develop as artists while simultaneously and confidently asserting their Aboriginality. Most were trained not in the remote bush or desert regions of northern Australia but, like many of their White contemporaries, in the art worlds and art schools of urban Australia. What was their relationship to other Aboriginal artists? What was the relationship between Aboriginal art and other contemporary Australian art? The paradox multiplied when non-Aboriginal contemporary artists such as Tim Johnson (b.1947) and Imants Tillers (b.1950) borrowed Aboriginal motifs (250). Tim Johnson even participated with Aboriginal artists in the co-production of paintings. Was a piece of Western Desert art contemporary Australian art when Tim Johnson painted some of the dots? Was it 'Australian' as opposed to 'Aboriginal' even if it was formally indistinguishable from other Western Desert pieces? If it was classifiable as avant-garde could it no longer be Aboriginal art? And if it was avant-garde then were not Aboriginal artists working in other avant-garde styles equally producers of Aboriginal art?

The apparent paradoxes arise because Western art history creates pigeonholes. It has a tendency to allocate individual works to single art-historical spaces, failing to recognize the fuzzy nature of the bound-aries between art styles and the multiplicity of influences on a particu-lar artist's work. The solution forced by the nature of contemporary Aboriginal art was the recognition both of its plural nature and of the consequences of this plurality for Western art-historical theory.

The 1970s saw major developments in Aboriginal art in southeast Australia, Queensland and the Perth region of Western Australia. A number of young artists began to gain reputations for themselves; their works drew inspiration from many different sources, reflecting the multiple influences on the life histories of Aboriginal people brought up in both urban and rural areas and disrupted by two hundred years of European colonization. These artists have sometimes been

250
Imants Tillers,
The Nine Shots,
1985.
Acrylic, oilstick
on 91 canvas
boards; 330·2 ×
266·7 cm,
130 × 105 in.
Sherman
Galleries,
Sydney

labelled collectively as 'urban Aboriginal artists' in contrast to those working in more remote and 'traditionally oriented' communities of northern and central Australia.

While Aboriginal people in the southeast sometimes refer to themselves as 'urban Aborigines' it is generally not a term they wish to be known by, since it carries connotations of being 'not real' or inauthentic. The opposition between 'urban' and 'traditional' is particularly misleading. As the curators Hetti Perkins and Victoria Lynn pointed out in 1993, 'As a specific geographical reference removed from inferences of authenticity "urban" may be applicable. However "traditional" remains problematic implying as it does a perpetually unchanging civilization.' Indeed, the diversity of Aboriginal Australia is such that these dualistic and stereotypic oppositions are meaningless. Regional generic labels are sometimes used by artists: Koori for southeast Australia, Murri for northern New South Wales and south Queensland, Nunga for coastal South Australia, Nyoonga for southwestern Australia and so on. But increasingly artists are happier with most general labels, Aboriginal or indigenous, or no label at all.

In Arnhem Land, central Australia and many other regions, group rights in designs and an emphasis on continuities of form influence the art more than in the south. The contemporary artists from the southeast tend to produce works that are based on individually constructed iconographies. As Robert Campbell junior, from Kempsey in northern New South Wales, wrote: 'As an urban Aboriginal artist my work does not look "typically Aboriginal" and I find that people are not looking for that in my paintings. My paintings are in fact very much what I feel in my own heart. Very personal.'

In this respect art from the south fits a general and global category of contemporary art which emphasizes individual style. However, there are common themes and patterns of influence which cut across Aboriginal art and constitute it as a distinctive field of discourse. Most artists draw on themes from their Aboriginal past and on shared experiences of oppression. Key events in the colonial history of Australia are common: Captain Cook, the early massacres, the Gurindji stockmens strike (see 246), the lost generations of children taken from their parents, the

251
Sally Morgan,
Citizenship,
1987.
From the
portfolio
*Right Here, Right
Now: Australia
1988.*
Screenprint
on paper;
58·6 × 36·4 cm,
23 × 14⅜ in.
National Gallery
of Australia,
Canberra

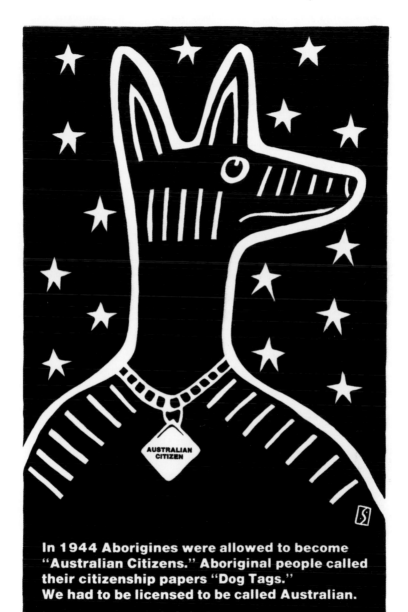

In 1944 Aborigines were allowed to become "Australian Citizens." Aboriginal people called their citizenship papers "Dog Tags." We had to be licensed to be called Australian.

Citizenship Sally Morgan 19/30

fight for citizenship (251), the struggle for land rights, the tent embassy
(see 1) and issues of sovereignty.

Another common element has been the very process of coming to terms
with Aboriginality in the post-colonial world and the problematic issue
of cultural identity. Many artists express regret that so much of their
heritage was lost and are determined to reconnect themselves to their
history. Many are angry that Europeans tried to separate Aboriginal
people from their past. As the painter Harry J Wedge (b.1957) states in
the caption to *Brainwash* (252):

252
Harry J Wedge,
Brainwash,
1994.
Acrylic on
canvas;
61 × 48 cm,
24 × 18⅞ in.
Queensland
Art Gallery,
Brisbane

253
Judy Watson,
our bones in
your collections,
1997.
Etching and
chîne collé on
haunemülle
paper;
30 × 12 cm,
11⅞ × 8¼ in.
Collection of
the artist

Down through the history of our life our people … was passing their
knowledge on to other people. So they thought about things, about the
Dreamtimes … their tribe and their ancestry. Some people still teaching
this precious gift … I haven't got no gift at all … 'cause these people
stopped our people passing down their knowledge to us … What I got is
this dream to tell about the past to tell what happened to my people …
And now through our dreams we are sharing the past, the present and
the future.

Some artists took part in personal pilgrimages to reconnect themselves with a heritage they felt had been denied them. Judy Watson (b.1959), who was brought up in the urban environment of Brisbane, is descended from Waanyi people from northwest Queensland. She visited her grand-mother's country with her relatives, listened to their stories and became immersed in the land. 'I listen and hear those words a hundred years away. That is my grandmother's mother's country, it seeps down through blood and memory and soaks into the ground.' Her work repre-sents 'memories washing over me'. The etching illustrated (253) is one of a series that reflects on the incorporation of Aboriginal material objects and skeletal remains in the collection of European museums.

This process of reconnection, together with a shared political history, creates a density of interconnections across Aboriginal Australia that allows for both unity and diversity. As Perkins and Lynn noted: 'The function of art as an agent for social justice is embodied in all Aboriginal and Torres Strait Island art. It is this collectively implied or stated position that is probably the only instance where a homogeneity of cultural expression can be suggested.'

The first significant figure to emerge from the first wave of 'urban' artists of the 1970s was Trevor Nickolls. Nickolls came from South

254
Trevor Nickolls,
Dreamtime
Machinetime,
1981.
Acrylic on
canvas;
122 × 60·5 cm,
48 × 23¾ in.
National Gallery
of Australia,
Canberra

Australia and went to art school in Adelaide in the early 1970s, where he was exposed to the influence of a wide range of styles of contemporary art. By the late 1970s his paintings had centred on the themes of Aboriginality and colonialism. He developed his own style of painting which drew its inspiration from Aboriginal art but was very distinctive in itself. Between 1978 and 1981 he painted a series of images under the title *Dreamtime Machinetime* (254) in which he reflected on the contrast between Aboriginal and post-colonial landscapes. His paintings often included a map of Australia in which an idyllic harmonious Aboriginal world is disrupted by the violence of mining, excavation and destruction, and in which the bountiful landscape of trees and fruits becomes dominated by the tall buildings of the urban townscape. He developed his own complex iconography to convey the message of colonial violence and greed, and the intrusive impact of technology. The mining pick and dollar sign that have prominent roles as symbols in many of his paintings strike a chord with many Aboriginal people. I am reminded of Narritjin Maymuru's summary of his experience of European culture in Ian Dunlop's 1986 film, *One Man's Response*, with the refrain, 'Money, money, money!'

Stylistically Nickolls's *Dreamtime Machinetime* paintings are influenced by Western Desert acrylics, being largely built up of dotted patterns. These give the paintings a decorative effect which contrasts sharply with the violence of his colonial imagery. This influence was reinforced in 1979 when he met the Warlpiri artist Dinny Nolan Tjamitjimba (b.1922) and began to learn about the desert tradition. In the 1980s he spent several years in Darwin as part of a personal quest to deepen his connection with 'traditional' Aboriginal art. His later paintings show the influence of this period. *Big Boss Hat* (255) presents a depressing and pessimistic image of cattle-station country. The concentric circles which come out of central desert art underlie an imagined landscape in which the Aboriginal components are dominated and replaced by symbols of European invasion; the boomerang, for example, is transformed into a gun which turns against the Aboriginal people. Nickolls also continued to paint decorative and picturesque visions of Aboriginal landscapes. The 1986 *Waterhole and Trees* (256) depicts a theme closely associated with Aboriginal spirituality. Nickolls himself remains fairly silent about

255
Trevor Nickolls,
Big Boss Hat,
1987.
Acrylic on
canvas;
153 × 111·5 cm,
60¼ × 44 in.
Museum voor
Volkenkunde,
Rotterdam

his art, leaving it open to interpretation by the viewer, but his paintings
seem to express a multiplicity of influences encountered in his personal
quest. *Waterhole and Trees* includes many references to Aboriginal
symbolism, for example the snails and the elliptical waterhole. The
flowers could allude to European folk-art traditions, whereas the dotted
background, the circle-and-line pattern of the trees and the formal
structure of the design are all reminiscent of central Australian art.
Yet it is just as easy to read in references to paintings by Fred Williams
(1927–82) of the 1950s and 1960s bush (257), a connection to the
European Australian landscape tradition that stretches back to Arthur
Streeton (see 7) at the end of the nineteenth century. Nickolls's art
gained international recognition when he was selected together with
Rover Thomas to represent Australia at the 1990 Venice Biennale.

Lin Onus was a Melbourne artist whose work, on the surface, seems
very different from that of Nickolls. Yet their paintings share many
themes. Onus's art, too, developed as part of a personal pilgrimage
which allowed him to establish fulfilling relations with fellow artists
in Arnhem Land. Onus's background illustrates the continuing strength
of Aboriginal identity in the lives of Koori people during the period of

marginalization that they endured for much of the twentieth century. His father, Bill Onus, was an entrepreneur and craftsman who manufactured boomerangs and put on performances of boomerang throwing at St Kilda in Melbourne. He set up an enterprise that sold Aboriginal art from the Northern Territory and encouraged Aboriginal people in the south to produce art for sale. He also encouraged the use of Aboriginal designs on artefacts and paid little attention to the thin line between art and craft, or between fine art and souvenir art. Thus Lin Onus grew up in an environment that was saturated with Aboriginal art. He himself wrote a general account of artists in southern Australia illuminated by his own experience:

In this one-hundred-year period issues of survival and family unity took precedence. Artistic and cultural practices declined dramatically yet in isolated pockets some traditions survived. Inspired principally by the need to earn some extra money, some groups and individuals produced boomerangs and other artefacts for the tourist market. In an ironical fashion the area of the market that is widely perceived as the enemy of fine art managed to keep the threads of a few ancient traditions intact.

Although he had no formal art school training (his initial training was as a mechanic) he grew up in an environment in which artistic activity was encouraged, and by the age of sixteen or seventeen his early landscape paintings were being sold by his father's enterprise. His inspiration came from those Aboriginal artists who had produced land-scape paintings in a European media: Albert Namatjira, the Nyungah artist Revel Cooper and the Wiradjari Gunai artist Ronald Bull. He grew up at a time when 'urban' Aboriginal artists felt ambivalent about their relationship to indigenous art forms and when the landscape tradition seemed the most sympathetic form to adopt. The late 1970s and early 1980s brought about a transformation in Onus's art. Inspired partly by Trevor Nickolls, Onus developed a close relationship with a number of Arnhem Land artists. Onus began to pay regular visits to Maningrida in the 1980s and in particular to Garmedi outstation. He was taught clan paintings by artists such as Jack Wunuwun and Johnny BulunBulun and he began to include motifs from the region in his paintings. Onus's extraordinary series of celebratory portraits came out of his

256
Trevor Nickolls,
Waterhole and
Trees,
1985.
Acrylic on
canvas;
110·8 × 167·6 cm,
43⅝ × 66 in.
National Gallery
of Australia,
Canberra

257
Fred Williams,
Burning Log,
1957.
Gouache
on paper;
62·5 × 44·8 cm,
24⅝ × 17⅝ in.
National Gallery
of Australia,
Canberra

relationship with these artists (258). The paintings incorporate realistic representations of the artists apparently integrated within their own paintings.

The underlying style of Onus's art is a form of hyperrealism, in which the image has many of the characteristics of a photograph. His Arnhem Land paintings, for example, incorporate the schematic images of Arnhem Land art within a hyperrealist frame. And, rather than making Arnhem Land motifs into elements of his own style, he incorporates representations of them within his paintings; they occur as elements of

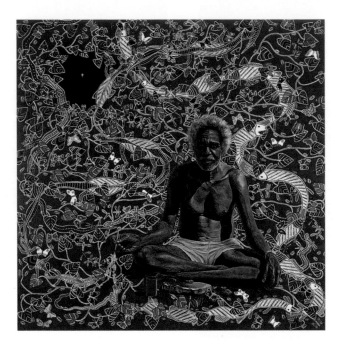

258
Lin Onus,
Portrait of Jack Wunuwun,
1988.
Acrylic on canvas;
182 × 182 cm,
71³⁄₄ × 71³⁄₄ in.
The Holmes à Court Collection, Heytesbury, Western Australia

259
Lin Onus,
Dingoes. (1) Birth, (2) Anal Fetish, (3) Why do dingoes lick themselves?, () Dingo proof fence, (5) Trap
1989.
Acrylic on fibreglass, wire, metal;
max. h.95·5 cm
37¹⁄₂ in.
National Gallery of Australia, Canberra

montage. Many of the paintings involve conceptual and visual puns: they are literal readings of Arnhem Land paintings as landscape, or they include Arnhem Land-style figurative representations as if they are actually occurring forms in the landscape. *Tracks*, for example, shows a Central Arnhem Land painting of a particular area of country superimposed on an image of feet walking across the red earth. These naked footprints in turn are covered over by Toyota tyre tracks. It is a very different image from Nickolls's *Dreamtime Machinetime* but it holds a similar message.

Towards the end of his relatively short life Onus turned increasingly to sculpture, producing works of art which were of great appeal but which often carried a sting in the tail. The dogs in his series of sculptures called *Dingoes* are realistic in form but are painted schematically in ochred colours (259). The sculptures again reflect his exploration of other Aboriginal art forms, as they are reminiscent of the spinifex resin and ochre dogs from Lake Eyre (see 50) and the dingo carving from Aurukun in the National Museum of Australia. The series illustrates the life cycle of the dingo from birth to death, and includes many pointed

and sometimes amusing images. One shows a dingo making its way through the dingo-proof fence, which according to Onus 'is a commentary on the treatment of these native animals, which in Aboriginal eyes closely approximates the treatment of Aboriginal people themselves'.

Lin Onus's connections to Arnhem Land were facilitated by the presence of Djon Mundine, an Aboriginal person from New South Wales, who was art adviser in Maningrida and Ramingining from the late 1970s and subsequently curator at the Museum of Contemporary Arts in Sydney and the National Museum in Canberra. Mundine acted as a channel of

communication between Aboriginal artists in the southern states and those in Central Arnhem Land; he helped to break down barriers raised by the different colonial history of the two groups, and to create an environment of shared experiences in which mutual understanding could develop. A number of other artists visited Arnhem Land during this time, including Robert Campbell junior, Fiona Foley (b.1964), Avril Quaill (b.1958), Michael Riley (b.1960) and Gordon Bennett (b.1955). Lin Onus wrote of the effect of these visits:

In each case these artists have experienced a profound and cathartic change, both personally and artistically. Whilst each change has been in some ways personally different a common thread seems to emerge. The deep spiritual relationship between the people of Arnhem Land and their land and environment has reawakened and magnifies each artist's relationship with their homeland.

260
Fiona Foley,
The Annihilation of the Blacks, 1986.
Plywood and wood;
h.60 cm, 23⅝ in.
National Museum of Australia, Canberra

261
Fish on Poles,
Collected 1962.
Paint on wood;
h.140 cm, 55⅜ in.
National Museum of Australia, Canberra

Fiona Foley's work exemplifies the complex nature of the influences and the sense of history that inspires many contemporary Aboriginal artists' work. Foley, a descendent of the Batjala people from Fraser Island, Queensland, was an early member of the Boomalli Aboriginal Artists Co-operative in Sydney, which was founded in 1987 by a group of artists that included Jeffrey Samuels (b.1956), Bronwyn Bancroft (b.1958), Raymond Meeks (b.1957), Brenda Croft (b.1964) and the photographer Michael Riley. Trained at the Sydney College of Arts, Foley has produced works in many different media and styles. They often draw inspiration from other Aboriginal art forms, but the content of her paintings is used to highlight the traumas of invasion and dispossession. Viewed from a distance the works evoke a variety of forms of Aboriginal art; on closer inspection they become a commentary on a history of racism and oppression. Her sculpture *The Annihilation of the Blacks* (260) looks at first sight like a fish drying rack from north Queensland, as represented in sculptures from Aurukun such as *Fish on Poles* (261) which was in the *Aboriginal Australia* exhibition (1981–2). It was collected by the archaeologist Fred McCarthy after it formed the focal point of a dance at Aurukun in 1962. The dance represented the hunting of fish at night by men in canoes and the suspension of the fish on a rack. The sculpture captures the sense of fish hanging as dead weights glistening in the

262
Judy Watson,
burning, 1993.
Pigment, pastel
and ink on
canvas;
185 × 118·5 cm,
72$^7_8$ × 46$^3_4$ in.
Collection of
the artist

263
Judy Watson,
*the guardians,
guardian spirit*,
1986–7.
Powder
pigment on
plywood;
180 × 58 cm,
70$^7_8$ × 22$^7_8$ in.
Art Gallery of
New South
Wales, Sydney

264
Termite
mounds,
Kakadu
National Park,
Arnhem Land

moonlight. In Foley's sculpture, however, rather than fish it is the dead bodies of Aboriginal people that are hanging. In an installation at the National Gallery of Australia, as part of the 1996 *Islands* exhibition, she created a spiral of flour reminiscent of ceremonial ground sculptures. Certain elements of the installation make it clear that, in colonial history, flour was far from a neutral substance. It was a means of attracting people to mission stations, a cheap way of paying labour and, laced with strychnine, a lethal weapon used against Aborigines.

Judy Watson's paintings and sculptures are equally concerned with issues of identity, relatedness to land and history. Her works evoke the spirit and feeling of place, but her style is predominantly non-figurative and expressionist, and the texture and surface qualities of the painted canvas are integral to its meaning (262). Many are designed to hang loose like textiles rather than to be stretched and framed. Her set of sculptures *the guardians/guardian spirit* in the Art Gallery of New South Wales is more obviously figurative than most of her work (263). The figures represent the matrilineal line of her family. The form of the figures alludes to ancestors' burial rights and to termite mounds (264) thought to be spirits of deceased people. The sculptures connect her to her land and her culture.

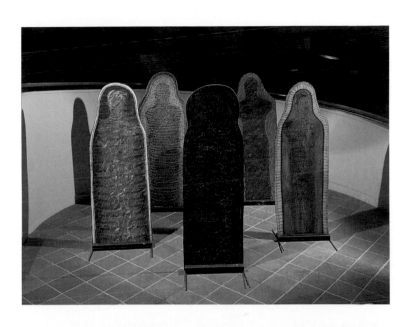

Many Aboriginal artists document significant events in the history of Australia from an Aboriginal viewpoint. The paintings of Robert Campbell junior, who grew up in northern New South Wales, represent, in a series of panels, events in his people's past or commentaries on contemporary issues. *Aboriginal Embassy* (see 1) shows the tent embassy put up outside the Parliament House in Canberra during the struggle for land rights in 1972. The tent embassy has become a symbol of the struggle for sovereignty and recurs as a motif in other artists' work. *Death in Custody* (265) documents another key issue of contemporary Aboriginal politics: Aboriginal people are the most imprisoned segment of the Australian population, and in the 1980s there was an outcry over the number of young Aboriginal men who died in jail.

A characteristic feature of Robert Campbell junior's paintings is the contrast between the bright optimism conveyed by the aesthetics of the paintings and the darkness of the themes they explore. The brilliant effect of multiple coloured dots characterizes both his work and the art of a number of other 'urban' artists, including Trevor Nickolls. The phrase 'flash art' is sometimes applied to paintings in this style. Campbell also used the technique in his less well-known landscape paintings which convey the scale of the rural New South Wales country. In fact, Campbell saw all his paintings fundamentally as narrative landscapes. On his return from Arnhem Land in 1990 he wrote, 'One of the greatest realizations was that all the paintings of the area were not of dreamings but images of landscape – in fact not very different from my own work.'

Harry J Wedge, a Wiradjurri man born in the late 1950s, did not begin painting until 1988. His work addresses many of the same themes in their emphasis on political history. The titles of his paintings signify as much: *Captain Cook Con Man*, *Genocide*, *Massacre*, *Alcohol Abuse*, *Deaths in Custody*. *No Respect*, painted in 1992, documents police aggression against Aborigines and the police attitude to the Royal Commission set up to investigate Aboriginal deaths in custody. The triptych *Mabo Country, Kingsize* (266), completed in 1993, records the events associated with the Mabo judgement, in which the legal fiction of *terra nullius* – the idea that Australia was effectively uninhabited at

265
Robert
Campbell
junior,
*Death in
Custody*, 1987.
Acrylic on
canvas;
82·2 × 120 cm,
32⅜ × 47¼ in.
The Holmes
à Court
Collection,
Heytesbury,
Western
Australia

the time of the European invasion – was overturned. Stylistically his paintings contrast markedly with Robert Campbell junior's. As the curator Judith Ryan writes, 'Wedge's figures are shown in close-up and stare out of the composition, menaced, indoctrinated, excited or joyful. The eyes of Wedge's characters provide the key to his highly personal emotions and attitudes, which he is concerned to communicate with the viewer.'

The paintings of Ian W Abdulla (b.1947) are also documentary but they convey little of the anger of Harry J Wedge's works. His paintings, in a naïve style reminiscent of the English artist Alfred Wallis (1855–1942), who worked in St Ives, Cornwall, record scenes from his early life, growing up at Cobdogla on the Murray River. The paintings are humorous and descriptive, evoking a bygone era, sometimes recording harsh realities but always with a sense of laconic optimism. The intrusion of Europeans is referred to in some of the inscriptions that routinely caption the paintings: 'Catching Fish in the Back waters with a Gillnet for eating before the white man changed our way of living off the land and along the River Murray' (267).

A very different concept of history painting has been developed by the Queensland artist Gordon Bennett, winner of the prestigious 1991 Moët & Chandon Australian Art Fellowship. Bennett's paintings are, in his own words, 'an ethnography of representation'. His style is characterized by the use of the representational systems developed in European art to reflect on the colonial process. His paintings draw complex analogies between the world as captured through art and the colonial domination of Aborigines. The potential for Aboriginal art to challenge and subvert European representational practice had always existed; Bennett's ethnography of representations uncovers this complex history. In the 1988 painting *Outsider* (268), the bedroom at Arles (269) of Vincent van Gogh (1853–90) is violated by a headless Aborigine in body painting with spirals of blood exploding from his neck. The picture is ambiguous: the Aboriginal person is clearly a victim and yet he stands menacingly not over his own head but over two classical heads that lie on the pillows beneath him. Perspective is an important theme in Bennett's next set of paintings. As he said:

266
Harry J Wedge,
*Mabo Country,
Kingsize*,
1993.
Acrylic on
canvas;
each panel:
122 × 182·5 cm,
48 × 71⁷⁄₈ in.
Gallery
Gabrielle Pizzi,
Melbourne

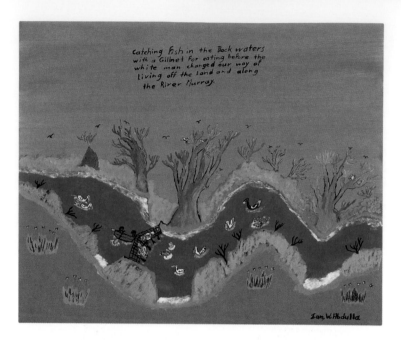

Catching fish in the Back waters
with a Gilnet for eating before the
white man changed our way of
living off the land and along
the River Murray.

Ian.W.Abdulla

267
Ian W Abdulla,
From *The River Series*,
1990.
Acrylic on canvas;
36 × 46 cm,
14$^1_8$ × 18$^1_8$ in.
Location unknown

268
Gordon Bennett,
Outsider,
1988.
Oil and acrylic on canvas;
290 × 180 cm,
114$^1_8$ × 70$^7_8$ in.
University Art Museum,
University of Queensland

269
Vincent van Gogh,
The Artist's Room in Arles,
1889.
Oil on canvas;
57.5 × 74 cm,
22$^5_8$ × 29$^1_8$ in.
Musée d'Orsay, Paris

'Aborigines caught in this system of representation remain "frozen" as objects within the mapped territory of a European perceptual grid.' The vanishing point of *Australian Icon* (270) provides a symbolic theme that recurs throughout his paintings of this period.

In 1997 Bennett turned his imagination to Margaret Preston who had played a significant role in making Aboriginal art part of the Australian art world of the 1930s. Although many of her works developed themes from Aboriginal art in interesting ways, her modernist aesthetic allowed this art only a subordinate position. In some of her later paintings she produced caricature-like figures of Aboriginal people that contrast markedly with the sophistication of much of her other work. Gordon Bennett seizes these images and traps them within a grid derived from Piet Mondrian (1872–1944). The paintings (271) are open to multiple interpretations: they comment in an ironic way on Preston's appropriation of Aboriginal images, they show how modernist appreciations of Aboriginal art actually primitivized Aboriginal people, and they continue the theme of the grid-like and containing nature of European representational systems as a metaphor for colonial control. Bennett himself describes the personal journey explored in his paintings:

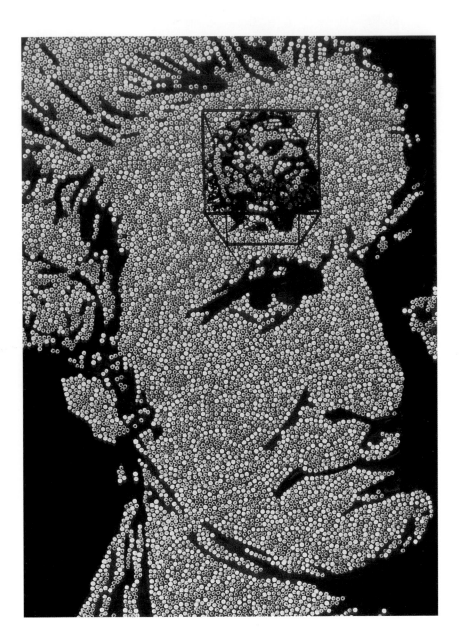

270
Gordon Bennett,
Australian Icon (Notes on Perception No. 1),
1989.
Oil and acrylic on paper;
76 × 57 cm,
29⅞ × 22⅜ in.
Private collection

271
Gordon Bennett,
Home Decor (Preston + De Stijl = Citizen) Umbrellas,
1997.
Acrylic on linen;
182·5 × 182·5 cm,
72 × 72 in.
Bellas Gallery, Brisbane and Sutton Gallery, Melbourne

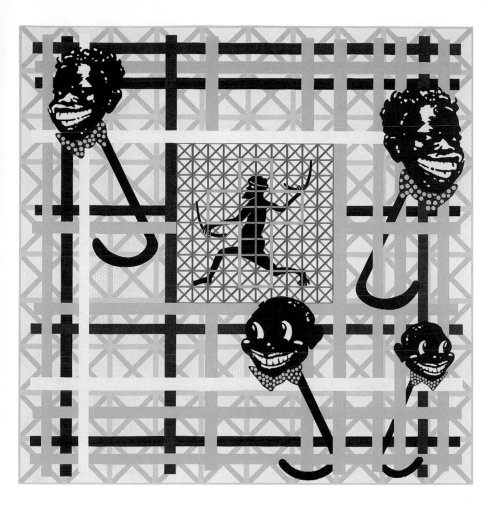

I was socialized into a Euro-Australian system of representation which included an art school education. However, my approach to aesthetics is to seek to extend my concepts of it and by extension to expand my concepts of representation. There came a time in my life in my sense and identity as an Australian, when I became aware of my Aboriginal heritage ... when the weight of European representation of Aboriginal people as the quintessential primitive 'other' is realised ... then it may be seen that such an awareness was problematic for my sense of identity'.

The work of Tasmanian artist Julie Gough is likewise art combined with analysis. Her works in mixed media, based on the ideas and obsession of collecting, are often organized as displays of items, designed to be attractive, to engage the attention of the viewer, to evoke memories of

childhood and past lives, but always with a sting in the tail. Her works are humorous but at the point where 'funny meets awful'. *The Trouble with Rolf* illustrates this well (272). At first this seems to be a decorative arrangement of lollipops, but it turns out to be the 'sambo' figures from days of childhood innocence which now seem so problematic. The arrangement of faces suspended on wire tied to fenceposts turns out to be a musical score, the verse from a well-known Rolf Harris song, 'Tie me kangaroo down sport'. The artwork can be sung and the words place the image at that point in recent history when equal wages were intro-duced for the first time to Aboriginal people working on cattle proper-ties. 'Good news,' one might have thought, but the response of many pastoralists was to sack the Aboriginal workforce and turn them off their own land: in Rolf's words, to 'let me Abos go loose'.

272
Julie Gough,
The Trouble with Rolf,
1996.
Plaster heads, pine fence-posts, fencing wire;
244 × 520 cm, 96 × 204¾ in.
Gallery Gabrielle Pizzi, Melbourne

273
Fiona Foley,
Native Blood,
1994.
Black and white photographs, hand tinted.
Roslyn Oxley9 Gallery, Sydney

Equally analytical is Fiona Foley's recent photographic work *Native Blood* (273). Like Gordon Bennett she explores a particular European representational genre through photographing herself in various primi-tivist erotic poses. By taking control of these images she retrospectively becomes an agent in a historical process and changes its meaning.

Photography has been an increasingly important medium for Aboriginal artists. Alana Harris (b.1966), Brenda Croft and Michael Riley, working in New South Wales, have produced photographs which, as well as documenting aspects of contemporary Aboriginal life, have consciously engaged with their historical position, challenging stereotypes and

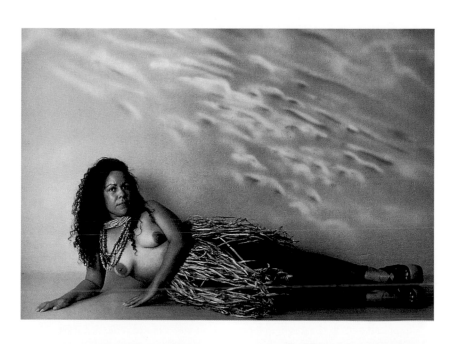

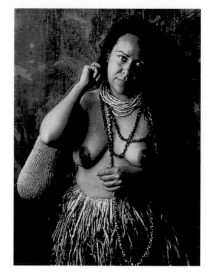

giving new interpretations to persons and events. Riley's portraits, such as his 1990 photograph *Grandmother with Dog* (274), are often enigmatic yet sympathetic, realist but on the edge of the surreal. The surreal likewise enters the photographs and films of Tracey Moffatt (b.1960), which explore issues of race, history and gender. *Nice Coloured Girls*, made in 1987, focuses on sexual relations. The film includes staged events of contemporary encounters between White men and Aboriginal women within a montage of references to colonial history and attitudes to colour. In *Night Cries: A Rural Tragedy* the messages are multiple and ambiguous. The film combines hyperreal photography in Cibachrome colour with evocative stage sets and power-ful sound. The images are beautiful and unnerving. The photographs of Destiny Deacon (b.1957) also have an element of the surreal. Her care-fully constructed ironic images often attempt to validate Aboriginality, challenge stereotypes and draw attention to the oppressive effect of colonial history. Her images of a black doll stretching through the bars of a cot, such as in *Meet Us Outside* (275), powerfully evoke the imprisonment of the Aboriginal population and simultaneously assert the positiveness of blackness, while alluding to the problematic nature of black dolls in the history of Western childhood. Other photographs are more in documentary or landscape modes, but always with a political edge to their content.

274
Michael Riley,
*Grandmother
with Dog*,
1990.
Photograph

There is a wicked ambivalence about many of Destiny Deacon's images that seems designed to challenge the viewer, to make them uncertain as to whether to relish the images or be disturbed by the political history to which they allude. Marcia Langton, the anthropologist, activist and cultural critic, writing in *Art and Australia*, speculates as to how people from different backgrounds might interpret her images and then links one of them, *Last Laugh* (276) to her own experience: 'I grew up in a humpy [shack] and without wishing to give the impression of unexamined nostalgia – I can say that it was heaven for me ... on the downside I was reviled by the pastoralists' kids at school for being one of those boongs from the blacks' camp down at the river. Corrugated iron has a special sweet-and-sour resonance for us fringe dwellers and Destiny has pushed the right buttons in this image to kickstart the memories, smells and emotions.'

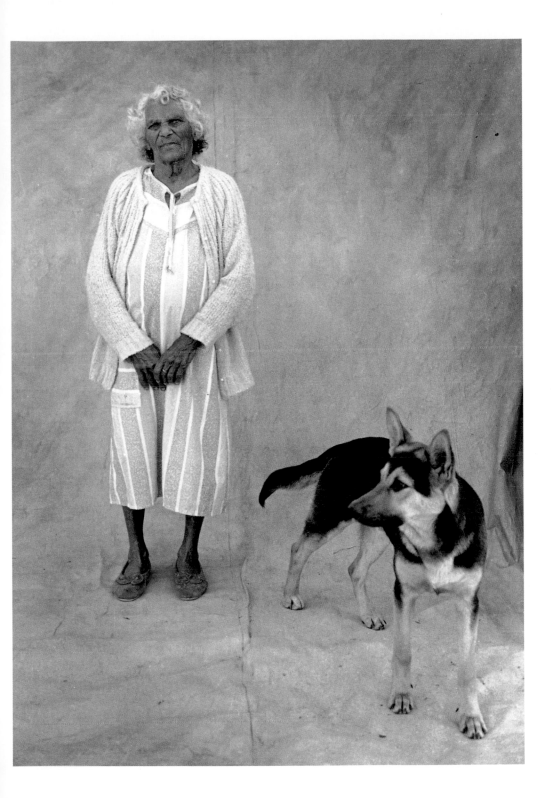

275
Destiny Deacon,
Meet Us Outside,
1994.
Laser print from
colour polaroid.
Collection of
the artist

276
Destiny Deacon,
Last Laugh,
1995.
Colour polaroid
bubble jet print
on paper.
Gallery Gabrielle
Pizzi, Melbourne

Print-making represents another medium of increasing importance. And as is the case with many other areas of Aboriginal art, people had been actively engaged in the practice long before it became generally recognized. Kevin Gilbert, the writer and political activist, for example, learnt linocut print-making in Long Bay Jail in the 1960s and on his release continued for a while to produce prints. Aboriginal print-making received a stimulus in the 1970s from the interest shown by the artists and lecturers Jorg Schmeisser (b.1942) and Theo Tremblay (b.1952) at Canberra School of Art. Around the same time Flinders University in Adelaide began its artist-in-residence programme. In both these cases the original intention was to bring Aboriginal people from remote communities to reproduce their designs through various print media. The programmes were very successful in helping to train artists such as Banduk Marika from Yirrkala and the Tiwi artist Bede Tungutalum (b.1948), whose work has subsequently influenced other artists in their home communities. The techniques of fine cross-hatching and incised woodcarving which are associated with the arts of Eastern Arnhem Land and Melville and Bathurst Islands have proved to be useful skills that can be applied to arts in various print media. Bede Tungutalum's linocuts, often include motifs from pukumani poles and other ironwood carvings (277). Jimmy Pike (b.c.1940), a Walmajarri artist from the region of the Great Sandy Desert in Western Australia, has also gained a considerable reputation as a printmaker by applying traditional engraving techniques used on pearl shell and wooden implements to the introduced medium of linocuts.

277
Bede
Tungutalum,
Untitled,
1988.
Linocut;
76 × 56·5 cm,
29⅞ × 22¼ in.
Canberra School
of Art Gallery,
Australian
National
University,
Canberra

The artist-in-residence programmes evolved very quickly to include Aboriginal people from all over Australia. At the same time community arts programmes began to provide wider opportunity for Aboriginal people throughout Australia to learn different artistic techniques. A sign of this was the major contribution that Aboriginal artists made to two collections of prints commissioned for the bicentenary: *Right Here, Right Now: Australia 1988* (which included works by Sally Morgan, b.1951, Bede Tungutalum and Byron Pickett, b.1955) and *The Bicentennial Portfolio* (which included works by Sally Morgan, Robert Campbell junior and Banduk Marika). The work of Sally Morgan, a Palku artist from Western Australia, moves from the surface beauty of the pastoral

Another Story Sally Morgan 2/95

station glowing in the sunlight to the bodies of the Aboriginal people lying below the soil, victims of the European invasion (278).

Aboriginal people in different parts of Australia, producing works in very different and often historically independent styles, nevertheless express common themes. This is one of the defining characteristics of Aboriginal art. The importance of landscape links artists in Arnhem Land and central Australia with those in southeast Australia, even though it is expressed in very different ways. The differences force us to recognize that landscape is conceptual and abstract, involving particular relationships between people and place. What Aboriginal people tend to share in common is an ideology of the importance of place and the inalienable nature of the relationship between people and place. Art in Arnhem Land and central Australia is as concerned with political issues as art produced in more urban contexts. In the new urban context the political is expressed through the way paintings are used in ritual and in discourse with Europeans, rather than through explicit political reference in the content of the paintings. In both cases, the art objects have political significance.

The 1988 bicentenary provided an important opportunity for political engagement. It presented a difficult context for Aboriginal artists – it was a celebration of two hundred years of colonial rule, during which many Aborigines had been subjected to appalling treatment and had their land taken away from them. Aboriginal people could have boycotted the festivities altogether or they could have organized counter-events with the aim of sabotage. Instead, their counter-events were directed at changing the meaning of the bicentenary.

The bicentenary also provided an opportunity to redress the balance. Australia invested considerable resources in making the celebrations a success and it was hoped they would generate global interest. And Australia wanted, even needed, Aboriginal participation. So there was an opportunity for Aboriginal people to influence the tone of the cele-brations and even to capture part of the agenda. Whereas in earlier times, perhaps even twenty years before, Aborigines would have been excluded by White Australia from taking part, would have been denied resources, would have merited a mention only as a footnote from the

278
Sally Morgan,
Another Story,
1988.
Stencil, colour
screen print on
wove paper;
50.4 × 32.7 cm,
23¾ × 12⅞ in.
National Gallery
of Australia,
Canberra

past, the political context of 1988 was very different. Australia had begun to distance itself from Britain and to position itself as an Asian-Pacific state with a positive reputation in the field of civil rights. The issue of reconciliation with Aboriginal people, of coming to terms with a colonial past and moving forward as a united nation, became important ideologically. White Australians needed Aboriginal participation if this rhetoric was to carry any conviction. The genius of Aboriginal participation in the bicentenary was to subvert the agenda but in the spirit of reconciliation.

Aboriginal people participated in the bicentenary in many ways. As well as the special editions of prints discussed above, Aborigines participated in the public performances and street theatre that were some of the most memorable experiences of the year. Australia Day became Invasion Day and brought Aboriginal people and their supporters from all over the country to Sydney for one of the largest marches ever seen in the city (279, 280). Above all, the Aboriginal Memorial took its place in the National Gallery (after initially being displayed in Sydney): two hundred hollow-log coffins made by people from Ramingining in Central Arnhem Land which commemorated the deaths of Aboriginal people as a result of two hundred years of European colonization (see 20, 21). Remembrance and the need for recompense were prominent themes of bicentennial art. The positive message that sung out was that, despite everything, Aboriginal people had survived to take part. The very fact that there were so many Aboriginal artists attested to this.

Within contemporary Aboriginal Australia art has also provided a context for exchange and for people to learn from one another. Aboriginal artists who incorporate elements from other regions in their works do so with due regard to the network of rights within which they are embedded. Lin Onus acknowledged the limited rights that he had acquired to use Arnhem Land designs in his paintings and the privilege he felt in being given permission to do so. When Gordon Bennett incorporates the concentric circle motif and dotted infill of central Australian forms, he is conscious of the need to avoid appropriation.

Borrowing, or more accurately the appropriation of, Aboriginal designs has become a highly contentious issue in Australia. In the recent past

279–280
Demonstrations
on Australia/
Invasion Day,
Sydney, 1988

Aboriginal designs were used, without permission, on fabrics, T-shirts and carpets by Australian and overseas commercial concerns. This problem can largely be resolved by the rigorous application of Australian copyright law, which covers Aboriginal art reasonably well without modification. The costs of legal action (and therefore of enforcement) remain significant, however.

A more complex issue is the use of Aboriginal motifs by artists such as Imants Tillers and Tim Johnson in their own work. The complexity deepens when Aboriginal borrowings from Aboriginal and European art are taken into account. What is the difference in principle between Gordon Bennett borrowing from Van Gogh and Imants Tillers borrowing from a work of Aboriginal art? Perkins and Lynn are critical of European borrowings, writing that: 'rather than seeing it as a post-modernist strategy that suggests the modernist notion of progress towards some ideal point, Aboriginal artists see it in the context of colonialist power relations between dominant and oppressed groups. It becomes a form of symbolic colonization.'

The issue of influence and borrowing in art is complex. It concerns both the rights of artists and their freedom to enter wider art discourses. The borrowing of forms is essential to artistic freedom, but the copyrighting of forms is also essential in order to protect artists' rights. The contradiction is real, but it is worked out in artistic practice over time. It can be noted, simply, that Aboriginal designs influence other artists' work and that Aboriginal artists are actively engaged in protecting their copyright. Both facts are signs that Aboriginal art is embedded in the contemporary world of art.

The contradiction between the legitimacy and even the desirability of influence and the protection of the rights of artists can be mediated by the concept of permission and, in the last instance, by complex laws of copyright which make allowances for creative borrowings. What Aboriginal artists have been arguing for is the right to enter the discourse of art on a basis of equality, and for the a priori recognition of their rights so that permission can be granted meaningfully. Permission brings with it the condition that the borrower respects the cultural integrity of the work and the contexts in which it has value. The issue

of power relations is relevant precisely because, until very recently, Aboriginal people were not asked, and were not acknowledged to have copyright in their own works. Their art was positioned outside the contemporary world. The more Aboriginal art becomes part of contemporary art, the more the question of influence is likely to recede into the background, not because permission will no longer be required but because it will no longer be taken for granted.

Aboriginal art is now being incorporated in the general discourse over Australian art. It is collected by the same institutions, exhibited within the same gallery structure, written about in the same journals as other Australian art. This has come about through the Aboriginal struggle to make their art part of the Australian agenda; incorporation should not be interpreted as the appropriation of Aboriginal art by a White Australian institutional structure. Issues such as the alienation of art from the producer, the protection of intellectual property, the role of the government in the production and marketing of art, the autonomy of tradition and the relationship between representation and abstraction have developed as critical foci in Australian art partly because of the inclusion of Aboriginal art within the debate. The breakdown of simple dichotomies has emphasized the diversity of Aboriginal art, and has allowed distinctions within the category to emerge in a non-prescriptive way.

Outside Australia there has been an exponential increase of interest in Aboriginal art, in particular since the mid-1980s. But this move out into the world has its dangers. Many of the changes that occurred in Australia have been paralleled elsewhere in the world, but – with the possible exception of the art of northwest coastal America – the inclusion of 'indigenous' art within the mainstream has not yet occurred. In overseas contexts, it is almost inevitable that the case for the authenticity of Aboriginal art in the contemporary world has to be reargued. Whereas White Australian art is likely to be categorized with mainstream European or American traditions because of its ancestry, Aboriginal art runs the danger of being re-pigeonholed as 'ethnic' art, and of occupying a slot in a programme or a space in a gallery that is otherwise filled by Makonde art or Inuit art or contemporary Papua

New Guinea prints. And Western art critics will try to draw analogies across that category. Aboriginal art entered New York through the galleries of the Asia Society, and at the Hayward Gallery in London, the 1993 *Aratjara* exhibition occupied a programming space allocated to ethnic art.

If there ever was a battle to respect the anonymous authorship of Aboriginal art which, some have argued, characterized its use in indigenous contexts, then that battle has been lost. Aboriginal artists are now recognized as individuals, and they have maintained a considerable degree of control over the exhibition of their work and the use of their names. They are usually consulted before their work is exhibited in Australia, and the names of dead artists are not used until their families consider that an appropriate time has elapsed since their death. The major Aboriginal art prize, the Wandjuk Marika prize, was known as the Son of Mawalan Prize following the artist's death, until his name became freed again for use.

Although Aboriginal etiquette and systems of rights in paintings do influence Australian 'art world' practice, the situation is different in Europe and America. There, Aboriginal art has been exhibited as a category, although the names of the artists are recorded where known and background information is made available through accompanying catalogues. Moreover, if an exhibition originates outside Australia, it is less likely that Aborigines will intervene to constrain the way in which the art is presented. Whereas in Australia the death of Aboriginal artists is respected by the silencing of their names, in Europe, were their names known, it is unlikely that the wishes of their kin would be respected.

The reincorporation of Aboriginal art, outside Australia, into the 'ethnic' category is not inevitable, however. The art world is becoming more willing to acknowledge complexities of influence and to recognize that, although the Western category of art in its greed can swallow the products of all other cultures, it can also respect their variety and difference. It is here that Australian Aboriginal art may have an important role to play. In Australia Aboriginal art has moved into the public eye partly because of the political action of Aboriginal people. The debates that have surrounded its public emergence in Australia, the breaking down

of categories that followed its movement from the museums into the art galleries, have followed it to Europe and America. Exhibitions that include Koori art with art from Arnhem Land and central Australia, or that explore the complex two-way relationship between Aboriginal art and painting by Australians of European descent, confront overseas audiences with the issues that lie behind developments in contemporary Australian art.

The present category 'Aboriginal art' is the product of a dual process of inclusion: first the inclusion of works from various regional art traditions in the category of Aboriginal fine art and its subsequent expansion to include work by artists such as Gordon Bennett, Tracey Moffatt or Trevor Nickolls that would otherwise have been classified as contemporary world art. The category 'Aboriginal art', then,

281
Gordon Bennett,
The Nine Ricochets (Fall Down Black Fella Jump Up White Fella),
1990.
Oil and acrylic on canvas and canvas boards; 220 × 182 cm, 86⅝ × 71⅝ in.
Private collection

challenges the traditional boundaries of the Western art world through its diversity. The global significance of 'Aboriginal art' as presently constituted is that it includes in an ethnically-defined category works that would equally fit into that dominant unmarked category – contemporary fine art. The very process, however, of incorporating some forms of contemporary art within the category of Aboriginal art while excluding others, in turn re-problematizes it. For if Aboriginal art is nothing other than art produced by Aborigines, then some of the works included within the category are most similar in formal terms to works excluded from it. Thus Imants Tillers's *The Nine Shots* (see 250), which provided the inspiration, or perhaps the irritation, for Gordon Bennett's *Nine Ricochets* (281), is excluded from Aboriginal art. Yet it is part of the history of Bennett's painting and therefore Aboriginal art history.

So one possible development, which follows logically from Bennett's historical ethnography of representation, would be to include within the category of 'Aboriginal art' other art that has influenced Aboriginal artists. The boundaries between Aboriginal and non-Aboriginal art history would be dissolved, but in such a way that world art history would be rewritten in relation to present Aboriginal art practice. Australian art would be seen from this perspective, as one stage in the history of Aboriginal art. This is simply a radical version of art critic John MacDonald's suggestion that Aboriginal art should disappear into a general inclusive category of Australian art. It accepts that different arts have different local histories, but it does not organize them into a hierarchical structure that reflects only the European perspective on world art.

Glossary

Altyerrenge An **Arrernte** word referring to the ancestral dimension of existence. The word was originally translated as **'Dreamtime'** by the anthropologists Baldwin Spencer and F J Gillen.

Anbarra A **language group** of Central Arnhem Land.

Ancestral Beings Spiritual or mythical beings whose existence preceded human life on earth and who through their epic journeys created the landscape as it is today. They may be human or animal, animate or inanimate and in many cases transform from one thing or state to another. They are a continuing influence on the world through processes such as **spirit conception** and provide the underlying source of spiritual power.

Ancestral Past The time when **ancestral beings** occupied the earth, or the dimension in which ancestral beings still exist.

Arrernte A **language group** whose land includes the area around Alice Springs.

Assimilation A policy pursued by Australian governments towards Aborigines which involved encouraging them to adopt Euro-Australian lifestyles and eventually to become assimilated within the Australian population as a whole. The policy often involved the repression of Aboriginal cultural practices, and in many parts of Australia was associated with the removal of Aboriginal children from their families. In the 1970s assimilation was replaced by policies that allowed Aboriginal people greater autonomy and which resulted in an increased recognition of their rights and the value of their cultural practices.

Bark Painting The practice of producing paintings on sheets of eucalyptus stringy bark. The sheets of bark are flattened over an open fire to prepare them for painting. The tradition is best known from the region of Arnhem Land in northern Australia, but evidence suggests it may have been more widespread at the time of European colonization, in regions where bark was used to make huts and shelters.

Batik A technique used for dyeing cloth in which the pattern is marked out using a wax resist. The technique has been used since the 1970s by Aboriginal artists, notably at Ernabella and Utopia in central Australia, but also more widely.

Birrimbirr The soul of the dead in **Yolngu** languages.

Bora The name of a regional initiation ceremony in southeastern Australia associated with the creation of well-defined ceremonial ground structures (bora grounds).

Bradshaw Figures A style of painting in the Kimberleys characterized by elegant dynamic figurative representations.

Burrkun A length of possum-fur string associated with clans of the **Yirritja moiety** in Eastern Arnhem Land.

Clan A group of people connected by descent who hold certain rights in common. In many parts of Australia rights in land and paintings are vested in clans, often formed on the basis of descent through the father (patrilineal clans). However, such clans are by no means a universal feature of Aboriginal Australia.

Conception Spirits Spirits which are necessary to initiate a pregnancy. Conception spirits are one of the continuing links between the present and the **ancestral past**.

Corroboree A word used across much of Australia to refer to Aboriginal ceremonies. It originally came from the language of the Dharuk people from the Sydney region of New South Wales.

Dendroglyphs/Carved Tree Deeply incised patterns made in the trunks of large trees in southeast Australia.

Dhuwa The name for one of the moieties in Eastern and Central Arnhem Land. The other **moiety** is the **Yirritja**.

Dilly Bag A widespread term for bags and baskets woven out of plant fibres. Originally from the Yagara language of the Brisbane region.

Djang A **Kunwinjku** term for **ancestral beings** and the sites associated with them.

Djang'kawu Sisters Two female **ancestral beings** who gave birth to many of the **Dhuwa moiety** **clans** of Eastern and Central Arnhem Land.

Djukurrpa/Jukurrpa A **Warlpiri** term referring to **ancestral beings** and to the places and times associated with them.

Djungguwan A regional fertility and memorial ceremony in Eastern and Central Arnhem Land associated with the **Wagilak sisters**.

Dreamtime/Dreaming A term first used by Spencer and Gillen which refers to the time of world creation or the **ancestral past**. It is a fairly literal translation of the **Arrernte** word **altyerrenge** which in turn corresponds with similar terms in many other central Australian languages. The term has been overused in popular literature and has almost become a cliché, but nonetheless it refers to an important component of Aboriginal cosmologies. The word Dreaming is preferred by some commentators and has the virtue of being the term frequently used by Aborigines themselves to refer to the ancestral dimension.

Dynamic Figures A term used to refer to figurative art styles in which human figures in particular are displayed in dynamic and graceful aspect.

Dynamic figurative styles are found in the rock art of the Kimberleys, Western Arnhem Land and Cape York Peninsula.

First Fleet The term used to refer to the fleet of convicts and settlers under the command of Captain Arthur Phillip that established the settlement at Port Jackson (Sydney) in 1788, thereby founding the British colony of New South Wales.

Gagadju (Kakadu) The language of the people who used to occupy land in the Alligator rivers region of Western Arnhem Land. They worked for the buffalo shooter and cattleman Paddy Cahill and at the time of Baldwin Spencer's visit in 1912 were the main informants on the rock art of the region around Oenpelli. Their population rapidly declined, mainly as a result of diseases introduced by European colonists. Kakadu National Park is named after them.

Ground Sculptures Sculptures made out of mounded earth or sand that are a characteristic feature of Aboriginal rituals.

Hermannsburg School A group of watercolour artists originally associated with the Lutheran Mission Station of Hermannsburg, southwest of Alice Springs. Its most famous representative was **Albert Namatjira**.

Hollow-log Coffin A tree trunk hollowed out by termites and subsequently painted and decorated, used as the final receptacle for the bones of the dead across many regions of northern Australia.

Inapertwa An **Arrernte** word for a class of embryonic **Dreamtime** beings.

Kadatja Central Australian term for a revenge killer who often travels silently masking his presence with shoes made of emu feathers.

Katej A **language group** in north central Australia.

Koori Term for a supra-regional ethnic group of Aboriginal people from New South Wales and Victoria.

Krill Krill A ritual cycle found in the Kimberleys.

Kunwinjku A **language group** in Western Arnhem Land.

Land Rights Since the 1960s land rights has been one of the major political issues for Aborigines. Until the 1967 referendum, Aborigines were not even full citizens in their own country and had no rights to their land. Since the passing of the Aboriginal Land Rights (Northern Territory) Act in 1976, Aborigines in many parts of northern and central Australia have gained title to their land. However, in many other parts of Australia Aboriginal rights in land remain minimal. Since the Mabo judgement of the High Court in 1992, however, the possibility of extending rights through native title claims has existed, though it remains largely untested.

Language/Linguistic Group In Australia more than two hundred languages were spoken at the time of British colonization and many continue to be spoken. Language is an important component of people's identity, though language groups are seldom political units in themselves.

Maari 'Mother's mother' in the languages of Eastern and Central Arnhem Land. The mother's

mother's **clan** is an important one in the political organization of society, and people's rights in paintings extend to those of their *maari* clan.

Macassans Peoples from the region of Macassar in south Sulawesi traded with Aboriginal people along the coast of Arnhem Land and the Kimberleys for nearly 300 years prior to the Australian government stopping the trade in 1906.

Manager The relationship of manager is an important one in ritual and social organization throughout much of Australia. Managers are a complementary group of kin to the owners of a ritual or an area of land and have the responsibility to see that it is looked after in the appropriate manner. Managers often undertake much of the preparatory work for a ritual.

Mardayin/Marrayin Mardayin is a **Yolngu** word that refers to the sacred dimension of things and to the most restricted objects belonging to a particular **clan**. The related word marrayin has a similar range of meanings in Western Arnhem Land languages, but it is also used to refer specifically to the regional ceremony in which the sacra are revealed.

Marradjirri An exchange ceremony in Central Arnhem Land associated with mortuary practices.

Mimi Stick-like figures associated with a particular phase of Western Arnhem Land rock art, though also a popular theme in contemporary **bark paintings**.

Miny'tji A **Yolngu** word for design, which can be applied to naturally occurring designs as well as humanly produced ones.

Moiety Literally a division in two halves. In Australia it refers to a division of society into two intermarrying halves with a corresponding division of the whole universe along the same lines.

Mokuy A **Yolngu** language term for ghost.

Morning Star An exchange ceremony associated with a pole that represents the passage of the Morning Star across the sky.

Muramura The **ancestral beings** from the Lake Eyre region.

Murri Term for a supra-regional ethnic group of Aboriginal people from southern Queensland.

Native Police The police force established in the early stages of colonization in various states to control the Aboriginal population, often using Aboriginal people from a neighbouring area.

Nyoonga Term for a supra-regional ethnic group of Aboriginal people from the Perth region of Western Australia.

Ochre Iron oxide used as red and yellow pigment throughout Australia.

Outstation Movement The reversal of the policy of moving Aboriginal people to government settlements and mission stations. Instead, people went to live in small communities on their own lands. Djarrakpi, established in the early 1970s, is one such community.

Owner Ownership in Aboriginal Australia is usually collective. Owner refers to the group of people

with primary rights in paintings, objects, land and other resources.

Pintubi A dialect group within the Western Desert **language group.**

Pitjantjatjara Term that covers speakers of a group of dialects of the Western Desert language.

Pukumani The state of bereavement among the Tiwi of Melville and Bathurst Islands. The term is also applied to the ritual paraphernalia associated with the burial ceremony.

Rainbow Serpent/Snake The belief in a transforming python-like creative being associated with rain and waterholes is widespread throughout Australia. The rainbow serpent can be manifest in the form of rainbows and in the sparkling water of streams.

Rom Name of an exchange ceremony in Central Arnhem Land.

Sacred Boards Sacred boards are used in rituals throughout central Australia. They are usually secret or restricted objects incised with geometric designs and decorated for ceremonial performance.

Section/Sub-Section Classificatory kinship terms used in many areas of central and northern Australia which place people into one of a set of four (section) or eight (sub-section) categories. The names by which central Australian artists are known often ends with a sub-section term as a *de facto* surname, as in **Clifford Possum Tjapaltjarri**. The sub-section term implies certain ritual connections and relations to land as well as people.

Song Cycle Sets of songs that recount the actions of **ancestral beings** as they journeyed across the landscape in the **ancestral past**. The concept of 'songline' popularized by the writer Bruce Chatwin has a similar reference.

Spearthrower An object for throwing spears. It is usually a length of wood which can be held in the hand at one end, with a peg at the other end that fits into a hole or groove in a spear. The spearthrower acts as a lever, increasing the accuracy and thrust with which the spear can be thrown. Within the limits of this definition there is enormous room for variation.

Terra Nullius The British legal fiction that Australia was an unoccupied land at the time of its invasion by the British and therefore a settled as opposed to a conquered land. Hence Aborigines were deemed to have no existence in law.

Toas Small sculptures from central Australia that had their origins in the form of direction signs or place indicators.

Totemism In the nineteenth century totemism was thought of as a particular kind of religion in which human beings were thought to have a particularly close relationship with certain animal species. Today, however, the word is applied in a much looser sense. In Aboriginal Australia the relationship between human beings and the spiritual dimension is mediated through landscape and the environment. The word 'totem' is used to refer to the links between people, **ancestral beings** and the landscape which includes the animals which are associated with it.

Tribe 'Tribe' has not proved a useful term in Australia: **'language group'** and **'clan'** or simply 'social group' have been the preferred concepts.

Tywerrenge/Churinga Engraved or incised stone or wooden ceremonial plaques that are the manifestation of **ancestral beings** and are often associated with individual spirituality.

Wagilak/Wawilag Sisters Two ancestral sisters who journeyed across Arnhem Land and laid the foundation for certain regional ceremonies.

Wandjina These **ancestral beings** from the Kimberleys are associated with a particular style of art.

Wangarr A **Yolngu** word referring to the **ancestral past**.

Warlpiri/Walbiri A **language group** in the region northwest of Alice Springs and into the Tanami Desert.

Western Desert Art/Acrylics Western Desert Art is the term that arose to refer to the painted acrylic traditions that have developed in central Australia since the 1970s. The term is a misnomer in the sense that the region it encompasses is much greater than the extent of the Western Desert itself.

Wild Honey/Sugar Bag Terms used to refer to the native bee and its hive and honey.

X-ray Art A style of art in which internal organs of animals or features of, for example, a boat, are shown, as if in an x-ray.

Yilpinji Women's ritual from central Australia.

Yirritja The name for one of the moieties in Eastern and Central Arnhem Land. The other **moiety** is the **Dhuwa**.

Yolngu A **language group** in Eastern and Central Arnhem Land.

Brief Biographies

Ian W Abdulla (b.1947) A member of the Ngarrindjeri people, Abdulla paints images from his childhood at Cobdogla, near Swan Reach on the Murray River, South Australia. These are annotated stories, painted in a naïve style. He began painting in the late 1980s, quickly establishing his reputation, and in 1992 he was awarded a full fellowship from the Aboriginal Arts Unit of the Australia Council.

William Barak (1824–1903) Born a member of the Woworung **language group** in the region of what became Melbourne, Barak was recruited into the **Native Police** in 1841 and served with them until they were disbanded in 1851. He lived in Aboriginal reserves in different parts of Victoria before settling at Coranderrk, where he became a community leader, and his surviving drawings were made there in the 1880s and 1890s. He drew on sheets of cardboard, sometimes backed or mounted, and used watercolours, charcoal and mud **ochres**.

Gordon Bennett (b.1955) A Brisbane-based artist whose 'history paintings' both question European representational practice and provide a commentary on Australian colonialism. In 1989 he was awarded a professional development grant from the Aboriginal Arts Unit of the Australia Council and in 1991 the Moët & Chandon Australian Art Fellowship enabled him to spend a year in France. His works have appeared in many international exhibitions, including *Aratjara* at the Hayward Gallery, London and elsewhere (1993–4), and *In Place (Out of Time)* at the Museum of Modern Art, Oxford (1997).

Johnny BulunBulun (b.1946) A member of the Ganalpuyngu **language group** of the **Yirritja moiety** in Central Arnhem Land, BulunBulun is a bark painter who has also produced works in **ochre** on canvas and has used print media. He has been actively involved in cases to protect the copyright of Aboriginal artists. In 1977 he completed a mural at the Department of Defence, Canberra, and in 1993 he produced a painting for the foyer of Darwin airport. His one-person exhibition at the Hogarth Galleries, Sydney in 1981 was one of the first for a bark painter. In 1991 he was awarded a professional fellowship from the Australia Council. His works have been included in many major exhibitions, including *Crossroads – Towards a New Reality, Aboriginal Art from Australia* in Kyoto and Tokyo (1992), and *Aratjara* (1993–4). He also taught **Lin Onus** clan paintings.

Jeannie Nungarrayi Egan (b.1948) A **Warlpiri** artist whose traditional country is in the Tanami Desert. In 1987 Egan won the Rothmans Foundation Award for Best Painting in Traditional Media. Her paintings, in comparison with those of other artists working at Yuendumu, are characterized by the use of a restricted range of colours. Her work is represented in galleries throughout Australia.

Fiona Foley (b.1964) Belonging to the Badtjala group from Fraser Island (Thoorgine), Queensland, and brought up on Hervey Bay, Foley studied at Sydney College of the Arts and St Martin's School of Art in London. She works in many different media and across media. Her works were included in the pioneering **Koori** art show in Sydney (1984) and she was one of the founding members of the Boomalli Aboriginal Artists Co-operative. She has been an art teacher and curator, and in 1985–7 she spent some time at Ramingining in Arnhem Land, where she has also run a print workshop.

Emily Kame Kngwarreye (c.1910–96) She was an Anmatyerre artist based at Utopia in central Australia. Her early life was spent on cattle stations and she did not begin working as an artist until she was in her seventies. She began making **batiks**, but it was not until she started to paint on canvas in 1988 that her work gained recognition. She was the Holmes à Court Foundation artist in residence at the ICA in Perth in 1988 and in 1992 she was awarded an Australian creative arts fellowship. In 1998, the Queensland Art Gallery curated a major retrospective of her work, which travelled to the Art Gallery of New South Wales and the National Gallery of Victoria.

Tommy McRae (c.1830s–1901) Little is known of his early life. He worked for some time as a stockman before settling at Lake Moodemere near Corowa on the New South Wales/Victoria border in the early 1880s, where he became the head of a self-sufficient community. He supplemented his income from the 1880s by selling books of his drawings, making possum skin cloaks and raising poultry. He may have produced his first drawings for Roderick Kilborn, a station owner at Goojung, on the New South Wales/Victoria border, as early as 1865 and his work appeared in Brough Smyth's *Aborigines of Victoria* (1878) and Katherine Langloh Parker's *Australian Legendary Tales* (1896).

David Malangi (b.1927) Malangi is a member of the Manharrngu **clan** of the **Dhuwa moiety** from Central Arnhem Land. He spent his early life at the Methodist mission at Milingimbi, an island off the coast of Central Arnhem Land. There, in addition to painting, he worked with cattle and made mud bricks for the missionary Edgar Wells. In 1960 he moved to the mainland, where he established a settlement beside the lake at Yathalamarra, near Ramingining. His early paintings impressed the French ethnographer, curator and collector Karel Kupka and as a result are well represented in European collections. Malangi achieved fame in 1966 when one of his early **bark paintings** was used (without his permission) as a design on the first Australian dollar note.

Subsequently, he has been an artist in residence at Flinders University (1982) and Sydney University (1983), and in 1988 he was invited to the opening of the *Dreamings* exhibition at the Asia Society Galleries in New York. Malangi's paintings have a high figurative content and many of them focus on themes from the life of Gumirringu, the great mythological hunter, as he journeyed through Manharrngu country.

Mawalan Marika (1908–67) Mawalan, a member of the Riratjingu **clan** of the **Yolngu**-speaking peoples of northeast Arnhem Land, occupies an important position in the history of Yolngu art. Born before intensive European colonization, he moved to the mission station of Yirrkala when it was established in 1935 on land belonging to his clan. Paintings by him were among the first commissioned by the missionary Wilbur Chaseling. In 1959 he was one of the artists who produced a series of paintings for Stuart Scougall and Tony Tuckson for the Art Gallery of New South Wales in Sydney. These paintings were characterized by the grandure of their conception and the fact that they represented myths in episodic form. With **Narritjin Maymuru** and **Munggurrawuy Yunupingu** he developed a narrative mode of representing myth that was characteristic of much Yirrkala art from the 1960s to 1980s. In 1962 he painted several sections of the panels for the Yirrkala church. He was also one of the leaders of the Yirrkala community in their fight for **land rights** in the 1960s and 1970s. Mawalan taught his daughters as well as his sons to paint and one of them, Banduk Marika (b.1954), has become a leading printmaker. His eldest son Wandjuk (1927–87) was also a respected artist and was a founding member of the Aboriginal Arts Board, becoming its chairman in 1979.

John Mawurndjul (b.1952) A **Kunwinjku**-speaking artist and member of the Kurulk **clan** who lives in the remote homeland centre of Mormega in Western Arnhem Land. He was taught by his father-in-law Peter Marralwanga (*c*.1916–87), and his figures are similarly covered in swathes of cross-hatching, which create a tapestry-like effect. Many of his paintings focus on the themes of the **rainbow serpent** and the Yawk Yawk female **ancestral beings**. His paintings were included in the *Aratjara* exhibition (1993–4) and *In Place (Out of Time)* at MOMA in Oxford in 1997.

Narritjin Maymuru (*c*.1914–81) A member of the Manggalili **clan** of the **Yolngu**-speaking peoples, Narritjin grew up in the Caledon Bay region of northeast Arnhem Land in the period before European colonization. He moved to the newly established mission of Yirrkala in the 1930s, where he was a 'houseboy' for the missionary Wilbur Chaseling. He later worked with an Englishman, Fred Grey, as a cook and deckhand, helping him to establish the Aboriginal settlement of Umbakumba on Groote Eylandt in 1938. After World War II, Narritjin began to paint pictures for sale through the Yirrkala Mission store. In 1962 he was one of the main painters of the **Yirritja moiety** panel for the Yirrkala church and from that period onwards he was a strong campaigner for **land rights**. In 1978, with his son Banapana (1944–86), he was jointly awarded a visiting artistic fellowship at the Australian

National University in Canberra, the first Aboriginal artists to be honoured with such an award. Like **Mawalan Marika**, Narritjin played a major role in encouraging women to produce sacred paintings and several of his daughters, including Bumiti (b.1948) and Naminapu (b.1952), have become widely recognized as artists. His paintings are known for their variety and the complex nature of their symbolism and many of them represent myths in narrative form.

George Milpurrurru (b.1934) Milpurrurru is a member of the Gurrumba Gurrumba **clan** of the Ganalpuyngu **language group** who occupy the region of the Arafura swamp in Central Arnhem Land. He was born at Milingimbi and began his working life as a stockman. Around 1960 he was taught to paint by his father, Ngulmarrmarr (*c*.1911–*c*.1977), a well-known bark painter. Milpurrurru gained a reputation as a leading artist when he lived at Maningrida in the early 1970s, from where he moved to his present residence at Ramingining, close to his clan lands. He paints themes from his Ganalpuyngu country, in particular ones associated with the magpie goose and the life of the swamp lands. He is a very innovative artist whose paintings have transformed over time, though always showing continuities with his clan's traditions. His first individual exhibition was in 1985 at the Aboriginal Artists Gallery in Sydney. His sister Dorothy Djukulul (b.1942) is one of the leading women artists in Central Arnhem Land.

Sally Morgan (b.1951) Artist, printmaker, author and playwright from Western Australia. She studied psychology at the University of Western Australia and is a self-taught artist who gained renown through her 1987 autobiography, *My Place*. Her work was included in two collections of prints commissioned for the 1988 bicentenary: *Right Here, Right Now: Australia 1988* and *The Bicentennial Portfolio*. She has been a member of the Aboriginal Arts Unit of the Australia Council and was created an AM (Member of the Order of Australia) in 1990.

Lofty Bardayal Nadjamerrk (b.*c*.1926) A **Kunwinjku** artist from Western Arnhem Land, Lofty was taught rock painting by his father. As a young man he worked at the mining settlement of Maranboy and later as a stockman on Mainoru Station, before spending the war at the army camp at Mataranka, southeast of Katherine. After the war he moved back to his own country, living at Oenpelli and Maningrida before establishing an outstation at Malkawo and later at Manmoy with Dick Nguleingulei (1920–88). The two artists worked in a similar style reminiscent of the region's rock art. In 1994 Lofty moved to Kamarrkawarn on the Mann River. As well as being a prolific artist, he has assisted with the community of Maningrida's Mann River rock art recording programme.

Albert Namatjira (1902–59) An **Arrernte** man, Namatjira grew up at Hermannsburg Mission, southwest of Alice Springs. He was a skilled stockman and craftsman making implements for sale through the Mission. After expressing a desire to learn to paint, in 1936 he accompanied the artist Rex Battarbee (1893–1973) on a painting trip to Palm Valley, in the hills not far from the Mission. His first one-person show was held

in Melbourne in 1939 and he exhibited regularly after that. He also taught others to paint, many of them his close kin. He was awarded the Queen's coronation medal in 1953 and was presented to her in Canberra in 1954. He was made an Australian citizen in 1957, which gave him the right to buy alcohol. This led to his arrest for supplying it to his relatives. He was sentenced to two months' detention at the settlement of Papunya in 1958 and died the following year.

Angus Namponan (1930–94) He was born at Aurukun, although he spent at least part of his childhood living in the Cape Keerweer region. A speaker of the Wik-Elken language, (also known as Wik-Ngatharr), his nickname was Kuuchenm, meaning 'From the Lancewood [Ridges]'. Angus was a carpenter and house painter whose artistic speciality was woodcarving, mainly producing crocodiles but also other figures.

Trevor Nickolls (b.1949) The son of an Aboriginal mother and an Irish father, Nickolls studied art at the South Australian School of Art in Adelaide and gained a reputation for his *Dreamtime Machinetime* series created between 1978 and 1981. He was a creative arts fellow at the Australian National University in 1981 and spent considerable time in the 1980s in the Northern Territory, based in Darwin, working with other artists. Together with **Rover Thomas**, he was selected to represent Australia at the 1990 Venice Biennale, the first Aboriginal artists to do so.

Lin Onus (1948–96) A self-taught artist based in Melbourne, whose father was a Yorta Yorta from Cummeragunja on the Victoria/New South Wales border. He began by painting landscapes and later also became a printmaker and sculptor. His work was strongly influenced by visits he made to Central Arnhem Land in the 1980s. He won the Museum and Art Gallery of the Northern Territory's Aboriginal Art Award in 1988 and the Australian Heritage Commission's Aboriginal Art Award in 1994. Onus was a member of the Aboriginal Arts Board 1986–8, an inspiring chairperson of its successor, the Aboriginal Arts Unit of the Australia Council, and an influential commentator on contemporary Aboriginal art. His sculptural installation *Dingoes* was part of the 1993–4 *Aratjara* exhibition.

Ginger Riley (Munduwalawala) (b.c.1937) A painter in acrylics on canvas, he belongs to the Mara people and comes from the area of Limmen Bight, south of Groote Eylandt. Riley made didgeridoos, model canoes, carved snakes and material culture items before he began painting in the 1980s at Ngukurr. In 1993 he won first prize in the inaugural Australian Heritage Commission's Aboriginal Art Award. His work was included in the 1993–4 *Aratjara* exhibition and in 1997 a major exhibition of his paintings was held at the National Gallery of Victoria.

Wenten Rubuntja (b.1926) An **Arrernte** speaker, he was born in Alice Springs and spent his early years at the Old Telegraph Station. He began painting in the Hermannsburg watercolour style, but later added Western Desert style acrylics to his repertoire. He is an effective political leader and was chairman of the Central Land Council for much of the 1980s. He has designed stained-glass windows for the Araluen Centre, Alice Springs, and in 1994 produced a series of paintings for the Aboriginal Areas Protection Authority.

Paddy Tjapaltjarri Sims (b.c.1916) Sims is a **Warlpiri** artist born southwest of Alice Springs. He was one of the first Yuendumu artists and in 1983 was centrally involved in the project to paint designs on the doors of the community school. One of his paintings featured in the 1988 *Dreamings* exhibition and the following year he was one of the artists who produced the **ground sculpture** for the *Magiciens de la terre* exhibition in Paris. His work is characterized by vibrant colours and often asymmetrical design.

Ken Thaiday (b.1950) He was born on Erub (Darnley Island) in the Torres Strait. His father was an important dancer and Thaiday began to paint while accompanying his father to ceremonies. He later moved with his family to Cairns, where he was a founding member of the Darnley Island dance group. He constructed masks for dances and this has significantly influenced the form of his sculptures; they have mechanical parts, which enable them to be actively involved in dance performance.

Rover Thomas (1926–98) A member of the Kukatja/Wangkajunga **language group,** Thomas was born in his mother's country along the Canning Stock Route, some 150–700 km (100–425 miles) south and west of Balgo. He spent most of his life working as a stockman on cattle stations throughout the north of Western Australia and only began working as an artist in 1981 at Turkey Creek. His paintings are derived from designs created on ceremonial boards used in rituals in the southern Kimberleys, especially themes associated with the **Krill Krill** ceremony which were revealed to him in dreams. In 1990, Thomas and **Trevor Nickolls** became the first Aboriginal artists to represent Australia at the Venice Biennale. A retrospective exhibition of his work, *Roads Cross: The Paintings of Rover Thomas,* was held at the National Gallery of Australia in 1994.

Uta Uta Tjangala (c.1920–90) A **Pintubi** artist who was born in the vicinity of the Kintore Range, west of Papunya, he was one of the original artists to work with Geoffrey Bardon at Papunya. Together with a number of other senior men, Tjangala produced a series of large-scale canvases in the mid-1970s. Paintings by him were included in the 1988 *Dreamings* exhibition.

Clifford Possum Tjapaltjarri (b.c.1932) An Anmatyerre/**Arrernte** speaker, he was born at Napperby Station, north of Alice Springs, in central Australia, where he worked as a stockman until he was in his mid-thirties. He was one of the last artists to work with Geoffrey Bardon at Papunya in the early 1970s and was chairman of Papunya Tula Artists during the late 1970s and early 1980s. His paintings have developed through a series of recognizable stylistic phases. Some of his early work was done in collaboration with his brother Tim Leura Tjapaltjarri (1939–84) and in the mid-1970s he developed an exceptional ability in handling large canvases. His work has gained an international reputation, and has been seen not only in exhibitions such

as *Dreamings,* but also in one-person shows such as the one at the Institute of Contemporary Arts in London in 1988. In 1985 he was commissioned to produce a mural design for the Araluen Centre, Alice Springs, in 1991 one for the Strehlow Research Foundation, Alice Springs and in the same year one for the new Alice Springs airport.

Johnny Warrangula Tjupurrula (b.*c*.1925) A Lurritja speaker born in the region of Lake Mackay, west of Mount Doreen, he was one of the original group of Papunya artists. Well before he achieved fame as an artist, however, he was recognized as a leading community figure and in 1954 was presented to Queen Elizabeth II, together with Nosepeg Tjupurrula (*c*.1925–93). Early on he developed a style of painting which created a multi-layered effect that led the viewer into the canvas.

Judy Watson (b.1959) A Waanyi artist whose country lies in northwest Queensland, Watson was born at Mundubbera, Queensland. A painter and printmaker, her work has strong environmental resonances and provides subtle social and cultural commentary. She has travelled widely, including residences in Tuscany, Bhopal in India and Samoa, and she spent the year 1995–6 in France on a Moët & Chandon Australian Art Fellowship. Together with **Emily Kame Kngwarreye** and Yvonne Koolmatrie (b.1945) she represented Australia at the 1997 Venice Biennale.

Billy Yirawala (1903–76) A **Kunwinjku** bark painter, he first gained a reputation as an artist when living on Croker Island. There he was a member of a group of artists that included Jimmy MidjawMidjaw (1897–*c*.1985) and Paddy Compass Nambatbara (1890–1973) whose work was collected in 1963 by Karel Kupka. Later, he moved to the mainland, settling at Marrkolidban, midway between Oenpelli and Maningrida. His painting went through a number of stylistic phases. He was perhaps the first bark painter to have a one person exhibition in 1971, which toured to the South Australian Museum, Adelaide, the Ewing Gallery at Melbourne University, and Sydney University. In 1971 he was awarded an MBE (Member of the British Empire). The large collection of Yirawala's works gathered by Sandra Holmes was acquired by the National Gallery of Australia, and in 1982 one of his paintings was used on the Australian 27 cent stamp issued to commemorate the opening of the National Gallery.

Munggurrawuy Yunupingu (*c*.1907–78) Munggurrawuy, like **Mawalan Marika**, was among the first artists who, in 1935, produced **bark paintings** for sale to the missionary Wilbur Chaseling at Yirrkala, and in 1959 his work was collected by Stuart Scougall and Tony Tuckson for the Art Gallery of New South Wales in Sydney. He was a prolific painter until the end of his life, and established a productive relationship with the Melbourne art dealer Jim Davidson, who sold many of his paintings. Munggurrawuy was also a significant carver, in particular of Wuraymu mortuary figures. Munggurrawuy was head of the Gumatj **clan** of northeast Arnhem Land and was one of the leaders of the **Yolngu** people in their fight for **land rights** in the 1960s and 1970s – a

critical period in the history of the Yolngu-speaking peoples. Uniquely, two of his sons became Australian of the Year: Galarrwuy, a well-known politician and chairman of the Northern Land Council, and Mandawuy, leader of the Yothu Yindi rock band.

Key Dates

Numbers in square brackets refer to illustrations

Aboriginal Art

A Context of Events

*c.*50,000–40,000 BP People arrive in Australia

30,000 BP (before present)	Ochre associated with human burial at Lake Mungo, New South Wales

*c.*25,000 BP Ground stone axes in northern Australia among the first in the world

*c.*20,000 BP	Markings made in Koonalda Cave [24]
*c.*18,000 BP	Rock paintings appear in Western Arnhem Land
*c.*13,000 BP	Earliest direct date for rock engravings, in the 'Early Man' rock shelter, north Queensland

*c.*8,000–7,000 BP Australia and New Guinea separate at the Torres Strait

*c.*7,000 BP	The beginning of x-ray art in Western Arnhem Land [31]

1606 AD The Dutch ship *Duyfken* under Willem Jansz makes the first recorded landfall by Europeans in Australia on Cape York Peninsula

1623 The Dutch ship *Arnhem* charts part of the coast of what subsequently became northeast Arnhem Land, in the Northern Territory

1642 The Dutch navigator, Abel Tasman, charts sections of the Tasmanian coast, which he calls Van Diemen's Land, after Anthony van Dieman

*c.*1650–1906 Macassan voyagers visit the north Australian coast annually to trade for trepang

1688 The Englishman William Dampier lands at King Sound in the Kimberleys and records tidal fish-traps along the coast

1770 Captain James Cook on his first voyage around the world charts the east coast of Australia and claims New South Wales for King George III

1788 First Fleet under Captain Arthur Phillip arrives and establishes penal colony settlement at Sydney Cove on 26 January (Australia Day)

1801–3	Matthew Flinders surveys the Australian coast and provides accounts of the rock engravings on Chasm Island, near Groote Eylandt
1802	Nicholas Baudin's expedition discovers painted walls of a bark hut in Tasmania [214]

1830–34 The last few Aborigines remaining in Tasmania are rounded up and forced into exile at Wybalenna on Flinders Island in the Bass Strait

1834 Massacre at Pinjarra of Nyungar by forces led by Stirling, governor of the Swan River colony

1835 The Batman Treaty initiates the alienation of Aboriginal lands in what was to become Victoria

1837	Sir George Grey records Wandjina paintings for the first time, attributing them to overseas visitors [10]

1844–5 Ludwig Leichhardt crosses Australia from Moreton Bay (Brisbane) to Port Essington

Aboriginal Art	A Context of Events
1855 Bark paintings exhibited at the Universal Exposition in Paris	
	1872 The Overland Telegraph between Adelaide and Darwin completed
1879 Bark paintings, probably from Port Essington, Northern Territory, exhibited at the Garden Palace Exhibition in Sydney	
	1884 Kalkatun armed resistance to European colonization ends in massacre at Battle Mountain, north Queensland
1898 Charles Kerry photographs the Burbong ceremony at Quambone Station, one of the last Bora ceremonies held in New South Wales [224]	
1912 Baldwin Spencer makes the first systematic documented collection of bark paintings from Oenpelli for the National Museum of Victoria, Melbourne [3]	
	1914–18 World War I, in which over 60,000 Australians die
	1928 Massacre of Warlpiri people, Coniston Station, near Yuendumu, central Australia
1929 The first major exhibition of Aboriginal art, *Australian Aboriginal Art*, held at the National Museum of Victoria, Melbourne [247]	
	1935 Wilbur Chaseling establishes missionary settlement at Yirrkala, northeast Arnhem Land
1936 Albert Namatjira begins painting in watercolours	
1939 Albert Namatjira's painting, *Haasts Bluff*, purchased by the Art Gallery of South Australia, the first acquisition of an Aboriginal painting by an art gallery	**1939–45** World War II, in which 27,000 Australians die
	1942 In February the Japanese bomb Darwin
1943 *Primitive Art,* the first major Australian exhibition of primitive art, organized by the National Gallery of Victoria and the National Museum of Victoria	
1948 The American–Australian Scientific Expedition to Arnhem Land results in collections of art from Groote Eylandt, Yirrkala and Oenpelli	
1957 Elcho Island Memorial	
1958–9 Scougall and Tuckson expeditions on behalf of the Art Gallery of New South Wales, acquire collection of pukumani poles [133] from Melville and Bathurst Islands and bark paintings from Yirrkala	
1963 The Yirrkala Bark Petition sent to the House of Representatives in Canberra [171, 172]	
	1965 Freedom ride to Moree in New South Wales leads to desegregation of the town swimming pool
1966 A work by David Malangi is reproduced (without his permission) on the first Australian dollar note when the currency is decimalized	
	1967 As a result of a referendum the government can formulate nationwide policy and legislation concerning Aboriginal Australians, and Aborigines are included in national census for the first time. The Gurindji strike at Wave Hill for equal wages
1971 Geoffrey Bardon encourages Billy Stockman, Long Jack Phillipus Tjakamarra and other senior men at Papunya to paint traditional designs on the school walls, marking the beginning of the Western Desert acrylic movement [191]. Yirawala's bark paintings are exhibited at Sydney University, the first individual exhibition of an Aboriginal artist working in a traditional medium	**1971** The Gove land rights case, lost by the people of Yirrkala

Aboriginal Art	A Context of Events

A Context of Events

1972 Aboriginal Tent Embassy set up in Canberra

1973 Establishment of the Aboriginal Arts Board of the Australia Council with Dick Roughsey as chairman

1976 Aboriginal Land Rights (Northern Territory) Act is the first federal land rights legislation to be passed in Australia

1978 Narritjin and Banapana Maymuru are the first Aborigines to be awarded creative arts fellowships (at the Australian National University, Canberra)

1981 *Aboriginal Australia*, the most comprehensive exhibition of Aboriginal art to date, is mounted at the National Gallery of Victoria, the Art Gallery of Western Australia, the Queensland Art Gallery and the Australian Museum.
Exhibitions of Peter Marralwanga's work at the Aboriginal Traditional Artists Gallery in Perth and Johnny BulunBulun's paintings at the Hogarth Gallery, Sydney, are the first individual exhibitions held at a commercial gallery

1983 Aboriginal art figures prominently in the new National Gallery of Australia in Canberra.
The first copyright case over the unauthorized use of Aboriginal art, *Yangarriny Wunungmurra* v *Peter Stripes Fabrics*, is decided in favour of the artist

1984 Museum and Art Gallery of the Northern Territory, Darwin establishes National Aboriginal Art Award

1985 Uluru (Ayers Rock) returned to its Aboriginal owners

1986 *Art and Land*, an exhibition of toas at the South Australian Museum, is a significant step in the exhibition of Aboriginal art as 'art'

1988–90 *Dreamings: The Art of Aboriginal Australia* exhibition tours New York, Chicago and Los Angeles, then the Museum of Victoria, Melbourne and the South Australian Museum, Adelaide

1988 The Aboriginal Memorial [20, 21] is an eloquent Aboriginal response to the bicentennial anniversary of British colonization.
Barunga Statement [173] sent to the House of Representatives in Canberra.
Forecourt mosaic by Michael Nelson Tjakamarra [19] for the new Parliament House in Canberra.
Clifford Possum Tjapaltjarri exhibition at the ICA, London; the first individual Aboriginal artist exhibition outside Australia

1989 *Magiciens de la terre* exhibition, Paris, includes a Yuendumu ground sculpture [249]

1990 Rover Thomas and Trevor Nickolls are the first Aboriginal artists to represent Australia at the Venice Biennale

1992 The Mabo judgement, in which Aboriginal native title to land was recognized for the first time, overturns the doctrine of *Terra Nullius*

1993–4 *Aratjara: Art of the First Australians* exhibition tours Kunstsammlung Nordrhein-Westfalen, Düsseldorf, the Hayward Gallery, London and the Louisiana Museum of Modern Art, Humlebaek (Denmark)

1997 Emily Kame Kngwarreye [212], Yvonne Koolmatrie [14] and Judy Watson represent Australia at the Venice Biennale, under the title *Fluent*

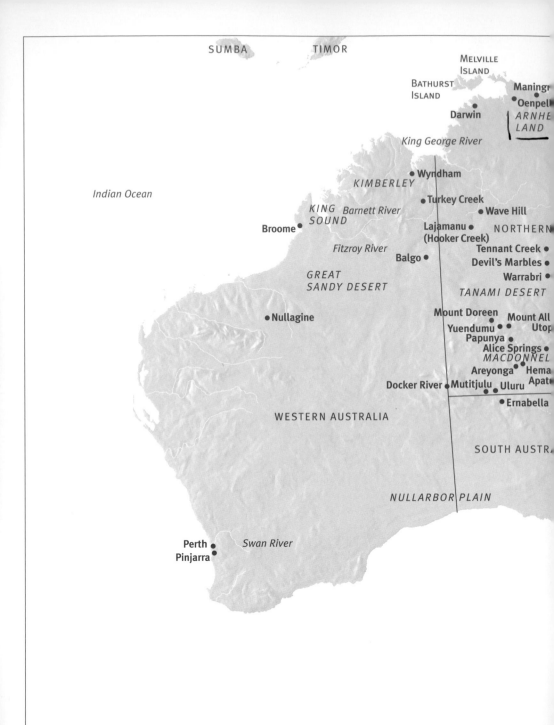

SUMBA TIMOR

MELVILLE
ISLAND

BATHURST Maningr
ISLAND •Oenpel

Darwin ARNHE
LAND

King George River

Indian Ocean •Wyndham

KIMBERLEY

•Turkey Creek

KING Barnett River •Wave Hill
SOUND
Broome • Lajamanu • NORTHERN
(Hooker Creek)

Fitzroy River Tennant Creek •

Balgo • Devil's Marbles •

GREAT Warrabri •
SANDY DESERT TANAMI DESERT

•Nullagine Mount Doreen • Mount All
Yuendumu • • Utop
Papunya •
Alice Springs •
MACDONNEL
Areyonga • Hema
Docker River • Mutitjulu Apat
Uluru

•Ernabella

WESTERN AUSTRALIA

SOUTH AUSTR.

NULLARBOR PLAIN

Perth • Swan River
Pinjarra •

Torres Strait

NEW GUINEA

CAPE YORK

ala

E

OT

*CAPE
KEERWEER*

of Carpentaria

MORNINGTON
ISLAND

• Weipa
• Aurukun

Archer River

Kendall River

• Kowanyama • Laura

Mitchell River

• Cairns

*ATHERTON
TABLELANDS* • Yarrabah

PALM ISLAND

Pacific Ocean

• Battle Mountain

QUEENSLAND

River

e Eyre

Killalpaninna
• Lake Hope

FLINDERS
RANGE

ootpa

de •

•*CARNARVON
GORGE*

Hervey Bay

• Mundubbera FRASER ISLAND

Cooper Creek

• Cherbourg

• Brisbane

Bangate Station • • Moree

Byrock • • Quambone Station
 • Kempsey

Macquarie River

Darling River NEW SOUTH WALES

Lachlan River

Lake Mungo

• Swan Reach

Murray River

Lake Tyrell

VICTORIA Echuca

• Sydney

Shoalhaven River

• Canberra
Corowa • Ulladulla

Overs River

Melbourne • • Coranderrk
Port Phillip Bay MT • Lake Tyers
 BAW BAW

Bass Strait Wybalenna
 • FLINDERS ISLAND
 CAPE BARREN ISLAND

TASMANIA

MARIA ISLAND

Hobart •

Further Reading

Introduction

For a general introduction to Aboriginal society the most comprehensive work remains Berndt and Berndt (1996). The best introductions to Aboriginal art are Berndt, Berndt and Stanton (1982), Caruana (1993), Lüthi (1993), and Sutton (1988). Cooper *et al.* (1981) provide a good pictorial record. Berndt (1964) is an important earlier work.

Ronald Berndt (ed.), *Australian Aboriginal Art* (Sydney, 1964)

Ronald and Catherine Berndt, *The World of the First Australians* (Canberra, 1996)

Ronald and Catherine Berndt and John Stanton, *Aboriginal Australian Art: A Visual Perspective* (Sydney, 1982)

Wally Caruana, *Aboriginal Art* (London, 1993)

Carol Cooper, Howard Morphy, John Mulvaney and Nicolas Peterson, *Aboriginal Australia* (exh. cat., Australian Gallery Directors Council, Sydney, 1981)

Bernard Lüthi (ed.), *Aratjara: Art of the First Australians* (exh. cat., Kunstsammlung Nordrhein-Westfalen, Düsseldorf, 1993)

Peter Sutton, *Dreamings: The Art of Aboriginal Australia* (New York and Ringwood, Victoria, 1988, and London, 1989)

Chapter 1

Smith (1991) provides an excellent outline history of Australian art. Morphy (1987) and Jones (1988) provide overviews of the European history of Aboriginal art. Altman and Taylor (1988) and Altman *et al.* (1989) provide overviews of the economic significance of art to Aboriginal communities. Spencer's descriptions of Oenpelli bark paintings are in Spencer (1914 and 1928). Grey (1841) includes his account of the Wandjina paintings. Rowlinson is cited from Cooper *et al.* (1981). For readings of the *Art and Land* exhibition see Jones and Sutton (1986), and Sutton (1987). For Preston and Australian modernism see McQueen (1979). Tuckson is cited from Berndt (1964). Elkin is cited from his introduction to Elkin, Berndt and Berndt (1950).

Jon Altman and Luke Taylor, *Aborigines, Tourism and Development: The Northern Territory Experience* (Canberra, 1988)

Jon Altman, Chris McGuigan and Peter Yu, *The Aboriginal Arts and Crafts Industry: Report of the Review Committee* (Canberra, 1989)

Ronald Berndt (ed.), *Australian Aboriginal Art*, op. cit.

Carol Cooper *et al.*, *Aboriginal Australia*, op. cit.

A P Elkin, Ronald and Catherine Berndt, *Art in Arnhem Land* (Melbourne, 1950)

George Grey, *Journals of Two Expeditions of Discovery in North-West and Western Australia during the Years 1837, 38 and 39* (London, 1841)

Philip Jones, 'Perceptions of Aboriginal Art' in Peter Sutton (ed.), *Dreamings*, op. cit.

Philip Jones and Peter Sutton, *Art and Land: Aboriginal Sculptures of the Lake Eyre Region* (Adelaide, 1986)

Humphrey McQueen, *The Black Swan of Trespass: The Emergence of Modernist Painting in Australia to 1944* (Sydney, 1979)

Howard Morphy, 'Audiences for Art' in Anne Curthoys, A W Martin and Tim Rowse (eds), *Australians: A Historical Library. From 1939* (Sydney, 1987)

Bernard Smith, with Terry Smith, *Australian Painting, 1788–1990* (3rd edn, Melbourne, 1991)

W Baldwin Spencer, *The Native Tribes of the Northern Territory* (London, 1914)

—, *Wanderings in Wild Australia*, 2 vols (London, 1928)

Peter Sutton, 'The really interesting suggestion ... Yet another reply to Donald Brook on toas', *Adelaide Review*, 34:5 (1987)

Chapter 2

There are a number of introductions to Aboriginal prehistory, of which the most accessible are Flood (1992), Lourandos (1997), and Mulvaney and Kamminga (1999). Flood (1997) provides a good general introduction to Aboriginal rock art. The main source on the history of Macassan contact remains MacKnight (1976). Jones (1985) provides an overview of the prehistory of the Kakadu region. The main sources on Western Arnhem Land rock art include Chaloupka (1993), Lewis (1988), and Taçon (1989 and 1992). Taylor (1989) elucidates x-ray art. My main source on the Wandjina and rock art in general is Layton (1992). Crawford (1968) is a pioneering study of the Wandjina, and Stanton (1989) and Ryan with Akerman (1993) provide excellent reviews of contemporary developments in the Kimberley region. The most comprehensive review of Groote Eylandt art remains Mountford (1956).

George Chaloupka, *Journey in Time: The World's Longest Continuing Art Tradition: The 50,000-year Story of the Australian Aboriginal Rock Art of Arnhem Land* (Chatswood, NSW, 1993)

I M Crawford, *The Art of the Wandjina: Aboriginal Cave Painting in Kimberley, Western Australia* (Melbourne, 1968)

Josephine Flood, *Archaeology of the Dreamtime* (Sydney, 1992)

—, *Rock Art of the Dreamtime* (Sydney, 1997)

Rhys Jones (ed.), *Archaeological Research in Kakadu National Park* (Canberra, 1985)

Robert Layton, *Australian Rock Art: A New Synthesis* (Melbourne, 1992)

Darrell Lewis, *The Rock Paintings of Arnhem Land, Australia* (Oxford, 1988)

Harry Lourandos, *Continent of Hunter-Gatherers: New Perspectives in Australian Prehistory* (Cambridge, 1997)

Campbell MacKnight, *The Voyage to Marege: Macassan Trepangers in Northern Australia* (Melbourne, 1976)

Charles Mountford, *Records of the American–Australian Scientific Expedition to Arnhem Land, vol. 1: Art, Myth and Symbolism* (Melbourne, 1956)

John Mulvaney and Johan Kamminga, *Prehistory of Australia* (Sydney, 1999)

Judith Ryan and Kim Akerman, *Images of Power: Aboriginal Art of the Kimberley* (exh. cat., National Gallery of Victoria, Melbourne, 1993)

John E Stanton, *Painting the Country: Contemporary Aboriginal Art from the Kimberley Region, Western Australia* (Nedlands, Western Australia, 1989)

Paul Taçon, 'Art and the Essence of Being: Symbolic and Economic Aspects of Fish among the Peoples of Western Arnhem Land' in Howard Morphy (ed.), *Animals into Art* (London, 1989)

—, 'The Power of Stone: Symbolic Aspects of Stone Use and Tool Development in Western Arnhem Land, Australia', *Antiquity*, 65 (1992), pp.192–207

Luke Taylor, 'Seeing the Inside: Kunwinjku Painting and the Symbol of the Divided Body' in Howard Morphy (ed.), *Animals into Art*, op. cit.

Chapter 3

Stanner's (1963 and 1979) writings on Aboriginal religion remain most insightful. Charlesworth *et al.* (1992) is a comprehensive reader on the topic. Morphy (1996) presents a considered defence of the concept of Dreamtime, and Morphy (1984) provides an account of the spiritual cycle. The main sources used on central Australia are Spencer and Gillen (1899 and 1927, on the Arrernte), Howitt (1904, on the Lake Eyre region) and Munn (1973, on the Walbiri/Warlpiri). Morphy (1993) discusses Ngalakan concepts of landscape and Berndt (1952) provides a detailed account of the mythology of the Djang'kawu, as does Dunlop's superb film *In Memory of Mawalan* (1983). Jones and Sutton (1986) and Morphy (1977) provide a detailed discussion of toas. On Aurukun sculptures see Sutton (1988). Morphy (1991) provides a comprehensive analysis of Yolngu art.

Ronald Berndt, *Djanggawul: An Aboriginal Religious Cult of North-Eastern Arnhem Land* (London, 1952)

Max Charlesworth, Howard Morphy, Dianne Bell and Ken Maddock (eds), *Religion in Aboriginal Australia: An Anthology* (St Lucia, Queensland, 1992)

A W Howitt, *The Native Tribes of South-East Australia* (London, 1904)

In Memory of Mawalan, film, directed by Ian Dunlop (Film Australia, Sydney, 1983)

Philip Jones and Peter Sutton, *Art and Land*, op. cit.

Howard Morphy, 'Schematisation, Communication and Meaning in Toas' in Peter Ucko (ed.), *Form in Indigenous Art: Schematisation in the Art of Aboriginal Australia and Prehistoric Europe* (Canberra, 1977)

—, *Journey to the Crocodile's Nest* (Canberra, 1984)

—, *Ancestral Connections: Art and an Aboriginal System of Knowledge* (Chicago, 1991)

—, 'Colonialism, History and the Construction of Place: The Politics of Landscape in Northern Australia' in Barbara Bender (ed.), *Landscape: Politics and Perspectives* (Oxford, 1993), pp.205–43

—, 'Empiricism to Metaphysics: In Defence of the Concept of the Dreamtime' in Tim Bonyhady and Tom Griffiths, *Prehistory to Politics: John Mulvaney, the Humanities and the Public Intellectual* (Melbourne, 1996)

Nancy Munn, *Walbiri Iconography* (Ithaca, 1973)

W Baldwin Spencer and F J Gillen, *The Native Tribes of Central Australia* (London, 1899)

—, *The Arunta*, 2 vols (London, 1927)

W E H Stanner, *On Aboriginal Religion* (Sydney, 1963)

—, *White Man Got No Dreaming* (Canberra, 1979)

Peter Sutton, *Dreamings*, op. cit.

Chapter 4

For a detailed analysis of Aboriginal mapping see Sutton (1998). The analysis of central Australian paintings is based on Munn (1973), Ryan (1989) Anderson and Dussart in Sutton (1988), and Johnson (1994). Johnson provides an excellent analysis of Clifford Possum Tjapaltjarri's paintings supported by Dick Kimber's documentation (1994). The references to Munn's work are all from *Walbiri Iconography* (1973). Galarrwuy Yunupingu is cited from Roberts (1978). Dunlop's (1990) film centres on the mythology ritual and landscape of Gurka'wuy. For a wider discussion of the Wawilag mythology in art see Caruana and Lendon (1997). Morphy (1991) provides detailed analysis of the landscape at Djarrakpl, see also Dunlop's *Narritjin* films (1981). On Rover Thomas see Thomas (1994) and for Ginger Riley see Ryan (1997). Sutton (1988) provides the best discussion of Daly River paintings.

Christopher Anderson and Françoise Dussart, 'Dreamings in Acrylic: Western Desert Art' in Peter Sutton (ed.), *Dreamings*, op. cit., pp.89–142

Geoffrey Bardon, *Papunya Tula: Art of the Western Desert* (Melbourne, 1991)

Wally Caruana and Nigel Lendon, *The Painters of the Wawilag Sisters' Story 1937–1997* (exh. cat., National Gallery of Australia, Canberra, 1997)

The Djungguwan at Gurka' wuy, film, directed by Ian Dunlop (Film Australia, Sydney, 1990)

Vivien Johnson, *The Art of Clifford Possum Tjapaltjarri* (Sydney, 1994)

Howard Morphy, *Ancestral Connections: Art and an Aboriginal System of Knowledge* , op. cit.

Nancy Munn, *Walbiri Iconography*, op. cit.

My Country Djarrakpi, film, directed by Ian Dunlop (Film Australia, Sydney, 1981)

Narritjin at Djarrakpi, 2 parts, film, directed by Ian Dunlop (Film Australia, Sydney, 1981)

Janine Roberts, *From Massacres to Mining: The Colonization of Aboriginal Australia* (London, 1978)

Judith Ryan, *Mythscapes: Aboriginal Art of the Desert from the National Gallery of Victoria* (Melbourne, 1989)

—, *Ginger Riley* (exh. cat., National Gallery of Victoria, Melbourne, 1997)

Peter Sutton, *Dreamings*, op. cit.

—, 'Icons of Country: Topographic Representation in Classical Aboriginal Traditions' in David Woodward and Malcolm Lewis (eds), *The History of Cartography, vol. 2:3: Cartography in the Traditional African, American, Arctic, Australian and Pacific Societies* (Chicago, 1998)

—, 'Aboriginal Maps and Plans' in David Woodward and Malcolm Lewis (eds), *The History of Cartography*, op. cit.

Rover Thomas *et al.*, *Roads Cross: The Paintings of Rover Thomas* (exh. cat., National Gallery of Australia, Canberra, 1994)

Chapter 5

The discussion on Eastern Arnhem Land clan designs is based on Morphy (1988 and 1990). The discussion of art in southeast Australia draws on Cooper (1981). Etheridge (1918) provides the most comprehensive record of carved trees. The analysis of Kunwinjku, Western Arnhem Land art is drawn from Taylor (1996). West (1995) provides additional insight into Kunwinjku art. Sutton (1991) discusses the Angus Namponan.

Carol Cooper, 'Art of Temperate Southeast Australia' in Carol Cooper *et al.*, *Aboriginal Australia*, op. cit., pp.29–40

Robert Etheridge, *The Dendroglyphs, or ' Carved Trees' of New South Wales* (Sydney, 1918)

Howard Morphy, 'Maintaining Cosmic Unity: Ideology and the Reproduction of Yolngu Clans' in Tim Ingold, David Riches and James Woodburn (eds), *Hunters and Gatherers, vol.1: History, Evolution and Social Change* (Oxford, 1988)

—, 'Myth, Totemism and the Creation of Clans', *Oceania*, 60 (1990), pp.312–28

Peter Sutton, 'Bark Painting by Angus Namponan', *Memoirs of the Queensland Museum*, 30 (1991), pp.589–98

Luke Taylor, *Seeing the Inside: Bark Painting in Western Arnhem Land* (Oxford, 1996)

Margaret West, *Rainbow, Sugarbag and Moon: Two Artists of the Stone Country, Bardayal Nadjamerrek and Mick Kubarkku* (exh. cat., Museum and Art Gallery of the Northern Territory, Darwin, 1995)

Chapter 6

Richard Schechner (1981) presents a lucid discussion of the concept of restored behaviour. The discussion of brilliance is drawn from Morphy (1992). Mountford (1958) remains the most detailed account of Tiwi art. Spencer and Gillen (1904) provide the account of the fire ritual. Peterson (1970) provides an excellent contemporary analysis of a Warlpiri version. My discussion of Katej ritual aesthetics is based on a reanalysis of Bell's excellent ethnography (1993). The funeral at Trial Bay is the subject of Dunlop's (1979) film, *Mardarrpa Funeral at Gurka'wuy*, and Morphy (1984).

Dianne Bell, *Daughters of the Dreaming* (St Leonards, NSW, 1993)

Mardarrpa Funeral at Gurka' wuy, film, directed by Ian Dunlop (Film Australia, Sydney, 1979)

Howard Morphy, *Journey to the Crocodile's Nest*, op. cit.

—, 'From Dull to Brilliant: The Aesthetics of Spiritual Power among the Yolngu' in Jeremy Coote and A Shelton (eds), *Anthropology, Art and Aesthetics* (Oxford, 1992)

Charles Mountford, *The Tiwi: Their Art, Myth and Ceremony* (London and Melbourne, 1958)

Nicolas Peterson, 'Buluwandi: A Central Australian Ceremony for the Resolution of Conflict' in Ronald Berndt, *Australian Aboriginal Anthropology* (Nedlands, Western Australia, 1970)

Richard Schechner, 'The Restoration of Behaviour', *Studies in Visual Communication*, 7:3 (1981), pp.2–45

W Baldwin Spencer and F J Gillen, *The Northern Tribes of Central Australia* (London, 1904)

Chapter 7

The best available account of Arnhem Land history remains the pioneering work of the Berndts (1954). Donald Thomson's (1949) account of trade and the economic impact of the Macassans remains an important source together with MacKnight (1976). Stephen Wild *et al.* (1986) and Ad Borsboom (1978) provide accounts of exchange ceremonies from Central Arnhem Land. Groger-Wurm (1973) provides excellent documented examples of Morning Star paintings. I used Flinders's (1814) own account of his clashes with Yolngu. For Berndt's collections see Hutcherson (1995). Chaseling (1957) and Wells (1982) are important missionary accounts of contact and in the latter case the struggle for land rights. Berndt (1962) provides a

first-hand account of the Elcho Island Memorial. Milpurrurru (1989) discusses his art. Wells (1971) illustrates the panels in the Yirrkala church and discusses their context. Some documentation of Scougall's collecting is provided by Tuckson (1964) and the *Gamarada* catalogue (1997).

acrylics, as do Anderson and Dussart (1988). For Yuendumu see Dussart (1997) and Congreve (1997) for discussion of the large Yuendumu canvases. On Balgo and Lajamanu see Glowczewski (1991). On Emily Kame Kngwarreye see Perkins (1997) and Neale (1998).

Ronald Berndt, *An Adjustment Movement in Arnhem Land* (Paris, 1962)

Ronald and Catherine Berndt, *Arnhem Land: Its History and Its People* (Melbourne, 1954)

Ad Borsboom, *Marajiri: A Modern Ritual Complex in Arnhem Land* (PhD dissertation, Katholieke Universiteit, Nijmegen, 1978)

Wilbur Chaseling, *Yulengor, Nomads of Arnhem Land* (Melbourne, 1957)

Matthew Flinders, *A Voyage to Terra Australis* (London, 1814)

Gamarada: Friends (exh. cat., Art Gallery of New South Wales, Sydney, 1997)

Helen M Groger-Wurm, *Australian Aboriginal Bark Paintings and their Mythological Interpretation* (Canberra, 1973)

Gillian Hutcherson, *Djalkiri Wanga: The Land is My Foundation. 50 Years of Aboriginal Art from Yirrkala, Northeast Arnhem Land* (exh. cat., Berndt Museum of Anthropology, Nedlands, Western Australia, 1995)

Campbell MacKnight, *The Voyage to Marege*, op. cit.

George Milpurrurru, 'Bark Painting: A Personal View' in Wally Caruana (ed.), *Windows on the Dreaming: Aboriginal Paintings in the Australian National Gallery* (Canberra and Sydney, 1989)

Donald Thomson, *Economic Structure and the Ceremonial Exchange Cycle in Arnhem Land* (Melbourne, 1949)

Tony Tuckson, 'Aboriginal Art and the Western World' in Ronald Berndt (ed.), *Australian Aboriginal Art*, op. cit.

Anne Wells, *This is their Dreaming* (St Lucia, Queensland, 1971)

Edgar Wells, *Reward and Punishment in Arnhem Land* (Canberra, 1982)

Stephen A Wild (ed.), *Rom: An Aboriginal Ritual of Diplomacy* (Canberra, 1986)

Chapter 8

Mountford (1949) and Battarbee (1951) provide first-hand accounts of Namatjira and other artists of the Hermannsburg school. Nelson Graburn's (1976) view is from his introduction. Hardy *et al.* (1992) provide an outstanding critical retrospective on Namatjira's work and place it in its social and historical context. Burn and Stephen are cited from their chapter in Hardy *et al.* (1992). Hermannsburg pottery is the subject of West (1996). Bardon (1991) gives his own account of the origins of the Western Desert acrylics. Maughan and Zimmer (1986) is an important source on early Papunya art, and Johnson (1994) is an important resource on artists. Myers (1989 and 1994) has contributed most to understanding the global context of Western Desert art. Ryan (1989) discusses regional forms of desert

Christopher Anderson and Françoise Dussart, 'Dreamings in Acrylic: Western Desert Art' in Peter Sutton (ed.), *Dreamings*, op. cit., pp.89–142

Geoffrey Bardon, *Papunya Tula*, op. cit.

Rex Battarbee, *Modern Australian Aboriginal Art* (Sydney, 1951)

Ian Burn and Ann Stephen, 'Namatjira's White Mask: A Political Interpretation' in Jane Hardy, Vincent Megaw and Ruth Megaw (eds), *The Heritage of Namatjira* (Port Melbourne, 1992), pp.249–82

Susan Congreve, 'Painting up Big: Community Painting at Yuendumu', *Art and Australia*, 35:1 (1997), pp.88–93

Françoise Dussart, 'A Body Painting in Translation' in Howard Morphy and Marcus Banks (eds), *Rethinking Visual Anthropology* (New Haven and London, 1997), pp.186–202

Barbara Glowczewski, *Yapa: Peintres Aborigènes de Balgo et Lajamanu* (Paris, 1991)

Nelson Graburn, *Ethnic and Tourist Arts: Cultural Expressions of the Fourth World* (Berkeley, CA, 1976)

Jane Hardy, Vincent Megaw and Ruth Megaw (eds), *The Heritage of Namatjira* (Port Melbourne, 1992)

Vivien Johnson, *Aboriginal Artists of the Western Desert: A Biographical Dictionary* (Sydney, 1994)

Janet Maughan and Jenny Zimmer, *Dot and Circle: A Retrospective Survey of the Aboriginal Acrylic Paintings of Central Australia. A Loan Exhibition from the Flinders University of South Australia* (exh. cat., Royal Melbourne Institute of Technology, 1986)

Charles Mountford, *The Art of Albert Namatjira* (Melbourne, 1949)

Fred Myers, 'Truth, Beauty, and Pintupi Painting', *Visual Anthropology*, 2 (1989), pp.163–95

—, 'Beyond the Intentional Fallacy: Art Criticism and the Ethnography of Aboriginal Acrylic Painting', *Cultural Anthropology*, 6:1 (1994), pp.26–62

Margo Neale, *Emily Kame Kngwarreye: Alhalkere – Paintings from Utopia* (exh. cat., Queensland Art Gallery, Brisbane, 1998)

Hetti Perkins (ed.), *Fluent: Emily Kame Kngwarreye, Yvonne Koolmatrie, Judy Watson* (exh. cat., Art Gallery of New South Wales, Sydney, 1997)

Judith Ryan, *Mythscapes: Aboriginal Art of the Desert from the National Gallery of Victoria*, op. cit.

Margaret West, *Hermannsburg Potters* (exh. cat., Museum and Art Gallery of the Northern Territory, Darwin, 1996)

Chapter 9

Griffiths (1996) is the best source on nineteenth-century collectors. Attwood (1989), Sayers (1994) and Broome (1994) provide a relevant historical background. Cooper (1981) laid much of the groundwork for understanding southeast Australian art. I have been strongly influenced by Kleinert's doctoral thesis (1994). The Tasmania analysis is based on Ruhe (1990). For a discussion of contemporary Tasmanian art see Gough (1997). The material on the Sydney region is based on Stanner (1979) and Collins (1798). Illustrations of artefacts from southeast Australia are found in Cooper et al. (1981) and Morphy and Edwards (1988). Sources used include Brough Smyth (1878) and Baudin's journal (Bonnemains et al. 1988). For Cape York Peninsula see Sutton (1988) and McConnel (1935). On Laura rock art see Rosenfeld et al. (1981). On Thancoupie see Isaacs (1982). Little has been written on the art of the Torres Strait. Beckett (1987) is the best general book. Cochrane (1997) provides a brief but useful account of their contemporary art.

Bain Attwood, The Making of the Aborigines (Sydney, 1989)

Jeremy Beckett, Torres Strait Islanders: Custom and Colonialism (Cambridge, 1987)

Jacqueline Bonnemains, Elliott Forsyth and Bernard Smith (eds), Baudin in Australian Waters: The Artwork of the French Voyage of Discovery to the Southern Lands 1800–1804 (Melbourne, 1988)

Richard Broome, Aboriginal Australians: Black Responses to White Dominance, 1788–1994 (St Leonards, NSW, 1994)

Susan Cochrane, 'Torres Strait Islander Art: An Outsider's View', Art and Australia, 35:1 (1997), pp.116–21

David Collins, An Account of the English Colony in New South Wales (London, 1798)

Carol Cooper, 'Art of Temperate Southeast Australia' in Carol Cooper et al., Aboriginal Australia, op. cit., pp.29–40

Julie Gough, 'Time Ripples in Tasmania', Art and Australia, 35:1 (1997), pp.108–115

Tom Griffiths, Hunters and Collectors: The Antiquarian Imagination in Australia (Melbourne, 1996)

Jennifer Isaacs, Thancoupie the Potter (Sydney, 1982)

Sylvia Kleinert, '"Jacky Jacky was a smart young fella": A Study of Art and Aboriginality in South East Australia 1900–1980' (PhD dissertation, Australian National University, Canberra, 1994)

Ursula McConnel, 'Inspiration and Design in Aboriginal Art', Art in Australia, 59 (1935), pp.49–68

Howard Morphy and Elizabeth Edwards (eds), Australia in Oxford (exh. cat., Pitt Rivers Museum, University of Oxford, 1988)

Andrew Rosenfeld, David Horton, John Winter, Early Man in North Queensland: Art and Archaeology in the Laura Area (Canberra, 1981)

Ed Ruhe, 'The Bark Art of Tasmania' in Alan and Louise Hanson, Art and Identity in Oceania (Honolulu, 1990), pp.129–48

Andrew Sayers, Aboriginal Artists of the Nineteenth Century (Melbourne, 1994)

R Brough Smyth, The Aborigines of Victoria: With Notes Relating to the Habits of the Natives of Other Parts of Australia and Tasmania, 2 vols (Melbourne, 1878)

W E H Stanner, 'The History of Indifference thus Begins' in White Man Got No Dreaming op. cit.

Peter Sutton, Dreamings, op. cit.

Chapter 10

This chapter is based on Sayers (1994), Kleinert (1994) and Cooper (1981). The Lin Onus quote is from Onus (1993).

Carol Cooper, 'Art of Temperate Southeast Australia' in Carol Cooper et al., Aboriginal Australia, op. cit., pp.29–40

Sylvia Kleinert, '"Jacky Jacky was a smart young fella", A Study of Art and Aboriginality in South East Australia 1900–1980', op. cit.

Lin Onus, 'Southwest, Southeastern Australia and Tasmania' in Bernard Lüthi (ed.), Aratjara, op. cit., pp.289–96

Andrew Sayers, Aboriginal Artists of the Nineteenth Century, op. cit.

Chapter 11

Many of the arguments in this chapter have been developed in Morphy (1996) and Morphy and Elliott (1997). Relevant discussion is provided by McLean (1998). For Aboriginal Australia see Cooper (1981), for Dreamings see Sutton (1988), and for Aratjara see Lüthi (1993). For Preston see McQueen (1979) and North (1980). Onus (1993) provides an excellent review of contemporary Aboriginal art from southeast Australia. For the historical background I am again indebted to Kleinert (1994). Martin (1993) is cited from his essay in the Aratjara catalogue. Perkins and Lynn are cited from their 1993 publication. Judy Watson is cited from the Wiyana/Perispheria (Periphery) exhibition catalogue. Robert Campbell junior is cited from Artlink (1990). Wedge's work is discussed in Ryan (1996). Caruana (1993) and Onus (1993) discuss Nickolls's work usefully, see also Nickolls (1990). Bennett (1993) discusses aspects of his own work (see also McLean, 1996). For print-making see Lendon (1996).

Artlink, 10:1 and 2 (1990)

Gordon Bennett, 'Aesthetics and Iconography: An Artist's Approach' in Bernard Lüthi (ed.), Aratjara, op. cit., pp.85–91

Wally Caruana, Aboriginal Art, op. cit.

Carol Cooper et al., Aboriginal Australia, op. cit.

Sylvia Kleinert, '"Jacky Jacky was a smart young fella", A Study of Art and Aboriginality in South East Australia 1900–1980', op. cit.

Marcia Langton, 'The Valley of the Dolls: Black Humour in the Art of Destiny Deacon', Art and Australia, 35:1 (1997), pp.100–107

Nigel Lendon, *Groundwork* (Canberra School of
Art, 1996)

Bernard Lüthi (ed.), *Aratjara,* op. cit.

Ian McLean (ed.), *The Art of Gordon Bennett*
(Roseville East, NSW, 1996)

—, *White Aborigines: Identity Politics in
Australian Art* (Cambridge, 1998)

Humphrey McQueen, *The Black Swan of Trespass,*
op. cit.

Jean-Hubert Martin, 'A Delayed Communication' in
Bernard Lüthi (ed.), *Aratjara,* op. cit., pp.32–48

Howard Morphy, 'Aboriginal Art in a Global
Context' in Danny Miller (ed.), *Worlds Apart:
Modernity through the Prism of the Local*
(London, 1996)

Howard Morphy and David Elliott, 'In Place (Out of
Time)' in Rebecca Coates and Howard Morphy
(eds), *In Place (Out of Time): Contemporary Art
in Australia* (exh. cat., Museum of Modern Art,
Oxford, 1997)

Trevor Nickolls and Rover Thomas, *1990 Venice
Biennale, Australia: Artists, Rover Thomas,
Trevor Nickolls* (exh. cat., Art Gallery of Western
Australia, Perth, 1990)

Ian North (ed.), *The Art of Margaret Preston*
(Adelaide, 1980)

Lin Onus, 'Southwest, Southeastern Australia and
Tasmania' in Bernard Lüthi (ed.), *Aratjara,* op.
cit., pp.289–96

Hetti Perkins and Victoria Lynn, *Black Artists
Perspecta 1993* (exh. cat., Art Gallery of New
South Wales, Sydney, 1993)

Judith Ryan, *Wiradjuri Spirit Man: H J Wedge*
(Roseville East, NSW, 1996)

Peter Sutton, *Dreamings,* op. cit.

Peter Timms, 'Judy Watson', *Moët & Chandon
Touring Exhibition* (exh. cat., Melbourne, 1995)

Wiyana/Perispheria (Periphery), (exh. cat.,
Boomalli Aboriginal Artists Co-operative, Sydney,
1993)

Index

Numbers in **bold** refer to illustrations

Acknowledgements

Photographic Credits

A book of this scope is necessarily a collaborative venture. My first debt is to the artists, in particular those of the Manggalili, Djapu, Mardarrpa, Marrakulu and Munyuku clans of northeast Arnhem Land who have taught me so much. Leon White and Naminapu Maymuru White have been invaluable and supportive friends at Yirrkala. I owe a special debt to Luke Taylor and Frances Morphy who read the book through and provided many helpful suggestions and to Sylvia Kleinert, Chris Watson and Nic Peterson who provided valuable comments on specific chapters. Geoffrey Bardon provided invaluable information on the early years of Papunya art. I could not have written the book without the assistance of many arts advisers throughout Australia who greatly facilitated my research, in particular, Andrew Blake and Will Stubbs at Yirrkala, Andrew Hughes at Maningrida, Susan Congreve at Yuendumu and James Cowan at Balgo.

Many people in museums and art galleries helped me with their advice and access to their collections. Margie West of the Museum and Art Gallery of the Northern Territory provided hospitality and inspiration, and helped me out of many difficulties, Djon Mundine and David Kaus of the National Museum of Australia, Carol Cooper, formerly of the Australian Institute of Aboriginal and Torres Strait Islander Studies, Philip Jones of the South Australian Museum, John Stanton of the Berndt Museum, University of Western Australia, Kate White of the Pitt Rivers Museum, University of Oxford, Judith Ryan of the National Gallery of Victoria, Lindy Allen, John Morton and Gaye Sculthorpe of the Museum of Victoria, Wally Caruana, Andrew Sayers, Roger Butler and Janie Gillespie of the National Gallery of Australia, and Mike O'Hanlon, formerly of the British Museum, all helped beyond the call of duty. Kim Akerman, Gordon Bennett, Leanne Bennett, Margo Smith Boles, Annie Clarke, Françoise Dussart, Ian Dunlop, Josephine Flood, Ursula Fredericks, Leanne Handreck, Rebecca Hossack, Jenny Isaacs, Vivien Johnson, Ian Keen, Nigel Lendon, Paul Magin, Vincent Megaw, Nancy Munn, Margaret North, Tony Redmond, Peter Sutton, Paul Taçon, Margaret Tuckson, Anthony Wallis, Judy Watson and Ian White all helped in important ways. At Phaidon Press, Pat Barylski, Julia MacKenzie and Giulia Hetherington were an excellent and indefatigable team.

H M

Australian Institute of Aboriginal and Torres Strait Islander Studies Pictorial Archive, Canberra: 156–7, 218, photo Ian Dunlop 35, photo Robert Edwards 24, photo Howard Morphy 154, photo Gerry Orkin 174; Kim Akerman: 9, 33, 89; Art Gallery of New South Wales, Sydney: 7, 14, 133, 136, 155, 180, 262–3, gift of Dr Stuart Scougall (1959) 43, 66, 97, 165, gift of Dr Stuart Scougall (1960) 16, 123, 152; Art Gallery of South Australia, Adelaide: gift of the Art Gallery of South Australia Foundation (1981) 15, Special Fund & Morgan Thomas Bequest Fund (1939) 182, South Australian Government Grant (1985) 200, Friends of the Art Gallery of South Australia (1990) 201, Australian National University, Canberra: 189–90, photo Howard Morphy 140; Australian National University, Canberra School of Art Collection: 272; Australian Picture Library, Sydney: photo C R Bell 228, photo John Carnemolla 19, photo Leo Meier 31, photo Oliver Strewe 229; Bill Bachman, Hawthorn: 28; collection of Geoffrey Bardon, photo H Munro: 191; Gordon and Leanne Bennett, John Citizen Arts Pty Ltd, Petrie: 270, photo Kenneth Pleban 271, photo Phillip Andrews 281; Berndt Museum of Anthropology, University of Western Australia, Nedlands: 106, 122, 164, 245; Boomalli Aboriginal Artists Co-operative Ltd, Chippendale: 252, 274; Bridgeman Art Library, London: 118; British Council, London: 124; British Museum, London: 170; Cambridge University Museum of Archaeology and Anthropology: 213; Centre Georges Pompidou, Paris: photo K Ignatiadis 249; Ian Dunlop: 80, 87, 96, 107; Eye Ubiquitous, Shoreham: 32; Flinders University of South Australia, Adelaide: photo Iain Willoughby, Multi-media Unit 65, 181; photo Ursula Frederick: 37, 153; Gallery Gabrielle Pizzi, Melbourne: 75, 208, 266, 276; Julie Gough: 272; Hogarth Galleries Pty Ltd, Sydney: 275; courtesy of The Holmes à Court Collection, Heytesbury: 169, 258, 265; Image Library, State Library of New South Wales, Sydney: 215; Jennifer Isaacs, Sydney: 235; Donald Kahn Collection, Salzburg: photo courtesy Exhibits USA, Kansas City 206; Ian Keen: 102; The Kelton Foundation, Santa Monica: 74; Richard Kimber: 137; Kluge-Ruhe Collection, University of Virginia: 56, 129, 139, 159, 160, 197, 203, photo Katherine Wetzel 207, 210; John Miles, Twickenham: 25, 36; Howard Morphy: 12, 17, 26–7, 40, 42, 63, 69, 81–3, 86, 99, 101, 108, 126, 138, 141–151, 167, 247, photo Mike Dudley 205; Mountain High Maps © 1995 Digital Wisdom Inc: pp.432–3; Nancy Munn: 192; Museum and Art Gallery of the Northern Territory Collection, Darwin: 48, 77–8, 112–13, 115–17, 130, 168, 184–8, 195–6, 198, 209, 246, Musée d'Histoire Naturelle, Collection C A Lesueur, Le Havre: photo Alain Havard 214, 219; Museum of Modern Art, Oxford: 253; Museums Board of Victoria, Melbourne: 3, 104, 193, 220–21, 243–4, Baldwin Spencer Collection, courtesy of the Museums Board of Victoria 6, photo by D F Thomson, courtesy of Mrs D M Thomson and the

Museum of Victoria 41, Donald Thomson collection on loan to the Museum of Victoria from the University of Melbourne 162; Museum voor Volkenkunde, Rotterdam: 255; National Gallery of Australia, Canberra: 1, 11, 38, 58, 91, 94, 183, 211, 225, 236, 248, 254, 257, 259, purchased with the assistance of funds from gallery admission charges and commissioned (1988) 20–21, purchased from gallery admission charges (1984) 59, 90, commissioned by the ANG, Canberra and the Australian Bicentennial Authority (1988) 100, Founding Donor's Fund (1984) 109, 194, purchased from gallery admission charges (1986) 114, 202, purchased from gallery admission charges (1987) 158, purchased from Aboriginal Art fund from admission charges 239, purchased from gallery admission charges (1988) 251, Gift of the Philip Morris Arts Grant (1988) 256, Gordon Darling Fund (1988) 278; National Gallery of Victoria, Melbourne: purchased through The Art Foundation of Victoria with the assistance of Esso Australia Ltd, Fellow (1989) 46, purchased from admission funds (1987) 73, presented through the Art Foundation of Victoria by the artist, Fellow, (1997) 93, purchased from admission funds, (1989) 95, purchased (1962) 237–8, purchased through The Art Foundation of Victoria with the assistance of ICI Australia Ltd, Fellow, (1988) 199; National Library of Australia, Canberra: 8; National Museum of Australia, Canberra: 60–2, 110, 178–9, 261, photo Matt Kelso: 34, 47, 131, 176, 223, 230, 260, photo David Reid 22, photo Ben Wrigley 119; Nature Focus, Sydney: photo Paul Taçon 30, 68, Nature Focus/Australian Museum 103, 163, 232; Panos Pictures, London: photo Penny Tweedie 23, 29, 45, 125, 226, 279–80; Parliament House Art Collection, Parliament House, Canberra: 171–3, Nicolas Peterson: 134–5; Pitt Rivers Museum, University of Oxford: 2, 13, 57, 177, 216–17, 222, 231, 233–4; Axel Poignant, London: 105; Powerhouse Museum, Sydney: photo Charles Kerry Studio, Tyrrell Collection, reproduced courtesy of the Trustees of the Museum of Applied Arts and Sciences 224; Queensland Museum, South Brisbane: photo Jeff Wright 120; Rebecca Hossack Gallery, London: 175; RMN Paris: 269; Roslyn Oxley9 Gallery, Sydney: 273; Royal Commonwealth Society Collection, by permission of the Syndics of Cambridge University Library: 10, 161; Sherman Galleries, Sydney: 250; South Australian Museum, Adelaide: 18, 49, 50, 79, 88, 204, 267, photo Scott Bradley 44, 51–5, 111; State Library of Victoria: 240–41; photo Luke Taylor 127; Margaret Tuckson: 132; University Art Museum, University of Queensland, St Lucia: 268; Wilderness Photography, Sedburgh: photo John Noble 264; William Mora Galleries, Melbourne: 227.

The publishers would like to acknowledge and thank the following artists and artists' representatives, galleries and organizations, who have kindly granted permission to publish copyright work:

Aboriginal Artists Agency Limited, Sydney: 22, 43, 56, 58, 65–6, 73–5, 77–9, 88, 136, 152, 165, 184–5, 195–201, 277; Alcaston Gallery, Melbourne: 93; Balang Crafts, Katherine: 38; Gordon Bennett: 268, 270–71, 281; Berndt Museum: 245; Boomalli Aboriginal Artists Co-operative Ltd, Chippendale: 252, 266, 274; Buku Larrngay Arts, Yirrkala: 16, 47, 63, 69, 80, 83, 87, 96–7, 99, 100–101, 129, 139–40, 154, 160, 162, 167–8, 171–2; Bula'Bula Arts, Ramingining: 20, 46, 48, 159, 170; Central Land Council, Alice Springs: 173, 186; Destiny Deacon: 275–6; Ernabella Arts Inc, via Alice Springs: 194; Gallerie Australis, Adelaide: 209; Golvan Arts Management Pty Ltd, Kew: 251, 278; Julie Gough: 272; Greenaway Art Gallery, Adelaide: 267; Hermannsburg Potters, Alice Springs: 187–8; Hogarth Galleries Pty Ltd, Sydney: 275; copyright Sandra Le Brun Holmes: 111; Injalak Arts & Crafts Association Inc, Oenpelli: 107–8, 114, 116–17; Jilamara Arts and Crafts, Melville Island: 133; Kamali Land Council, Broome: 34; Yvonne Koolmatrie: 14; Legend Press Pty Ltd, Artarmon: 11, 180–81, 183; Mary Mácha, Subiaco: 90–91; Claude Mamarika: 37, 153; Maningrida Arts and Culture, Winnellie: 59, 94, 112–13, 115, 118, 155, 158, 169; Manth Thayan Association, Aurukun: 60–2, 119, 261; Milingimbi Community, via Darwin: 123; Minjilang Community Inc, Croker Island: 110; Rachel Nimilga, care of Minjilang Community Inc: 106, 109; Northern Land Council, Casuarina: 173; Parliament House, Canberra, House of Representatives: 171–2; Permanent Trustee Company Limited, Sydney: 15, 248; Queensland Museum, South Brisbane, Board of Trustees: 120; Bridget Riley: 124; Roslyn Oxley9 Gallery, Sydney: 1, 246, 260, 265, 273; Sherman Galleries, Sydney: 250; Basil Roughsey: 236; Ken Thaiday: 225; Tiwi Land Council, Winnellie: 130; Utopia Art, Sydney/Public Trustee of the Northern Territory: 210–12; reproduced by permission of Vi$copy Ltd, Sydney 1998: © Judy Watson 253, 263, © Lin Onus (1988) 258, © Lin Onus (1989) 259; Warlayirti Artists Aboriginal Corporation, Balgo Hills: reprinted with the kind permission of the artist and Warlayirti Artists 95, 175, 207–8; Warlukurlangu Artists Aboriginal Association Inc, of Yuendumu: 189–90, 192, 202–5; Warnayaka Arts Centre, care of Lajamanu Community Government Council: 206; Dianne Whittle: 254–6; William Mora Galleries, Melbourne: 227; Lyn Williams: 257.

Every effort has been made to trace and acknowledge all copyright holders. The publishers would like to apologise should any omissions have been made.

Note

In many Aboriginal communities the use of the names of the recently dead is avoided as a mark of respect and sorrow. Readers should therefore be cautious in using the names of Aboriginal artists referred to in the book when in Aboriginal communities.

This book also contains photographs of some people who have since died, and for their relatives viewing these images without prior warning may cause distress.

Phaidon Press Limited
Regent's Wharf
All Saints Street
London N1 9PA

Phaidon Press Inc.
180 Varick Street
New York, NY 10014

www.phaidon.com

First published 1998
Reprinted 1999, 2001, 2003, 2004, 2006, 2007
© 1998 Phaidon Press Limited

ISBN-13 978 0 7148 3752 9
ISBN-10 0 7148 3752 0

A CIP catalogue record for this book is available
from the British Library.

Typeset in Meta

Printed in Singapore

Cover illustration Mundarrg, *Waijara Spirit
with Wallaby and Honey-Collecting Bags*, 1979
(see p.176)